Rethinking Women's Roles

Rethinking Women's Roles

Perspectives from the Pacific

Edited by
Denise O'Brien
and
Sharon W. Tiffany

UNIVERSITY OF CALIFORNIA PRESS

Berkeley Los Angeles London

University of California Press
Berkeley and Los Angeles, California

University of California Press, Ltd.
London, England

Library of Congress Cataloging in Publication Data

Main entry under title:

Rethinking women's roles.

 Based on papers presented at 2 consecutive meetings of the Association for Social Anthropology in Oceania.
 Bibliography: p.
 Includes index.
 Contents: Feminist perceptions in anthropology / Sharon W. Tiffany—Domesticity and the denigration of women / Marilyn Strathern—Complementarity, the relationship between female and male in the East Sepik Village of Bun, Papua New Guinea / Nancy McDowell—[etc.]
 1. Women—Melanesia—Congresses. 2. Sex roles—Melanesia—Congresses. 3. Women—Oceania—Congresses. 4. Ethnology—Methodology—Congresses. 5. Melanesia—Social conditions—Congresses. 6. Oceania—Social conditions—Congresses. I. O'Brien, Denise. II. Tiffany, Sharon W. III. Association for Social Anthropology in Oceania.
GN668.R45 1984 305.4'2'099 83–24213
ISBN 05–520–05142–4

To
the memory of
Margaret Mead

Contents

Editors' Preface

This volume grew out of papers on the general topic of Women in Oceania presented at two consecutive meetings of the Association for Social Anthropology in Oceania. After a working session in Clearwater, Florida, in 1979, in which over twenty scholars participated, it was clear that a formal symposium and any resulting publication must focus on a limited number of themes in order to be successful. The most significant issues emerging from the working session concerned models and images of women in society, the relationship between women and power, and the historical change in women's roles. We asked members of the 1980 symposium in Galveston, Texas, to discuss one or more of these themes, which, in turn, have structured the chapters in this book.

Our work began with the intent to produce a book about women of the Pacific. Instead, this is a volume about the lives and experiences of women in Melanesia, and it does not give comparable coverage to the other culture areas of Oceania. The reasons for this concentration are various. Some are particular to this book; others are related to the nature of anthropological research in Oceania and to the nature of Pacific Island societies. With the exceptions of Tiffany, who worked in Samoa, and Forman, whose research extends beyond Melanesia, all other contributors conducted their primary research in Melanesian societies. Chapters with a strong ethnographic focus (Counts, chap. 5; McDowell, chap. 3; Nash, chap. 6; and Sexton, chap. 7) are based on the authors' fieldwork in Papua New Guinea. The historical and theoretical chapters (Boutilier, chap. 9; Forman, chap. 8; O'Brien, chap. 4; and Strathern, chap. 3) deal primarily with Melanesian data, although there is comparative material from Australia, Micronesia, and Polynesia in three chapters (Tiffany, chap. 1; Forman, chap. 8; O'Brien, chap. 4).

Anthropologists have long been fascinated by the cultural diversity of Melanesia, and one has only to mention Mead and Malinowski to recall that some of the classic ethnography of this century has been done there. After World War II, when anthropological research intensified throughout the Pacific, researchers were drawn to Melanesia by the dual opportunities of building on these classic foundations and of working in societies that had experienced little or no contact with the non-Melanesian world. For historians, Melanesia is an arena where the influence, ideas, and ambitions of European and Asiatic powers have met and mingled for centuries, most

dramatically during the last hundred years. Events in Melanesia offer unique perspectives on the diversity of colonial experiences, frontier situations, and emerging nations.

A final reason for our initially unintended focus is that the ethnographic and historical questions about women raised in this volume can be discussed in terms of Melanesian societies. Melanesia highlights, often in striking and flamboyant ways, the differences between female and male and the importance of gender in social, economic, and political institutions. We emphasize that this book is about women *in* Melanesia. Although much of our attention has been directed to indigenous women, we have also been concerned with the role of European women in the Pacific as missionaries and venturers to the frontier (Boutilier, chap. 9; Forman, chap. 8), and as ethnographers (O'Brien, chap. 4; Strathern, chap. 2).

Place names in the Pacific have had a confusing evolution over the last hundred years, reflecting the many political changes in the area. The geographic and political connotations of the names used in this volume are as follows:

Oceania (fig. 1) includes four major culture areas: Australia, Melanesia, Micronesia, and Polynesia.

Melanesia (fig. 2): Geographically the principal land areas are the island of New Guinea, the Solomon Islands, New Britain, New Ireland, New Caledonia, Vanuatu (formerly the New Hebrides), Fiji, and the Loyalty Islands.

New Guinea (fig. 2): Now divided politically into Irian Jaya, a province of Indonesia, and referred to geographically as West New Guinea; and Papua New Guinea, a country that became independent in 1975, referred to geographically as East New Guinea. Politically, Papua New Guinea also includes the neighboring islands of Manus, the Trobriands, the D'Entrecasteaux, the Lousiade Archipelago, New Ireland, New Britain, Buka, and Bougainville. Buka and Bougainville are geographically part of the Solomon Islands archipelago. Prior to 1963, when West New Guinea passed under Indonesian control, it was a colony of the Netherlands and was called Dutch New Guinea or Nederlands Nieuw-Guinea. Since 1963, West New Guinea has sometimes been called West Irian or Irian Barat. Prior to 1975, East New Guinea was divided into two political units, both under Australian control: the Territory of Papua and the Territory of New Guinea, collectively known as the Territory of Papua and New Guinea (abbreviated TPNG). The Territory of New Guinea has also been known as Northeast New Guinea, the Mandated Territory of New Guinea, and the Trust Territory of New Guinea. Early in the twentieth century, reflecting colonial conditions, Papua was called British New Guinea, and Northeast New Guinea was known as German New Guinea.

Highland New Guinea (fig. 2), or the *Central Highlands of New Guinea*: A geographic and cultural designation which includes the mountain ranges and valleys extending throughout the center of East and West New Guinea, roughly from the Wissel Lakes (Paniai, Irian Jaya) in the west to Kainantu, Papua New Guinea in the east.

Solomon Islands (fig. 6): Includes geographically Buka, Bougainville, Shortlands, Choiseul, Santa Isabel, Guadalcanal, Malaita, San Cristobal, New Georgia, the Russell Islands, the Santa Cruz Islands, and several Polynesian outliers, among them Tikopia, Ontong Java, Sikaina, Rennell, and Bellona. Politically, Bougainville and Buka are part of Papua New Guinea; the other islands, since their independence in 1978, are designated politically as The Solomon Islands. Prior to independence, they were known as the British Solomon Islands Protectorate (abbreviated BSIP).

Figure 1 illustrates the boundaries of the major Pacific culture areas and identifies the location of peoples and places in Australia, Micronesia, and Polynesia mentioned in the text. Figure 2 depicts Melanesia in more detail, including the locations of peoples and major places mentioned in this volume. Figure 6 delineates populations and place names in the Solomon Islands archipelago. Population names have also changed over the years or have had variant spellings. The alternative spellings of population names have been explained when relevant within particular chapters. The groups include: Belau (formerly Palau, see fig. 1 and chap. 1); Kapauku (sometimes called Ekagi, see fig. 2, and chap. 1); Kuma (fig. 2 and chap. 4), part of a larger population called Minj (fig. 2 and chap. 7); Simbu (formerly Chimbu, see fig. 2 and chap. 7); and Siwai (formerly Siuai, see fig. 6 and chap. 6).

With the exception of proper names, all foreign words are italicized, and their English glosses are written in single quotes. Foreign words in the text are primarily from the indigenous languages of Melanesia and from Neo-Melanesian, a language sometimes called Pidgin, widely spoken and written throughout Papua New Guinea, the Solomons, and Vanuatu. Occasionally a term is enclosed in single quotes (e.g., 'big man') even though its foreign language equivalent is not given, to indicate that the term is originally derived from a Melanesian or other non-English language. Translations from foreign languages, one sentence or more in length, are enclosed in double quotation marks, sometimes with one or more words enclosed in single quotes to indicate that these are glosses for terms already mentioned in the preceding text. Otherwise, double quotation marks are used for statements from English-speaking informants. Sparingly, italics are used to indicate an author's special or restricted usage in English. Long quotations or case studies have been set off by indentations from the body of the text. *European* is used to refer to any person whose ethnic origins are in Western Europe, although he or she may be American, Australian, British, Canadian, or French.

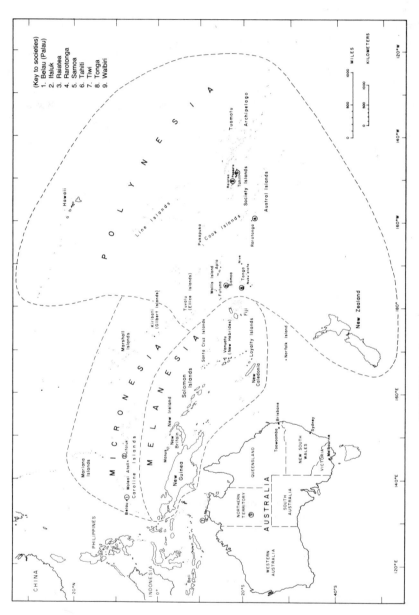

FIGURE 1: Culture Areas of the Pacific

We thank the Association for Social Anthropology in Oceania for providing the forum out of which this book developed, and all the participants in the working session and symposium, whose ideas and comments influenced the final form of this book. In particular, we thank Ward Goodenough, L. L. Langness, and Annette B. Weiner, who were discussants at the 1979 working session, and Ruth Finney and Martha Ward, discussants at the 1980 symposium. Their insights brightened and informed communication among everyone attending the sessions and aided the authors and editors in their tasks of shaping the material for publication. The 1980 symposium was enriched by the presence of several Pacific Islanders: Latu Fusimalohi from Tonga, a student at Stanford University; Lolita Huxel, Department of Literature and Modern Languages at the University of Guam; Piti Maike, Social Development Officer in the Ministry of Youth and Cultural Affairs, Honiara, The Solomon Islands; and Mary Karen Sungino, a student at the University of Guam. Their participation was a highlight for all of us, and we regret that prior commitments precluded their contributing chapters to the volume. We are grateful to the Wenner-Gren Foundation for Anthropological Research and to the Foundation for the Peoples of the South Pacific for grants that covered the travel expenses of some participants in the 1980 symposium. We are further indebted to the Wenner-Gren Foundation for a grant to assist in preparing this book for publication. Thanks go also to our respective academic homes, Temple University and the University of Wisconsin-Whitewater, for their support including travel, typing, and other expenses, and to Jonathan Church, Marilyn Enstad, Laura Isakoff, Rosemary Porter, Carrie Ulrich, and Doris Weiland, who provided valuable editorial assistance. Doris Weiland also drew the figures, and Gloria J. Basmajian, assisted by Sylvia Kaikai, typed the final manuscript.

We are grateful to Jane Goodale, Leonard Mason, Lita Osmundsen, and our editor, James Kubeck, for their encouragement and support during the various stages of this project. The editors have worked together closely on all phases of the work, and our names are listed in alphabetical order. We regard this book as a collective effort which would have been impossible without mutual support and commitment from our contributors. We are especially appreciative of their careful and patient responses to our queries and suggestions and for the alacrity with which they met our various deadlines. Finally, we wish to express our gratitude to the Dani women of Irian Jaya and to the women of Samoa who first helped us recognize and understand the links between their lives and ours.

D. O'B.
S. W. T.

1

Introduction:
Feminist Perceptions
in Anthropology

Sharon W. Tiffany

This book is about women in the Pacific. It is also about knowledge. In it, we examine the diverse experiences of indigenous and expatriate women whose lives shaped and were influenced by their respective societies. We explore the perceptions and values of outsiders, who came to the Pacific to trade, farm, missionize, govern, visit, or conduct research, in terms of the dialectic between Western perceptions of and responses to Pacific Island women. Westerners viewed this island world as complex and occasionally hostile. Similarly, while acknowledging cultural diversity, anthropologists, like other outsiders, have maintained specific presumptions about sex and gender relations—presumptions that have profoundly influenced the understanding of Pacific Island women. In addition to being about women in Oceania, then, this book is also about ourselves as observers and interpreters of exotic others.

Our work is a product of two related concerns: feminist scholarship, and reflexivity—the ideological, social, and personal dynamics of the research process. Each involves assessing past and present knowledge and assuming a critical awareness of self in relation to others. Scholars interested in understanding ethnography must deal with the anthropologist's values and understandings before, during, and after research. Moreover, analyzing interactions of self and others entails considerations of sex and gender, as contemporary feminist scholarship in the social sciences and in the humanities has demonstrated. This book addresses these problems by presenting new research

I am grateful to Ivan Brady, Denise O'Brien, and Marilyn Strathern for their comments on earlier drafts of this chapter.

1

about women in the Pacific and by critically evaluating anthropological discourse about women from a feminist perspective. In the discussion that follows, I briefly outline some issues that highlight these concerns.

Feminism and the Anthropological Enterprise

Feminism questions assumptions concerning what we know about ourselves and others. Anthropology, like other behavioral sciences and humanistic disciplines, is not isolated from feminist issues. Indeed, as the growing literature shows, anthropologists have begun to examine their intellectual frameworks and methods in response to feminist criticisms. Recognizing feminist inquiry as a core concern of anthropology entails a critical examination of anthropological discourse about human relationships.

Recognizing women is a preliminary step in the process of feminist reassessment. By the end of the 1970s, anthropological research on women's lives had achieved a modicum of legitimacy. The rapidly increasing literature emphasizing women as subjects worthy of serious study attests to changing values and perceptions within anthropology (see Tiffany 1978a, 1982c). However, these changes do not necessarily reflect a radical restructuring of the anthropological enterprise, including its modes of discourse and organization of knowledge. Feminist scholars in anthropology are a minority. Their research and writings are likely to be dismissed by colleagues concerned with what the latter perceive as more significant problems. At best, feminism is viewed as a subset of special, even fashionable, topics within the discipline.

This book is part of the growing interest in feminist concerns and their relationship to anthropological inquiry. Focused on indigenous and expatriate societies of the Pacific, the following chapters proceed beyond both geographical and disciplinary boundaries by focusing on feminist issues: Why, for example, have women been perceived as marginal or muted "others"? What are the theoretical implications of excluding women from research and from scholarly discourse? What does being female mean in social systems considered foreign and seemingly irrelevant to Western experiences? How can historical perspectives contribute to an understanding of women in different times and places?

These questions focus attention on existing knowledge about women and on the premises implicit in this knowledge. Three examples will serve to outline the problem. First, conceptualizations of women in Oceania entail ambiguous, even contradictory meanings. Pacific Island women are variously described in fictional, historical, and anthropological literature as chaste or wild, passive or active, queens or slaves, mindless pawns in male intrigues or subverters of men's interests, oppressed drudges or powerful Amazons,

devoted mothers or callous perpetrators of abortion and infanticide (O'Brien n.d., chap. 4; Tiffany 1983, n.d.; Tiffany and Adams 1984).

Second, conceptualizing women also involves what is *not* said about them. Malinowski's voluminous writings on the Trobriand Islands are notable for the invisibility of women. Similarly, Firth's (1959 [1929], 1965 [1939]) volumes on the economic organization of Tikopia and the New Zealand Maori virtually ignore women, despite their important roles in subsistence and ceremonial redistributions in Polynesia (see O'Brien, chap. 4; Tiffany n.d.). Or, to take only two of many examples from more recent anthropological works, Kelly's *Etoro Social Structure* (1977) and Labby's *The Demystification of Yap* (1976) present elegant models of societies that preclude the existence of women. This sort of discourse effectively ignores and silences women.

Third, a cursory overview of the anthropological literature on Pacific Island societies shows that aside from their procreative and domestic functions, Micronesian women, even in matrilineal descent systems, are politically dominated by men; women in Polynesia, regardless of rank, are politically and economically peripheral; relations between the sexes in Melanesia are uniformly characterized by opposition and hostility; and, Australian aboriginal women are brutalized drudges. These conceptions convey specific meanings about women who are dismissable, except when they interfere with male interests. In other words, women are subjects of anthropological inquiry when they pose problems for men.

Feminists maintain that women have been muted by dominant modes of male discourse, beginning with the researcher's assumption that knowledge, derived from relationships among men and from understandings of men, is male. Are Australian aboriginal women independently minded wielders of digging sticks? Or, are they oppressed drudges? Which conceptualization is presented, and from whose perspective? What selective process, for example, led to Freeman's (1983:250) conclusion that in Samoa "the cult of female virginity is probably carried to a greater extreme than in any other culture known to anthropology," or to Whiting's (1941:112) contention that among the Kwoma of Papua New Guinea, "Women never hunt" (O'Brien, chap. 4)? Feminist inquiry challenges anthropological understandings and conclusions about women derived from exclusively male discourse.

Fieldwork, Gender, and Reflexivity

Anthropological knowledge of women is influenced by the dynamics of fieldwork in complex ways. Relations between researcher and informant, as well as assumptions underlying statements such as "the people say" or "informants claim," need to be considered from a feminist perspective. Most dis-

cussions of fieldwork emphasize individual responses to unique situations or how one's gender helped or hindered the work at hand. Golde's *Women in the Field* (1970) focused on women as researchers and the differential responses to female anthropologists by people in the societies studied. Gender, as contributors to Golde's anthology recounted, can have direct and unintended consequences on fieldwork (see also Bowen 1954; Cesara 1982; Slater 1976; Wax 1979). Moreover, fieldwork is an intensely personal and, at times, emotionally charged experience, as Malinowski's (1967) diary of his work in the Trobriand Islands and Mead's (1972) description of her research in Melanesia attest.[1]

The researcher's gender is an important variable in many contexts. But it is only one of many factors operating in the dynamics of participant observation and interaction with informants. The anthropologist's gender should not deflect attention from the fieldwork enterprise itself, and neither should anthropological understandings about women that researchers take to the field with them. Most writings on fieldwork fail to address the problem that the researcher operates within a professionalized domain of male-oriented discourse about sex and gender that reinforces existing understandings of women.[2] Anthropologists of both sexes are socialized into assuming that their observations will focus primarily on men and that most of their informants will be male; by contrast, female perspectives and female knowledge are understood as supplemental to the more general perspectives and knowledge of men.

Meggitt's (1962) book *Desert People*, on the Walbiri aborigines of Australia, provides a subtle illustration of anthropological presumptions about the specificity of female knowledge and of women's place. *Desert People* is supplemented with Meggitt's wife's observations on "child-birth, child-rearing, women's food-gathering activities and the like" (Meggitt 1962:xiv). The unstated assumption seems to be that information about female knowledge and women's domestic roles is nice to collect, if possible, but not essential. The ethnographer's interest in women's knowledge is structured by the presumption that parturition, childcare, and the domestic routine constitute the entirety of women's activities and interests. In other words, the female world is perceived as limited and specific. The male world, by contrast, is considered broad and generalized; it can therefore serve as the core of adequate ethnog-

[1] Detailed discussion of the literature on reflexivity and the anthropology of fieldwork is beyond the scope of this chapter. Readers who wish to pursue additional sources on these and related topics may consult the various references in Freilich (1970:595–624), Golde (1970:333–335), Rabinow (1977:163–164), and Scholte (1972:453–457).

[2] A case in point is the recent anthology on anthropology and reflexivity edited by Ruby (1982), a volume that is flawed by omission of a feminist perspective. The problem of feminism, fieldwork, and reflexivity is discussed in greater detail by Tiffany (n.d.) and Tiffany and Adams (1984).

raphy. Somehow, male anthropologists—lacking wives as helpmates willing and able to observe women and to collect female knowledge—still manage to write balanced ethnographies "designed to bring . . . insights into the richness and complexity of *human* life as it is lived in different ways and in different places" (Spindler 1978:v, emphasis added).[3]

Students of anthropological thought must ask how and why classics published during the early decades of this century, such as *Life in Lesu* (Powdermaker 1933), *Both Sides of Buka Passage* (Blackwood 1935), *Coming of Age in Samoa* (Mead 1928), and *Aboriginal Woman* (Kaberry 1939) were written by female anthropologists about women *and* men, while their male colleagues (e.g., Firth 1957 [1936]; Fortune 1963 [1932]; Malinowski 1922; Whiting 1941) of the same period concentrated almost exclusively on men (see also O'Brien, chap. 4; Tiffany n.d.). Furthermore, one must ask why women's voices are now being heard and heeded by researchers of both sexes. Clearly, this volume speaks to the current challenge of feminist issues posed in Euro-American societies. A study of women's lives, perceptions, and aspirations involves several dimensions. Similarly, the chapters in this book reflect the diverse interests and backgrounds of contributors and are part of the ongoing examination of existing knowledge about women. The authors ask questions and suggest new directions for understanding and incorporating women's experiences into anthropological and historical discourse about Pacific Island social systems.

Women in Pacific Anthropology

Criticizing old models and creating new ones are interdependent activities—both are essential components of intellectual inquiry and paradigmatic change. Feminist inquiry has the potential for bringing about paradigm-induced changes in values and perceptions—changes that provoke controversy and a sense of crisis within a discipline (Kuhn 1970). Yet controversy and crisis are essential to the process of critical self-scrutiny demanded by feminist analysis. By examining the anomaly of women in Pacific Island anthropology, one begins to understand how women are perceived as social and conceptual

[3]George and Louise Spindler are general editors of an extensive series, Case Studies in Cultural Anthropology, published by Holt, Rinehart and Winston, Incorporated, and widely used in undergraduate anthropology courses. Three particularly androcentric case studies of Pacific societies in the series are Barnett's *Being a Palauan* (1960), Hart and Pilling's *The Tiwi of North Australia* (1960), and Pospisil's *The Kapauku Papuans of West New Guinea* (1978). Barnett focuses on dispelling the notion of matriarchy in Belau (formerly Palau) rather than giving a balanced account of a matrilineal descent system. Hart and Pilling depict Tiwi women as political currency exchanged among men. In Pospisil's description of the patrilineal Kapauku (now Ekagi), women are completely marginal.

problems by scholars whose works are considered classics or significant contributions to the discipline.

Marilyn Strathern's richly detailed analysis of the Hagen of Papua New Guinea highlights the difficulties of linking dualistic contrasts to notions of gender and personhood (chap. 2). The problem of conceptualizing non-Western women as "others," using semantically and culturally loaded terms, is at issue. Is it meaningful to speak of Hagen women as domestic and denigrated and Hagen men as public and significant? The nature/culture dichotomy, Strathern argues, is part of the current anthropological preoccupation with oppositions and contrasts. To dichotomize means, in Western thought, to order objects or concepts in a hierarchy of significance. Western dichotomies are also genderized and, therefore, politicized (see also M. Strathern 1980; Tiffany 1979a, 1982a, n.d.). The Western conception of domesticity—as a condition of childlike dependency from which women must be liberated in order to become autonomous persons—is a significant feminist concern in Euro-American societies but inappropriate to Hagen conceptions of women and what is domestic. Strathern concludes that one must "dislodge Hagen notions of domesticity from this sort of matrix" (p. 31).

The concept of complementarity is another example of Western concern with relations of gender and opposition. McDowell discusses (chap. 3) the varied meanings of complementarity in the anthropological literature, particularly within the social and ideological contexts of female/male relationships in Melanesian societies. Genderized dichotomies of opposition or equivalence imply notions of totality or wholeness of symbols, concepts, groups, categories, or other entities that vary situationally or contextually (Feil 1980; O. Harris 1978).

Genderized dichotomies of opposition and equivalence also pose issues of perspective. Do women, as Ardener (1972:135–139) suggests, give inarticulate or muted voice to models of society to which their own menfolk, including the anthropologist as ultimate arbiter of other people's realities, do not respond? Do women accept or dismiss, agree or disagree, with men's models of intersex relations? Do women construct their own models? Are men articulate exponents of male and female realities? Whose models are incorporated into anthropological discourse? McDowell's discussion of gender in Bun, a Sepik village in Papua New Guinea, illustrates the complexity of these questions. Relations of complementarity in Bun society encompass varied understandings of opposition, contrast, sharing, reciprocity, and exchange. No single conception of complementarity suffices to make meaningful, from the perspectives of Bun men and women, the diversity of human behavior.

What women *are* is paradigmatically linked to what they *do*. In chapter 4 O'Brien focuses on ethnographic depictions of what women do in Melanesian societies. Women emerge from anthropological portrayals of the past sixty

years as shadowy anomalies. Contradictory and denigrating images of Melanesian women in the literature demonstrate that women have not been important concerns of anthropological research, nor has the picture substantially changed in more recent times. Women's roles are implicitly connected to the presumed constraints of childbearing and rearing. What women are, accordingly, limits what they can do.

O'Brien's discussion also considers the issue of reflexivity. The complex dialectic of self-evaluation, cross-cultural experiences, researcher/informant relations, and the role of ethnographers as presumptively objective interpreters of others' behavior, links the anthropological enterprise to feminist inquiry. The process of knowing entails perception, articulation, judgment, selection, and synthesis. What anthropologists think they know about women is bound up with culturally loaded valuations of gender, sex, and power.

Women represent special problems in anthropological discourse about politics. Grounded in relations of hierarchy and control, political paradigms conceptualize women as usurpers, subverters, deviants, polluters, troublemakers, or merely nuisances. Thus, women who engage in political action are explained and then dismissed as interlopers in a social world dominated by men (Tiffany 1979b). Among the Lusi of New Britain, Papua New Guinea, women and men utilize similar resources when they have grievances (Counts, chap. 5). Their options include: self-help; appeals to male kin, spouses, or lovers; appeals to other persons of the same sex; appeals to government courts for redress; submission; or suicide. Counts describes the situational contexts of these options for Lusi women. She discusses suicide as a desperate, last-resort strategy when other alternatives or appeals for intervention fail. Suicide, according to Counts, is a culturally patterned expression of power available when other alternatives for redress are exhausted. Self-destruction is the ultimate social act of indirect power over others. The anomaly of assertive and, occasionally, suicidal women confounds conventional political paradigms that focus on male-defined relations of power and authority.

Nagovisi women of Bougainville Island, Papua New Guinea, similarly confound anthropological discourse about matrilineal descent, women's status, and work. Principles of kinship, descent, and residence are linked to social relations and ideological valuations of work and gender in Nagovisi society. Nash writes in chapter 6 that she initially posed the question of "whether changes in relative work contribution by sex and changes in the kind of production associated with each sex have led to changes in the relationships between men and women" (pp. 94–95). Nash's question raises intriguing issues.

The concept of status in anthropological discourse entails specific assumptions about gender. The term *status* presumes structural patterns of differential privileges and rights over persons and resources, including

ideological assessments of relative significance or worth. Discussions of women's status in the anthropological literature involve considerations of opposition and power asymmetries articulated in vocabularies of sex and gender differences. Conceptualizing gender and status in a framework of differential rights and evaluations of self and others parallels anthropological models of work.

The domain of work is more than material transformation of resources and of the social relations involved in economic transactions. Work is linked to notions of identity and personhood and to relations of differential control and privileges (Tiffany 1982*b*; Wallman 1979). According to Nash, correlating indices of status to subsistence must include some notion of how labor itself is evaluated. Nagovisi conceptions of subsistence activities are not framed in the idiom of a sexual division of labor. Rather, "garden-related tasks are conceived of as husband's work and wife's work. There is a strong feeling that shared garden labor is almost as much a part of marriage as is shared sexuality" (p. 100). The intimate connection between Nagovisi marital relations and the social relations of food production is critical. The garden work of Nagovisi wives is viewed as nurturance, a public affirmation of positive social and affective ties that underpin the obligations of marriage.

The introduction of cash cropping has altered spouses' contributions to subsistence but, Nash argues, it has not structurally modified the matrilineal inheritance of land and uxorilocal residence. Government policymakers do not necessarily share Nagovisi conceptions of land tenure and inheritance but, as Nash points out in this volume and elsewhere (Nash 1974), the Nagovisi system of matrilineal descent is not disintegrating under the impact of these externally imposed changes. Instead, Nagovisi women and men are developing new economic strategies within the more traditional framework of matriliny and uxorilocal residence.

The concept of solidarity, like status and work, is multidimensional. The varied contexts and meanings of solidarity suggest the importance of clarifying the social, ideological, psychological, and symbolic components of women's support groups (Bujra 1979:12–17). Sexton describes women's organizations in the Eastern Highlands of Papua New Guinea (chap. 7). Female networks of savings associations and exchange systems, referred to as *Wok Meri* 'women's work', illustrate the collective nature of Highland women's response to a rapidly changing economy oriented toward cash crop production. The political and economic content of 'women's work' relationships is symbolically reinforced by ritual enactments of bride-price and marriage payments and by rituals of marriage and birth—significant events in the female life course.

Eastern Highlands women are active agents of change, using both indigenous and introduced rituals and organizations to achieve their goals. It is

too early, Sexton writes, to determine the potential of 'women's work' for restructuring relations between men and women. As Eastern Highlands women acquire independent resources, as well as organizational and business skills, will they collectively or individually challenge male conceptions of gender relations?

Women in Pacific History

Rethinking anthropological knowledge about women necessarily involves considerations of social change. Historians have given little attention to women's roles in Pacific Island societies. Forman considers the influence of expatriate and indigenous women in shaping religious ideas and institutions (chap. 8). The church, associated with colonial imperium and men, was perceived by islanders as a powerful, authoritative organization that articulated new realities and provided unique opportunities. The development of mission and church organizations, and island women's varying participation in them, were mediated by many factors. These include the organizational structures of specific denominations; the historical circumstances of missionary/islander contact; the types of enterprises undertaken by missionaries (e.g., schools, medical dispensaries, trade stores, cooperatives); the extent of Western contact prior to the mission presence; and, of course, the organization of Pacific Island societies themselves (Tiffany 1978b).

Forman discusses the transformation of religious institutions in island social settings, including the creation of new opportunities and the modification of established roles that island and expatriate women acquired or demanded from the missions (see also Boutilier, chap. 9). Women, particularly the wives of expatriate and island missionaries (the latter were officially called "native teachers") were a significant presence in the societies in which they lived. Island pastors and their wives changed established structures and developed new patterns of mission organization in the societies they served (Forman 1970; Lātūkefu 1978; Wetherell 1980). Wives of expatriate missionaries worked outside formal church structures while fulfilling extensive responsibilities as helpmates to their husbands. Unfortunately, details of these women's lives are, in many cases, lost; even their names are frequently omitted from church records (Charles Forman 1980: personal communication; Wetherell 1980:130, fn. 2).

Most unmarried female missionaries who served in the Pacific were Catholic nuns. By contrast, most Protestant women came to the region as wives of pastors, rather than as missionaries in their own right. Single Protestant women were usually associated with established denominations. A unique exception was Florence S. H. Young, founder and powerful force

behind the Queensland Kanaka Mission (later known as the South Sea Evangelical Mission), which she established on Malaita, Solomon Islands, in 1905 (Boutilier, chap. 9; F. S. H. Young 1925).

Expatriate and indigenous women—as wives, missionaries, members of religious orders, educators, deacons, and as organizers of church groups—assumed diverse roles. Some promoted Victorian models of women as self-sacrificing helpmates to the pastoral endeavors of men. Others created new organizations or modified established ones to meet their own needs and aspirations. The Lutheran mission in the Eastern Highlands of New Guinea, for example, provided indigenous women with opportunities to organize and acquire entrepreneurial and financial experience (Sexton, chap. 7). In comparison, the localized autonomy and affluence enjoyed by Samoan pastors would not be possible without the political and economic support of chiefs' wives and women's church groups (Schoeffel 1977; Tiffany 1978c:441-443).

Western women changed male-defined parameters of the appropriate and expected. Women lived and worked in male-dominated institutional structures of missions, colonial governments, and plantation economies in Pacific Island societies. In chapter 9, Boutilier considers the complex issues raised by nineteenth-century conceptions of women as wives, mothers, civilizers, and moral guardians. The class backgrounds of expatriate women who came to the Solomon Islands at the turn of the century shaped their views about gender, sex, and race. Expatriate women—wives of missionaries, traders, planters, and government officials, as well as married or single women who nursed, taught, proselytized, or traveled in the islands—were arbiters of late ninteenth-century Victorian values and expectations. They domesticated their own men and civilized their dark-skinned charges. In addition, these women responded to rigorous challenges of the unforeseen in a frontier society considered a pestilent backwater of the Empire. Women continually demonstrated their capabilities, resulting in redefinitions of their roles and self-perceptions. Expatriate women were simultaneously colonizers, pacifiers, Victorian role models of the perfect lady, and powerful agents of change in an island setting perceived as a "rough and ready" and thoroughly masculine world.

Western women in the Solomon Islands lived and worked under the constraints of gender, class, and race. The compounding of gender distinctions with those of class and race in the Solomons (and in other Pacific Island societies) was shaped by Western ideas about femininity, sexuality, domesticity, and the noble (or ignoble) savage (see Barwick 1974; Bell 1980; Inglis 1974; Laracy and Laracy 1977; Pearson 1969; Saunders 1980). The complex dynamics of perceptions and values—cast in oppositions of male/female, civilized/pacified, and white/black—were played out in the Solomons by a

small, expatriate community that saw itself as an isolated enclave in a foreign heart of darkness.

The chapters that follow speak to the significance of women. The contributors demonstrate that rethinking Pacific Island societies within the contexts of women's experiences is a preliminary but critical step for defining feminist relevance in Oceanic research, and for incorporating women more completely into anthropological and historical discourse of the future. We have only begun to discover the intellectual challenges that these diverse perspectives have to offer.

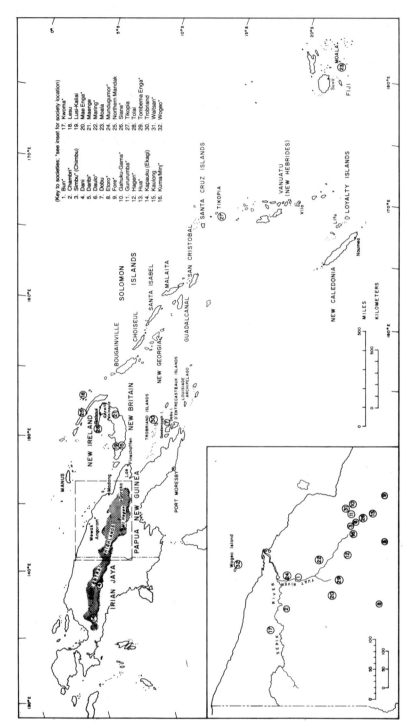

(Key to societies; *see inset for society location)
1. Bun*
2. Chambri*
3. Simbu* (Chimbu)
4. Dani
5. Daribi*
6. Dauo*
7. Dobu
8. Etoro*
9. Fore*
10. Gahuku-Gama*
11. Gururumba*
12. Hagen*
13. Hua*
14. Kapauku (Ekagi)
15. Kaulong*
16. Kuma/Minj*
17. Kwoma*
18. Lesu
19. Lusi-Kaliai
20. Mae Enga*
21. Maenge
22. Maring*
23. Moala
24. Mundugumor*
25. Northern Mandak
26. Siane*
27. Tikopia
28. Tolai
29. Tombema Enga*
30. Trobriand
31. Waitsan*
32. Wogeo*

FIGURE 2: Melanesia

12

2

Domesticity and the Denigration of Women

Marilyn Strathern

It sounds a simple enough proposition that in order to understand other people's models of gender, we first have to be aware of our own, and thus of our own cultural premises. Yet in deliberately detaching oneself from Western stereotypes of male and female, one may well take refuge in postulates based on general theories of the person or of human nature that in the end turn out to be reference points for these very images. Recent criticism of the older ethnography on Melanesian women incorporates two types of explanation. One is that the domains within which women possess power have not been adequately investigated; the other is that women's role in decision making and politics has been underestimated. I argue that both contentions rest on unstated assumptions concerning social behavior, and that these assumptions are rooted in our own cultural formulation of a relationship between nature and culture. The key motivation that makes us search for new ways to describe women's involvement in society lies in the western denigration of domesticity.

Models and Comparisons

As anthropology changes, so do our sensitivities. The demand for contemporary relevance ensures that we constantly outdate ourselves. Fresh thought is frequently signaled by its challenge of older ideas and conceptualizations

I am grateful for discussions with Andrew Strathern on a number of the issues raised here, to Peter Gow, the participants of the ASAO 1980 symposium on Women in Oceania, and especially to the thoughtful comments of Denise O'Brien and Sharon W. Tiffany. Carol D. MacCormack and Gillian Gillison have been supportive and stimulating colleagues. None of these individuals, however, are involved in the position I have taken with respect to the provocative works of Daryl Feil and Annette Weiner, to whom I wish to add my very real thanks for forcing me to reconsider aspects of the Hagen material. Finally, I acknowledge the stimulus of Jean La Fontaine's (1981) paper, "The Domestication of the Savage Male," which I read in manuscript.

Girton College, Cambridge, and the Wenner-Gren Foundation for Anthropological Research assisted with travel expenses, and I am grateful to both institutions.

(see Tiffany, chap. 1). In ethnographic presentations these advances must simultaneously handle questions of cross-cultural comparison and social change, and thus deal in the realm of specifics in the endeavor to set up new models of a general nature. This chapter is concerned with specifics, and for a straightforward, methodological reason. If new ethnography is to throw light on the old, first one has to be certain that the same things are being compared and, second, one must be clear about the source of the new values being introduced in the place of the now-outmoded fallacies that have become easy to discard.

Perhaps anthropology is ultimately saved from perpetual tautology by its dialectic with the social theories of those its studies. These theories can also be included in "the facts," and new viewpoints are often prefaced with the claim that they take up a perspective from within the culture (M. Strathern 1981b). The study of women may thus be legitimized by the claim to see things from a woman's perspective. I do not wish to denigrate this source of anthropological creativity. I merely wish to comment that the sense of reve- lation with which old ethnographies are shown to have been written within a specific cultural/academic framework is matched only by the energy with which contemporary ideas about individual autonomy, women and cultural achievement, minority groups and their rights, society as oppression, and such, are evoked in their stead.

Changing preoccupations in the study of women within the single coun- try of Papua New Guinea over the last decade or so are extremely informative about the enterprise of model building. In order to handle the important question of cross-cultural comparison in detail, I restrict attention to three cases. One is my own field area, Hagen. The second is a neighboring Highland New Guinea society, Tombema Enga (Feil 1978a, 1978b, 1978c); and the third is the more distant Trobriands (Weiner 1976, 1978). Both Feil and Weiner use their own ethnographic experiences as the base upon which to offer substantial criticisms of my presentation of Hagen gender (M. Strathern 1972). They suggest that while some intercultural differences exist, others are illusory, and that my writing is informed by cultural biases. The issue of bias is not one I intend to go into fully (cf. Milton 1979). The problem that ought to interest us as anthropologists is not how bias-free we can become, but how to identify the inevitable sources of bias in our models. It simply gives credence to our own theories of human action to acknowledge ethnocentricity in the discipline. Where Feil and Weiner draw the line be- tween what they are ready to admit as cultural differences and what is mistaken interpretation, arises, I surmise, from ideologies of their own.

Weiner (1976) explicitly argues that my representation of Hagen women ignores a potential female domain of both social and cosmic dimensions. Femaleness in Hagen, she suggests, cannot be fully understood without

taking into account women's exchanges and the symbolism of nurturance and reproduction. Feil (1978a:275) also wonders if my model of interaction between the sexes is at times a male rather than a female one. The Enga women he knows exercise considerable power and make key political decisions in the sphere of ceremonial exchange. My version seems to him blinkered by the ideological division between private and public domains which bolsters the status of men. I have been led astray by the prominent group ideology that colors male transactors' views of themselves (Feil 1978a:268). Weiner and Feil both point to various sociological differences in the organization of Hagen and of the societies of their study; but each also implies that I have not "seen" what is there. It is a serious charge that one has not taken some aspect of one's field situation seriously (see Weiner 1976:13).

There is, of course, constant interplay between what we imagine is before us and the acknowledged theoretical predeliction which alternately blinds and illuminates. In persisting to believe in "the facts" that current theory brings to light, we sustain the reproduction of our discipline. At any specific juncture we are necessarily required to believe that the facts are independently revealed by the new approach, as they were obscured by the old. A desire to treat particular sets of data seriously does not do away with this problem, namely, that analysis itself is not produced by an appeal to a validating body of facts but always requires a specific theoretical orientation. We cannot assume that in correcting a male bias in our models we thereby become bias-free. Neither Feil nor Weiner are guilty of this credulity, for their analyses are informed by explicit approaches to the data. Nevertheless, the way in which they bring Trobriand and Enga women into focus and extrapolate to the Hagen situation involves their drawing on implicit and unstated Western concepts of personal and social action. These are used to great effect. But as unspoken, self-evident premises they are in turn worthy of scrutiny.

To assert that there are crucial differences between women's roles in Hagen and either Enga or Trobriands would be a retreat into ethnography that would resurrect the very problems of interpretation raised by the critics. A more interesting course of action is to inquire both why the criticisms fail to ring true for Hagen, and yet why they also sound so persuasive.

Nature and Culture: The Hidden Dimension

To see things from a Hagen or a Trobriand point of view is the ethnographer's signal that he or she aims to be receptive to actors' categories of action. A similar receptivity is claimed in the intention to see from a woman's point of view. In this case, however, what one sets out to look for may well

incorporate assumptions about social relations contingent upon one's own uses of gender as a source for symbolism. It is this connection that gives rhetorical force to the demand that we consider women's domains of power.

The two writers with whose criticisms I am concerned differ from each other in one regard. Feil suggests that women in fact have greater access to the same spheres of action as are open to men than men's statements alone would indicate, and that what women do is as political as what men do. Weiner points to a domain of feminine power revealed in activities that specifically concern women, a domain that is overlooked if one concentrates simply on the politics of social relations. There is an interesting congruence in their accounts, however, insofar as both imply that to ignore these factors is to see women as less than full persons.

In response to the phrase "women are persons" in an article by Faithorn (1976), Feil (1978b:220) writes: "Women are 'persons' in New Guinea whatever the received notion and whether or not they appear so in the literature." He refers to women as "essential political persons" (Feil 1978a:268), as part of his wider interest in the "individual with his choices, relationships shaped for himself and personal strategies" (Feil 1978c:399). Weiner (1976:212) notes that in the Trobriands "each person is accorded some degree of autonomy in all social relationships. . . . [women] remain decision makers in their own right, . . . individuals with some measure of control" (Weiner 1976:228). What are these constructs of personhood or individuality?[1]

Weiner's material suggests that femaleness emerges ultimately from the artifacts, ideas, values, and symbols associated with women.[2] The basis for her insistence that one should appreciate the power Trobriand women exercise are those culturally explicit activities that not only dramatize female value but also create for women a domain of action. Their cultural achievements are at least equal to those of the men; these are functionally significant to the overall ordering of Trobriand society but, at the same time, are expressed through media appropriated by women themselves. Feil's case fits a rather different supposition, not that women have, as it were, a cultural life of parallel importance to men's but that to treat women as persons one must show them participating in the same spheres as men. As Feil (1978a:265) notes, "They are essential participants . . . influencing and contributing to the exchange partnerships and relations of men whom they link." Tombema

[1]In this chapter I concentrate on formulations of the person rather than of individuality as such, to draw attention to the ways people judge the meaning of others' actions in reference to motivation and intention. I thus use *person* as an evaluative or culturally specific construct. Wagner's (1977:147) term *the cultural self* is perhaps more felicitous. Hagen concepts of the person are discussed in relation to gender imagery in M. Strathern (1981b). (This and following self-references are not offered in an authoritative manner, but to indicate other places where data relevant to the present chapter may be found.)

[2]*Men* and *women* refer to persons; *male* and *female* to gender constructs.

Enga women have power in the realm of *tee* 'ceremonial exchange'. Indeed, women epitomize the essentially interpersonal functions of the ceremonial exchange, and they remind men of its capacity to "transcend the structural units of the society" (Feil 1978*b*:229). Men's and women's interests are to some extent opposed; but women's power and influence lie in matters basic to men's own acquisition of prestige.

Within our own society it is possible to conceive of certain categories of persons being rather less than persons. I take my cue from Ortner's (1974) important publication on nature and culture. Women, she suggests, can appear closer to nature than men in societies where women are associated with children, who must be moved from "a less than fully human state" to full humanity through the offices of men (Ortner 1974:78). Reproduction may compensate for cultural creativity, but domesticity confines women to a low order of social integration. Ortner (1974) attributes these formulations, which are certainly part of our own culture, to the thought systems of other cultures. Western women run the danger of appearing as less than full persons—either because their creativity is in natural rather than cultural matters, or because they belong to the narrower world of the domestic group rather than to the wider social world of public affairs. The very idea of partial humanity or incomplete social orientation rests on a paradigmatic relationship between nature and culture.

Elsewhere MacCormack and I (1980) have argued that, however useful this paradigm is to our concerns as social scientists, we should be cautious about transferring our categories and relationships in the interpretation of other systems of thought. For example, none of the various oppositions that Hageners set up between male/female or collective/personal or even domestic/wild can be satisfactorily glossed by our Western contrast between nature and culture. There is more than semantics involved here. Socialization and social formation are concepts embedded in our own evolutionary and indus-trial heritage. The Hagen view of the person does not require that a child be trained into social adulthood from some presocial state, nor does it postulate that each of us repeats the original domestication of humanity in the need to deal with elements of our precultural nature. "Society" is not a set of controls over and against the "individual," and people's achievements do not culminate in "culture."

Western notions about personhood are set within the framework of evolution. Industry and culture involve a break from nature and domination over it. Within these terms, to be a full person one must be culturally creative.[3]

[3]There is a general tendency, rightly criticized by Weiner, for writers to assume that female reproduction (a "natural" process) is essential to a universal definition of the domestic domain. Bujra (1979:20) suggests that women are "anchored in domestic labour simply because of their innate link with biological reproduction." Rosaldo (1974:24) argues that the "domestic orientation

Western notions are also set within a political and economic formation that assigns autonomy to the workplace, a public sphere away from the infantilizing home. The non-wage earner at home is dependent upon the wage earner, even as the household depends for subsistence on institutions outside it. To be adult, one must break out of the domestic circle.

In Hagen social theory, however, women's identity as persons does not have to rest on proof that they are powerful in some domain created by themselves, nor in an ability to break free from domestic confines constructed by men. Hagen women have no distinctive "culture." Through both symbol and social convention femaleness is associated with domesticity, and in turn this domesticity may symbolize interests opposed to the public and collective interests of men. Yet Hagen women are not thereby overshadowed by the possibility, so denigrating in our own system, that they are somehow less than proper persons.

The Trobriands and Aspects of Reproduction

If I use the word *culture* in relation to Weiner's discussion of Trobriand women, it is in response to her insistence that the value of femaleness is represented through objects and ceremonies of which women are the owners. In this sense they are credited with distinctive achievement, as against the kinds of achievements that bring men renown. It would, nonetheless, be misleading to imply that women are sole creators of this value. Weiner (1976:18) makes it clear that "differences in power structures, for both sexes, are culturally integrated into logical orders of events," and that "women and men, exemplified in the objects they exchange, perceive the value of each other" (Weiner 1976:231). This mutual evaluation comes "through the interface of the value of human beings and the value of regenesis" (Weiner 1976:231).

The power of Trobriand women rests, Weiner argues, on evaluating femaleness in terms of their contribution to reproduction. But this is not mere biology:

We must recognize that one must understand the power structure in which Trobriand women operate in order to understand how Trobriand men perceive themselves.

of women" arises from women's role in child care. MacCormack (Hoffer) (1974) in the same volume presents a contrary case, where childbearing demonstrates women's capacity to hold political office. Perhaps we should take a hint from La Fontaine's (1978) observation that the extent to which a sexual division between domestic and other domains is seen to rest on naturally or biologically prescribed attributes of men and women is itself a conceptualization of the social order (see also Mathieu 1979).

Nature exists in order to be shaped and transformed to serve one's purposes. All manner of human resource and energy is turned to this effort. The basic premise on which this effort is sustained is the regeneration of human beings. The symbolic qualities of exchange objects mirror the preoccupation with the developmental cycle of life and death. . . . Each object symbolically represents some measure of regenesis. (Weiner 1976:230–231)

It is unclear whether one is meant to understand that Trobriand Islanders entertain a distinction between nature and culture; Weiner's own argument apparently derives much of its force from such a scheme. First, biological facts are represented as being put to cultural use: "The natural value of women is made culturally explicit in a variety of primary social and symbolic contexts" (Weiner 1976:17). Thus women contribute to the social value of men and women in such a way as to make human regeneration a central concern of Trobriand culture. Second, Weiner brilliantly inverts our own denigration of women as mere reproducers by demonstrating that in the Trobriands, reproduction itself is presented as a cultural achievement.[4] Third, at issue is not simply the production of children but social reproduction, the perpetuation of certain social identities. At each point, then, women have value because reproduction falls into a *"cultural* domain" (Weiner 1978:175, emphasis in original).[5]

This deliberate widening of the notion of reproduction is compelling in the Trobriand context. Women contribute to the construction of matriliny; they are charged with regenerating the *dala* 'matrilineal kin group', not only through childbirth but also through ceremonies and wealth exchanges.[6] Ties through women are the essence of group definition, and women have the

[4]"Traditionally, reproduction has been viewed in its biological context only. In our own society, we attach little public value to the fact of reproduction, and we forget that a similar view may not be universally shared. In other societies the *cultural* domain of reproduction may be the very basis . . . through which social and cosmological concerns are integrated" (Weiner 1978:175, emphasis in original). In other words, we do not give cultural value to natural processes as Trobrianders do. My analysis here is based on Weiner's published works; I have since had the privilege of reading as yet unpublished papers that both expand and modify her position.

[5]Weiner (1978:183) writes: "I analyze reproduction not as a biological construct, but as a cultural concept in which the basic processes for reproducing human beings, social relations, cosmological phenomena, and material resources are culturally defined and structurally interconnected." Edholm, Harris, and Young (1977) would take exception to the manner in which Weiner runs together human reproduction, social reproduction, and material resources that presumably include labor.

[6]Editors' note: In the text of her monograph Weiner (1976) avoids giving a gloss for the term *dala* and specifically rejects (1976:38–39) the 'subclan/lineage' gloss used by Malinowski and others. In the book's glossary (1976:253), Weiner defines *dala* as "unnamed ancestral beings through which Trobrianders trace their descent through women. . . . *Dala* also refers to hamlet and garden lands. . . ." We have chosen to gloss *dala* as 'matrilineal kin group' in accord with our policy of providing glosses for all foreign terms and with Weiner's usage throughout the monograph, where she refers to *dala* exogamy (1976:451) and *dala* members (1976:38, 43, 45, 49, 55, 225).

task of ceremonially setting *dala* interests off from other categories of relationships. Women thus celebrate an abstract formulation of femaleness that is a vehicle through which specific social relationships are conceptualized.

Trobriand men are in charge of basic food production. They convert labor into prestige, to the extent that certain foodstuffs, particularly yams, circulate as valuables. Women own wealth, and they are recipients of valuables, as they are of male labor. Since it is through women that major group-based ties are traced, transactions between the sexes are bound up with the relationship of individuals to 'matrilineal kin groups', with social continuity and long-term identity. Transactions between men, by contrast, bring renown in a personal, short-term sense. Men bring renown chiefly to themselves, whereas women act on behalf of men and women alike.

A notion of social reproduction in Hagen would have to take different organizational features into account. There is a constant effort on the part of Hagen men to separate labor from prestige. Women produce food, but this is not itself wealth, though it can be tranformed into pigs and, nowadays, money. Wealth objects are the means by which men combine personal renown with that of their clan or subclan. The primordial basis for group solidarity is traced through males; thus there is a congruence between a man's desire for prestige and promotion of his clan and its social continuity (A. Strathern 1972). Insofar as the clan is seen as a set of males, females represent personal, even antisocial concerns. Intersexual transactions are domestic, not political or sociocosmic, events. Hagen women do not manipulate wealth on a public scale, for their contribution to social reproduction is in symbolic antithesis to the flow of wealth through men that ceremonializes all manner of social relations.

Thus Hagen women give little systematic ceremonial expression to their part in human regeneration. They own no counterpart to the skirts which are Trobriand women's social media for controlling "immortality through the recapitulation of *dala* identity" (Weiner 1976:231). The Hagen net-bags to which Weiner draws attention are certainly symbols of nurturance, and the provisioning of food has a central place in women's image of the female. Yet these bags circulate among women along lines of friendship or kinship without also *creating* significant social identities meaningful to either sex.[7] Unlike Tobriand husbands who assist in the procurement of women's skirts,

[7]Among women, net-bags are important gifts at marriage and at the birth of a child (new net-bags are for the bride and old ones are for the mother who will soil the net-bags in which the newborn child is laid). Women may use net-bags to compensate another for some wrong. They are significant items of apparel at death—the widow is overshadowed by the net-bags that bear her husband's soul—but they play no part in mortuary exchanges because they do not have the status of a valuable (M. Strathern 1981a). Hagen women today have not entered the sphere of public exchanges in the manner described by Sexton (chap. 7) for the Daulo area of Highland New Guinea.

Hagen husbands are not involved in the accumulation of net-bags. Whatever power these items represent, it remains covert. Women's net-bags cannot be used in Hagen to make the kind of public announcements that Trobriand skirts effect; Hagen net-bags are not true analogues to Trobriand women's wealth.

It is significant that Hagen clan formation is perceived to turn on ties between males. To be sure, Weiner (1976:118) suggests that ethnographic emphasis on the reproduction of patrilineal identity in accounts of Highlands societies has neglected the regeneration of affinal ties, and that Trobriand women document the importance of their own and also of their husbands' and fathers' *dala*.[8] But more than descent principles are at issue. In Hagen it is *maleness* that carries much of the symbolic load borne by femaleness in the Trobriands. Definitions of maleness are specifically bound up with certain extrasocietal claims to power.

Hagen concern with regenesis is expressed most clearly through the performance of spirit cults (A. Strathern 1970, 1979b). The stated aim of these cults is both fertility in general and clan growth in particular. They are organized by men to the exclusion of women, with men representing a synthesis of male and female powers. Given the Hagen association of males with collective ends and females with personal ones, male cults convert fertility individually manifested into fertility for the clan. At the same time Hagen men bring to bear on domestic reproduction special powers whose sources lie in male access to the wild and to the spirit world.

This access is demonstrated on many occasions. It is recalled, for example, in decorations worn at exchange festivals, when assertions of group strength and identity are made against others. Human clan ghosts figure in support of these political demonstrations. The cults are rather turned inward, in the manifestation of internal health, and the spirits invoked are nonhuman. It is an aspect of their being male that men are able to mediate between these spirits and the human world. Men's interests are not, however, bound by a narrow concern for agnatic welfare. Males are seen to promote clan continuity that is inseparably bound up with their land, their livestock, and the health and fecundity of their wives as much as themselves.[9]

[8]Weiner (1978:175) specifically makes this point against Meggitt (1965), though I fail to see how Meggitt's extensive documentation of Enga wealth exchanges and transfers at marriage and death, in which affinal and matrilateral kin figure, qualifies for "almost a total" lack of attention to the regeneration of affinal relations.

[9]In the context of *moka* 'ceremonial exchange', it is Hagen women's links *between* clans that are celebrated, as well as their role in raising pigs. When women dance, the color of their decorations contains a high element of red. Red is incorporated into the decorations of male participants in the female spirit cult, at one point in an explicit pairing of red and white plumes (A. Strathern 1979b). Femaleness in this context points inward rather than outward, incorporated within the vitality of the clan body.

In the same way as the ceremonial endeavors of Trobriand women embrace the identity of men, so Hagen men through their cults bring fertility to men and women alike. Their aim—the birth of children, productive pigs, and plentiful gardens—is not located within the domain of one sex or the other. Men do not have an exclusive reproductive prerogative; it is as agents of conversion that they participate in the cults—by tapping extrahuman sources of power and by making the fecundity of individuals a matter for clan concern.

Fertility itself is not an exclusive male power, nor is it considered especially female. Its *bisexual* nature is explicit in cult symbolism. Andrew Strathern (1979*b*) notes that for the female spirit cult, not only do the men participating play male to the spirit's female, but they also divide themselves into two sides, representing 'men' and 'women'. Sexual identity as such is not being manipulated; the men are not imitating women. Rather, they present femaleness as a given constituent of the world along with maleness, and the 'men's' and 'women's' sides act in concert.

The exclusion of women does not mean, then, that femaleness is discounted. Hageners believe neither that essential fertility rests with men nor that women have powers men must imitate and control. A male/female contrast *is* being used to differentiate special, nonhuman powers from the mundane and to make statements about social reproduction. Thus women cannot participate because they are held to be polluting, and their destructive potential is, in this context, set against life-giving forces of the spirit. The collective benefits of fertility for the whole clan therefore counter individual interests. Poison, a secret weapon men may deploy against clan solidarity, is said to be as inimical to the female spirit as menstrual fluid is to men.[10] In this equation females are represented as exogenous and intrusive, a danger that comes from beyond the clan boundary, as wives must come. A quite different combination of male and female is recreated within the body of clansmen. There is precise symmetry between the 'men's' and 'women's' sides acting in the cult: male and female come together in procreation as joint contributors to clan strength. Indeed, there is a whole other domain of symbolism invoked outside the cult context which uses intersexual pairing as a metaphor for social interdependence. The mutuality and assistance that should characterize relations among clan brothers is sometimes likened to interaction between spouses, and vice versa.[11] I shall return to this point. For the moment, note

[10]In the female spirit cult, human women are represented as polluting beings from whom the participants are to be protected. If fertility as such is located in neither male nor female but in both, pollution by contrast is humanly female.

[11]Comparisons between clan solidarity and husband/wife cooperation are made outside the cult context as well as within it. In the cult, however, this is a salient emphasis, which is muted elsewhere by other images of husband/wife relations that point to the dangers wives represent to male solidarity.

that in the female spirit cult the reproductive contribution of females is celebrated in a way that clan continuity and solidarity are attributed to the joint interests of men and women.

The incorporation of femaleness within their endeavors should not be interpreted as men trying to control women's biology. In Hagen there is no concept of a "nature" to be shaped and transformed (Gillison 1980; M. Strathern 1980). It would be a travesty of Hagen cosmology to suggest that men imagine they manipulate "nature" through ritual that is "culture." And this is certainly not an antithesis relevant to Hagen gender symbolism.

Weiner's (1976:14) emphasis on the necessity to recognize the kinds of cultural resources at women's disposal partly rests on the extent to which Trobriand Islanders' evaluations of reproduction are different from our own. In stressing the cultural quality of women's roles, Weiner is writing about the significance Trobriand Islanders give to human regeneration; but her intention also seems to be to rescue women from that state of nature implied in our own nature/culture constructs. For her further emphasis on our acknowledging that Trobriand women's symbolic contribution to regenesis is a matter of "power" arises from, I would suggest, a Western equation between culture, control, and personhood. Femaleness in Hagen does not have the range of meanings it carries in the Trobriands. More importantly, one does not have to find for Hagen women a domain of cultural activity that refers to their own special powers in order to take them seriously.

The Enga and the Domestic

There is an analogy between Hagen representations of male and female in the spirit cults and the way the sexes are used as symbols of achievement in *moka* 'ceremonial exchange'. Even as the cults bring fertility to both, men and women alike are held to be interested in the acquisition of prestige. At the same time, Hageners employ a contrast between male and female to differentiate the special nature of these aims from other affairs. As cult fertility appears to be of a pure, male kind against its destructive female counterpart, so prestige appears as a male attribute against the 'rubbishness' of females. The abstract qualities of femaleness used in these evaluations are not to be confused with the Hagen definition of women as persons.

Feil indicates that to take women seriously one must show them as independent actors, as persons whose spheres of action are as significant as those of men. Analytically impeccable as this tenet is from the observer's point of view (since it is the observer who runs the risk of thinking women might not be persons), Feil seeks validation in terms of Tombema Enga ideas. When men put *tee* 'ceremonial exchange' into the context of group relations,

they lose sight of "individuals qua individuals. . . . [By contrast,] women are ever mindful of the interpersonal content of *tee* gifts . . . a woman's perspective on it most closely coincides with what is needed to make [the basic *tee* process] work" (Feil 1978*a*:276). The women's perspective is thus the anthropologist's. This is the same epistemological gambit on which Feil faults my own account: "Strathern's view [also, he suggests, the view of Hagen men] of the *moka* places the public/political/exchange realm separate from and in potential conflict with the private/personal/production sphere" (Feil 1978*a*:268). In place of the Hagen male-dominated contrast between political and domestic domains, Feil puts an Enga female-dominated interest in interpersonal relations. At some points in his analysis these interpersonal networks appear as the essence of the system, in contrast to group-based relations, and at other points these networks are to be seen as being in themselves politicized, so that the political is inseparable from the private.

As an analytical construct, the division between domestic and political domains has been questioned in many recent writings (for an overview, see Yanagisako 1979). Reference should be made to the analyses of Reiter (1975*b*), Rosaldo (1974), Sanday (1974), and Tiffany (1978*a*:42–46), which specifically query the utility of equating a division between the public and domestic with political and nonpolitical action. This is close to Feil's position, except that he does not make the same terminological distinction. Lamphere (1974) gives an effective analysis of women as "political actors" in terms of a sociological differentiation between societies in which domestic and political spheres are separated and those in which no such distinction classifies the activities of men and women. In the former, she suggests, women engage in political action insofar as they bring their own strategies to bear upon men; in the latter, their strategies are more economic in character, directed toward cooperation in everyday activities (Lamphere 1974).

For an understanding of women's position in a sociological sense, these refinements of our notions of political action are helpful. Certainly Feil's criticism of my "group-based analysis" is well taken. Indeed, simply to accept at face value the kinds of evaluations that Hageners make in terms of a domestic/political contrast might obscure the power and influence women exert. Feil is primarily talking about women's power in mundane social affairs, rather than the ceremonialization of femaleness prominent in Weiner's analysis. His account raises important issues for understanding women's involvement in the Tombema *tee*.[12] Nonetheless, in relation to the Hagen material, two methodological reservations are in order.

[12]An ethnographic comparison between Enga and Hagen 'ceremonial exchange' in this context is found in A. Strathern 1979*a*. In suggesting that past accounts of Highland New Guinea men and women have paid undue attention to programmatic statements offered by men, Feil (1978*c*) seems to indicate that individual strategies represent an underlying "reality" (note Feil's metaphor of competition as *below the surface* of agnatic clanship).

First, if we are going to talk about women as persons, we need to clarify whether this simply signals our intention to analyze their behavior as socially meaningful, or whether we are also attempting to encompass indigenous theories of personhood and individual action. On this latter ground, Hageners' concepts of person do not rest on the public dimension of people's actions. Second, if we turn from sociological analysis to the analysis of ideology, then it is a fact that Hageners discriminate between domestic and political domains to evaluate what people do. These categories are relevant to both sexes. Paradoxically, were we to ignore these categories we should also ignore a crucial rubric through which women make a stand for independence.

Hagen men and women both subscribe to a set of equations that associate maleness with public endeavor and prestige, and femaleness with private interests. In opposition to *nyim* 'prestige', private interests are *korpa* 'rubbish'; but they also signal the possibility for autonomy, a highly loaded concept in this culture (M. Strathern 1981*b*). These ideas underpin the extent to which men and women are seen as participating in clan affairs, thus defining actions as falling into the 'open', public domain, or that 'of the house'. Within this scheme the cultural meaning of women's actual influence or decision making is constantly relativized apropos men's influence.

As in Enga, Hagen women's interests do not entirely coincide with those of men. Hagen women, however, do not disagree with the public evaluations made of political and domestic activity; on the contrary, they use this dichotomy for their own ends. They remind men that prestigious transactions rest on domestic production. They remind men of the constant balance that men must keep between social and personal ends (cf. A. Strathern 1979*a*). In stressing the interpersonal basis of *moka* 'ceremonial exchanges', Hagen women do not merely act in accord with its structural principles, as Feil observes for Tombema Enga. The framework set up by the 'prestige/rubbish' or public/private matrix gives Hagen women the terms of reference through which they pursue their own autonomy. The pursuit of personal interests is thereby acknowledged, for it falls into a meaningful pattern. If women appear to be antisocial, undoing the works of men, this arises from the status of personal interests in relation to group-based ones. Similarly, just as women's contribution to procreation is as essential as men's, the classification of males as socially oriented and females as personally oriented symbolizes components found in every individual. Both men and women are as interested in personal goals as women are interested in social ones. Hagen concepts of the person embrace both characteristics.

Feil does not say what theory of the person he is using. It seems compounded of the following elements: that attention is focused on individual women's behavior, intent, and motivation; that women acting by reference to interpersonal interests are acting as persons; and that the person is made visible in contexts of network and choice when decisions are made and influ-

ence is exerted. This leaves in the air the status of men's rubrics that appear to have a more exclusively political or group-oriented basis. Are men less than persons when they "lose sight of the personal content . . . [of] *tee* ['ceremonial exchange'] arrangements" (Feil 1978*a*:276)? There is another implicit dimension to Feil's notion of person. Women as persons apparently have individual power to the extent that they can impose their wishes on others, mainly husbands and male kin in the case of Tombema. This means, we are told, that Tombema Enga women are "clearly not *passive* observer's of men's *tee* activities" (Feil 1978*a*:272; 1978*b*:224, emphasis added). Active, not passive, women are "full participants in social, economic, and political decisions beyond the household level" (Faithorn 1976:87; see also Langness 1976:101). Tombema Enga women's interests are most articulately expressed at home, in private discussions, though these "will certainly have ramifications beyond the private, domestic domain" (Feil 1978*a*:273). Such decision making is to be understood as politically significant, in other words, women are shown as powerful within the very transactional sphere that "Enga men value . . . more than any other" (Feil 1978*a*:276).

Underlying this presentation of Tombema Enga women as persons is a set of ideas specific to Western culture that turn on a denigration of domesticity. To be fully persons in the Western formulation, individuals must be acknowledged as subjects rather than as objects, discrete entities set against society so that subjective autonomy must be demonstrated (in the "real" world.) Two further ideologies may be superimposed on this notion: (1) the real world is to be recognized by its distinction from a domestic domain; and (2) a division between the social/public and private/domestic echoes the equation between culture and the work of man as against nature. Women, tied to the natural processes of reproduction and child care, and confined to a domain set apart from the wider society, are on both counts liable to be conceptualized as less than full persons.

In the Hagen world view there is no counterpart to such anxiety. Whatever the case in Enga, the denigration of domesticity in Hagen is contained within a specific evaluation. It is in respect to activities that lead to prestige that things 'of the house' are 'rubbish'. That female concerns are 'rubbish' within this scheme does not touch on women's stature as persons.

Hagen women exert a more limited influence than men. At times women are placed in humiliating positions of powerlessness; they are "political minors" (M. Strathern 1972:293). Yet it is also true that women are credited with will, volition, and the capacity to put things into a social perspective. Elsewhere I have glossed this as *autonomy*, in the sense that the self and its interests are acknowledged reference points for action. Hagen women are always held responsible for their actions, and it would be inappropriate to conceptualize their status as childlike (cf. M. Strathern 1972:260ff.). A differ-

ence between men and women is that men are institutionally capable of aligning self- and social interest, whereas female autonomy—though it can also achieve this—may be most visible when it flies in the face of social ends. Both women and men have *noman* 'minds', a capacity for judgment and choice, as well as a consciousness of selfhood and of social relationships. There is no single term in Hagen to describe these attributes, unless it is that of being *mbo* 'human'. If we regard these as constituting a theory of personhood, then it is clear that the amount of power women exercise in the public world (i.e., the political content of their decisions) is irrelevant to their definition as persons. Indeed, women often go their own way, following the dictates of their *noman* in the very act of refusing to acknowledge what men would classify as appropriate public goals. But this connotation of autonomy must not be overstressed. Women are also credited by men and believe themselves to set their minds on goals that benefit both sexes.[13] The most regular context in which women's *noman* are engaged in collective endeavor is that of household production—domesticity itself.

The *noman* 'mind, will, awareness' first becomes visible when a child shows feeling for those related to it and comes to appreciate the interdependence that characterizes social relationships—that its mother needs sticks for the fire as much as the child needs food to eat (see McDowell, chap. 3). A gloss of mutuality is put upon the otherwise unequal power relationship between parent and child. The child has a further model of interdependence in the figures of his parents. As two mature adults, husband and wife are portrayed as *mutually* dependent on each other.[14] This interdependence turns on the value put on work as production and as an index of intentional endeavor which is the mark of maturity (A. Strathern 1982). Reciprocal labor within the household comes to symbolize other-directed intentionality (see La Fontaine 1978 for a general discussion, and Harris 1978 for a comparative case). A person's *noman* 'mind' is evinced in *kongon* 'work'. Husband and wife each contribute their labor to the household, a contribution seen as expressing intention and effort, and such labor is not differentially measured by the extradomestic world. The male work of preparing gardens is not esteemed more highly than the female tending crops or cooking of food. The domestic

[13]Insofar as male and female orientations are contrasted, men and women may be said to have differently constituted *noman* 'minds' (see M. Strathern 1978). It is important to reiterate the point that although antisocial manifestations of autonomy are characterized as female, a strong cultural value is put on the preservation of autonomy itself. Since persons are self-governing, cooperative enterprises between the sexes in the household or between sets of clan members are seen to depend on enlisting the interests of individuals.

[14]In Hagen there is no exclusive association between marriage and labor as Nash (chap. 6) describes for the Nagovisi of Bougainville. Nevertheless, there is a degree of explicit mutuality in the relationship between spouses found in no other relationship.

context of women's labor does not reduce their efforts, as in our own society, to something less than work.

The conversion of 'work' into 'prestige' belongs to another realm of discourse, for it remains true that labor (production) is devalued in relation to activities surrounding ceremonial exchange (transaction). This should not be confused with the status of domestic work in a capitalist, wage earning economy (see Bujra 1979; Edholm, Harris, and Young 1977). The domestic unit in Hagen society is not seen to depend on wider institutions, as the Western household depends on an outside workplace, but is viable on its own.[15] Men's public affairs and the pursuit of prestige may belittle the value of domestic labor in the rhetoric of social interests, but this only reminds men that as males they must be effective in their own domestic obligations in order to ensure the willing cooperation of women.

I have tried to separate evaluations of activities that draw on male/female symbols from the constructs of the person by which Hageners of either sex also judge the behavior of men and women. In practice, deliberate play may be made on their overlap. When men state that women are 'strong things' on whom they depend, this acknowledgment is muffled by other assertions that men alone are 'strong' because of their public roles. It is, therefore, helpful to have something of a test situation handy.

The Negation of Personhood

Hageners, mostly young and male (and it is the men I consider here) have been migrating to the coast for some years (M. Strathern 1975). Urban migrants recreate an adolescent culture, at home typified by youths' lack of commitment to ends preoccupying the older men. Migrants avoid ceremonializing public occasions: they downplay oratory, the supreme political art; and they reject any serious application among themselves of those salient epithets, the 'prestigious' and the 'rubbish'. In removing themselves from the world of politics, they may jokingly say they are 'all rubbish' by contrast with people at home. But there is also sarcasm in such a label, for they are questioning the very point of striving for prestige.[16] Migrants would never use the expression frequently applied to true 'rubbish men', that they are 'like women'.

[15] Hence, perhaps, some of the symbolic force in the equation between the husband/wife dyad and a set of clan agnates referred to earlier.

[16] I interpret the sarcasm not as meaning that they really think the men at home are 'rubbish' and themselves 'prestigious', but rather that they have drained the contrast of status value and reduced it to a comment on power: "The men at home think they are great, but their concerns do not touch us. We are beyond their influence." The idiom of 'rubbishness' ("we have nothing to transact with") removes the migrant from the arena in which persuasion and appeal is effective.

To those left at home, the absent migrants show much of the same kind of irresponsibility said to typify female behavior. Yet in terms of the domestic/political framework, which is crucial to evaluations of this nature, migrants confound other aspects of femaleness. Far from being confined to the house, they are mobile and free—in a sense, supermales. Mobility, however, is prized only when it is purposeful. The migrant ostensibly travels to gain money. It is when he fails to return or send money back home that kinsfolk start to label him 'rubbish'. Like the migrants themselves, however, kin back home do not resort to male/female metaphors.

People at home thus continue to judge migrants' behavior by whether it will bring anyone prestige. But they abandon domestic/political and female/male idioms. The reason for this I would suggest is that the longer the migrant stays away, the more crucial the question of mutuality becomes. Relatives get increasingly restless as the optimum time for the youth's marriage comes and goes and they are unable to discharge their obligations. This feeling is matched by concern at the absentee's lack of feeling for them, the inadequacy of the gifts he sends, and the subsequent slide from negligence into neglect. Interdependence is gone. Women, as much as male kinsfolk, are upset by this. The restoration of familial, domestic relationships, let alone clan ties, emerges as the first need.

For their part, if migrants depoliticize their urban affairs, they also dedomesticize them. They ignore the passing of time which at home turns a feckless adolescent into a responsible adult. And in a context where a contrast between male and female is not used to evaluate political and non-political orientations, the female comes to stand for something quite different. Women, as mothers or potential wives, represent adulthood, social responsibility, and interdependence.

Youths in their teens and twenties at home enjoy considerable freedom. Although they marry young, obligations to in-laws and even household duties may be met by others for some years. Most migrants are unmarried, or only newly wed, and they continue to think of themselves as untrammeled by such obligations. These young men constantly remind themselves that they are free to do what they like. Some say they ran away from home to escape marriage. The idea of matrimony is bound up with a man's feelings toward his elders who interest themselves in his general prospects. Above all, it foreshadows an explicit interdependence with the woman who will be his wife. Among the visitors who travel to town or relatives who send messages, women much more potently than men remind migrants of the binding nature of the relationships they sometimes pretend to have shaken off.

Despite criticism at home of migrants, when nonmigrant men visit town they tend to take time off and indulge themselves as heroic supermales. Neither women visitors nor the few women residents in town can do this.

Tearing around and getting drunk are male activities. Perhaps because women in town are so peripheral to men's life there, they are an immediate reminder of ties beyond this domain. Migrants are embarrassed by the presence of female visitors, apologize when they give them gifts, and may express bad feelings at having abandoned their mother or sister. Women's requests lead them back into the responsibilities they have partially discarded.

Migrants are able to ignore the politics and rhetoric of senior men. They find it much harder, however, to denigrate the claims of women. I suggest that it is easier for migrant males to cast themselves into the role of 'rubbish man' than it is to deny those appeals to interdependence with others that make for a proper person.

Conclusions

Concepts of maleness and femaleness may be used to rank activities of one kind or another; yet for Hageners we do not have to erect a model of person-hood predicated either on extradomestic domains of power nor on a politici-zation of domesticity. Indeed, it is the division of labor between spouses that stands for mutuality in general. Within the domestic domain, Hagen women are full persons.

My dialogue with Weiner and Feil has been for a specific purpose. In our models we inevitably draw on our own preoccupations. It is understand-able that approaches to the study of male/female relations should be informed by gender symbols from our own culture. One powerful set of symbols is based on a nature/culture paradigm that denigrates domesticity and raises the question of whether women are regarded as full persons. Yet to insert these values into a description of social behavior that does not rest upon such a paradigm is, at the least, risky.

In Hagen terms, women's association with procreation and children renders them polluting and weak, yet these symbols are to be distinguished from our own. We regard the housebound woman as childlike and dependent. Western women may be agents of socialization, but they are associated with its earliest phases, which involve anxiety over the preverbal training of infants in whom must be instilled certain habits.[17] Socialization reproduces the social evolution of humanity and the creation of culture. Children become persons as they begin to manipulate artifacts and learn social rules. The mother, in

[17]O. Harris (1980) gives an interesting account of Bolivian education, which uses language as the instrument of socialization, in contrast to our own practices in their habit-forming, stimulus-response methods of training. These latter practices are based partly on our ideas of the person as made up of a mixture of innate and malleable components.

the Western world view, is gatekeeper to the outer world; hence, our paradoxical concept of independence to refer to entry into this world. The mother is tainted by this state of dependency, reinforced in her role as wife, and dependent—as the subsistence of the household is dependent—on the husband's income. Work in the world outside the home liberates women from this condition (Wallman 1978:49).

This rendition of Western stereotypes is spelled out in order to dislodge Hagen notions of domesticity from this sort of matrix. In Hagen, those confined to the domestic domain are not regarded as less than adult, as incapable of autonomous action. A woman's contribution to the household is seen as a matter of her emotional and rational commitment. Hagen notions of human nature posit that self-identity and social consciousness mature over time. The *noman* 'mind, will' is nurtured, showing evidence of itself in a child's growing self-determination and his or her awareness of others. Mental growth turns on a consciousness of being embedded in social relationships, as physical growth involves a nurturing that 'plants' a person in clan land (A. Strathern 1977). There is no concept of childhood prolonged beyond physiological adulthood through continued dependency, because there is no equation between adulthood and independence. On the contrary, children grow *into* sets of social relationships rather than away from them, predicated on the relationship that exists between them and their parents. Childhood dependency on parents is given social value as a matter of mutual *kaemb* 'feeling' between them. These notions of personhood do not turn directly on power. It is not the case that a person can be himself or herself only through freeing the self from constraints imposed by others, an idea that shadows some of our own constructs.

The denigration of domesticity in Hagen is used to symbolic effect, and women's association with the domestic domain gives a particular value to femaleness. But for all their surface similarity, these symbols do not in the end correspond to the connotations of domesticity and femaleness in Western culture. I have demonstrated this difference by following through on the plea that we treat women as persons who have authentic sources of power. It is from our own denigration of the domestic that this plea arises.

3

Complementarity: The Relationship between Female and Male in the East Sepik Village of Bun, Papua New Guinea

Nancy McDowell

 Anthropologists frequently use the concept of complementarity to describe various aspects of the relationship between women and men, or of gender roles in general. The frequency with which the concept is invoked suggests that in some way it is central, that it encompasses many of the issues we confront in the anthropological study of women (for examples, see Brown and Buchbinder 1976, Faithorn 1976, Hays and Hays 1982, Schwimmer 1973, and Weiner 1976). Primarily for this reason, and because we use it unselfconsciously and without an explicit consideration of its precise meaning, I have chosen to use this concept as a way of exploring the contexts in which women live and give meaning to their lives in a specific Oceanic society. This chapter is exploratory; by examining Bun women through the notion of complementarity I raise issues rather than resolve them.

On the Meaning of Complementarity

If two entities, groups, ideas, or things are complementary, it usually means that they are related or somehow connected, either in a metaphorical sense

I wish to thank the National Institute of Mental Health and the Institute for Intercultural Studies for providing the financial support for my first field trip to Bun (October 1972– November 1973), and the National Endowment for the Humanities and Franklin and Marshall College for the second (July—August 1977). I am also indebted to Linda Cunningham and Marilyn Strathern for their helpful comments on an earlier version of this chapter.

or in a metonymic sense, either paradigmatically or syntagmatically. It also means that they are different in character or content and that these differences are substantial. Further, these differences are reciprocal, as each complements or completes the other in some essential way to form a whole. Following American usage, the *Random House Dictionary of the English Language* (unabridged edition, 1967) offers three central meanings for *complement*:

(1) something that completes or makes perfect . . . (2) the quantity or amount that completes anything . . . (3) either of two parts of things needed to complete the whole; counterpart . . . to complement is to provide something felt to be lacking or needed; it is often applied to putting together two things, each of which supplies what is lacking in the other, to make a complete whole.

Two anthropological examples illustrate how these elements underlie our use of the term. Weiner (1976:11), for example, argues "that in Melanesia female/male symmetrical and complementary oppositions constitute elements basic to a conceptualization of the social order." Her notion of complementarity between female and male domains in the Trobriands is clarified in a later statement:

Therefore, the first frame of reference that I use for the basis of this study is the division of society into two *separate but articulating* female and male domains. Within their own domains, men and women control *different kinds of resources* and hence effect different degrees and kinds of power over others. Thus it is essential to understand the way differences in power structures, for both sexes, are *culturally integrated* into logical orders of events that distinguish different codes and forms of behavior. (Weiner 1976:18, emphasis added)

Forge (1972:36) has similar notions about complementarity:

In egalitarian New Guinea society it is only the men who are equal in the sense of being at least potentially the same or identical. Women are different, as has been observed before, the differences are those of complementarity; men and women are interdependent but are in no sense the same or symmetrical and cannot be identical.

Forge muddles the issues unnecessarily, however, by linking complementarity with asymmetry and hierarchy. The mistake he makes is a common one; he assumes that things that are different must in some sense be unequal.[2]

[1] The extent to which complementarity is inextricably related to dualism is a fundamental question but one beyond the scope of this chapter. I plan to consider this issue in a future publication. (See also M. Strathern, chap. 2.)

[2] For a provocative analysis using the concept of complementarity in a non-Melanesian society, see Rosaldo and Atkinson 1975. They clearly recognize the absence of incompatibility between complementarity and equality; they use the concept to describe both symmetrical and asymmetrical relationships.

The current debate about anthropologists' valuations of the domestic and public spheres of activity is directly related to the problem illustrated in Forge's statement. If domestic and public are separate, one (inevitably the domestic) must be inferior. We are beginning to question such assumptions which we bring to bear on our data (e.g., Sacks 1976; M. Strathern, chap. 2). For the purpose of this chapter, I assume that no necessary or inherent connection exists between complementarity and hierarchy, and that the equality or inequality of the two complementary items is an empirical question.

Concern with complementarity in Melanesia is not restricted to the realm of male/female relations but is manifest in a variety of sociocultural contexts. Kelly (1977:274–275), for example, maintains that the relationship between siblingship and exchange among the Etoro of Papua New Guinea is one of complementary opposition.[3] The most significant consideration of the issue is found in Bateson's classic, *Naven* (1958 [1936]). His concepts of complementary schismogenesis and the related diagonal dualism have wide applicability throughout Melanesia. These ideas are certainly not restricted to intersexual relations, although Bateson's best example is that of contrasting male and female ethos (i.e., emotional or affective orientation).[4]

Bateson also describes the complementary behavior of female and male in the ritual context of *naven*, a ceremony in which the mother's brother celebrates the achievements of his sister's children, reminding us of a critical point in considering male/female relations. While behaviors, affective postures, ideologies, and cognitive organizations may be ascribed to a particular sex, these attributes are not necessarily immutable but can be relative and reversible. In the *naven* 'sister's child achievement ceremony', some men dress and act like women and some women dress and act like men. The situation is more complex than simple gender reversal, however, as a mother's brother's wife can assume the manner and attire of either sex. Thus, behavior in this ritual context is complicated by, and dependent on, the particular kinship categories involved. It is significant that although there are complementary patterns characteristically female or male, individuals and groups shift from one to the other. Depending on circumstance or context, they are required at times to do so, as in the ritual case of *naven*. Further, the nature of complementarity can change through time. Gewertz (1981), for example, shows how behavior patterns among the Chambri of the East Sepik Province of Papua New Guinea shift with specific historical context. Relations between

[3] Another fundamental question concerning complementarity is the nature of its relationship to opposition. Is opposition inherent, or can complementary relations exist without opposition? Clearly opposition can characterize two groups or ideas and imply no complementarity, but can the reverse be said to be true?

[4] A. Strathern (1971) applies schismogenesis to Hagen clan groups. Dualism and oppositions pervade the literature on Melanesia. See, especially, Rubel and Rosman 1978.

the sexes can also change through time in another sense. According to Meigs (1976:406), among the Hua of the Papua New Guinea Highlands, "gender is not an immutable state but a dynamic flow. Such a view permits most persons to experience both genders before they die." It is also possible that complementarity is not related to gender at all. Goodale (1980:121, 132–139) argues that this is true for the Kaulong of New Britain; here, basic complementarity exists between the married and unmarried rather than between female and male.

Bateson's pioneering analysis serves to remind us of a second important consideration. Human feeling, thought, and behavior relevant to a particular problem depend on the context defined by, or theoretical approach taken by, the anthropologist. Bateson analyzes the *naven* from five different but related perspectives: structural, affective, ethological, cognitive (Bateson's term was *eidological*), and sociological. Understanding *naven* requires all five dimensions.[5] By excluding any aspect of the total sociocultural system (as we practically must always do), we preclude a complete understanding of it.

This concern for totality pertains directly to a major question concerning anthropological treatments of male/female complementarity: What element complements or completes what other element to make up a totality? Using Bateson's outline, one questions if the complementary emotional and affective orientations of men and women form a coherent subsystem; or, do complementary behaviors combine as elements in what may awkwardly be called a subsubsystem of the social subsystem? Anthropologists have not adopted Bateson's specific approach, however. Rather, our concerns about female/male complementarity seem to focus primarily on three contexts: (1) subsistence, economy, and the sexual division of labor; (2) behavior and social interaction; and (3) ideology, culture, and conceptual subsystem.

The first context—subsistence, economy, and the division of labor—is the least problematic. Female and male tasks and products are complementary in that each sex contributes to the material maintenance of some group (e.g., household, lineage, society) or entity. A garden and its products could comprise the relevant whole and men might clear while women plant, weed, and harvest; or an entire meal may result from male hunting and female sago processing. The contributions of the sexes are indeed complementary as both complete the totality; only how the anthropologist or the people themselves define the relevant entity may vary (see Nash, chap. 6).

In the second context, that of behavior and social interaction, it is more difficult to grapple with the issue of complementarity. One problem is the relativity and reversibility discussed above. Men and women behave in dif-

[5]Bateson (1958:30 [1936]) lists, but does not discuss, two additional perspectives: developmental psychology and economics.

ferent ways, but we recognize that in some situations women adopt the patterns of men and men adopt those of women. In some cases, the context is ritual; in others, age is the relevant factor as postmenopausal women gradually assume male behaviors. The distinction between how men and women behave is not always clear. Another problem concerns our inability to specify the nature of the relevant whole to which complementary behaviors contribute. Is it the social system or some part of it? Isolating a particular segment of the total behavioral system relevant to female/male interactions seems especially difficult, given our theoretical problems in defining and delineating the relationships between such concepts and abstractions as individual, role, group, and society.

In the third context, the cultural or ideological realm, the complementarity between female and male generates the most interesting questions and is the most problematic. Confusion arises from three related but analytically distinct phenomena.

First, some cultural systems incorporate a female/male differentiation by using sex or gender dichotomies symbolically or as metaphors for diverse domains of conceptual and experiential reality. Clay (1977) illustrates how this is accomplished among the Northern Mandak of New Ireland. There are many questions in this context: To what extent is female and male incorporated as a metaphor for complementarity in specific societies? Is the dichotomy used as a metaphor for something other than complementarity? Have we allowed the metaphor to influence our perception of actual behavior and on-the-ground political and economic relations? What do metaphorical reversals mean?

A second source of discomfort is that the conceptual models and cultural constructs we study have come predominantly from men. As Ardener (1972, 1975) suggests, what goes on in the heads of women may have little resemblance to the public, official male models diligently recorded by anthropologists. If Ardener is correct about disparate models for women and men, are the models themselves complementary? Is each a part of the cultural model, the totality of which is possessed by neither sex? How do the models articulate? Do they involve, as Wallace (1961) suggests is possible, diverse cognitive maps? Is the metaphorical use of male and female the same in both models?

A third problem involves the relationship between the contexts and domains, expecially the ways in which cultural concepts interpenetrate with

[6]A symposium on male initiation, for example, was held at the 1979 Association for Social Anthropology in Oceania meetings in Clearwater, Florida. Most of the papers read, quite rightly, included some mention of concepts of maleness and femaleness. However, at least in the oral versions, there was no evidence that any female informants had spoken.

behavior and affect. Do the same relationships obtain in ideology and social process as well as in emotional and cognitive organizations? Are the differences the same in each area? Are the patterns isomorphic, or do they involve cause and effect? How do these patterns reinforce or conflict with one another?

Bun: Subsistence and the Division of Labor

This chapter explores the concept of complementarity in the context of these issues and questions. I examine relationships between female and male in Bun, a small village (population 230) on the Biwat (or Yuat) River in the East Sepik Province of Papua New Guinea. Bun is an isolated community. It is not part of a broader unit, and the people do not identify themselves as members of a larger group. Bun language is related to others used by peoples living on the river, but it is not spoken elsewhere (Laycock 1973). Informants maintain that a second Bun-speaking village formerly existed but was decimated by warfare. The Bun recognize various kinds of intervillage ties based on trading, political alliance, warfare (formerly), and kinship and marriage. They also participate in the Angoram Local Government Council by uniting with the tiny upriver village of Avangumba to elect a representative. On the whole, however, the community is relatively isolated; although it is impinged upon by outside agents (particularly missions and government authorities), it operates by and large as a self-sufficient social system.[7]

Unlike many Sepik villages, Bun is located in a tropical rainforest rather than in marsh or grassland. The natural resources of the forest are diverse, and the environment is rich. The river and inland bodies of water provide a variety of fish, especially during the drier periods when the swamps shrink. During peak fishing periods, the catch is so abundant that portions of it are smoked to preserve what cannot be immediately eaten. The swamps are ideal for the growth of sago, the staple without which no meal is complete. The forest still contains game, including wild pigs, cassowaries, crocodiles, marsupials, and a great variety of birds. The villagers keep a few pigs and chickens as well as dogs and cats. The Bun practice swidden horticulture and are

[7]There have, of course, been profound changes in Bun during the last one hundred years. Warfare, raiding, and cannibalism have ceased; male cult activities (centering on the men's house, from which women were excluded) have been abandoned; money is now a primary concern and value. Missionaries, traders, and administrators have influenced Bun values, behavior, and social institutions. However, Bun has not been subjected to massive and rapid change, as many Highland New Guinea groups have, for example, and European attempts to change Bun have not been intense and continuous. The situation in 1973 was one of passive neglect: if the people did not cause trouble, they were simply left alone.

relatively land rich. No one has difficulty locating appropriate sites for new gardens to grow yams, taro, sweet potatoes, bananas, coconuts, tobacco, betel, and a multitude of introduced crops (e.g., pumpkins, watermelon, peanuts, corn, rice, and coffee). Some products (greens and nuts) are gathered directly from the forest.

Ownership of land resources is loosely vested in matrilineal clans, but anyone related to the appropriate clan may request use rights which are rarely denied. Because the village is small and currently contains only four exogamous matrilineal clans, most individuals are related in some way to people in all clans and thus have ample access to land. Whoever plants a garden harvests it. Sago and coconuts are planted in a particular person's name (usually by kin), and that person only (or a designated relative) may reap the benefits when the tree matures. Disputes over land and its products are rare.[9]

An examination of the division of labor reveals a complementary relationship between the sexes. In general, women and men produce and do different yet necessary things. An adult who does not have access to the products and labors of a member of the opposite sex (typically, but not necessarily, through a spouse) will find himself or herself poorly fed and housed. Few tasks are strictly reserved for one sex. Women make sago pudding (although men can and do prepare other sago dishes), and the Bun gleefully ridicule an upriver group of people in which men typically perform this task. There is also some flexibility and consciousness about these rules. Old men, for example, sew thatch for roofing houses. One young man noticed a shortage of old men for the job and seriously proposed that women be taught the skill so they could assist in home construction. One day an older man noticed several edible crustaceans along the riverbank and grabbed his wife's fishing net to scoop them out of the water. Children nearby mocked him for performing women's work; his response was that he would laugh at them while they were hungry, and he ate his delicacies. Such actions are, however, relatively rare, since people follow rules concerning tasks appropriate to their sex.

Hunting is almost exclusively the province of men, and they spend a significant amount of time individually searching for game. Indeed, the only time I was chastised for doing something inappropriate was when I insisted on accompanying men who were going to hunt for a wounded wild boar. (Part of their concern was that I would be in some danger because I was not

[8]There were formerly six exogamous matrilineal clans, but the Bun say that two of them died out. The land associated with these clans is gradually being absorbed by other clans. For a description of the traditional descent structure, see McDowell 1975, 1977.

[9]During fifteen months of fieldwork, I observed only one serious land dispute. A woman of the Pig Clan planned to work sago on land associated with her clan. A member of the Rat Clan, whose father was in the Pig Clan, put a taboo on activities on this land to prevent wild pigs from being frightened away. For the details of this case, see McDowell 1978a.

especially adept at climbing large trees and thus could not reach safety quickly
if the pig charged.) Women gaily recount stories of capturing or killing some
animal they encountered accidentally in the bush—they will do what they
can if they come upon some creature—but they clearly regard such activities
as aberrant. On the rare occasions when spears or poison are used for fishing,
it is the men who do it. Both sexes use hooks and lines for fishing, but it is
not a common method. Most fish are caught by women wading in streams
and swamps with their individual nets. Fishing is regarded as female work,
and women are as proud of their fishing prowess as men are of their hunting
skills.

Both sexes process sago. Men fell the palms, cut the trunks into segments,
and split the bark to expose the pithy interior. Men, women, or children
pound the pith into small slivers, and women "wash" these to leach out the
sago paste. Women are responsible for storing the paste, and only women
cook sago pudding, the mainstay of most meals. Women usually prepare the
entire meal, although men occasionally cook for themselves and their children
if a wife, sister, or mother does not.[10] Women are also in charge of routine
domestic tasks such as sweeping; they gather most of the firewood as well.

Most of the gardens are joint ventures. Men cut the large trees while
women clear the area of small saplings and undergrowth. Both sexes assist
in the firing. Men do much of the planting, but they are frequently assisted
by female relatives. Many women plant crops on their own. Weeding is
almost exclusively women's work. Men occasionally help with harvesting,
especially if the garden is a long distance from the village, but it is usually
the women, preparing meals, who do this chore. Long yam gardens are an
exception. They are ritually associated with men, and women are forbidden
to enter them because the long yams dislike the general smell of women and
"run away" if exposed to it. Most of the rituals associated with these special
gardens are no longer performed. Women today rarely assist in the initial
stages, and many do not participate in any task except the final harvesting.

It is not unknown for a woman to initiate garden work. A female infor-
mant had been haranguing her husband about clearing a new garden they
had just begun. He, however, was more interested in playing cards with a
group of men when she insisted that they depart for the garden, and he
refused to accompany her. A heated argument followed his refusal. She
decided that if he wouldn't help, he wouldn't play cards either; she grabbed
a large piece of firewood and clubbed him with it. The result was, I think,
a broken clavicle; he neither gardened nor played cards, but shouted his
anger from within his house.

[10] A man who quarrels with his wife must either seek food from a female relative or cook it
himself. Such domestic quarrels are common.

Men engage in building and house construction. Gathering certain materials, such as sago leaves for thatch and sago ribs for the walls, is, however, women's work. Men carve the plain dugout canoes and serve as artists in the community.

Child care is primarily a woman's responsibility; she gets assistance from female relatives, her own elder children, and other women who, for whatever reason, must remain in the village. Only when she has a young infant is her movement circumscribed. When a woman has important tasks outside the village (especially during peak fishing and harvesting times when all women are busy), her husband not infrequently remains at home to watch the children.

Conducting warfare, raids, and alliances was the traditional business of men. Today they have replaced these activities with extravillage tasks associated with pacification, contact, and independence. Men are still engaged in political activities that cross village boundaries: talking with government authorities, learning about and experimenting with various new cash crops, and participating in local government. Women tend to be involved in political processes that are primarily internal to the community and are concerned about extravillage events only if they impinge directly upon their lives. For example, few women would attend a village meeting to discuss regional or national political issues, but almost all would be present to arrange marriage exchanges or to settle an intravillage dispute. In 1973, few women attended a meeting on taxation because they were not subject to the Local Government Council head tax, but almost all appeared to talk about the possibility of appointing a *nurs meri*, 'midwife' in Neo-Melanesian, a woman trained in the rudiments of modern medicine, particularly pregnancy and childbirth.

Many contemporary anthropological analyses of women's roles stress the importance of public and domestic spheres of activity (see, for example, Reiter 1975b, Rosaldo 1974). The distinction is relevant in Bun. Women are more concerned with family, household, and consumption, men with intergroup relations and extradomestic transactions. Women take care of children, men take care of "business." It is important to note two circumstances, however, that mitigate the stringency of this contrast. First, in traditional Bun, taking care of "business" overlapped extensively with taking care of children; arranging strategic marriages was, and to some extent still is, a critical political and economic activity, and both sexes participated. Second, Bun is a small, nucleated village in which face-to-face interaction is predominant. Although private events do occur in houses, there is no clear physical demarcation between the domestic and the public, as in some other societies (see, for example, Reiter 1975b). Most events take place outside, and women are in no way discouraged from appearing "in public."

In summary, the following list of relative contrasts partially serves to express male/female complementarity in the context of subsistence:

male	female
hunting	fishing
constructing	cooking and child care
clearing	weeding
external	internal
cash crops	subsistence crops
public	domestic

Rosaldo and Atkinson (1975) suggest that the dichotomy between female and male is expressed everywhere by the contrast between life-giving and life-taking activities. Because men's tasks are "cultural" while women's are "natural," men are culturally more valued. This argument is used to explain what Rosaldo and Atkinson perceive as a universal devaluation of women (see also Ortner 1974). The debate of nature/culture and the universal devaluation of women is beyond the scope of this chapter, although the life-giving and life-taking dichotomy is relevant. It cannot, however, be applied to Bun in any simple fashion. Men, indeed, kill game, and they were the ones who participated in raiding and warfare (although one old woman regaled anyone who would listen to the story of how and when she had "axed" an enemy); women nurture children and plants. But male and female subsistence roles do not fit completely and neatly into the distinction between life-giving and life-taking. Men do hunt and therefore take life. But the opposing female task is not gardening but fishing, an anomalous activity. Fish die, but one does not kill them as one kills a wild pig; one catches them (in Neo-Melanesian: *em i kilim pig* but *em i kissim pis*). Thus it is only in a relative way that women are less involved in life-taking activities. A difficulty in using the life-giving and life-taking dichotomy to characterize female and male is that there is no evidence to indicate that the Bun do so. It is of course possible that such an association existed in past rituals that are now forgotten, but supporting data are scarce.

Subsistence and Value

Subsistence roles in Bun are in an etic sense complementary. They are different, yet interdependent; each set of tasks completes the other. Sago

itself serves as a focal symbol for the complementarity of female/male subsistence activities. It is the one item that must accompany all meals. Only women process and prepare the essential sago pudding, but both sexes are required for its production. A meal of sago alone is fit only for pigs—it must always be garnished or supplemented with meat, fish, or greens. That is, for it to be fit for human consumption, it must be complemented with the products of female *or* male labor. The Bun are fully aware of the central significance of sago in their lives. One man told me that sago was the mainstay by comparing it to the storeroom of European traders. Sago is the source of replenishment for ongoing life.

If we shift to an emic context and examine people's valuations of tasks other than sago production, the perspective and nature of complementarity changes. Each sex believes the other to be lazy and inferior. Men often likened the human species to that of the great horned-bill bird (*kokomo*): males move about continuously in search of food, while females remain at home and sit on their eggs. Women react with fury if such assertions are made to them. Women believe they are the economic mainstays of their families, whereas men do nothing but roam around looking unsuccessfully for game (a woman includes as "family" not only her husband and children but also her parents, siblings, and other relatives). Although women value products of the hunt, especially pork, they quickly assert that their sago and fish usually constitute the family's meal. When I repeated these words to a group of men, they replied in chorus, "food, food, that's all women ever think about."

In a sense, the men are right—but so too are the women. Each sex denigrates the other because each values different things. Men do appear in, and value the activities of, the public realm much more than women, and they are primarily concerned with settling disputes, dealing with outside agents, and cash cropping. Men, as they traditionally did, continue to face outward from the village and now provide the bridges that articulate Bun with the rest of the region, the country, and the world. Women, however, face inward and are primarily concerned with intravillage affairs and continuity. Their internal orientation is paralleled by their concern for intrafamily continuity. Men can experiment with their cash crops if they want, but women perceive their own work, that of provisioning themselves and their families, as the major task human beings must face. If this reflects a public/domestic dichotomy, it certainly implies no inherent moral valuation. Each sex perceives itself as fulfilling tasks of primary importance.

The values themselves are complementary; they are interconnected because the differences are relative, not absolute. Each sex values the activities, products, and views of the other. The Bun, as a totality, subscribe to both sets of values, each of which could be described as one component in their system of values. Women recognize that what men do and produce is impor-

tant; it is just not as important as what they do and produce. Men would find it difficult to deny the value of food, family, and children; they see these as an essential baseline beyond which only they themselves go. These values do not imply a difference in ethos between women and men. The contrast that fascinated Bateson is not marked, and both women and men, like their downriver neighbors, the Mundugumor, are assertive, aggressive, hostile, and volatile, quick to take offense and ready to defend themselves (Mead 1935). Women become as angry as men, but they do so about different things.

Conceptual systems throughout the world make use of contrasts in order to construct a universe, provide a framework for social action, and make meaningful human experience. In Bun, the complementarity between female and male is only one such element, but it is an essential one. These complementary values pertain directly to, and participate in, Bun world view and culture. The values are isomorphic with major constructs in the conceptual systems and thereby serve to express and articulate that system. The Bun do not use a female/male metaphor extensively, but these contrasts of valuation are central, both to the ways in which they conceive of the nature of human beings and the world and to the ways in which they behave and order their social relations within it. Rosaldo and Atkinson (1975) suggest that among the Ilongots of the Philippines, plant metaphors provide the context for the articulation of male and female. In Bun, however, this articulation occurs in two related, nonmetaphorical contexts: the ideology of being human, and the kinship tie between cross-cousins. When we look to these larger contexts of culture and social action, it is apparent how male/female complementarity serves to structure, express, and unify diverse domains of meaning and experience. In the next section, I briefly show how female/male relates to the cultural ideology of being human, and in the final section I discuss how the dichotomy and its cultural manifestations pertain to interpersonal relationships and the nature of the social order.

World View and the Human Paradox

What it means to be 'human', or *barajik*, is a core element in the Bun world view. It mediates and unifies various conceptual and behavioral contrasts and collapses them into a single context. Elsewhere I have described how this construct affects politics, kinship, and ideology in general (McDowell 1978a, 1980). Here I would like to suggest how this notion pertains to the problem of complementarity between female and male.

What I refer to as the "human paradox" is the problem that to be human in Bun, one must somehow do two mutually contradictory things. First, human beings are, by definition, free, independent, and autonomous. Yet,

second, they must also participate in relationships with others, they must participate in ties that necessarily impinge on their autonomy because these relations are associated with rules, norms, and obligations. Thus the Bun find themselves in a classic double bind: if they accomplish one, they automatically violate the other. They solve this paradox by striking a balance, by defining all social relationships in terms of balanced and reciprocal exchange. Thus, each individual can avoid being controlled by or indebted to anyone else, and yet continue to participate as an independent person in human relations. To be fully human, one must be both autonomous and bound to others. The Bun compromise by allowing themselves to enter into binding relationships only insofar as they can remain equal and unindebted. All social relationships are characterized by balanced, equal, and reciprocal transactions.

The contrasting values of women and men described above fit neatly into this paradox; each sex stresses a slightly divergent strategy to attain the status of *barajik* 'human'. Women tend to focus on interpersonal relations and to participate more in the relational aspects of the paradox; they are bound to others and value personal ties more than men. Men, by contrast, emphasize strength and autonomy to an extent uncharacteristic of women; their primary concerns focus more on maintaining freedom and remaining uncontrolled. Thus, to the list of male/female contrasts must be added:

male	*female*
separation	relation
autonomy	embeddedness
free	bound

It is important to remember, however, that these differences are relative, not absolute. Both men and women must strike the balance between autonomy and relatedness in order to be 'human'. Women must achieve some measure of autonomy and independence, and men are subject to obligations entailed in social relationships. An example illustrates women's concern with their status as human beings. An old woman was angry because a man was slow to complete an exchange with her; she entered the village and expressed her concerns by shouting, "I am not a ghost, I am not a pig, I am a human being."[11]

Examination of the sexual division of labor and Bun valuations of it has led to an exploration of central questions about female/male complementarity. The subsistence activities of the sexes are complementary, as are the values

[11] In Bun, "*ane shigeun na, ane vuli na, ane barajik, ane barajik!*"

pertaining to them. But what of Ardener's (1975) suggestion that each sex might possess a different model for structuring experience, reality, and behavior? The data suggest that Bun models are similar, but there are relative differences in the way in which women and men actualize their human status. The models themselves (as well as the behaviors predicated on them) are also complementary, contrasting yet interdependent.

It is important to recognize that had I acquired data predominantly from men, it would have been difficult, if not impossible, for me to construct the paradox of being human in Bun. It was only by gathering data from both sexes that I could understand the contrasting emphases on embeddedness and autonomy, both of which are necessary elements of the whole.

One question remains: How do these cultural concepts and models interpenetrate with social process and structure?

The Social Domain

The articulation of cultural concepts with behavior, affect, and social process occurs primarily within the domain of interpersonal relations and kinship. The attempt to balance autonomy and relatedness, not descent, serves as the major organizing framework for Bun behavior and social interaction (see McDowell 1975, 1977, 1978a, 1978b, 1980). In order to ensure autonomy, every relationship must in some general but basic way be one of reciprocity and balanced exchange. Even the most intimate of human ties, that between mother and child, is explicitly one of delayed egalitarianism. Mothers say they care for their children who will, in turn, care for them when they are elderly. Thus, the concept of what it means to be human pertains directly to the way the Bun relate to one another. Reciprocity is an essential element in achieving the necessary balance.

But to be human, it is not sufficient for all of one's relationships to be based on equal transactions. There is another domain in which balance must be achieved. The Bun elaborate on the theme of balance by defining different kinds of relationships and by attempting to achieve a balance among these as well. Just as women and men differentially stress autonomy and relatedness, so too do categories of relationship involve relative differences in the degree to which each includes elements of freedom and embeddedness. In fact, the Bun distinguish sharply between two types of relationship. The distinction is based on contrasting and mutually exclusive modes of transaction—sharing and formal exchanging. I use the words *exchange* and *exchanging* in two ways; they broadly refer to all transactions involving reciprocity of any sort, and they narrowly refer to all transactions that contrast with sharing. Formal exchanging and sharing define certain categories of relationship for

any particular ego. Every person shares with some people and formally exchanges with others. Every relationship an individual has with another (except that with a stranger, which involves no transaction except perhaps that of hostility) is based on and characterized by one or the other of these two modes.[12] What is especially significant is that the modes correspond directly to the paradox of being human: sharing relates to the need for warm human relationships and ties, whereas formal exchanging relates to the requirement of defining the self as a separate, equal, and autonomous person. An individual must transact in both modes to be fully human; sharing and formal exchanging relationships must be balanced.

Sharing is the way in which close kin (parents, siblings, and children) relate to one another. It accompanies all ties characterized by intimacy and identity. In fact, sharing defines and creates these relationships; those who share, especially distant or classificatory relatives, are establishing the relationship to be a close one. A woman, for instance, may assert that a genealogically distant brother is a "real" brother because he shares game with her. These relationships have a content of marked positive affect and sentiment; sharing is the primary way in which the Bun express affection and concern (McDowell 1975, 1979). No precise accounting of transactions is kept in this context. However, these ties are still based on generalized reciprocity because individuals with whom one shares are expected to share back whenever they have the means to do so. The incest taboo applies to all close kin. Distant classificatory relatives who are potentially sharing kin but who do not share, occasionally engage in sexual relations but rarely marry; however, this behavior is seen by most to be repugnant and in violation of moral rules.

Formal exchanging pertains to the concern for freedom, autonomy, separation, and equality. All of these relationships are characterized by distance, formality, respect, and name taboos. Precise equivalents are critical, because these transactions serve to define and differentiate equal human beings. Unlike sharing, however, formal exchanging contains subcategories. There are two mutually exclusive ways in which one can exchange, based on the content of the transaction. One involves marital transactions, discussed in detail later; the other includes the exchange of tangible and intangible items between relatives called *kamain* 'formal exchange partner'.

Kamain are formal exchange partners who exchange food at feasts. They are not the typical Melanesian 'big men', because most men and women participate in one or more 'formal exchange partner' relationships, and feasts

[12]Hostility itself could also be incorporated into this model because it too is always reciprocated. But a difference does appear, especially in the context of relations with strangers: repaying hostility and enmity is not one of balanced repayment but would include as much harm as possible. Traditional Bun raids were not conducted to "even the score" but to kill as many of the enemy as possible.

are designed to be balanced (McDowell 1975, 1976). The equivalence extends to intangible activities and transactions as well. If, for example, a man's 'formal exchange partner' falls down in his presence, he too must fall. Although there are some 'formal exchange partners' who are lazy and do not reciprocate as quickly as they should, the equivalences are always precise and exact. Intimacy and closeness are strictly forbidden; these kin may not even sit near each other in a canoe or at a meeting. Any reference to sex is also taboo in their presence, and the notion of sexual relations between them is abhorrent and unheard of. Marriage between 'formal exchange partners', informants maintain, is simply impossible.

The 'formal exchange partner' relationship is based on transformation of the cross-cousin relationship (children of opposite-sex siblings). In traditional Bun society, a person could ritually change a cross-cousin into a 'formal exchange partner' by presenting her or him with the head of a slain enemy at a special feast. Today, the transformation still occurs through feasts—only the heads of slain enemies and some of the ritual itself have been deleted. Once established, these ties are inherited. Usually the children of 'formal exchange partners' become 'formal exchange partners', but occasionally sister's children or brother's children are recruited. Sex is irrelevant in establishing or tracing the inheritance. More importantly, each individual has the opportunity, through these formal exchange relations, to establish himself or herself as a separate, autonomous, and equivalent human being.

Women and men must therefore strike the balance between sharing and exchanging and participate in both kinds of relationships, with close kin and 'formal exchange partners'. But the relative degree of participation, and the value in which it is held, varies by sex. Women are more concerned with relationships based on sharing than are men. If one asks a Bun woman what women do, she will undoubtedly describe a fishing expedition after which women share their prize catches with one another and their children before returning to the village. Men are more explicitly concerned with formal exchanging. Although it is important for both sexes to participate in 'formal exchange' relations, it is the men who appear in public to make formal presentations. If one's 'formal exchange partner' is a woman, it is likely that her husband, brother, or son will officiate at the feasts. Men, when asked what they do, invariably include a variety of tasks (e.g., hunting and house construction), but they stress the work of giving formal feasts. Thus, the dichotomy between sharing and exchanging is added to the list of contrasts associated with female and male.

Transactions in marriage constitute the second mode of exchange and contrast with both sharing and 'formal exchange' relationships. The Bun practice brother/sister exchange marriage; that is, a brother/sister pair marries a second brother/sister pair. The Bun (both men and women) conceive of

these transactions as exchanges between males. A man sends his sister to marry the brother of his wife, or two men swap sisters. Women also discuss the exchange in these terms; for example, women frequently say that their brothers' wives were exchanges or returns for themselves. This does not mean, however, that women are passive pawns in men's games; they rarely enter into any undesirable marriage (see McDowell 1978b). The Bun clearly conceive of these transactions as exchanges. The relationship between affines is one of formality, respect, and name taboos. Exact equivalences—a sister for a sister—are mandatory. Yet it also contrasts sharply with that of 'formal exchange' relations because it is based fundamentally on a sexual tie.

Each person must transact in three modes, with three different kinds of person: close kin, 'formal exchange partners', and affines. The social reality is more complex than this simple statement indicates, however. Do these modes constitute a system that operates over time? How are these different kinds of ties generated, and how do they articulate with one another? Do they comprise a whole in any sense other than that they are all transactions and relationships pertaining to the human paradox?

To answer these questions, one must understand the nature of the cross-cousin relationship, that is, the relationship between children of opposite-sex siblings. The cross-cousin relationship from the Bun perspective is, in Ortner's (1973) terms, both a summarizing symbol and an elaborating symbol. Ortner (1973:1340) describes summarizing symbols this way: "they operate to compound and synthesize a complex system of ideas, to 'summarize' them under a unitary form which, in an old-fashioned way, 'stand' for' the system as a whole." The cross-cousin relationship brings together a whole variety of Bun ideas, such as sharing/exchanging, embeddedness/autonomy, and female/male. It is also an elaborating symbol that sorts out and organizes concepts and experience. Ortner (1973:1340) distinguishes analytically between two kinds of elaborating symbols:

Symbols can be seen as having elaborating power in two modes. They may have primarily conceptual elaborating power, that is, they are valued as a source of categories for conceptualizing the order of the world. Or they may have primarily action elaborating power; that is, they are valued as implying mechanisms for successful social action.

The first she calls "root metaphors," the second "key scenarios" (1973:1341). The cross-cousin relationship in Bun acts in both ways. It helps people to conceptualize and distinguish sharing and exchanging, female and male, embeddedness and autonomy, as well as to think about and organize these concepts. The cross-cousin tie also has a behavioral component "because it implies clear-cut modes of action appropriate to correct and successful living" (Ortner 1973:1341).

The cross-cousin relationship is a key *symbol* in Ortner's sense because it is a symbolic mediator between sharing and exchanging, female and male, relatedness and autonomy. But it is in reality more than a symbol. It is also a key *institution* because it is the main mechanism for balancing and maintaining the system through time. It does this by generating relationships from which new and necessary ties can be derived. As the following discussion indicates, the cross-cousin relationship is especially significant because it performs both of these functions—symbolic and behavioral—simultaneously and thereby provides the context within which all complementary elements—both behavioral and conceptual—can articulate as a systemic whole.

The cross-cousin relationship is inherently ambiguous in Bun. To know that two individuals are cross-cousins is to know nothing about the way in which they behave toward each other. The Bun use this kin category as a reservoir for various kinds of relationships, any one of which an individual can call into being by action. One can transform a cross-cousin into a 'formal exchange partner' and thereby create a permanent exchange partner. One can also choose to do the opposite; cross-cousins may be redefined as intimate relatives and brought into the category of sibling. Kinship terminology always reflects these changes. Instead of calling cross-cousins by the terms for them (*vavadaveut* 'male cross-cousin', *vavadabwi* 'female cross-cousin'), they can be called by sibling terms (female ego: *jimwan* 'brother', *niamwi* 'elder sister', *sabi* 'younger sister'; male ego: *samwin* 'sister', *yi* 'elder brother', *sap* 'younger brother').[13] This terminology change converts the ambiguous cousin into a close relative with whom one shares. Individuals who feel they lack close kin frequently bolster this kind of tie by such transformation. Thus the cross-cousin relationship, by its ambiguity and potentiality, provides the necessary dynamic allowing individual men and women to balance ties of sharing and exchanging. Because both 'formal exchange partners' and close kin have the same origin and are differentiated out of the same category, cross-cousins also serve as a symbol of the essential complementarity of sharing and exchanging.

Ambiguity remains if cross-cousins are neither changed into 'formal exchange partners' nor brought within the category of close kin. The neither-one-nor-the-other quality is reflected by the obligatory joking of a sexual nature that goes on between them. In fact, sexual joking may only occur between cross-cousins; it is forbidden between close kin and between 'formal exchange partners'. This neatly expresses the third potentiality of cross-cousins: not only may one marry one, but one must.

[13]Bun terminology is very flexible. Often they will use a combination of cross-cousin and sibling terms. For example, a woman may call a close (male) cross-cousin *jimwan-vavadaveut* 'brother-male cross-cousin' using this rather cumbersome term in both reference and address.

All marriages should occur between cross-cousins, and Bun rarely violate this rule. Although some marriages take place between nonkin (strangers from other villages), most conform to the rules of cross-cousin marriage and sister/brother exchange (see McDowell 1978b). A properly executed marriage involves at least two brother/sister pairs who intermarry. Affinal relationships begin as exchange transactions between sets of siblings related as cross-cousins. The transaction is indeed an exchange, and some of the behaviors characteristic of affines are consistent with this mode. Brothers-in-law, especially, must remain at a respectful distance from one another; they may not speak each other's names or mention sex in the presence of the other. These behaviors also apply, but less stringently, to sisters-in-law. At the same time, however, the complex constellation of relationships established among the four people by proper marriage also includes sharing. Brothers and sisters continue to share, husbands and wives (former cross-cousins) share, and thus the sharing mode encompasses all four participants. For example, a man shares meat with his wife who, in turn, gives some to her brother who shares it with his wife, the sister of the original hunter. Alternative ties could be used to distribute the meat among them, but the point is that whatever routes are taken, the meat is shared eventually among all. Assistance in various kinds of labor, such as garden clearing, is a common form of sharing, particularly between brothers-in-law. They also support each other in disputes and quarrels, not infrequently against some of their own close kin.

Exchanging and sharing thus come together in the context of the proper marital arrangement. By structuring affinal relationships, as well as generating new 'formal exchange partners' and close kin, cross-cousins mediate between these various categories and concepts. The practice of cross-cousin marriage and sister/brother exchange is the core summarizing framework which unifies and brings together social, cultural, and symbolic complementarities and oppositions in one coherent affective, behavioral, and conceptual context. It provides the structure for the articulation of the isomorphic dichotomies (such as sharing/exchanging, female/male, relatedness/autonomy) and brings the oppositions together in actual behavior and a central social institution.

This same unification continues in a dynamic and temporal way in future generations. Parents share with their children, who share with one another. The result of two marriages is the creation, in the second generation, of two sets of siblings who are related as cross-cousins. Hence the possibility of exchange is reintroduced and new cross-cousins once again embody potential relationships. Thus the cross-cousins help to elaborate, to sort things out, as well as to summarize. In this sense the relationship is a driving mechanism for the regeneration of Bun categories of person: one can define this relative as close and sharing, and convert her or him into close kin (which is frequent in the case of double or bilateral cross-cousins); one could transform them

permanently into 'formal exchange partners'; or, finally, one could arrange a marriage exchange and begin the process again. In a very real sense, then, cross-cousin marriage with brother/sister exchange is the mediating core of the system, because it unites sharing and exchanging, embeddedness and autonomy, and because it literally provides further cross-cousins necessary for the system to function in a balanced way over time. The relationships among these kin (brother/sister, husband/wife, husband's sister/brother's wife, and wife's brother/sister's husband) and their children are a microcosm of Bun notions about personhood and the framework in which complementarities come together to complete each other.

The complementary relationship between female and male is inextricably intertwined with and central to this process. Without a contrast between the sexes, the central mechanism could not exist. Cross-cousins, children of a brother/sister pair, provide the framework. Brother/sister pairs are fundamental to the marriage process. Finally, in marriage itself, cross-cousins and sister/brother pairs are brought together in husband/wife relations. All three of these dyads (two cross-cousins, such as mother's brother's daughter/father's sister's son, sister/brother, husband/wife) are central socially and culturally; further, all three are based on sexual contrast. It is only when all are collapsed that one can speak of a whole. Female/male complementarity is the powerful context in which sharing and exchanging, autonomy and relatedness, are articulated and their opposition mediated.

Conclusion

The nature of female/male complementarity in Bun is complex. It is relevant in a variety of interrelated contexts: subsistence, values, world view and the definition of human being, and the social domain.

Complementarity in the realm of subsistence is relatively simple. The activities of men and women are complementary, that is, each sex characteristically does different tasks but the labor of both sexes is needed to ensure survival. A household, the basic unit for the production and consumption of goods, must include functioning members of both sexes if it is to persist. The activities of men and women articulate in the context of the domestic economy.

Values espoused by the sexes are also complementary—women and men value different things. Women value continuity, provisioning the family, and interpersonal relationships; men tend to focus their concerns on public activities, intergroup politics and cash cropping, and autonomy. These values are not merely opposed but complementary because they overlap. Together they comprise the "whole" of Bun values because both sexes to some degree

hold both sets—they differ only in the extent to which they stress one or the other.

Relative differences also obtain in the context of world view and the definition of human being. To be human, one must balance relatedness and autonomy, and members of both sexes strive to do so. However, women value and participate in human relations more than men, who strive to achieve autonomy to an extent uncharacteristic of women. Thus it is possible for the Bun as a whole to achieve this balance on another level. One sex provides the necessary counterpart to the other, that is, men and women "balance out" each other in trying to arrive at human status.

The ways in which female/male complementarity penetrates the social domain are especially complex. The sexual contrast in values and in world view pertains directly to the distinction between sharing and exchanging, and to the kinds of social relationships based on these transactional modes; indeed, all of these phenomena are deeply embedded in, and derived from, one another. Sexual complementarity is especially critical in the operation of Bun society and the generation of human relationships over time. I have argued that the cross-cousin relationship is the key symbol and institution for two reasons. First, it generates social relationships that reproduce the system and provide the mechanism for balancing, sharing and exchanging, autonomy and relatedness. Second, cross-cousins act as symbolic mediators by bringing these dichotomies into relation with one another and collapsing them into a single whole. Female/male complementarity is an essential element in this process: without the sexual contrast provided by the relationships of cross-cousin/cross-cousin, brother/sister, and husband/wife, there would be no social context for the unification and articulation of these various aspects of culture and there could be no social whole. A conceptual resolution to the human paradox is paralleled by a social and behavioral solution in the form of cross-cousin marriage and sister/brother exchange. Thus the contrast between the sexes is the primary means by which Bun men and women resolve their paradox, make sense of their lives, and become full human beings.

4

"Women Never Hunt": The Portrayal of Women in Melanesian Ethnography

Denise O'Brien

This chapter reviews ethnographies about Melanesia to determine how women have been portrayed by British and American anthropologists since 1920.[1] The review is neither a random sample nor an exhaustive survey of the voluminous ethnographic literature on Melanesia. Rather it examines a few works about socialization and social organization, as well as more general studies in an attempt to answer some fairly simple questions. What do Melanesian women do? What kind of data have ethnographers presented about women? Have any changes occurred in how female behavior is described? Are there any differences between the way in which male and female ethnographers depict women?

The title statement "Women never hunt" is taken from John Whiting's ethnography of the Kwoma (1941:112) and is relevant to the central inquiry of this chapter on several levels. Women are not totally ignored in this statement, but what interests Whiting is that they do not perform a male activity. Like Whiting, many ethnographers present women as reflections of men. The general picture of women emerging from Melanesian ethnographies

For their comments on earlier drafts of this chapter, I am grateful to Diane Freedman, Regina Oboler, Lorraine Sexton, Cathy Small, Marilyn Strathern, and Sharon W. Tiffany.

[1]Australian, Canadian, and New Zealand ethnographers are included in the broad Anglo-American category. I am not concerned here with how an ethnographer's ethnic background or adherence to a particular theoretical school may have influenced his or her depiction of women. Discussions of ethnography as a genre are sparse (Edgerton and Langness 1974; Marcus 1980; O'Brien n.d.). For the purposes of this chapter it is sufficient to define an ethnography as a book describing a society and its culture written by a trained anthropologist who has conducted fieldwork in that society.

over the last fifty years is very shadowy. Men are visible and what men do is equated with culture. Women are not quite invisible, but they are portrayed primarily as mothers and wives. Women's economic activities are minimized or ignored. Experiences common to both sexes are described only from the male point of view; or, the male experience is described at length and the female experience is briefly noted, mostly in terms of how it differs from the male experience. What men do is described much more fully and richly than are women's activities, and male social roles—whether as common as father or as rare as cult leader—are presented with more detail than are analogous female roles. Men appear as individuals with names and identities and differing opinions and experiences. Individual women appear less often and are frequently not identified by name, but are described in general terms, such as "an old woman," or in terms of their relationship to a particular man, such as "Kilai's wife." Women as women and women as individuals are presented with much less affect than are men.

Some of the flat, shallow depiction of women is no doubt due to the nature of Melanesian cultures, particularly where male dominance is marked by color, flamboyance, and ritual; even in those societies, however, women are always present, doing vital and interesting things. The portrayal of women is shadowy in another way. Not only are female activities, roles, and beliefs minimally described, they are ambiguously described. Male ethnographers get confused about what women do and who they are. They make contradictory statements about women's behavior, or they fail to notice that male informants have contradicted themselves in talking about what women do. Female ethnographers provide more information about women, a tendency often implicit in studies prior to 1970 and strikingly explicit in ethnographies since then.

To illustrate these general statements about the portrayal of Melanesian women I analyze as case studies, ethnographies representative of the period since 1920. Socialization and social organization were chosen as focal points in this chapter not only because they are well represented in Melanesian ethnographies but because they are also of enduring interest. Ideally, studies of socialization and social organization should contain data about women and men in fairly equal proportion.

Growing Up and Growing Old

Becoming a Kwoma by John Whiting (1941) is the initial work of an anthropologist who became a major force in the study of socialization (M. Harris 1968:450–462; Voget 1975:469–473). Although the foreword and preface of Whiting's ethnography suggest a general purpose—the application of learning

theory to the transmission of culture in a primitive society—the data pertain almost exclusively to males. The text leaves problematic whether the two male researchers (John Whiting and Stephen W. Reed) were unable to work with women, though it is clear they did have problems in photographing women (1941:76) and some problems in establishing rapport with women (1941:65). By contrast, Whiting describes his friendly, daily interaction with two adolescent girls who lived near his house (1941:19) and makes it clear that much of his information about adult men came from observation (1941:106). If the daily activities of men could be observed and described, why couldn't the activities of women similarly be noted? Part of the difficulty in establishing rapport with women may have been due to a language barrier, since Whiting worked primarily in Neo-Melanesian, then understood by only about a dozen young men (1941:xviii). However, he did gain some fluency in the local language as well (1941:xviii), and because many of Whiting's descriptive statements are based on observation, linguistic problems need not have significantly deterred him from providing more data about women.

Whiting (1941:111–116) devotes four and a half pages to male hunting and is careful to note that "women never hunt" (1941:112). Well, what *do* women do? Both the introductory chapter (1941:12) and the description of Kwoma economics (1941:119–120) stress that a regular exchange of sago for fish takes place between the sago-producing Kwoma and their river-dwelling neighbors. The trading occurs once or twice a week and is entirely run by women. Kwoma women are responsible for seeing that a surplus of sago flour is produced for trade and for scheduling and carrying out the actual exchange. But there is a tantalizingly brief description of how the exchange actually occurs, and one can only infer its significance to the maintenance of Kwoma culture in terms of nutrition and economic and political organization. It is ironic that Whiting devotes four and a half pages to male hunting activities and less than one to the sago trade. Hunting is not as important to the functioning of Kwoma society as is the sago-fish exchange. Indeed, not every man learns the skills necessary to be a hunter (Whiting 1941:114).

In addition to trading for fish, Kwoma women and girls fish regularly in informal groups based on residence in the same hamlet (1941:12, 116). Whiting downplays the economic significance of women's fishing, saying that most fish is obtained through the sago trade (1941:116), but women's fishing contributes to the Kwoma diet and is probably at least as important nutritionally as male hunting. Whiting's contrastive attitude toward male hunting and female fishing typifies the attitude of many ethnographers to the sexual division of labor. Not only is female fishing not described at any length but its economic significance is ignored and it is described as "recreation" (1941:116), which small boys and grown men regard as "fun" for

females but "demeaning" for males (1941:47). Although Whiting notes that a married woman has to learn to fish in a new locale with the other women of her husband's hamlet (1941:116), he fails to consider the significance of female fishing groups as an important socialization mechanism for young girls, as well as for newly married women, and as an opportunity for women of the same hamlet to develop solidarity and community.

In various contexts of Kwoma culture, ranging from gardening to sexual behavior, male activity is seen as the norm or standard, the lens through which female activity is viewed. In describing gardening, Whiting specifies what men do and what women do, but he devotes less time and attention to describing activities performed solely by women (1941:107–111). Behavior between different types of kin is described from a man's point of view for almost four pages (1941:152–156), followed by two pages on a woman's relationships with her kin (1941:156–158) which opens with an explicit note contrasting the experiences of adult men and women. By far the greatest part of the description of a woman's kin behavior focuses on the co-wife relationship and acknowledges that this is an important social relationship which a man never experiences (1941:157). Whiting's figures on polygyny are not explicit (1941:11,129), but they suggest that over half the women experience polygyny at some time during their lives. After describing the co-wife relationship, Whiting says that "a woman's relationship to other relatives need only be briefly sketched" (1941:158) and proceeds to dismiss them in four short sentences. Whiting does not explain why a woman's behavior toward her other kin can be so summarily dismissed, but he may focus on the co-wife relationship because polygyny is exotic to Western sensibilities. His portrayal of co-wives is ambiguous in that he begins by saying "there is considerable antagonism between them" (1941:157), presents a detailed case study of co-wife hostility (1941:157–158), but concludes by noting that "Kwoma co-wives are usually quite amicable" (1941:158).

An intriguing aspect of Whiting's differential treatment of Kwoma males and females is his confusion over the names and identities of adult women and female children. From figures detailing the household and lineage structure of the hamlet where Whiting lived (1941:11, 13, 17), it is relatively easy to identify by name sixteen adult men, twenty-four adult women, eleven female children, and thirteen male children, many of whom recur in case studies throughout the book. A careful examination of charts and passages incorporating names reveals a rash of mistakes involving female names, but establishes that Pamba (1941:13) is actually Famba (1941:11, 16, 65, 78), that the Bora of chapter 1 (1941:11) is the Mbora of chapter 6 (1941:146), that the child Uka (1941:11) is actually named Buka (1941:13, 14, 38, 45, 48, 178–179, 181, 183–184) and not to be confused with the adult woman Uka (1941:11, 13, unnumbered plate 4), and that the child Mano (1941:11) is

actually Mana (1941:13, 16) and should not be mistaken for the adult woman, Mano (1941:13). In contrast to these errors involving six different females, only one male name appears to have been slightly mangled, that of an infant who appears as Angeyamar (1941:11) and as Angemar (1941:17, 18). There are no linguistic differences between male and female names which could account for the confusion. Phonologically and morphologically it should be as easy to confuse the male names Mes and Mey, or Mar, War, and Kar as it is to confuse the female names Uka and Buka or Mano and Mana.

Two additional examples of Whiting's language use are illustrative of his attitude toward women. "A woman *supposedly* [emphasis added] takes the initiative in sexual intercourse *even* [emphasis added] after marriage. It is the wife who visits her husband's bed. Informants *admitted* [emphasis added] that the husband sometimes takes the lead, but that much more frequently the woman does so" (1941:126). Is Whiting expressing here an ethnocentric or chauvinistic male skepticism about female sexuality or simply the caution of a researcher who has been unable to adequately verify a statement? In other statements about female thought and behavior that he had been unable to check with women, Whiting is careful to note this lack of verification (e.g., 1941:65, 86, 151). A final illustration as to the unconscious primacy of the male point of view in Whiting's writing is this quotation: "The fact that Kwoma children will mutilate their penises and willingly undergo scarification. . . ." (1941:185). Obviously only Kwoma *male* children can mutilate their penises, willingly or otherwise.

Whiting's work on Kwoma socialization was preceded by Margaret Mead's research on Manus (1930). There are great contrasts between Mead's and Whiting's presentation of gender. Mead's Manus study, *Growing Up in New Guinea* (1930), provides a much more balanced representation of male and female socialization. A chapter entitled "The Development of Personality" deals with both boys and girls and the two subsequent chapters, "The Adolescent Girl" and "The Adolescent Boy," are approximately equal in length. Nowhere does Mead attempt to illustrate the norm with data pertaining only to males. In fact, in one chapter with a comprehensive title, "The Family Life," Mead presents case studies that focus sympathetically on women, women who are mistreated or misunderstood by their families. In four instances women are shamed or castigated by their husbands and children for actions (e.g., sleeping nude) innocuous in Western terms but contrary to Manus culture. Mead represents the women as victims of a system, a view that may or may not be fair to the Manus, but one that clearly indicates Mead's perceptions of gender, power, and autonomy. Much of the chapter on "Family Life" (1930:42–54) is taken up with following a girl through betrothal, marriage, and childbirth. The choice of a female protagonist to illustrate the major events in "Family Life" is unusual in that similar sections

in other Melanesian ethnographies (e.g., Whiting 1941, Fortune 1963 [1932]) employ a male protagonist.

Hortense Powdermaker's *Life in Lesu* (1933) and Beatrice Blackwood's *Both Sides of Buka Passage* (1935) are two rich sources of data on Melanesian women from the 1930s. These ethnographies are more holistic than either Mead's (1930) or Whiting's (1941) and are especially strong in their description of the life cycle. In both monographs women appear as named individuals with personalities, though Powdermaker sometimes identifies an individual in general (and not necessarily flattering) terms, such as "One old woman, now a frightful-looking hag" (1933:244). Blackwood devotes a few pages to the daily round of activities (1935:25–29), giving equal time and space to both sexes and making it very clear what women do. To demonstrate the range of activities during the week, Blackwood uses three individuals as examples, two women and one man. Similarly, Powdermaker, in describing a typical day's activities, gives equal weight to male and female behavior (1933:26–30).

Much more of the texture of female behavior and attitudes is presented by Powdermaker than by Whiting (1941) or contemporaneous male ethnographers, such as Reo Fortune in his *Sorcerers of Dobu* (1963 [1932]). In Powdermaker's chapter on childhood she compares boys' experiences with girls' experiences rather than giving priority to the male viewpoint (1933:86–93), while the behavior of girls is used in illustrative case studies (1933:82–83). Throughout the ethnography, both men and women appear often as individuals with names and specific characteristics. Powdermaker includes short life histories of seven women but no men and focuses primarily on the women's sexual experiences (1933:277–285).

The degree to which the ethnographer's gender can skew perceptions of gender in the cultures being studied is illustrated by Whiting and Mead. However, though Mead may overemphasize female roles in the Manus family, Mead, Powdermaker, and Blackwood—all female ethnographers—give a more balanced picture of gender roles in Melanesia than do male ethnographers such as Whiting and Fortune.

The Missing Link in a Cognatic System

H. W. Scheffler's *Choiseul Island Social Structure* (1965) is a good example of an ethnography tightly focused on a particular problem, much more so than the ethnographies by Blackwood or Powdermaker or even Whiting who, while concentrating on socialization, presents more general information about Kwoma culture. Scheffler reconstructs Choiseulese social structure as it was circa 1900 in an attempt to analyze the workings of a cognatic social organi-

zation. Why in depicting a cognatically-based society, where a person's rights to land may depend equally on links through females or males, is there so little insight into what women do or think? There is no indication that Scheffler faced difficulty in working with women as informants or was prevented from observing them. In his acknowledgments he thanks six individual Choiseulese as being particularly helpful during his research, and one of these is a woman (1965:x). Scheffler does not describe behavior much and fails to note the sexual division of labor in subsistence activities, either in the traditional taro-based economy or the newer copra-based economy. One learns that in the contemporary peasant economy "income varies widely for any one man" (1965:31), but aside from the statement that copra is produced by both "individuals and families" (1965:31) one knows nothing of the female role in copra production or the extent to which Choiseulese women have access to cash income. Kin categories and behavior between kin are described almost entirely from a male point of view, despite the cognatic nature of the society and the repeated statements of the Choiseulese (1965:62,69) regarding the importance of tracing relationships through the "mother's side." For example, Scheffler notes that same-sex siblings are ideally very supportive toward each other but illustrates his generalization with examples only from brothers.

It is clear from general statements and case histories that men frequently gain rights to land and become temporarily or permanently incorporated into a descent group because of their status as a woman's son or husband. In at least three specific cases it is the intent and action of a woman that precipitates residential movements from one group to another, with long-term consequences for her children and for other kin, including, in two cases, her husband (1965:142ff., 163, 256–257). Furthermore, the Choiseulese repeatedly state that "it is women marrying about who bring groups together" (1965:176, cf. 178), thus seeming to be well versed in the elements of alliance theory. Scheffler himself states that a woman has "social identities apart from her status as a wife" (1965:203), but he provides no hint as to what these other identities might be.

Like most Melanesians, the Choiseulese treasure pigs as well as shell valuables and use the shells as a prestige marker, a major component of bride prices, and in ceremonial exchange at large feasts (1965:199–216). Ownership of pigs and shell valuables is always described as male ownership and male 'managers' are portrayed as responsible for the organization of exchange feasts. There are only tantalizing clues as to how women may be involved in the ownership and exchange of shell valuables and in the production and distribution of food for feasts. For example, one might infer that women must possess shell valuables from the statement (1965:206) that a woman who broke a taboo regarding a man's weapons had either to pay a fine in

shell valuables or be taken hostage. However, Scheffler says nothing about whether women do own shells or about the possible responsibility of a woman's male relatives toward paying her fine. Nowhere, either in general statements or case histories, are women presented as the owners of either pigs or shell valuables, yet from what we know of similar Melanesian societies—even the most male-dominated—it is unlikely that Choiseulese women have no rights at all in pigs or shells.

Women must have played a role in producing the food distributed at exchange feasts, but no data are presented on women's participation in production. In addition to the competition inherent in the exhibition and distribution of shells and food at a feast, a taro and nut pudding served as the prize in a "mock battle" between hosts and guests "which the guests eventually won only after the intercession of the women of both groups" (1965:214). As the only explicit mention of women at feasts, it raises several questions, among them the nature of the women's intercession and the possibility of women being "warriors" in a "mock battle."

Not only are women largely invisible in Scheffler's depiction of Choiseulese society, in one of their rare appearances, Scheffler contradicts himself as to the exact nature of their behavior. Choiseulese women are often accused of sorcery, though men also can be sorcerers. Scheffler is primarily interested in the relationship between the structure of descent groups and "patterns of expectation and accusation" (1965:123) regarding sorcery. After noting one specific case in which a woman who had married into a descent group was accused of sorcery, he states, "but there was otherwise no indication, and certainly not stated as such, that in-marrying women are especially suspect" (1965:123). Yet the exact opposite appears in a succeeding chapter: "I have already noted that in-marrying women often are suspect of sorcery against personnel of the descent group" (1965:176). Do the Choiseulese fear that foreign wives will be sorcerers or don't they?

Women are missing in Scheffler's ethnography, ignored in their roles as links to land use and membership in cognatic groups. Their contributions as producers and transactors are similarly slighted, and ambiguity persists in the depiction of women as sorcerers.

Classic Studies of Highland New Guinea

Since the 1950s many ethnographers have worked in Highland New Guinea. Marie Reay's *The Kuma* (1959), Richard Salisbury's *From Stone to Steel* (1962*a*), and Mervyn Meggitt's *The Lineage Structure of the Mae-Enga of New Guinea* (1965) are among the earliest results of this intensive scrutiny of Highland

societies. They provide further evidence that an ethnographer's gender structures his or her perceptions of Melanesian women.

Marie Reay's ethnography on the Kuma (1959) is an excellent example of how a female anthropologist, even though she has not explicitly set out to delineate the female side of culture, provides more information about what women do and think than do male ethnographers. Reay's preface creates the impression that she intends to present a general ethnography, a holistic picture of Kuma culture, and she lists the standard things we may expect to find described in such an ethnography—the environment, the people's "dominant interests" (1965:v), kinship, religion, and the life cycle. While she says nothing explicit about intending to focus on gender roles, the most specifically descriptive passage in the short, page-length preface is the following: "It is a male-dominated society, where the men reserve for themselves the creative and spectacular tasks, leaving the drudgery to the women. The men practise polygyny but the married women are enjoined to strict chastity, forced on them after a carefree girlhood of actively encouraged promiscuity" (1959:v). Reay says little about her fieldwork methods—the degree to which she used women or men as informants, for example—and she only makes one statement as to how the Kuma regarded her: " 'My' people (the Kuma of Kugika clan) looked after me well, at times saved my life, and were quick to interpret as a slight upon themselves any misunderstanding of the presence of a solitary European women in a native community" (1959:vii). One can only speculate as to the nature of this "misunderstanding" or by whom it was displayed.

In her description of Kuma behavior, Reay allots equal space to men and women and does not appear to take male behavior as the standard against which female behavior is contrasted. For example, in a section entitled "Tillers of the Soil," men's and women's gardening tasks are alternately described; in a section on "Organization of Labour," women's work is described first and then men's; and the section on "Ideas of Work and Leisure" begins with the statement: "A woman who is asked about her work . . . " (1959:16) and later goes on to describe male ideas about work. Kuma culture is usually not identified with male Kuma culture, and Reay meticulously distinguishes between male and female points of view, not only about work but also about other central values and attitudes (1959:23, 24, 97, 113, 161–162). In a discussion of behavior appropriate to certain kin roles, Reay devotes considerable space to a discussion of female roles, in sections entitled "The Mother," "Sisters," and "Women of the Domestic Group" (1959:76–82). Narrating the advent of a cargo cult, introduced by a young married woman and a low-ranking "rubbish" man (1959:194–200), Reay is careful to note that the cult leaders acted independently of one another (1959:195) and details the behavior of each leader and the reaction to them evenhandedly. In describing the life

cycle, Reay spends six pages on "Learning Situations for Boys" (1959:164–170), five pages on "Male Initiation" (1959:170–174), and seven pages on "Learning Situations for Girls" (1959:175–181). A section in this chapter entitled "Women's Interpretations of Male Values" (1959:181–184) explains how Kuma women resolve some of the conflicts in their lives resulting from male dominance and how throughout her life a woman identifies with a group of men—first with her brothers, then with her husband and his clansmen—rather than with women per se or with any group of women with whom she may interact owing to shared age, residence, or work. Only in the final chapter does Reay briefly characterize Kuma culture exclusively in male terms when describing the "typical Kuma" and how he looks forward to having more wives, more wealth, more pigs (1959:193). On the preceding page, however, Reay has pointed out that "women are brutally and, since they protest, ineffectively conditioned to put up with a most unequal social position and a less advantageous ration of effort and reward, the effects of male-imposed ideals" (1959:192).

Salisbury appears initially to treat the behavior of males and females fairly evenhandedly in his study of socioeconomic change among the Siane, *From Stone to Steel* (1962a). For example, in a short section on "The Individual Life Cycle," he devotes about equal space to a description of male and female development (1962:35–37). In discussing the sexual division of labor, Salisbury notes that while Siane men view women as "rather stupid" and "irresponsible," "It will be noted that skill is in fact needed by the women, although men despise their jobs as 'unskilled' " (1962:49).

An important aspect of Salisbury's study is his attempt to discover to what extent introduced steel axes have affected the way the Siane spend their time. To determine what men do in Siane society, Salisbury selected a sample of twelve individuals who were representative of the "total population of the village" (1962:216) and noted the activities of these men on a daily basis for several weeks (1962:107–110, 216–220). Actually the sample is not representative of the "total population" since it includes no women.[2] Salisbury is careful to explain that "women regularly perform the same sort of tasks, day after day, so a consideration of the typical daily schedule and of the occurrence of exceptional days is all that is needed to establish the pattern of allocation of their time" (1962:107).[3] He gives figures for women's work time, based simply on general observation, and it is remarkable how neatly their days

[2]An interesting parallel is Hogbin's description of "An Average Day" in Busama village (1951:39–42) which is based on the daily work schedules of two men and one woman for three days (1951:304–307) and the work diaries for twelve men over a two-month period (1951:308–313). In the "average day" section Hogbin says "the women" do this or that without ever explaining why women are so scantily represented in the data base.

[3]I am grateful to Lorraine Sexton for first calling my attention to this passage.

divide. Siane women spend 20.5 percent of their time on each of four major subsistence tasks (e.g., "cooking and crafts," "garden work" for a total of 82 percent) and the remainder of their time (18 percent) is divided among being sick, visiting, and ceremonials (1962:108). What is even more remarkable is Salisbury's belief that, except for a possible slight increase in ceremonial visiting, women spent their time in 1953 exactly as they did in 1933, whereas men's lives had been radically altered by the introduction of steel axes.

Salisbury attributes the lack of change in women's lives to the fact that they did not use steel tools themselves and so did not experience the reduction of time expended on basic subsistence work that steel tools made possible for men. He also states that Siane gardens did not change in size between 1933 and 1953 and that the new technology was not used to produce more food (1962:107, 118), an important factor in keeping women's work constant. As Siane men reduced the time spent in subsistence activity, they greatly increased the time spent on ceremonial activity, which in Siane society nearly always involves food distribution and the exchange of valuables. Salisbury notes that pig herds have grown since 1933 (1962:119) as one response to the increase in ceremonial activity, but he does not make the connection that more pigs meant more work for Siane women (since the figures on male time allocation have no category for pig care). The existence of more ceremonies and more pigs calls into question the Siane claim, accepted by Salisbury, that garden size and food production had not increased in the twenty years between 1933 and 1953. An integral aspect of most ceremonies is feasting, and pigs eat sweet potatoes. More feasts and more pigs mean a need for more food in the form of crops produced by Siane women, yet Salisbury concludes that women's work lives have not changed in the wake of new technology.[4]

Meggitt's ethnography, *The Lineage System of the Mae-Enga of New Guinea* (1965), does not attempt to present a whole picutre of Mae Enga culture. Rather, it is a problem-oriented study focusing on the structure of the agnatic descent system. Implicit in Meggitt's analysis of the lineage system is the notion that it is crucial to determine and explain how men are related to other men, and only, it seems, from a male point of view. For example: "I list the kinship-based marriage prohibitions from the viewpoint of Mae man" (1965:92).

Meggitt gives scant information on the circumstances of his fieldwork, and it is impossible to determine exactly the degree to which he did or could work with women informants. Explanations of Mae attitudes and behavior are often prefaced with "people said" (e.g., 1965:110, 123, 163, 170, 177) or

[4]An alternative explanation for the reported equilibrium in garden size and food production is a decrease in the number of people, but Salisbury (1962a:11) reports that the population size has remained "relatively stable."

with "men told me" (e.g., 1965:29, 163, 172, 232, 252, 269). Only once does one encounter the statement "women said" (1965:145), and "people" should probably be understood as "men," particularly given the following note by Meggitt: "My use of the terms 'the men' and 'the people' when discussing Mae cosmology is for convenience only. Most people, especially women, express no definite opinions at all about such matters and are not interested" (1965:49). One cannot tell from Meggitt's text whether women expressed opinions about matters less esoteric than cosmology, but it is difficult to imagine a society, however male-dominated, where they do not. The one instance of a "women said" statement occurred in a brief explication of infanticide. It was immediately preceded by mention of the negative attitudes toward contraception and abortion expressed by "all men and women with whom my wife and I discussed the matter" (1965:145). This appears to be the only mention of Meggitt's wife, and it is impossible to judge whether she worked with Mae Enga women and Meggitt did not, or to what degree Meggitt depended on her inquiries and observations. For example, approximately two pages (1965:165–166) are allotted to a description of childbirth, and the details of eight births are summarized in his table 62 (1965:166). No Mae Enga males were present at these births, and we can only speculate as to the source of the relevant data. It is possible that Meggitt was present at some or all of the births, or that his wife was, or that the information came to Meggitt or to his wife from female informants. It is even possible that the data was transmitted from Mae Enga women to Mae Enga men and thence to Meggitt.

Meggitt presents extensive data on marriage and divorce but, despite this voluminous material, there is minimal information on women's desires and actions, except as they affect men. Clearly a wife is crucial to a man's success, even his survival, through her work in gardening and pig husbandry (1965:157), and she gains some control over the production and allocation of resources as a result of this need (1965:245–246). But the need is presented as a male need—that is, "Men must have gardens" (1965:258)—rather than as a societal need or a need women share. In another example of how women are ignored, Meggitt twice refers to an old man who wishes his young wife to bear children—especially a male heir—and who arranges for his younger male kin to copulate with her (1965:144–145, 255). The attitudes and actions of all the men involved are discussed, including future hypothetical or expected reactions toward the desired male heir, and it is noted that this is a "delicate situation" (1965:144) that "must be handled with great discretion" (1965:145). Yet the young wife's attitude is never mentioned. Apparently neither Mae Enga men nor Meggitt consider her reaction relevant. One learns that women do leave their husbands (1965:148) and that the grounds on which men and women may obtain jural divorces vary (1965:143–145), but

one learns very little about women's attitudes toward marriage and divorce. It is particularly instructive to compare Meggitt and Reay as ethnographers of marriage. Kuma and Mae Enga men share many of the same values about the economic and political aspects of marriage, but Kuma women stand out more vividly within their male-dominated system than do Mae Enga women.

Comparisons from Polynesia and Micronesia

Because Melanesian societies are often characterized as male-dominated (e.g., Chowning 1977:57), one might expect that Melanesian women will always be shadowy and ambiguous figures, regardless of the ethnographer's intent or gender. What of other Pacific societies? Fiji is geographically part of Melanesia but has close ties to Tonga in western Polynesia (Brookfield and Hart 1971:xlv) and is sometimes classified as part of the Polynesian culture area (e.g., Langness and Wechsler 1971:9). Moala, a small island in eastern Fiji on the boundary between Melanesia and Polynesia, is the subject of an ethnography by Marshall Sahlins which provides one of the more quotable answers to the question, What do women do?, reflecting both his and the Moalan male's view of Moalan women.

As for Moala, it is commonly stated: "In this land, women rest." One man more picturesquely put it that Moalan women do nothing all day but sit around and "fart" (*ci*). While this is certainly unjust, it is true that in households with many women and girls, *members of the fair sex* do seem to spend an extraordinary amount of time in *idle, sometimes vicious, gossip*. Certain of the young girls take particular delight in tale-bearing; many of the squabbles between women result from slanders which were made in the privacy of the cook house, but carried to the libeled party by such girls. (Sahlins 1962:121, emphasis added)

The overwhelming impression of women gleaned from this quote is that they are lazy and nonproductive. Sahlins does provide some information about women's economic activities and their kin roles, but he gives fewer details about female activity than about parallel male activities. For example, when describing appropriate behavior within the family, over a page is devoted toward the brother/brother relationship (1962:112–113), but less than a quarter of a page to the relationship between sisters (1962:116). Similarly, a description of the father/child dyad extends for a page and a half (1962:113–114), while the relationship between mother and child is disposed of in less than half a page (1962:114). Sahlins does describe two wholly female relationships, that between mother-in-law and daughter-in-law and that between or among husband's brothers' wives (1962:116–117), without mentioning the reciprocal male relationships. These affinal relationships are included because

they are significant in the domestic household culture of traditional extended families. In analyzing kindred structure, Sahlins lists the frequency of different kin relationships among the men of three villages, noting, for example, how many males of a village are related to each other as fathers and sons or as cross-cousins (1962:163–165). He provides no corresponding data for women.

Fishing, cooking, child care, and the manufacture of mats and bark cloth are the most important contributions of women to the Moalan economy. Women control the production and distribution of mats, a necessary component in ceremonial exchanges (1962:137), life crisis rites (1962:175, 180, 183–185, 187–189, 191), and interisland trade (1962:421–422, 428, 430). Sahlins spends eleven and a half pages (1962:203–214) on a discussion of *kerekere* 'daily reciprocal exchange among kin' and presents detailed information involving the transactions of six men. Although women engage in this type of exchange (1962:202), no women are included in the focal set whose transactions are presented as illustrative. The interisland trade, controlled by women, is mentioned frequently but never analyzed in depth. It is impossible to gauge the scope of interisland trade or the number of women and mats involved in domestic transactions.

The tone of an ethnographer's comments about women calls for more subtle judgment than simply noting whether or not comparable information is provided for both sexes. Sahlins uses language about women that is both pejorative and belittling. Conflict among men is regarded as relatively normal. Brothers can be hostile and antagonistic toward each other (1962:112) and still exhibit solidarity (1962:117) without the ethnographer sounding surprised. However, conflict among women in a family is described as "bickering" (1962:117, 138). Sahlins sounds bemused by their solidarity: "And notwithstanding the *petty* quarrels that may divide them, *even* the women of a family are capable of concerted action against women of other houses" (1962:117, emphasis added). Men disagree about "economic matters" (1962:112) which are presumably important—they argue about coconuts—but Sahlins views women as merely having "petty quarrels" (1962:117) without indicating the substance of their disputes. Women in a Moalan household could argue about interisland trade or the number of mats they should contribute to the village stockpile, economic matters on a par with coconut claims. Despite repeated statements regarding women's dominant role in life crisis rites (1962:175) and interisland trade (1962:421–422, 428–430), when describing village organization Sahlins again sounds surprised at what women can do: "The married women *are capable* (emphasis added) of organizing for economic activities, such as communal netting, but do not ordinarily combine in purely social groups. They *may even* (emphasis added) call meetings to organize their labor in preparing mats for a village contribution to some island

activity, or for a trading festival (*solevu*) with the women of another village outside Moala" (1962:301). Sahlins does not expect women to have autonomous economic roles, shows surprise at their cooperative labor, and may well have overlooked other female contributions to production and exchange.

By reviewing William H. Alkire's book, *Coral Islanders* (1978), I have departed from ethnographies describing a single culture to discuss a more general comparative study of coral island societies in Micronesia and Polynesia. I have analyzed, however, only the section based on Alkire's own fieldwork on Woleai in the central Carolines (fig. 1) consisting of excerpts from his "activity diary" (1978:45–63). Scanning these entries for an answer to the question, What do women do on Woleai?, reveals that on thirty-eight days (61 percent) they were doing nothing, or nothing that Alkire thought necessary to record. Of the total sixty-two days, thirty (48 percent) are devoted solely to male activities, nineteen (31 percent) include both male and female activities, eight (13 percent) are indeterminate as to whether men or women or both are performing the activities described, and only five days (8 percent) are concerned solely with the activities of women.

The five "women's days" all describe unique events, including: a girl's puberty ceremony at menarche (1978:50–51), an unusually large taro harvest (1978:58), a dance to honor students departing for Ulithi (1978:59), a request for medicine from Alkire for the girl whose menarche had been celebrated but who then ceased to menstruate (1978:61–62), and a gift by women to Alkire at a going-away party for him (1978:62). (One assumes that men were present at this feast, but they are not mentioned.) Although some routine female activity such as breadfruit processing (1978:55) is included on those nineteen days mentioning both men and women, the moral of this diary is that for women to be noticed by the male ethnographer, they must do something unusual, ranging from commencing menstruation to giving him a present. Yet, according to Alkire, "this summary of day-to-day events is generally representative of the subsistence-oriented adaptation common to the central and western Caroline islands of Micronesia" (1978:65).

One should not conclude that women play an insignificant part in Micronesian subsistence, but rather that Alkire has underreported their participation. In minimizing women's work, Alkire provides one more example of the failure to fully document female contributions to production. Yet another example is Raymond Firth, who, in his study of Tikopian society, is concerned with the ceremonial exchange of pandanus mats and bark-cloth blankets, both of which are made exclusively by women (1965:111). Firth quotes an unidentified woman viewing the mats piled high at a ceremony, who says that "the backs of the women are aching with the plaiting" (1957:448), but he does not elaborate further in either *We, the Tikopia* (1957) or in *Primitive Polynesian Economy* (1965) on the production process (in contrast to a detailed

account of how men make fish nets (1965:95–100) or on women's role in the distribution of mat and blanket wealth.

There are ethnographies in which female behavior is weighted more or less equally with male behavior, among them *Flower in My Ear: Arts and Ethos of Ifaluk Atoll* by Edwin Grant Burrows (1963), and Robert I. Levy's *Tahitians: Mind and Experience in the Society Islands* (1973). It is no accident that neither of these ethnographies deals with the economic aspects of Ifaluk or Tahitian culture in any significant way. The impression of women gleaned from Melanesian ethnographies is not challenged by comparison with the Micronesian and Polynesian material reviewed here. This is not to say that there are no important differences between gender relations in Melanesia and Polynesia or Micronesia but rather to emphasize that respected ethnographers (e.g., Firth 1957, 1965; Sahlins 1962) simply do not provide adequate, unbiased data on women comparable with the data on men.

Conclusion

Among the major points demonstrated by this review of Pacific ethnography is that women's economic roles are ignored, whereas the role of mother, a cultural role that depends on biology, is emphasized. One thing male ethnographers are clear about is that women give birth to children, and field-workers often feel obliged to describe the behavior surrounding childbirth, even if they have not witnessed any births (e.g., Whiting 1941:151, Hogbin 1963:55–58). By the 1970s, the interest of at least some male ethnographers in childbirth had shifted from behavior to attitudes and ideology. Michael Young, for example, does not describe childbirth per se but mentions male attitudes toward childbearing. Interestingly enough, the male attitudes noted by Young are not consistent, a fact he neither examines nor even appears to notice. For instance, men are said to look down on some women because they are "reluctant bearers of children" (1971:47), yet later Young states that "women are not highly valued for their child-bearing capacity" (1971:94). Even though the mother role is seen as central for women, some ethnographers present more descriptions of father-child interaction than they do of mother-child interaction (e.g., Firth 1957:160–164, Sahlins 1962:113–114).

In the last decade monographs have been produced that portray female economic roles with the same amount of fullness and complexity as has been devoted to male economic roles. Two outstanding examples by female ethnographers are Marilyn Strathern's *Women in Between* (1972) and Annette Weiner's *Women of Value, Men of Renown* (1976). In both cases, male economic roles for these societies had been described already by male ethnographers (Andrew Strathern 1971, Malinowski 1922). The Stratherns' Mount Hagen studies

are complementary, whereas Weiner (1976), studying the Trobriands long after Malinowski (1922), is clearly revisionary toward his work and goes beyond supplementing his view of Trobriand exchange. Our understanding of Melanesian women, and indeed all women, will benefit from increased attention to their productive capacity in a full social sense, rather than focusing only on their reproductive capacity.

What women do, if not invisible to male ethnographers, is ambiguous and is denigrated both by male ethnographers and their male informants. One has only to recall the bickering, farting, gossipy Moalan women. The language one uses in presumably objective description is a powerful tool (see Tiffany, chap. 1) and to call women's talk "gossip" and men's talk "social communication," as is common in ethnographies (Reiter 1975a:14), inevitably prejudices our comprehension of women, men, and the society they form. The invisibility of women means that they appear as an amorphous mass rather than as individuals, even in ethnographies that emphasize individuals in illustrative case material (e.g., Young 1971:xxi, 44–45, 68–69, 90–91, 102–103, 132, 134–136, 140, 183–184, 192). Male behavior and male experiences are presented as normative. It is not sufficient to say that male ethnographers are simply mirroring the views of the cultures they are studying. For one thing, given their general lack of information about female culture and perhaps lack of contact with it, it is unlikely that they are reflecting the views of indigenous women. Secondly, there are too many ethnographies by females that contradict the sparse and ambiguous picture of Pacific Island women found in male-authored monographs, and this distinction generally holds true even when the female ethnographers have not explicitly focused on women in their research. And finally, the fact that gender influences perception is by no means limited to the authors of Pacific ethnographies.

The most significant message emerging from this chapter is that the ethnographer's gender is the dominant variable in answering the question, What do women do? This conclusion contradicts reports by Whyte (1978b:74) who argues that the "gaps" in reports by male ethnographers "are not ones that result in a systematic distortion" when the topic under study is women's status or position, and M. Martin (1978:310), who concludes that "female ethnographers cover essentially the same topics in general ethnographies as do male ethnographers." Martin's conclusion is based on a review of sources in the Human Relations Area Files. Though comprehensive, it is seriously flawed by a reliance on counting the number of passages dealing with " 'traditional' women's roles" (1978:307) rather than on a textual analysis of ethnographies. There is no attempt to evaluate content, but any discussion of observer bias requires a close qualitative analysis of the observers' reports.

Returning to John Whiting's assertion that "women never hunt," it seems clear that this statement, and many others like it in Pacific ethnographies,

says much more about the ethnographer and his culture than it does about a Pacific Island woman and her culture. Eleanor Leacock (1972:40) has argued that hunting is overemphasized in ethnographies and anthropological theories because ethnographers, who are products of industrial, urban cultures, regard hunting as a romantic and exciting adventure. Feminists are not just castigating old models that are being replaced by new versions. What is important about the skewed perception and underreporting of what women do is its enormously damaging effect on our ability to construct adequate explanatory models of the totality of human behavior. Undoubtedly men could be trained to produce adequate descriptions of culture, as easily in the Pacific as anywhere else. The increasing number of good sources on the ethnography of Pacific Island women have been produced because female culture is now being examined more aggressively, more intensively, and most importantly, more consciously by female ethnographers—and perhaps, one may hope—by male ethnographers.

5

Revenge Suicide by Lusi Women: An Expression of Power

Dorothy Ayers Counts

In his recent cross-cultural study of deviant behavior, Edgerton (1976:42) discusses examples of revenge suicide from the Trobriands, Dobu, and Africa. In the African case, a young woman committed suicide in preference to an objectionable marriage arranged by her father. Her death brought down a multitude of troubles on her father and on her entire clan. The repercussions of such a death are serious for the suicide's survivors as well as for those adjudged to have caused the death. Edgerton (1976:42–43) comments that the act of suicide in these cases "is seen, particularly by men, as highly deviant. . . . Obviously, then, suicide can be a serious form of deviance."

Although Edgerton (1976:1) does not provide a concise definition of *deviance*, he consistently uses it to mean behavior that breaks widely held social rules and causes trouble. In addition, he apparently assumes that it is enough to label suicide as deviant if it is so regarded by men, particularly the men for whom it causes trouble. I suggest, alternatively, that suicide may not be deviant behavior at all. Rather, it may be a political act, perhaps the only effective one available, under certain circumstances, to powerless persons.

The research on which this chapter is based was conducted in northwest New Britain in 1966–67 and was supported by the National Science Foundation and Southern Illinois University; for three months in 1971 with support from the Wenner-Gren Foundation for Anthropological Research and the University of Waterloo; and in 1976–77 with the support of the Canada Council.

I wish to thank David Counts, William Thurston, Richard Golden, and the organizers, participants, and discussants of the Association for Social Anthropology in Oceania, Symposium on Women in Oceania, for their advice and their criticisms of earlier drafts of this chapter. I also have a special debt to the people of Kandoka village, Kaliai, West New Britain, for their patience and willingness to help me understand their world.

Since 1954, when Leach published *Political Systems of Highland Burma*, it has been an anthropological truism that a society may well have two seemingly contradictory sets of rules that permit people to make choices. This inconsistency may mean that two very different courses of action are both equally right or wrong, depending on context and circumstance (Leach 1954:167). The effect is a flexibility that permits people to manipulate the system and to avoid concentrating power in the hands of a single group or category.

In this chapter, I extend the concept of alternative rules to revenge suicide. I suggest that revenge suicide is not deviant, but a behavioral alternative that is an integral part of cultural knowledge. Using data from the Lusi-speaking Kaliai of northwest New Britain, I demonstrate that suicide is part of a pattern of behavior for powerless people, that this pattern is communicated in oral literature, that it follows rules, and that it has predictable results. Suicide is a political alternative that permits the powerless, frequently women, to limit the use of power by others.

A political act is one that influences or changes the decisions and behavior of others, or which is intended to do so. In the case of revenge suicide, *others* refers to those persons who wield power. A political strategy is a device or an act intended to obtain an advantage for the actor, to give him or her some measure of power. Power is the ability to perform effectively, to have influence or control over the behavior of others. Power may be held legitimately, by consent, and it may be an aspect of positive interpersonal relations. By contrast, power may be held as a result of aggression, force, or coercion. In this circumstance, the persons on whom power is imposed have not given their consent and are likely to consider it illegitimate.

Revenge suicide may be a reasonable, culturally patterned act of political strategy, even though the suicide may not live to enjoy the benefits of the deed. This reasoning is not entirely alien to Westerners. The self-immolations of Buddhist monks in Vietnam during the 1960s, made dramatically familiar by television coverage, were certainly political acts that were also rational within the terms of Vietnamese culture. Revenge suicide is an efficacious political act despite the fact that, from our ethnocentric view of death, it ends the life of the suicide. Melanesians view death differently than do English speakers. The people of Hagen, Highland New Guinea, and the Lusi Kaliai, to name two examples, assume that a ghost has consciousness and that it is aware of the effects of its suicide on its survivors and on mundane events. Hageners assume that the ghost itself has the ability to avenge past wrongs (M. Strathern, personal communication). Anthropologists have no reason to challenge informants' assertions that death is not the end of existence.

Revenge Suicide: Cross-Cultural Examples

The American Heritage Dictionary of the English Language (1969) defines suicide as "the act or an instance of intentionally killing oneself." Suicide has long been associated in psychoanalytic literature with the desire to kill someone else. Menninger (1966) states that suicide must contain three elements: a desire to kill, a desire to be killed, and a desire to die. Anthropologists, however, recognize that suicide may be committed to punish someone else. This kind of suicide, termed *revenge* or *samsonic suicide* after the biblical hero who pulled down the pillars of his enemies' house on his own head in order to kill his captors, occurs throughout the world and appears to be the ultimate strategy available to powerless people for influencing the behavior of others (Jeffreys 1952). Muslim women, for example, reportedly threaten suicide as a way of achieving their will (Fluehr-Lobban 1977:135), while a Havik Brahman woman of India may resort to suicide as her only recourse because she has "no formal power" (Ullrich 1977:101).

In the Pacific, revenge suicide is committed by both men and women. For instance, Malinowski (1922) recounts the suicide of a Trobriand boy who jumped to his death from the top of a palm tree in order to compel his kin to take revenge on a man who had publicly accused him of incest. Fortune (1963 [1932]) comments that on Dobu Island, the husband of a consistently unfaithful wife might commit suicide in order to cause his kin to take revenge upon his wife and her lineage. He writes: "The point of suicide" was to force "one's kin to avenge one on one's cruel wife's kindred" (Fortune (1963 [1932:3]). Brown (1978:159, 204) notes that the Chimbu of Highland New Guinea often reported that a woman who was forced to marry a man she did not like or to stay with a man who beat her excessively might hang herself. Her death humiliated both her kin and her husband's kin, requiring the two groups to make mortuary payments and exchanges (Brown 1978:204). Leenhardt (1979:39) observes that in New Caledonia "the decision to commit suicide is caused by social impotence." Insulted or betrayed wives dress in their finery and hang themselves, take poison, or leap from the top of trees as an act of revenge. A woman does this, says Leenhardt (1979:37), in order to

be able to torment her husband as a punishment and keep him terrified. She kills herself to become one of the Furies. Such actions are not without their measure of shrewdness!

The men have none of this dramatic revenge. They believe in their strength, which allows them to take measures which are less harsh for them and more cruel for their wives.

In some circumstances revenge suicide is regarded as a correct course of action. Berndt (1962:181) says that this is the case with the Fore people of Highland New Guinea. To understand revenge suicide among the Fore, Berndt suggests, there are two points to be considered. First is the importance to the Fore of reciprocating a wrong and the fact that suicide will "more likely than not set in motion the machinery of revenge" (Berndt 1962:181). Second is the positive evaluation that the Fore place on strength and assertion. Suicide may be an aggressive ('hot belly') response to humiliation which provides "a favorable setting for inflicting harm and injury on the supposed offender—even if this takes the extreme form of an act of aggression against the self" (Berndt 1962:204). A Fore woman may commit suicide if she has been wronged and has no effective recourse. Berndt (1962:205) states that, except for the southern Fore, "a wife has no legal rights in the village into which she is married." She usually lives in a different village or district from her brothers with whom she continues to share allegiance. A husband who wants to get rid of his wife may try to achieve this by abusing her, and a woman so treated has the option of eloping with a lover, returning to her own village, or committing suicide (Berndt 1962:191, 205). Apart from seeking external help, the choices open to a wronged wife

are to continue to quarrel with her husband, to leave him, to attempt a reconciliation, or to do her best to injure him. The circumstances may be such as to suggest suicide. Taking this step involves a specific attempt to injure the offending person; the primary intent, however, is to right a wrong. (Berndt 1962:205–206)

Popokl 'revenge-anger' or 'grievance-sickness' may lead a Hagen woman to kill herself (M. Strathern 1972:281–283). *Popokl* 'revenge-anger' permits a wronged person to express anger and frustration and is intended to shame others and cause them to regret their behavior (M. Strathern 1968, 1972:142–152). As Andrew Strathern (1975:351) notes, the concept of *popokl*, expressed both as 'revenge-anger' suicide and as 'grievance-sickness' "points out the guilt and hence the responsibility of others in relation to a harmed person."

We see, then, that in three Highland New Guinea societies, the Chimbu, the Fore, and the Hagen, a woman can express her anger and frustration, establish that someone else is responsible for her misery, and aggressively humiliate or injure those who have wronged her, by killing herself. She is indeed causing trouble, but it is trouble for those who have mistreated her and whom she can reach in no other way. This is not deviant behavior. Rather, the woman is acting according to accepted norms of balance, reciprocity, and assertive aggression; she is following a political strategy.

Panoff (1977) suggests that for the Maenge of New Britain there is one set of rules for men of renown and another for women and for men who are

'men of silence' and considered 'rubbish men' by their peers. Suicide is not considered proper behavior for everyone, and in fact it occurs most often among women and orphans, "precisely those categories whose members have the fewest opportunities to pour out their aggressiveness" (Panoff 1977:55). For the Maenge, suicide "is a type of death appropriate only to 'rubbish men' and women" and, Panoff (1977:50) concludes, it belongs to Jeffreys's (1952) category of samsonic suicide.

The Lusi

Kaliai is a political district on the northern half of West New Britain, Papua New Guinea. The Lusi are an Austronesian-speaking population who live along the Kaliai coast (fig. 2) in villages of about 50 to 250 persons. The Lusi are formally egalitarian, with no ranked hierarchy or inherited offices. However, people are not equal in these normatively patrilineal and patrilocal villages. Power differences exist between people on the basis of age, sex, and birth order. An older, first-born male, for example, has a power advantage, but there are constraints on his use of it. Supernatural sanctions exist against misuse of power. There are a number of myths in which the neglect or abuse of powerless, undefended orphans and women eventually angers the ancestral spirits who punish such mistreatment. However, in spite of the often-stated value that people should care for the defenseless, people who are in a subordinate position must cope with the fact that others may use power to compel their behavior.

Alternative Responses to Abuse

Suicide is certainly not the only strategy available to a Lusi woman who is abused by her husband, whose wishes are ignored by her kin, or who is shamed. Her options vary, depending on whether her tormentor is her husband, a relative, or a neighbor. She may appeal to her male kin for help; she may try to help herself; she may receive assistance from other women; she may look to her lover or husband for support; she may appeal to the national code of law as a source of authority that upholds her rights; she may respond to aggression with passivity; or she may commit suicide. I will briefly discuss each of these alternatives.

Appeal to Male Kin

Most married women live near their natal villages or in the same community as their male relatives. Although a man can beat his wife without inter-

ference from her male kin, there are limits to this husbandly prerogative. A husband who exceeds the limits of what may be termed "reasonable abuse" of his wife may find himself in a direct and, perhaps, violent confrontation with her male kin. For example, during the course of one domestic quarrel, a husband chased his screaming wife into the middle of the village square, stripped off her pubic covering, and began kicking her, "as though she were nothing but a dog," to quote one of her relatives. Men who stood in the relationship of father and brother to the woman quickly gathered and soundly trounced her husband, who subsequently left the village. The woman's kin, angered that she had been treated as though she were an animal, felt they had to avenge her shame immediately. Significantly, they also considered themselves humiliated by the husband's treatment of their kinswoman.

Clearly, marriage does not terminate relations of common identity, allegiance, and mutual support between a woman and her relatives. It is, I think, an open question as to whether the men's swift and angry response was in reaction to their kinswoman's shame or their own. This and other examples discussed later suggest that men respond to abuse of their married female kin because their rights and collective lineage pride have been violated by a husband's mistreatment.

Self-Help

A woman abused, shamed, or ignored by her own male kin has no source of public support equal to that available to a man. Her options are to engage in self-help or to look for her female relatives for assistance. Women occasionally choose the first option. For example, Joyce's father arranged her marriage to a young man with whom she was having an affair.[1] Before the wedding, the couple quarreled and broke off their relationship. Nevertheless, Joyce's father proceeded with his plan to arrange her marriage to the young man. In a rage of protest she kicked in the wall of her father's house. The tactic worked. The marriage was called off, and the woman later found her own husband without consulting her father. I will discuss below her family's attitude and response.

Support by Other Women

Although there is no Kaliai equivalent to *Wok Meri*, 'women's work' in Neo-Melanesian, a phenomenon described by Sexton in chapter 7, women do support one another. The relationship between co-wives is ordinarily one of jealousy and either overt or controlled hostility. Occasionally, however,

[1] Personal names are fictitious.

they join together against their husband, particularly if he plans to contract a new marriage. The three wives of one polygynist announced to him that if he went through with his planned fourth marriage they would all leave him. He married the fourth woman, and his first three wives returned to their natal families.

A cooperative relationship does exist between sisters or between mother and daughter. I know of no case in which a woman publicly supported her sister or daughter against her male kin. However, women quietly attempt to influence their male relatives, and occasionally they conspire with a young kinswoman to defy them.

It is the traditional right of a father to arrange the marriage of his daughter without consulting her or considering her wishes. A loving father attempts to select a man acceptable to his daughter, but a father's most important consideration is promoting his interests and those of his sons. If these priorities conflict with a daughter's wishes, the male interest takes precedence. The advantages of this tradition are more immediately obvious to a Lusi father than they are to women or to a young man with a sweetheart who has been promised to another man.

In the village where I did most of my research, only half of the middle-age couples had gone through an arranged marriage; the others had eloped. Ironically, an elderly 'big man' who was most critical of the degenerate morals, manners, and marriage practices of modern youth, and who made speeches on this topic at almost every public meeting, chuckled as he admitted that his wife's mother had sneaked him into her house and had helped him and his bride to elope the evening before the girl was to be married to another man of her father's choosing. It would seem that this patriarchal ideal has never been enthusiastically shared by young women or their mothers, and that women have long conspired to circumvent the plans of their menfolk. A woman who strongly opposed her father's marital arrangements for her might have the support and help of another woman, or a lover, in her defiance. Rarely, however, would anyone else come to her assistance.

Support from Brother or Husband

The situation of a married Lusi woman is ambiguous. As I have noted, a woman's ties with her natal group continue throughout her life. Close ties, for instance, exist between a woman and her brother. She supports him by contributing women's goods, such as pandanas mats, baskets, and household property, as well as cooked food to ceremonies that he sponsors. He comes to her assistance if she is abused by her husband; he contributes to the bride-wealth collected for her sons; and her children inherit his coconut palms after his death. However, when a woman marries she also becomes associated

with her husband and his kin. Her husband has use rights in property she inherits and in the products of her labor. She will raise his pigs and garden land controlled by his kin group. Also, in modern Kaliai a married woman who works for wages will use her money to benefit herself, her children, and her husband. Her natal family has no claim on her wages and can expect to see little of the money that she earns, especially if she does not live in her parents' village. As a result, fathers are reluctant to spend resources on daughters if they have sons. For example, in 1976 some fathers were unwilling to spend the eighty *kina* 'unit of Papua New Guinea currency' (abbreviated as K) for school fees to send their daughters to high school.[2] I discussed the matter at length with Carl, the father of Melissa who had been at the top of her class since grade one and whose academic ability was obviously superior. Carl argued that 80K was a sizable expenditure for a household that would expect to earn no more than 400K in a year from its sale of copra. He would, he said, not hesitate to spend the money on a son with Melissa's ability, for a son's future earning power would benefit his siblings and his parents for years to come. However, when Melissa married, her husband would control her earnings, and as a result Carl and his family would sacrifice to pay Melissa's school fees only to enrich another man and his kin.

Appeal to National Law

A Lusi woman has use rights in the property controlled by her *kambu* 'patrikin group', and she may inherit coconut palms from her mother's brother. Traditionally, coconuts were hospitality food and were required to make taro puddings prepared for feasts. The Lusi associate coconuts with females. In myth, they become women. Coconuts are identified with mother's milk and, as a mother establishes her relationship with her child by suckling it, a mother's brother expresses his kinship by bringing the infant green coconuts to drink.

People inherit coconuts from their maternal kin. However, after World War II, copra became an important cash crop, and by the late 1970s it was the single most important source of money for the people of Kaliai. This fact resulted in a change of attitude toward the inheritance of coconut palms. Men wished to secure for their children, particularly for their sons, rights in palms planted by them on *kambu* 'patrikin group' land, for the nuts, together with the land on which they were planted, are *the* important source of modern wealth. Emphasis was placed on the inheritance of palms by sons because use rights in property owned by a married woman are usually exer-

[2]In 1976 the *kina* was at par with the Australian dollar and equivalent to about U.S. $1.40.

cised by her husband. Men were reluctant to see the benefits of an important cash resource pass through their female relatives to the control of their husbands, men who would necessarily be members of other, perhaps competitive, kin groups. Consequently, in 1971 a group of men attempted to deny the rights of a married woman to inherit coconut palms. Specifically, the men, supported by one old woman, Panga (the relationships of the involved people are shown in figure 3) tried to reject the claim of their kinswoman, Puri, that she was entitled to use a stand of coconut palms that she and her siblings had inherited from their father, Simon. In response, Puri argued the facts of the case and appealed to national law as an authority that would uphold her rights. The details of this dispute and discussion of property rights are given elsewhere (Counts and Counts 1974:141–149).

FIGURE 3: Relationships of Disputants Over Simon's Coconut Palms

Briefly, the circumstances of the dispute are as follows. Before his death, Simon had marked one grove of coconut palms for his three children. Puri, Simon's daughter, resided in Kaliai, collected nuts from the grove, and processed them for copra. Puri's cross-cousin, Benny, began collecting nuts from the same trees to process as copra, declaring that he was doing so on behalf of Akia, a young man who had been raised from childhood by Simon after the death of Akia's father. After several futile protests, a furious Puri cut down two of the disputed trees as a dramatic demonstration of ownership, the ultimate test of the right of ownership being the right to destroy. In angry response, Benny called a *lupunga* 'public meeting' to castigate Puri and to mobilize public opinion behind his assertion that she had no right to the trees. Puri's relatives attempted to challenge her rights of ownership and

inheritance because she was a married woman. "You are only a woman, and you are married," shouted Kanga. "You belong to another family, and you get what you need from them. You cannot come back. You have no claim on your family. You aren't a man; these things belong to men. . . . Your younger sister still has a claim because she's not yet married [Puri's younger sister was a nun], but not you." Puri's counterstrategy was to threaten to take the matter to the patrol officer for settlement, assuming that he would base his decision on national law and therefore uphold her claim.

Disinterested villagers thought that Puri was foolish but within her rights to cut her trees, that she could not be expelled from her kin group by anyone but her agnatic kin, and that she would be upheld by the patrol officer should she take the dispute to court. Her strategy was apparently successful, for in 1975–76 she and Akia (with her permission) were the only ones making copra from the disputed coconuts.

Passivity

Another option available to a shamed or abused woman is extreme passivity, that is, allowing herself to be publicly humiliated so that her kin are moved by pity or shame to come to her defense. The furious response of the kin of the woman whose husband publicly kicked her and exposed her genitals illustrates the potential effectiveness of this strategy. The behavior of Agnes before her suicide (case 7, below) exemplifies this tactic. For over a week before her death, Agnes increasingly withdrew from the company of her friends; she refused to cook or eat with other women, giving as an explanation to a friend that she had overheard a mother scolding her child with the warning that if the little girl did not behave she would grow up to be like Agnes. She was also seen weeping quietly. After her death, villagers with the advantage of hindsight said that Agnes's shame at being a subject of gossip, her withdrawal from others, her weeping, cooking, and eating alone were signals of distress that should have alerted her kin. Rather than aggressively challenge her tormentors, Agnes passively signaled her misery, an unsuccessful tactic for it did not result in changing the behavior of others.

The theme of passive response recurs in the oral literature of northwest New Britain. The story of Silimala presents two women in conflict, one aggressive and the other passive.

Akono, who has married Galiki, goes to his uncle's village to collect bridewealth to give Galiki's family. Silimala, a pesky and unattractive woman (her nickname is "Paddle Legs") who lives in the uncle's village, rushes out to greet Akono. She claims that he has come to marry her and that the bridewealth is for her kin. Akono and his relatives attempt unsuccessfully to drive Silimala away. Finally, in desperation,

Akono kills her and cuts her body into little pieces. However, the body rejoins, and in spite of all her efforts to get rid of her, Silimala returns home with Akono as his wife. Akono and his sister urge Galiki to help them drive Silimala away, but Galiki refuses saying, "I'm sorry, Akono, but I can't do anything about her. You have to deal with her. It's your fault that she's here. You went and got this woman to be your wife. You're the one who brought her here. It's all right. What's my body for? It's for her fire if she wants to burn me. It's all right."

Silimala then takes the place of passive Galiki; she moves into Galiki's house and throws her belongings onto the ground; she claims all the bridewealth valuables and takes possession of them; and she kicks and burns Galiki until her body is covered with sores. Akono watches Silimala's aggressive abuse of Galiki with mounting anger. Finally he devises a plan and tricks Silimala into thinking that he is dead so that she will ask to be killed too. Akono's sister kills her with a wooden sword, Silimala is buried in what she thought was Akono's grave, and Galiki and Akono live happily together.

This story provides a number of insights into the complexities of a Lusi woman's role. In the first place, although Silimala is an aggressive, despicable woman, she is also an obedient, dutiful wife and it is, in fact, this aspect of her character that leads to her destruction. She is twice fooled by Akono, and on both occasions he is able to delude her because she unhesitantly volunteers to perform a service for her husband by getting water for him. Akono never doubts that she will serve him, and this confidence enables him to plot successfully to trick her into asking for her own death. I discuss widow killing in detail elsewhere (D. A. Counts 1980b:342–343), but for the purpose of this analysis it is necessary to realize that in precontact times a Lusi widow was killed, at her request, by her own kin so that she might live in the spirit world with her husband. A widow who asked to die was not, by Lusi norms, behaving deviantly. In fact, her act was thought to be rational and honorable, and her descendants kept as an heirloom the wooden sword with which she was slain. This sword was brought out on ceremonial occasions as an act of homage.

The reaction of villagers to the story suggests that rules of behavior for Lusi women are complex. This tale implies that the aggressive woman is the villain, rightly defeated in the end, while the passive woman is the heroine for whom the audience feels pity and sympathy. And this is, indeed, the way men react to the story. My male informants said that the actions of Silimala made them angry and that they wanted to kill her themselves each time they heard the story. However, women obviously enjoy the tale, for they laugh both at the story and at the audible responses of the men. Unfortunately, I failed to talk with them specifically about their reactions, but my impression was that the women were amused by and sympathetic to Silimala, the aggressive woman, rather than Galiki. The subject of humor and women's

attitudes toward aggressive women is one on which I hope to do further research.

A Continuum of Behavior

It may help our understanding of the behavioral dynamics involved if we view three responses—passivity, unsuccessful suicide attempt, and successful suicide—as analytic points along a continuum of behavior. On the surface, passive behavior seems to be an act of submission. The abused person is unable or unwilling to defend herself against aggression by responding in kind. It is a request (within the context of suicide, a demand) for intervention by others in her behalf. The expectation is implied that a person's kin will be alert to her needs and so concerned for her welfare that her shame and abuse angers them and causes them to intervene.

It is difficult to judge whether an unsuccessful suicide attempt is in fact a serious effort. Several points are relevant in assessing a Lusi suicide attempt. First, the rules for committing suicide (which I detail below) require that it be done before witnesses or in a place where the body is certain to be found. These conditions may result in a person whose intent is serious being saved from death. Because Agnes left a suicide note and hanged herself on a well-traveled path to the gardens, we cannot assume that she intended others to prevent her from being successful (case 7, below). Nor can we dismiss Ruth's attempt as feigned because she drank poison where others would be certain to see her (case 1).

A second relevant point is that Lusi do not verbally threaten suicide. Rather, they give culturally recognized behavioral signals which should be understood by others. A person's close kin and neighbors, who are familiar with her circumstances, are responsible for drawing parallels between her situation and those that have resulted in suicide. They should understand the implications of her behavior and intervene, relieving her shame and therefore eliminating her reason for killing herself. Third, there are no sanctions invoked against a person who unsuccessfully tries to commit suicide nor, as far as I know, is culpability assigned in such a case. I know of no situation in which the kin of a person who has attempted suicide have exacted compensation from or taken vengeance against those whose behavior drove the person to the act. However, it is possible that culpability may sometimes be assigned, a question requiring further research.

The Lusi woman who commits suicide does so as a desperate act of last resort. She is not behaving in a deviant manner. Rather, she is adopting a course of behavior that is socially defined as appropriate. Indeed, such behavior may be the only way that she can redress her shame and take revenge

against her tormentors. To be sure, a woman who commits suicide does cause trouble—one of the characteristics of deviance—but she is not behaving outside the rules appropriate to her condition. Furthermore, the expectation that her suicide will surely cause trouble for someone almost certainly contributes to her decision.

I have discussed in detail elsewhere women's roles in Lusi society (Counts 1980*b*). Therefore, I will summarize briefly some factors affecting women's behavior that directly pertain to the present discussion of suicide as political strategy.

Social Factors

A Lusi woman's ability to challenge male authority directly is limited by the fact that she is identified with the man, usually her husband or father, who controls rights over her economic production and sexuality. There are, however, factors that temper this masculine control.

First, birth order overrides sex with regard to relations between siblings. I have seen a woman order her younger brother to get up and give her a desirable seat. When the man smilingly protested that he did not have to move because he was there first, his sister replied, "I'm older. You're younger. Move!" He did.

Second, a woman is responsible for her own behavior unless her mind is controlled by sorcery (e.g., love magic or sorcery-induced suicide). After her death, Agnes's kin held a divination ceremony to determine whether she had been enchanted into killing herself or had committed suicide of her own will.

Third, some Lusi women are aggressive, assertive, and powerful. All of these women for whom I have data were first-born children and are the wives and/or daughters of influential men. I will briefly describe three of these women.

Sisivua was the daughter of a powerful 'big man' and the wife of another. She brought her husband a wedding gift, a terrible spirit personified by a mask which was fed the flesh of pigs and human beings. She was reputedly a woman of commanding presence. The men of her husband's village acknowledged her heritage and character by according her the right to remain in the village and witness the dance of her mask. Other women were driven out of the village and were forbidden to see the mask on pain of death. Sisivua is remembered by her descendants as being a powerful woman who was the daughter, wife, and mother of powerful men: she was the only Kaliai woman granted the right to witness this ceremony, hitherto restricted to men.

Puri, discussed above, asserted that she had property rights that her kin argued belonged only to men. She defended these rights and refused to be intimidated by male relatives who loudly asserted that she was insolent, shameless, and crazy. They reminded her that she was not a man but a married woman who, they claimed, had no inheritance rights. Puri was a first-born child and the wife of a village business leader.

Joyce, the woman who kicked down a wall of her father's house during her angry protests against an arranged marriage, was the subject of virulent gossip by her kin and neighbors. She was said to be quarrelsome, stubborn, violent, and disrespectful of her parents. She was criticized for denying hospitality to her kin and fellow villagers when they visited her in town (Joyce was a teacher who had returned home to her natal village for Christmas vacation to acquaint her kin with her new baby). She reputedly refused to share with her husband and children things she bought with her own income. She was said to purchase food for herself which she ate alone. The intensity of the gossip about Joyce suggests that her behavior violated socially accepted rules of behavior and caused trouble for others. In short, it was behavior of this kind, rather than suicide, that was considered to be deviant for women. The manner in which her male kin responded to her demands that they build her a village house with a locking door, where she could store her goods, is fascinating. The men did not challenge her authority to order them to work for her. They did not argue with her or refuse to do the job. Instead they responded passively. They sat impassively while she berated them for not meeting their obligations to her and then simply disappeared and went about their own business. Joyce's house was in process for six months and had not been completed when I left Papua New Guinea. When I asked her kin about their intentions, they chuckled and remarked that when Joyce returned to her job they would finish the house for her father to live in.

There are rules of behavior, explicitly set out in public statements and oral literature, which assert that fathers and husbands are dominant and the masters of wives and children. This domestic authority is reinforced by the possibility of violence, for fathers may strike their children without external interference, while the husbandly prerogative of wife beating is limited only by the fact that her kin (usually her brothers) will interfere if she is too severely abused.

The relationship of male dominance is not as strongly expressed between siblings and cousins. It is, as noted above, tempered by relative age. There seems to be little violence between male and female kin of the same generation. I know of no instance of a brother beating his sister, or of a man striking his female cousin. In fact, during the public debate over Simon's coconuts, Puri's cousin approached her at one point in a threatening manner as if to hit her.

Puri stood her ground and the man lowered his arm and walked away. Puri made no threatening movements toward him.

There was no confusion in the gender identity of Sisivua, Puri, or Joyce. Sisivua was a powerful woman who was granted rights usually reserved for men; Puri (illegitimately, according to some of her male and female kin) claimed property rights deemed appropriate to men; Joyce, who was the butt of gossip by men and women alike, was considered disagreeable, violent, selfish, and unsociable. The behavior of these women was variously admired, disliked, or thought to be foolish or inappropriate, but it was always the behavior of *women*. No one suggested that any of them had assumed a masculine role or that they were acting like men.

The idea of paternal authority and male dominance is countered by a contrasting, underlying theme of covert and complementary feminine power. This theme runs through oral literature and suggests that if she wishes to get her way and to counter male authority successfully, a woman must employ indirect tactics.

The Context of Suicide

I concentrate on women's suicide as political strategy because Lusi women are ordinarily subject to male authority and are therefore less powerful than men of the same age. Women do not usually respond to difficult, tense situations by attempting suicide. Instead, they use other available options. However, there are certain social relationships that create so much shame that women's alternatives are limited or ineffectual. It is under these circumstances that women commit suicide. The nexus of relationships created by marriage may be especially tense, particularly those between co-wives and between a woman and her affines.

Co-wife relations are characterized by tension and conflict, and this strain may result in extreme passivity or suicide. For instance, Galiki, Akono's first wife, responded passively to the aggressive presence of Silimala, while June (case 2) attempted suicide in response to her husband's decision to marry again. Ruth's suicide attempt (case 1) followed her unsuccessful effort to prevent her husband from marrying a second time by taking him to court as well as a long history of violent conflict among Ruth, her co-wife, and her husband.

Obviously both women and men have affines, but the relationship is more likely to be a problem for a Lusi woman than for a man. Married couples usually settle virilocally. As a result, a woman is in daily contact with her in-laws and suffers stresses inherent in affinal relationships, charac-

terized by avoidance. The burden of responsibility for proper avoidance behavior is placed on the younger person or outsider who has married into the community. A wife who is alone with, eats before, or calls the name of her husband's brother or father is shamed, and any suggestion of sexual contact between them is likely to drive her to suicide. This potential for tension and shame limits the alternatives available to someone humiliated by an in-law. If one is shamed by one's mother-in-law, for example, one cannot "remove" the humiliation or turn it back onto the perpetrator by taking the matter to court, by violence, or even by appealing to one's own kin. Under these circumstances, the only appropriate and effective response may be suicide. The behavior of affines, spouses, and co-wives is a motivating factor in all of the cases of suicides summarized below.

Suicide in Kaliai

Suicide is not commonplace in Kaliai, and women are not the only persons who perform the act. Between 1966 and 1976, over the course of three stays in northwest New Britain for a total of twenty-three months, I gathered information on only six suicides (four by women and two by men) and on two attempted suicides by women.[3] It may be significant that the two male suicides occurred in the early 1900s, while women have committed all of the suicides since the mid-1960s. While suicide is not an everyday happening, it has great emotional impact on the community. It is also a recurrent theme in the oral literature of northwest New Britain. The pattern in both contexts is similar. A person commits suicide because she is the victim of sorcery or because *ei aia mamaia* 'she has her shame' and cannot endure the humiliation she is suffering. A divination may be required to ascertain the cause beyond doubt. As noted above, both men and women kill themselves during sexual or marital strife or following an episode in which they were shamed or abused by their affines.

Why do some people choose the alternative of suicide? There is no clear answer to this question. When I asked my Lusi informants, I was almost always told that it was because of sorcery, or shame, or simply that they did not know. One man provided an insight when he observed that suicide seemed to run in families. In fact four of the seven cases summarized below (cases 1, 5, 6, and 7) and one suicide committed in September 1979 took place in one village and involved a single patrikin group. This place has twice

[3]David Counts and I have, since returning from New Britain, received a letter from an informant telling us that in September 1979, another young married woman from the village killed herself. I do not yet know any details of her death.

the population of any other Kaliai village and was my research base. Its size, and the fact that I have more detailed information about its people, partially explains why this one community seems to have such a high proportion of suicides. Note, however, that my informant was himself puzzled by the apparent tendency of one group of people to kill themselves. He, in fact, brought it to my attention as a peculiarity and observed that none of his agnatic line had ever committed suicide. "If I got that upset," he commented, "I'd kill someone else, not myself."

Revenge suicide is part of the cultural pattern of Kaliai. The act follows generally known rules and can be expected to have predictable results within the community where it occurs. There are two ways in which a Lusi woman will probably kill herself. Suicides either hang themselves or drink *tuva* 'fish poison' made from the derris plant. When Lusi speak of self-killing, they say *i pamatei* 'she killed herself.' They describe the method of death by saying 'she hanged herself'; 'she drank fish poison'; or they attribute responsibility for the death: *ti pamate eai ngani posanga* 'they killed her with talk.'

There are also rules governing the context in which a person takes her life. She should not kill herself impulsively or secretly. Rather she should plan her act and warn others of her intention. There are a number of signals. She may destroy her personal items, things that she values or uses every day, such as her shell armbands and her cooking pots. Or, as one woman chose to do, she may break up her canoe with an axe. Alternatively, a woman may leave hand or footprints in ashes.[4]

A woman planning suicide should dress in her finest clothes or traditional costume, and she should take her life in the presence of others, preferably the person(s) whom she holds responsible for her act. In one Kaliai tale, the hero drinks fish poison in the presence of his brother and then says to him, "Brother, you have killed me." Furthermore, a person's body should not be allowed to rot, undiscovered and unburied. In all cases for which I have information, the person committed suicide either in clear view of others or beside a busy public path. In most cases the suicide shouted out her intention before acting, and sometimes she asked others to apprise a particular person, the one responsible for her death, of what she had done.

A person contemplating suicide has the reasonable expectation that her kin and neighbors will respond to her in certain predictable ways. The phrase, "They killed her with talk," and the cry of a Lusi father whose young daughter had just killed herself, "Why did you kill my child?" suggest that Lusi consider self-killing to be a form of homicide, an act for which another

[4]Ashes are associated with death and mourning in the oral literature of northwest New Britain. Persons planning suicide leave imprints of their hands or feet in ashes. People in mourning lie in the ashes of their cooking fire.

party is culpable. A woman may expect her kin and friends to hold someone else responsible for her death. Suicide obliges a woman's kin to avenge her. They expect her ghost will continue to appear to them (as does the spirit of any victim of homicide or sorcery) until the duty is met. There is no notion that any ghost possesses malevolent power. In death, as in life, the suicide must wait for others to act on her behalf.

Revenge suicide is a political strategy because of the element of culpability. The suicide makes certain that others know why she has taken her life and whom she holds responsible for her unbearable situation. Once her kin are apprised of these facts, the suicide may expect that her shamed, grieving, angry kin will avenge her death upon her tormentor. Note that the kin of the suicide are themselves shamed by her death. In the case of one suicide that took place during my research, the dead woman's parents refused to accept the compensation payment made by the culpable party, indicating that it should go instead to her maternal relatives, who lived in a neighboring village. The parents, and the woman's agnatic relatives, could not accept payment because they felt that they had contributed to her death by their insensitivity to her unhappiness and to the warning signals that she liberally gave until the very morning of her suicide.

The suicide's kin may attack the responsible person with direct physical violence or engage a sorcerer. At best, the responsible party must pay dearly to placate the suicide's survivors. But the wealth is not well spent, for a few strands of shell money and a pig do not erase the misery or replace the life of a loved one, and the guilty live in fear that they will be the victims of sorcery. Lusi know the probable results of suicide, and this shared knowledge makes suicide a reasonable alternative for a powerless, shamed, angry woman who cannot otherwise alter the balance of power or relieve an intolerable situation.

Suicide in Story and in Fact

I have claimed that suicide is part of the culture of the Lusi Kaliai. While I know of no myth that suggests a person *should* kill herself, the society provides numerous instances of revenge suicide in story and in fact. A person will probably know about these examples, and their aftereffects, and she can draw her own conclusions. Suicide is a theme in Kaliai oral tradition, and while not all stories are considered historically factual, the storytellers with whom I worked said that tales were frequently intended to teach people the rules of proper behavior as well as to entertain. Storytelling is a popular evening pastime and an effective way of transmitting values and beliefs. When stories about suicide are compared with instances of actual behavior,

we may gain useful insight into the cultural context of this behavior. I will give a few examples.

Examples of Suicide in Oral Tradition

Tuna Akono and Galolo: Akono is coerced by his brother Galolo into remaining home with Galolo's wife and children to gather nuts while Galolo goes fishing with other village men.[5] Galolo's wife makes sexual advances to Akono and, in anger and shame, Akono prepares three containers of fish poison. When Galolo returns, Akono tells him that he is responsible for Akono's death and drinks the poison. Galolo kills his wife at Akono's grave. None of her kin object.

The Cassowary Brother-in-Law: There are several versions of this story, but they all agree that Akono lives with his older sister and her husband, who is a cassowary. Akono works every day in their garden, and his sister prepares food for him, but her husband steals the food and substitutes stones. Akono feels humiliated by this treatment and asks his mother to help him prepare a feast which he gives to his sister while telling her of his shame. Then he dresses in his finest clothing, oils and paints his body, breaks his turtle shell bracelets, and makes his footprints in ashes. This done, he runs away, his sister following. He either drowns himself in the sea or leaps from a cliff, and his sister responds either by killing her husband and being turned to stone or by driving her husband away.

Katimu: An old man lives alone in the forest with his two daughters. An evil man finds them and forces the women, one by one, to be his wives. The women faithfully prepare food for their father, but the husband insists upon taking it to the old man and eats it on the way, substituting stones for the food. Finally the husband tires of the burden of the old man, and burns him in his house. The women hear their father's death song and rush to find out what has happened. They confront their husband with the murder and then jump from the top of a palm tree. The shamed husband falls on his spear.

Akro and Gagandewa: Gagandewa, a spirit woman, lives with her husband in a human village. The husband's mother verbally abuses Gagandewa and her son, so Gagandewa returns to her spirit village, symbolically committing suicide. When her husband learns what has happened, he kills his mother. The spirits declare war on the human village, and the trading relations between men and spirits established by the marriage are permanently terminated.[6]

[5]Akono is the name of a hero in many Lusi *ninpunga* 'folk tales'.
[6]I provide a detailed analysis of this story in D. A. Counts (1980*a*).

Contemporary Cases of Suicide

Case One: Ruth. Ruth often fought with her co-wife and with her husband, returning his blows. Finally, after he had beaten Ruth unconscious and fearing that he might kill her in a future rage, the husband called on his relatives in a nearby village to come bearing a *varku* 'mask'. This mask represents ancestral spirits and is a traditional instrument of social control. The masked figure shaved the man's head, gave him a new name, and danced with him through the village announcing that henceforth he was under its protection and forbidding his wives from striking him under the penalty of paying a large fine to the mask. No similar prohibition on violence was placed on the husband. Following a subsequent quarrel, Ruth, who reportedly received a beating, prepared fish poison and drank it near a village copra shed in the presence of other villagers, who forced her to vomit up the poison. Her act apparently affected her husband's behavior. When I was in the village in 1976, nearly a year had passed since her suicide attempt and, although Ruth had quarreled with her husband and fought with her co-wife, her husband had not beaten her again.

Case Two: June. June was barren, and her husband's relatives pressured him to take a second wife. He reluctantly agreed, and June responded by drinking fish poison. She was forced to vomit and did not die, but his kinsmen stopped urging her husband to marry. As of four years later he had not done so.

Case Three: Nancy. Nancy committed suicide after she was accused, by her affines in public meeting and then privately by her husband, of having sexual relations with a catechist for whom she provided food and water while her husband was working at a nearby plantation. Her husband paid compensation to her kin.

Case Four: Biliku. Biliku was alone in her house when her elderly, senile father-in-law entered and allegedly exposed himself to her. Later she and her husband went to their gardens in separate canoes, and she noticed him in the canoe laughing with a young woman and looking in her direction. When they reached the gardens she accused her husband of laughing at her, broke her canoe with an axe, and went into the forest where she prepared fish poison. She returned to the beach, drank the brew in sight of others, and died. Biliku's husband and his kinsmen paid compensation to her relatives.

Case Five: Tomas. Tomas, who had two wives, beat one of them for fighting with the other. The male kin of the abused woman surrounded Tomas's house and sounded the bull-roarer, signaling the anger of her kin and ancestors at his treatment of her, and berated him for the beating. Tomas distributed pigs to them and, after they left, prepared three containers of fish poison which he drank in the presence of his wives and children. Tomas's

relatives held the beaten wife's kin responsible for his suicide, claiming they had killed him with their talk. Her relatives paid thirty fathoms of shell currency and one pig in compensation to Tomas's kin.

Case Six: Nathan. Nathan was unable to subdue the fighting of his two wives and was shamed by their violence and by his inability to control them. He prepared poison, climbed to the top of a tree, and placed a rope around his neck. Then he called out his intentions, drank the poison, and jumped.

Case Seven: Agnes. Agnes committed suicide after Victor, with whom she was living, refused to formally marry her. His mother reputedly called her a whore, and Victor's parents publicly refused to pay the bride-wealth demanded by her kin, citing the fact that she was living with Victor before marriage as evidence of her deficient moral character (Counts 1980*b*). For several days before her death, Agnes left farewell messages scratched on the skin of green coconuts around the village. On the morning of her suicide, she sent a note to Victor's mother's sister asking her to tell Victor of her death. Then, dressed in her best clothing, she hanged herself from a tree near a path to the gardens. Agnes's kin allegedly considered killing Victor's parents, especially his mother, with sorcery, but they accepted a compensatory payment of sixty-five fathoms of shell money, six *kina* 'unit of Papua New Guinea currency', and a pig. Shortly after payment, Victor's parents left the village—my informants assumed that they feared death by sorcery in spite of the payments, and considered this to be a reasonable fear—and had not returned when I left Papua New Guinea six months later.

Agnes's suicide had long-term consequences in her village. A month after her death, a young husband declared his intenton to divorce his wife after a particularly acrimonious quarrel. Relatives of the couple called a public meeting, and the husband's father emphatically stated that he considered his son's behavior to be unacceptable. "I will not have this trouble," he said. "I do not want another woman ruined as Agnes was. This pattern of breaking up established marriages results in tragedy, and I will not have it laid at my door. Before I will permit this, I will take the quarrel and this couple to the court and let the patrol officer decide what they should do. Then everyone must abide by his decision." The father's reminder of Agnes's suicide, and his threat to take the dispute to court to avoid another tragedy quickly quieted tempers. Shortly after the meeting, the young couple resumed living together.

In another instance occurring four months after Agnes's death, village officials called a meeting to discuss the problem of Rose and Victor.[7] Rose's father had arranged her betrothal, without consulting her, to a man Rose disliked. She loudly informed her father that she would never consent to the marriage, and he responded that she would do as she was told or receive a

[7]The same young man, Victor, was a principal in Agnes's suicide.

beating. A few days later Rose ran off with Victor and, when they returned to the village after several days alone together, Rose announced that because she was no longer a virgin, her betrothed's father would not wish to arrange her marriage with his son. Her furious father was restrained by his kinsmen, but the question was then raised as to whether Rose and Victor should be required to marry. Rose's father was not permitted to speak (he did not want Victor as a son-in-law), and the embarrassed couple admitted that neither of them wished to marry the other. Others then spoke, agreeing that the wishes of Rose and Victor were of primary importance. A man whom many villagers suspected of planning to avenge Agnes's death by working sorcery on Victor's parents, made a speech. "The time of telling young people whom they should marry is finished," he said. "The attempt to do this results in tragedy. Young people must be consulted and their agreement secured before marriage arrangements are made." At this, people applauded. Rose married neither Victor nor the man to whom her father had betrothed her.

As these two examples demonstrate, the indirect and long-term effect of a single successful suicide was that even the possibility of suicide—to my knowledge neither woman had threatened to kill herself—was a deterrent to the use of coercive power against women. People were intensely aware that suicide was a realistic alternative available to women who saw themselves as wronged. The possibility that the tactic might be used again alerted community leaders to the necessity of supporting women who otherwise had little power, thus curtailing the traditional right of men to control women and giving public sanction to social change.

Conclusion

Studies of women in the political arena should be concerned with expressions of power such as suicide (Tiffany 1978a:44). I have argued that revenge suicide is part of a cross-cultural behavioral pattern appropriate to the powerless, particularly women, especially in situations where options for direct response to aggression, abuse, or shame are limited. There is considerable evidence that this is true throughout Melanesia, among the Hageners, Fore, and Chimbu, and in New Britain, to name a few examples. In these societies, and probably others throughout the world, "suicide is a form of indirect power over others' actions that may be resorted to when other strategies fail" (Tiffany 1979b:438).

To be sure, suicide is not a desirable strategy, either for the suicide or for other community members. Lusi assert that it has dreadful consequences for the suicide's soul. The abrupt disjunction of relationships in the context of anger and shame prevents this kind of death from being amenable to the

efficacy of mortuary rites. Lusi assume that the ghost of a suicide remains angry and ashamed; it therefore cannot join ghost society and indeed never completes the process of dying, of achieving indifference to this world and integration into the next. Instead it wanders, perhaps to be captured and forced to be a familiar to sorcerers. A woman's suicide may also make it difficult or impossible for those in authority to achieve their desired goals, and it will cause serious trouble for them if they are held culpable for her death. But these results do not make suicide deviant behavior. Instead, they are evidence that suicide may be an effective form of political behavior. As Tiffany (1979*b*:439) observes, suicide is not necessarily deviant behavior because "it conflicts with men's interests, values, and objectives, even though it may be perceived as such by those who hold formal positions of power and authority."

Melanesian women ordinarily do not play a conspicuous part in the political and economic life of their societies. Anthropological studies have traditionally emphasized the flamboyant side of Melanesian life while ignoring more subtle aspects of decision making and policy making that occur behind the scenes. Many studies have dismissed women as uninterested in or unable to generalize about the public arena, where the attentions of men and of anthropologists have been focused. Yet, although they are ignored by social scientists, Melanesian women are not a stupid, downtrodden, subjugated lot who suffer abuse in silence; they play a vital part in social life. Recent anthropological analyses (for example, Feil 1978*a*, 1978*b*; M. Strathern 1972, 1980; Weiner 1976, 1978), including the studies presented in this volume, permit us to look beyond the obvious, past the feathers and oratory, to discover arenas where women make decisions, influence behavior, and exercise power. These analyses allow us to understand the alternatives available to women in what is formally a male-dominated world. This interpretation of suicide as a realistic and effective political strategy is intended to contribute to that understanding.

6

Women, Work, and Change in Nagovisi

Jill Nash

This chapter began as an attempt to describe and analyze changes in female participation in food and cash crop production among the Nagovisi of southern Bougainville, North Solomons Province, Papua New Guinea. The Nagovisi are non-Austronesian speakers who numbered about eight thousand in 1980. They inhabit the southwest-central part of the island at elevations ranging from 80 to 300 meters. The Nagovisi are matrilineal and reside uxorilocally in hamlets and villages, ranging from one to perhaps as many as twenty households.

Two major innovations that have occurred in historic times involve the work or livelihood of women and men. First, the original food staple, taro (*Colocasia esculenta*), has been replaced by sweet potato (*Ipomoea batatas*) as a result of a taro blight (viz., *Phytophthora colocasiae*), that swept through the Solomon Islands after World War II (Anonymous 1953). Second, cocoa (*Theobroma cacao*) cash cropping has been introduced, in which an alien—and from the Nagovisi point of view, inedible—tree crop is now extensively planted for the purposes of sale by nearly every Nagovisi household.

My original intent was to ask whether changes in relative work contribution by sex and changes in the kind of production associated with each sex

Fieldwork among the Nagovisi, North Solomons Province (formerly Bougainville District), Papua New Guinea, was carried out during the following periods: April 1969 to August 1970, December 1971 to April 1972, June 1972 to January 1973, and August 1973 to December 1973. Financial support was provided by NIMH Predoctoral Fellowships and an NIMH Field Research Grant in 1969–70. Partial support was also provided by a U.S. Public Health Service Grant. Field research in 1971 to 1973 was financed by the New Guinea Research Unit of the Australian National University. To all of these institutions I express my thanks. I am also indebted to the Nagovisi people, in particular, the inhabitants of Pomalate village. I was accompanied by my husband and colleague, Donald D. Mitchell, during all periods of fieldwork, and I am grateful for his companionship and support. This chapter has benefited from comments by Donald D. Mitchell, Denise O'Brien, Marilyn Strathern, and especially Sharon W. Tiffany.

have led to changes in the relationships between men and women. I was specifically interested in whether the position of women had been lowered by these historical changes.

Women's status is multifactorial, as several writers have shown (e.g., Quinn 1977, Schlegel 1972, Whyte 1978a). Because of this, most literature on the subject of changing female status attempts to deal with many variables. In contrast, I have restricted my attention to one factor only: work. There is ample precedent for viewing work as an index of the status of women. Whyte (1978a:44) notes that some prior theorists have seen work contribution as one of the crucial rights and powers that women must have if they are to have relatively high standing. In preindustrial societies, which tend to be occupationally undifferentiated, work is closely associated with other aspects of gender roles. Work, insofar as it consists largely of food production, is both routine and life-sustaining. It is also closely connected to questions of land rights, kinship obligations, property inheritance, production of prestige items, and exchange.

Various writers have posited a relationship between the nature of women's work and how women fare in society. Most have also attempted to assess the effect of change on female status. One of the first attempts to connect work and status is found in Engels's (1972 [1884]:121–122) pioneering book, in which he asserts that as women's work lost its public character, women themselves lost much of their own independence and became subservient to men. Modern interpreters of Engels, such as Leacock (1972) and Sacks (1975), have explained Engels's meaning as follows: when a woman worked for the clan (Leacock 1972:41) or for several households (Sacks 1975:218), her contributions were public, and her standing was higher than in later times, when her work solely benefited her own household of husband and children. Thus, it is not simply work itself but the context in which work takes place that influences status.

Boserup's (1970:50) well-known book linked colonialism and Western concepts of economic development to the decline of female participation in food production, especially in Africa. African women traditionally did a large amount of farming, which was a source of some economic independence for them. A consequence of colonial policies was to remove important productive tasks from the hands of women. Sometimes the belief that women should stay out of "unladylike" productive work was inculcated. At other times, or perhaps simultaneously, modern and prestigious forms of wage earning work were taught primarily or exclusively to men. Boserup (1970) shows that one result of these policies has been a loss of status for women in the modern period.

Similar events have taken place in the Pacific. Brookfield and Hart (1971:122) demonstrated that the historical trend in Melanesian production

is characterized by the loss of labor-intensive crops and gardening practices. The introduction of new plant varieties, population decline through disease or warfare, and recruitment of male labor are some of the factors responsible for retrogression of cultivation practices. Men no longer take part in food production, and this job, which is increasingly considered backward and lacking in esteem, is left to women.

Although Brookfield and Hart (1971) do not make a connection between farming practices and female status, anthropologists who have worked in Highland New Guinea have done so. Both Lindenbaum (1976) and Langness (1967, 1977) see men as trying to get women to work for them because, as Langness (1977:16) puts it, in order to live well, men require the fruits of female labor. Bena Bena men of the eastern Highlands recognize this, saying "Women are our tractors" (quoted in Langness 1967:172). In other words, the more work that women do in the gardens, compared with what men do, the better off men are, and the more freedom they have to spend their time in prestige accumulation, whether by modern or traditional means. Women, by performing garden drudgery, are a kind of early proletariat in this interpretation.

Last, Sanday (1974:198) used work contribution as one of several indices of female status and noted that "when the percentage of female contribution to subsistence is either very high or very low, female status . . . is also low." Thus, it appears that women should do some work, but not all of it, in order to have high status. An unspoken corollary of Sanday's finding is that men, unlike women, may gain high status by monopolizing subsistence work, or they may be able to avoid subsistence labor as a result of their high position. Perhaps by avoiding subsistence work men are able to attain higher status. This observation fits our conceptions of work and status in state societies, in which a mark of high status is avoiding certain kinds of work (such as cleaning one's bathroom, done by a low-status cleaning woman) or monopolizing other kinds of work that most of the population is de facto ineligible to perform (e.g., brain surgery, or being a member of the Joint Chiefs of Staff). Exclusivity or exemption as a correlate of high status applies only to men. It appears, then, that work for men is different from work for women, and this casts some doubt on the notion of a unified entity that one can call "work."

Because of these doubts, it appeared to me in the course of preparing this chapter that the category of work is complex. Moreover, the ideological meaning of work assumes great importance in discussions of its relationship to female status. One cannot consider work by itself, as I had hoped to do, because work is not the same as production, calories produced, or hours spent in the garden. It is difficult to isolate what is significant about work; in the West we confuse it with occupation.

So far I have used the term *status* without explanation but, like *work*, it must also be examined more closely. What constitutes status? How do we ensure that measures of status that seem appropriate for one society are useful cross-culturally?

Discussions of women's status often refer to several things. The concepts of power and autonomy may be central; that is (1) the ability to tell other people what to do, and (2) the ability to do what one decides to do. These propositions imply opposite conditions, since power suggests preventing others from doing as they please, while autonomy suggests that one does not have to do as other people say. While applicable to an understanding of gender roles, the kinds of power and autonomy available to a person is also related to the sociopolitical organization of his or her society and to social context as well.

Some kinds of autonomy are features of small-scale social systems or contexts of particular work competences. In foraging societies, women do not have to punch a clock five days a week in order to gain the basic resources of life. Furthermore, no one supervises their berry picking or root gathering or urges them to go faster or to pick more carefully. Women in foraging economies have autonomy with regard to when and how often they will work, and how they will go about working. No other individual or group has power over them in this context.

Another type of autonomy is characteristic of advanced industrial societies, in which one's actual subservience to anonymous forces is great, but in which the illusion of autonomy, especially in one's personal life, is strong. Thus, a woman who works for a failing company is probably powerless by herself to prevent its going out of business, and yet she feels "free" to change jobs, skip meals, fly to Europe for a vacation, and so on, simply because she decides to do so. The negative side of this personalized autonomy is alienation or anomie, since few people care whether or not she does any of these things. It is questionable whether the autonomy of the woman in state society and the autonomy of the female gatherer have much in common, but this issue is beyond the scope of this chapter.

The preceding discussion illustrates the kinds of serious and largely unresolved problems that the concept of women's status raises. A more manageable topic concerns what others have said about status. Discussions of women's status often attempt to define it. Whyte (1978a:10), for example, defines status as "a broad and inclusive term that may cover the differential power, prestige, rights, privileges and importance of women relative to men." Whyte thus introduces a comparative element—namely, that the statuses of men and women in any one culture can and should be measured against each other. Implicit in his definition is the notion that the term is or should be

useful cross-culturally as well. Whether explicit or unspoken, the assumption that the relations of women to men stand in an inverse proportion, or form a closed system, is an example of what Sacks (1976) calls "state bias." This is the idea that women cannot be "equal" to men if they are socially and culturally different from men. Sacks argues that equality as androgyny is valid only in capitalist states, but not in all forms of human societies. Several writers, including Whyte himself, have discussed the difficulties of identifying cross-cultural indices of female status (Quinn 1977; Tiffany 1978a; Whyte 1978a). We are attached to the term *status*—I myself have used it before repeatedly—but it is not a concept that increases our understanding. In fact, *status* deludes us in certain ways because its usage often exemplifies the logical fallacy of explanation by naming.

In this chapter, let us instead consider rights that males and females exercise, the claims they can make against each other, and the responsibilities they have toward each other, which result from membership in both gender and kinship categories. Are the efforts of one sex socially ignored, or are they recognized? If so, how and in what contexts? Who receives the prestige and/or material benefits, if any, from the performance of an activity or the fulfillment of an obligation?

To avoid concepts that are vague or have multiple meanings, I begin by describing the activities involved in food and cash crop production and the social relationships they entail in Nagovisi. It is my hope that this approach will lead to a clearer understanding of the more abstract concepts such as work, status, and public/domestic domains, frequently used in discussions of gender.

The following section describes two aspects of Nagovisi production, which are discussed in more detail later. First, the ratio of male to female work in food production has been altered by a change in the staple food crop, but the overall relationships of women to men do not appear to have changed significantly. Second, cocoa has been deliberately introduced as a man's crop; however, the net effect of adopting cash cropping has been to strengthen matrilineal institutions rather than erode them.

Production of Food and Cash Crops

Food Crops

Both taro and sweet potato are cultivated by the swidden, or slash-and-burn method. According to the classification provided by Brookfield and Hart (1971:105), Nagovisi horticulture is a low intensity system, which relies upon a lengthy interval of natural regeneration between periods of cultivation.

Brookfield and Hart (1971:107) focus on certain key characteristics of low intensity systems: gardens are planted in ashes among the fallen trees; gardens generally include a variety of crops, but one staple can be identified; planting is done by means of a stick, with which holes are made in the ground, and some tillage or soil mounding may also be done with this tool; gardens usually yield a single crop, but less important crops may be planted as successors to the main cultigens; and, finally, useful trees may also be planted and harvested during the fallow period.

Sweet potato is the modern staple in Nagovisi, and most of my information on its cultivation is taken from Mitchell's (1976) study, conducted during the late 1960s and early 1970s. The first stage in garden preparation is to clear trees by chopping them down with axes or ringing the bark. The land open to sunlight is left for two or four months, during which time a characteristic plant association called *lakena*, 'cover plants', grows. This is progressively cut back with a bush knife as garden area is needed. If the initial clearing has been extensive, additional heavy clearing need not be done for some time—several months, in fact—but the clearing of the cover plants proceeds continuously (Mitchell 1976:56).

Purchased steel hoes used in planting have no traditional counterparts. Earth is broken up with the hoe and formed into mounds of about one square meter. Vines from mature plants, either fresh or day-old, are stuck into the mounds. The number of mounds a gardener makes depends on soil conditions. Few mounds are prepared in virgin land, whereas more are made if the land has already yielded a harvest and its fertility has consequently declined. The plan is to plant no more than can be harvested in three or four trips to the garden (Mitchell 1976:57).

Harvesting may begin after twenty weeks, and the old mound is broken up and reworked at this time if the area is to be replanted. Nagovisi figure that a plot of average fertility will yield three harvests, after which it must be abandoned—sometimes to other crops such as manioc, peanuts, and wild sugar cane—and then to fallow. However, gardeners pay close attention to yields. If a second planting is not doing well, a third will not be attempted. If the yields remain high, more than three plantings may be made. Gardening, then, is a continual occupation. There are no specific seasons for clearing or harvesting, and each garden task is repeated numerous times during the course of a year.

Some work assignments may fall to either males or females, while others are fairly consistently associated with one or the other sex. Heavy clearing is men's work. I never saw a woman do this work, although Nagovisi men named certain women who had done and could do it. Either sex may cut and burn the cover plants that grow in newly cleared areas. Planting is normally done by women, although men may do so from time to time.

Harvesting is, likewise, women's work, but some men also do it. The management of the garden is associated with women, who are

the true garden "authorities." Usually the woman is the only one who understands the complexity of the internal differentiation—she knows which areas were planted at which times, whether there is an acceptable balance between first, second and third plantings, whether yields are as they should be, and whether her husband is making satisfactory progress in his heavy clearing. Men usually depend on instructions from their wives with regard to further clearing, cleaning and even planting. . . . Probably the majority of men have a poor-to-fair knowledge of how the gardening is going at any given time, at least insofar as the actual plantings are concerned. (Mitchell 1976:55)

I have spoken here of men's work and women's work. In Nagovisi, garden-related tasks are conceived of as husband's work and wife's work. There is a strong feeling that shared garden labor is almost as much a part of marriage as is shared sexuality. Sexual and economic involvement is patterned in much the same way. A man and a woman, such as a brother and sister, who may not have sexual relations with each other, ought not to cooperate economically by sharing garden work. Just as sex is a part of marriage, so the making of a garden together is one of the signs by which Nagovisi recognize that a couple is married. For this reason, some men state that it would be too shameful to ask others to take their place in heavy clearing. Widows are sometimes denied assistance in clearing, to encourage them to remarry (Mitchell 1976:55). It was said of a feebleminded adolescent in one village that the impediment to his getting married was not his stupidity, but the fact that he was not strong and thus could not clear bush. Robust mental defectives have little difficulty in finding someone to marry.

"Most women work in their gardens three times a week, usually on Tuesday, Thursday, and Saturday. . . . [Husbands'] attendance at the garden is not always necessary, and there are few men who accompany their wives on every trip" (Mitchell 1976:55). Men who do so are usually young newlyweds, excessively (in the view of older people) devoted to their wives. One seventy-year-old groom (a former widower), who insisted on accompanying his aged wife on every garden trip, was the butt of many jokes. Gardeners usually plan whether they will work or simply harvest and return. The garden trip is an all-day affair, and the entire household is likely to go if heavy work is anticipated.

Most garden sites are located on tracts controlled by the woman's matrilineage. Every adult woman has the inalienable right to use some of her descent group's land for food gardens and to transfer title to her daughters. Even in cases in which a woman has been expelled from her village or voluntarily leaves it, she still retains these land rights. Married men of a

descent group (especially in the past) could make subsistence gardens on land belonging to their own descent group, but only if the women of the descent group approved (Nash 1974:29).

A woman will try to cultivate where her mother previously gardened. In the recent past, if no suitable site was found, permission to make a garden would be sought from members of another descent group, since cultivation does not establish permanent rights. After about 1960, however, couples ceased to plant food gardens on land to which the wife did not have title, because gardeners wished to grow cocoa on plots retired from food production (Mitchell 1976:52–54). This topic is dealt with at greater length later.

The sweet potato is not an aboriginal crop; it became a staple for the Nagovisi after World War II, when a taro blight appeared in the Solomon Islands. The change from taro to sweet potato occurred within the memory of older informants who provided information on taro-growing practices, which also provides an instructive comparison with sweet potato. There is information also from an eyewitness, the ethnographer Douglas L. Oliver, in neighboring Siwai.[1]

Oliver (1949:24) describes the general process of garden work by means of a diagram (see fig. 4) and an example:

Let us suppose that a single family consisting of a man, his wife, and two children is the gardening unit, and that this unit is gardening in the above plots. The members arrive at the site in the morning and begin work. The husband and older son will start felling all the saplings and medium sized trees left in Plot F, and will split them in building a fence at x. During the course of the day, they will probably build as much fence as indicated in [fig. 4], and will ring-and-strip bark off a few of the larger trees left standing. Meanwhile, the wife and older daughter will rake together the rubble left in Plot F and burn it, scatter the ashes—effective fertilizer, they realize— over the cleaned area. The females will then turn to Plot E and with the aid of digging sticks, will plant the taro stalks which they piled there the day previously. In mid-afternoon, the wife and daughter will harvest several taro from Plot C, cut off the edible tubers to be carried home for cooking, and pile the stalks in a corner of Plot E, ready for planting on the following day. Then, before finally returning home, all of them will go to Plot B and secure large loads of firewood by dismantling the now dried-out fence and by felling the dead ring-barked trees.

This general outline is in accord with Nagovisi accounts of taro production. Oliver (1949:28, emphasis in original) also notes that women are the authorities in gardening and that they direct the garden work: "they tell the

[1]Siwai appears in some publications as Siuai. When Oliver did his initial fieldwork in 1938–39 there was no standard orthography for the local language, and he spelled the name of the population Siuai. Since then missionaries, linguists, administration personnel, and the Siwai themselves have come to prefer the spelling Siwai, and Oliver himself now uses this form.

FIGURE 4: Process of Garden Work in Siwai

men when to begin clearing a new plot, where to pile and burn rubble, and even when to turn up for work in the gardens. . . . *Women* are the originators of action and the men are the terminators."

Women's control of garden work and produce was apparently widespread in Bougainville. Ogan (1972) notes the same series of stages in preparing gardens in neighboring Nasioi, with men responsible for heavy clearing, either sex taking care of cleaning and burning, and women in charge of planting. Ogan (1972:24) writes, "After [cleaning] was complete, gardens became the exclusive province of the women . . . a hungry man did not dare go into his wife's garden to get food without her permission."

Blackwood (1935:300) notes in her study of north coast Bougainville and the people of Buka Island (located near the northern coast of Bougainville) (fig. 6) that the work of women was considered indispensable to the success of the crop. "Men may . . . help with weeding, [but] the actual planting must on no account be done by them. The reason given by the women was that the men did not know how, and if they did it the taro would not thrive" (Blackwood 1935:300).

While there are similarities between the cultivation of sweet potato and taro, significant differences also exist. To cultivate taro required greater effort than to cultivate sweet potato. Since only one harvest might be taken from any given plot planted in taro, more cleared land was needed than for the production of sweet potato, where each plot yields an average of three harvests. Taro, furthermore, had to be weeded during its immaturity; whereas sweet potato, while probably benefiting from weed removal, quickly smothers competing weeds with its vines.

Although I have not been able to find a direct statement to this effect, different sources on taro cultivation suggest that slips were not simply cut

and immediately put into the ground (e.g., Handy and Handy 1972:94; Hogbin 1967:62; Oliver 1949:24). Rather, some time was required (overnight at least) for a scar to form on the cut stem before planting could be done. This meant that two trips to the garden were essential—a trip before planting to cut the shoots, and a second trip to plant. Finally, although this factor is intrinsic neither to taro nor to sweet potato cultivation, the historial fact is that Nagovisi gardens were fenced to keep out potentially destructive pigs when taro was the staple. More or less coincident with the adoption of sweet potato, pigpens were built, obviating the need for fences around gardens. Ogan (1972:28) states that Nasioi men complained far more about the difficulties of fence construction than they did about any part of garden work, presumably because of its laborious and time-consuming nature.

These greater inputs—fence building and clearing of heavy bush—are men's work; weeding and additional trips to the garden to plant are women's work. The change from taro to sweet potato meant, then, that male jobs were either eliminated (e.g., fence building) or were reduced to tasks requiring approximately one-third the time they formerly had (e.g., primary clearing).

The ratio of men's to women's work was, therefore, altered, and the relative contribution made by each sex to food production changed markedly. Oliver (1955:131) estimates that among the taro-producing Siwai, women worked in the gardens four times as long as men. As a result of greatly reduced male labor, the proportion of female food production increased (although it should be noted that women, too, were released from some kinds of work). At the same time, sweet potato cultivation as practiced in present-day Nagovisi is more complex than taro-raising. It requires women to oversee the progress of plots in different parts of their three-harvest cycle, to estimate potential yields based on previous plot performance, and to plant accordingly. Sweet potato cultivation, then, involves an element of skill based on the ability to calculate and predict.

Cash Crops

Production of cocoa, the most important cash crop in Nagovisi, and subsistence gardening differ in several important respects. Cocoa does not require repetitive clearing and planting. Once established, the trees produce pods at intervals, more or less continuously over the life of the trees; recurrent jobs involve maintaining the orchard and harvesting it. There is a longer time span between planting and first harvesting of cocoa in comparison with sweet potato (four years instead of twenty weeks); thus, a different rhythm of work is involved. Unlike food gardens, tree crops are conceived of as permanent; thus, deciding where to plant them is a matter requiring careful consideration. Finally, cocoa is not considered edible, as garden produce is.

Cocoa is planted to make money, and it is therefore attached to the descent group property complex in a different way than food crops are. Nagovisi consider cocoa production to be a money-making business, and adults who would shrink from hiring help for their food gardens consider it perfectly appropriate to pay, either in cash or in meals of imported food, for help with cocoa.

Cocoa trees produce pods containing beans which, when fermented and dried, are sold overseas to make chocolate and other products. Trees are ideally spaced fifteen feet apart in blocks, to form orchards or stands. The Department of Agriculture, Stock, and Fisheries (henceforth DASF) suggests that each family initially plant an orchard comprising five hundred trees. Cocoa trees grow for about four years before they begin to bear fruit, after which they continue to produce for several decades. Young trees require shade from other larger trees, which should be removed when the cocoa trees are mature. Pods develop year round, but production is intensified during three or four periods throughout the year, known in agricultural terms as *flushes*.

Nagovisi plant on tracts to which the wife of the household has title. Most plantations of cocoa were made in abandoned sweet potato gardens, although this practice was against the advice of DASF officers. Their objections concerned the relatively depleted soil in used garden plots compared with virgin forest land (Mitchell 1976:92).

Rows were laid out according to an equilateral triangle system, with each side about fifteen feet long, though actual spacing varied from twelve to sixteen feet. In the early days, the local Nagovisi rural development officers of the DASF often provided information on positioning seeds or seedlings. In general, Nagovisi men are more familiar with spatial measurement, since their work in building houses requires the ability to reckon distances. Setting out the grid for planting was usually done by men, although actual planting (i.e., inserting the bean or seedling into the ground) might be done by either sex.

In the early years, emphasis was placed on encouraging everyone to plant cocoa, but little attention was given to instruction of tree care. Mitchell (1976:93) estimates that of the Nagovisi cocoa farmers, fewer than one in a hundred understands the technique of pruning or other maintenance procedures required to produce high yields. The only form of regular maintenance is cutting grass and removing large growths of vine from the trees. Grass is cut with hoop iron, a skill acquired by men and younger women, who learned it at school or (for men only) on plantations. Groups of outsiders are occasionally hired to do this work. My impression is that men decide when the grass is ready to be cut, although women surely participate in cutting it. Men also tend to be the ones who remove vines that may smother the trees.

Either men or women harvest by removing ripe pods from the trees and breaking them open to remove the beans inside. Beans are packed in burlap sacks or work baskets and transferred to local driers if the grower intends to process them further. If not, the wet bean is either transported by foot (or occasionally by bicycle) to the locally run Banoni-Nagovisi Producers' Cooperative Society (henceforth Society), which buys and processes cocoa from its members. Sometimes the wet bean is picked up at a terminus by the Society's tractor.

Most marketing of cocoa in Nagovisi is done through the Society, to which nearly all households belong. Society members are nominally men, although occasionally a widow is listed. The Society's organization is similar to the listing of telephone numbers in the United States, in which the family telephone number appears under the husband's name. Women take little interest in the affairs of the Society and rarely attend meetings. During the period of study, all Society employees—chairman, clerk, drier operators, drivers, and rural development assistants—were men.

Effects of Cash Cropping: Land Use and Residence

In Nagovisi, women are the repositories of matrilineal property. Women use and profit from matrilineal resources; their married brothers may not profit from their own matrilineage property, but use instead their wives' property. Married men have rights to matrilineal resources; however, their rights are to advise, to testify about land in court, and to use land (but not to bequeath it) in the event of no surviving females in their lineage.

Nagovisi have adapted the new crop of cocoa to their rules in this way. Cash cropping is carried out on the land of the wife. Daughters are heirs to both the land and the trees. Money earned from the sale of cocoa bean benefits the wife, her children, and her husband, that is, the household. This money is not lineage property. The wife's male relatives (brothers, maternal uncles, and married sons) neither maintain the crops nor receive recompense from their sale.

It is evident that Nagovisi do not treat cocoa in the same way as they do food, although their methods of planting it have been co-mingled (cf. Mitchell 1976). Trees are a means to wealth, whereas food is a necessity. Informants stressed the difference between rules relating to land used for cash cropping versus land used for subsistence crops. Formerly, it was said, people might make gardens anywhere, so long as permission was secured from whomever had primary rights to the land. An individual who used another person's land had rights to the food produced, but cultivation did not establish permanent rights over the tract of land itself. In 1969, although

most married couples established food gardens on the wife's land, it was still possible to plant on ground that did not belong to one's wife, merely by asking permission. Mitchell (1976:34) notes that one informant claimed that his gardening activities would be welcomed on land owned by nonkin: "These people would be glad to have me come and garden because I would do all the work of cutting bush and they would come afterwards and plant cocoa." Permission in this case was granted with the understanding that food raised on the plot was for domestic consumption. The following incident is illustrative: Lapunai, the surviving male of a lineage that owned a great deal of land, lent some of this to Nuai, a female in a related lineage (i.e., a clanmate). When it became apparent that Nuai intended to *sell* the sweet potatoes raised on this plot to a Nagovisi man who ran a fish and chips restaurant in the town of Arawa, Lapunai became angry and told her in a loud voice that he had lent her the land in order to feed his nieces and nephews, not so that she might make money.

Tree crops are not unknown to Nagovisi. There are traditional rules regarding trees with useful yields, and these may be compared with those relating to cash crop trees. *Marewa* 'trees with useful and usually edible crops', may be planted by a boy or a young man on his own lineage's land, and he may be allowed, with his sister's permission, to take some of what these trees bear after his marriage. In the event of marriage with his father's sister's daughter (i.e., marriage into his father's lineage), a son could rightfully consume tree crops his own father had planted, since they would be situated on land of the son's wife's descent group.

These rules are unlike the rules regarding cash crops, for no man can plant cash crops on the ground of his own lineage. In the past, the planting of coconut (one kind of edible tree crop) was said to stake a claim to ground to which no one else had exercised rights. Cash crops today are always planted on land that is the indisputable property of the wife's descent group, or on plots to which she and her children have personal rights, acquired either through gift or purchase.

Cash crops differ in two other respects from traditional tree crops. Cocoa trees are planted in multiples, in large orchards, unlike traditional tree crops which are planted singly (e.g., almond), in small groups (e.g., coconuts), or in a single row (e.g., sago). Large areas are required for planting cocoa compared with traditional tree crops, the amount of land being comparable with or exceeding the size of a food garden. Furthermore, as I have mentioned, cocoa is viewed as inedible; its only use is to be sold for money. The treatment of cash crops, then, has more to do with the Nagovisi belief that the labor of a father must benefit his children. A man uses the matrilineally inherited resources of his wife to provide for his wife and her children. If the wife's

land can be used to make money, which is seen as benefiting the children, it is incumbent upon the husband to do so (Nash 1974:53, 124).

To review, cocoa is not a food, but a form of wealth. It is not a necessity of life, but something extra, like pigs or shell money, which the ambitious and energetic are preoccupied with producing. It is considerably easier to acquire wealth through cocoa than it is through pig-raising; thus, the appeal of planting cocoa is practically universal. Its mode of planting resembles food planting because it is planted in old gardens, but it is emphatically not food. This fact caused Mitchell (1976:81) to note that cocoa appears to have been put "where it does not belong—within the temporary and shifting system of root-crop gardening." People may allow others temporary use of their land for food production but not in order to produce wealth. This fact accounts for the generosity (both straightforward and calculated) with garden land for food (whereby nonowners do the work of preparing it for tree planting) and the reluctance of people to work at clearing tracts of land to garden in places where they subsequently may not plant cocoa, unless they are utterly lacking in suitable garden sites.

Thus, anticipation of planting cocoa in abandoned sweet potato gardens was a factor that affected residence and settlement patterns from the late 1950s through the decade of the 1960s. The most efficient thing to do would be to clear the wife's land, make a garden, and then plant cocoa. Cash cropping influenced traditional patterns of land use, making them more uniform. The effect was also felt on residence patterns. In the past, Nagovisi claim, married couples might live where they wanted, providing that there was no objection from their neighbors. Today, however, Nagovisi say that men must live with their wives' kin on their wives' land (Nash 1974:82).

Information on the residence of couples married before World War II shows that about half were residing uxorilocally, while the rest were divided between virilocal and alternating forms of residence. The latter refers to instances in which a couple either maintained two houses at any given time, or in which they shifted several times between uxorilocal and virilocal residence. During the postwar period, when Nagovisi settled in large villages of unprecedented size, 58 percent of couples in my sample lived in villages in which both of the spouses' descent groups were well represented.

With the breakup of large villages during the 1950s, uxorilocal residence emerged as a dominant pattern. The 1960s saw the creation of new lineage-based villages and the gradual emigration of females who were not lineage members of the village in which they had been residing, to new villages formed by their co-resident female matrilineal relatives and spouses. Informants, almost without exception, attributed this action to the desire to plant cocoa on the wife's land. Thus, of all married couples surveyed in 1970, the

majority (82 percent) were living uxorilocally. Furthermore, some of those who were not living uxorilocally considered their situation temporary (e.g., initial virilocal residence by newlyweds) and could be reasonably expected to change to uxorilocal residence in time.

Implications of Change

The Nagovisi material illustrates two points that bear closer examination. First, there has been a change in the staple food crop, and with it a change in the proportion of male to female labor. Nagovisi women, who perform more work now than men, engage in proportionately more food production than formerly. Women's work has also become more complicated. Given the different work requirements of taro and sweet potato, one may ask why there has been so little change in the economic relationships between men and women. What has stayed the same, despite the change of crop and work requirements? How does this particular kind of activity—subsistence work— fit into the complex of women's productive responsibilities, and how does it fit into a general concept of work?

Second, discussion has focused on structural change or transformation, that is, on the broader intentional or nonintentional effects of an introduced innovation. Cash cropping knowledge was made available to men, apparently with the expectation that this would help to usher in other "modern" changes—male control of lucrative production, father-son inheritance, and preeminence of the nuclear family. To date, contrary to predictions of economists and anthropologists, the most striking effect of cash cropping has been the increased adherence to matrilineal principles and uxorilocal residence.

Women's Work and Change

Work is considered an important determinant of female status. Work can also be seen as exploitation; thus, the context of work is important in assessing the prestige it does or does not confer. Work for household consumption, compared with public work, lowers female status, and when work is overwhelmingly associated with or denied to women, they suffer by comparison with men.

Is gardening work considered demeaning in Nagovisi, and does it rob women of respect and importance? Do men try to control women by making them work long hours in the garden? My impression is that these ideas and actions do not occur (see also M. Strathern, chap. 2).

First, the Nagovisi wife remains the garden authority, as she was in the days of taro production; she has the major responsibility for running her garden. The husband is an important helper, but the wife manages the garden. Informants mentioned that in the days of taro production, a bachelor or widower occasionally maintained his own garden. To the best of my knowledge, men today never have gardens, but are fed from those of female relatives. Men are more dependent on women's cultivation, since no man seems willing or able to make his own garden these days. A situation such as this does not signal an erosion of female status.

Second, it is notable that Nagovisi consider a poor female gardener to be lacking in ability, whereas, a poor male gardener is thought to be lacking in will (i.e., he is lazy).[2] The woman's contribution is viewed as a skill, while the man's contribution is brute effort or application of strength. People laughed privately about those with sloppy or needlessly large gardens. As Oliver (1955:482) notes for Siwai, it is a matter of pride to estimate and meet one's consumption needs.

Third, the wife's importance in managing the garden is well understood by men. Every Nagovisi family is aware of what happens if the wife is temporarily incapacitated (e.g., by advanced pregnancy or parturition). The garden gets out of sequence and, unless preparation has been made well in advance, people may not get enough to eat (Mitchell 1976:59). Even when plans have been carefully made, there may be grumbling at mealtime about sweet potatoes that have stayed too long in the ground and have consequently become big and fibrous.

Women take pride in their gardening responsibilities.[3] Anyone other than a bride feels ashamed to ask another person—even a relative—for sweet potatoes, regardless of whether her own garden has temporarily failed through no fault of her own (e.g., because of heavy rains or her illness). Brides who have not yet learned how much or how often to plant may ask a sister or mother for an occasional handout. Women who stole from gardens were looked down on and considered to be somewhat crazy.

Any gardening activities of young unmarried women are desultory and a kind of practice for their future responsibilities. Gardening with one's spouse, by contrast, is part of the definition of marriage, and neither men nor women have gardens nor raise any significant amount of food until they

[2]The term Nagovisi use for inferior women gardeners is *aro malaka*, which has a variety of connotations including immaturity, insanity, and stupidity. A lazy man is a *nakiro* 'one who doesn't want to'.

[3]Oliver (1955:132) writes about the Siwai: "In fact, most women are very proud of their industry, skill, and knowledge of gardening; and one of the most infuriating insults is one woman's taunt to another that she is a poor gardener, that she produces so little food that her husband must purchase taro from a neighbor or beg it from a relative."

are married. It would be considered highly improper for a man to share cultivation work on a regular basis with his sisters, his daughters, his mother, his wife's sisters, or his mother-in-law.

Like the symbolism of gardening together, food provision is linked to marital well-being in south Bougainville. Oliver (1949:28) reports that Siwai men who had quarreled with their wives refused to eat food from their wives' gardens. A man signals his desire to reconcile by resuming to eat his wife's food.

Something similar happens in Nagovisi. If a couple quarrels, the man will stop eating coconuts from his wife's trees, sometimes because she forbids him to eat them, and sometimes because he chooses to avoid them. A conciliatory act (usually the gift of a pig) is required before the man will eat his wife's coconuts again. Even if both spouses are to blame for the quarrel, it is usually the wife who must pay a fine to her husband and his relatives in order to restore good relations. A husband's right to receive compensation seems to be a way of materially recognizing his prerogatives and of balancing his wife's considerable jural control of inheritance, household wealth, and children in this matrilineal and uxorilocal society. Informants told me that it would be impossible for a man to avoid entirely eating produce from his wife's garden and continue to live in their household; if she told him that he could no longer eat food from her garden, this would be tantamount to a request for separation or divorce.

The authors cited in the introduction of this chapter assert that variations in female status are related to public contexts of work in contrast to those based on kinship. The Nagovisi data raise questions about the Marxist and neo-Marxist idea that wifely duties, which benefit household members, are more demeaning than a citizen's duties, which benefit the clan or several households. Sacks (1975:213, emphasis in original) states that female status declines "as women are transformed from free and equal productive *members of society* to subordinate and dependent *wives* and wards." The public/domestic dichotomy is evoked here (see also M. Strathern, chap. 2).

It must be stressed that Nagovisi women do not perform garden work as citizens or clanswomen. Their work is not even women's work, a part of gender role, but of wife's work, an obligation to husband and children. The requirement to garden is not an ascribed property of having been born female, but the achieved ability of a wife. D. Schneider (1968:40–44) has shown that one must distinguish between sex role and kinship role if one is to understand either of these domains.

This point assumed significance when the sexual division of garden labor in other Melanesian societies is considered. A brief survey of gardening practices elsewhere does not show the same exclusive connection between fulfillment of marriage obligations and performance of garden work. And in

all these groups, there appears to be more asymmetry between the sexes than in Nagovisi.

Clarke (1971:122) describes the recruitment of garden partners among the Jimi Valley Maring who live on the fringes of Highland New Guinea. Two unmarried brothers about eighteen and twenty years old "found two women who agreed to be their garden partners. These women were sister-in-law and another unrelated woman." The women gave the brothers food nearly every day in return for the cleared land the men had provided them. Clarke (1971:132) mentions another case in which a young bride begins by working exclusively in her husband's garden, but she is also expected to work in the gardens of other men as she settles into the community.

M. Young (1971:89, 149), describing Goodenough Island, states that husbands and wives have separate plots and separate seed yams. Furthermore, men may work communally to break up the soil for all the new gardens (M. Young 1971:149). The situation among the Baegu of Malaita, Solomon Islands is similar. Baegu men and women have their own separate gardens, although a man helps his wife with clearing (Ross 1973:208).

Among the Simbu of Highland New Guinea, a married man may prepare gardens for a woman he does not actually take as an additional wife, and communal work parties of men and women are said to labor on individual family garden plots (Brown 1972:33–34).

In these few examples I have cited, Melanesian women are described as gardening and providing produce for men to whom they are tenuously related or unrelated, as making gardens separate from those of their husbands, as receiving cleared land from men who act like husbands but who are not, and as participating in large work groups to do women's garden labor on other peoples' plots. In none of these societies is there the intimate and exclusive connection between marriage and garden labor by husband and wife that exists in Nagovisi.

At first glance, the work requirements of women in the Melanesian groups I have mentioned appear to be public in the positive sense noted by Engels (1972 [1884]). Women in these societies are not slaves to their husbands' needs, but work for many other individuals and even for themselves. Thus, these women present the appearance of autonomy.

However, I would like to suggest an alternative view from the standpoint of Nagovisi ideology. The use of a wife's labor in extrafamily contexts can be seen as a kind of economic promiscuity, a sort of prostitution of what in Nagovisi is wifely work. The disengagement of gardening duties and the provision of food from the context of marriage opens the door to the exploitation of the female work effort. There develops some advantage to controlling women and their productive efforts, and women become interchangeable as a source of their sex-specific labor. It is appropriate for women to work, not

as a responsibility to loved ones, but simply because they are members of the category *woman*. In Nagovisi, there is little point in trying to control women in this sense; instead, a man must cooperate with his wife if he wishes to attain prominence through feasting. In fact, economic cooperation between husband and wife was the stated ideal of a good marriage by older informants—garden industriously, raise many pigs, and give big feasts.

In traditional Melanesia, labor-intensive horticultural work is the basis of pig production, which itself is the basis of feast-giving and the political renown that this brings. In order that large feasts be possible, there must be some way to induce large numbers of workers to take part in a common effort. As I have noted, food production in other areas of Melanesia is disengaged to some extent from its domestic context. It is not inappropriate nor apparently difficult to persuade or to coerce women to make labor contributions to nonfamily causes.

In Nagovisi, however, garden work is a wife's obligation to her husband and children; by no means can a woman's husband lend her efforts to some political leader. Some collective efforts in Nagovisi even have a spurious quality to them. When a number of women work together in amassing pigs for lineage-related feasts, each household appears to be simultaneously motivated to participate for benefits to itself. For example, if a funeral feast is required by the death of a man, A will want to take part since she was related to the deceased; B, also being related, wants to take part too, and so on. Each household decides by itself whether to participate and how many pigs to give. The number of pigs adds up, but on the basis of individually motivated contributions.

Perhaps the inability of men to make use of women's work—either in the sense of any and all women, or one's clanswomen—has had its effect on the low level of political development in traditional Nagovisi, compared with Siwai, Buin, and of course, the New Guinea Highlands. As it is structurally difficult to control women and their work, it is similarly hard to control men and their work. Without strong leaders and willing followers, there will be no large-scale feasts or massive communal efforts; neither will there be exploitation of followers. Both, of course, are characteristic of politically complex systems.

The Nagovisi give many indications of a general antipathy toward leaders. For example, during World War II, a single individual rose to prominence in Nagovisi and played a major role in the reorganization of life in the postwar period. He is referred to as "the Black Brigadeer" in patrol reports and war histories (Long 1963). His zealous leadership did not seem to wear well with most Nagovisi, however; ultimately he lost the confidence of his people and was betrayed to the police for one of his high-handed acts. After a year's imprisonment in mainland New Guinea, his power was effectively broken,

to the apparent satisfaction of most Nagovisi (Nash 1974:128–129). Outsiders have noted the Nagovisi disinclination to work in large groups for someone else's goals. Numerous patrol reports repeatedly state how uncooperative the Nagovisi are in comparison with the Siwai and Buin peoples (Nash 1974:129). The Nagovisi are well aware of their own anarchistic tendencies and are occasionally annoyed by them. When a project bogs down, an exasperated comment one may hear can be linguistically and culturally translated as "too many chiefs and not enough Indians." Finally, the Nagovisi indicate their opinion of leaders in the often repeated joke that the greatest 'big man' of all is *ma* 'shit', because only that can make you leave your warm bed on a cold rainy night.

Even though the daily gardening efforts of Nagovisi women do not benefit the whole clan, as Engels thought nondemeaning female work would do, women's work takes place in a far less private setting than efforts of the bourgeois housewife. Women's work in Nagovisi is eminently visible. Women go back and forth between village and garden; people visit or pass by one another's gardens on the way to their own. Women bring back food to the village in full view of others. It is not easy for people in Nagovisi to ignore what women do on behalf of others, since in effect, it is paraded in front of all on a daily basis. The assertion of a sharp distinction between public and domestic domains is not supported by evidence from Pacific Island societies.

My examination of Nagovisi leads me to ask, is it not the *privacy* of kinship obligations carried out in a household context (perhaps assumed by Engels to be an unvarying concomitant of wifely duties), rather than the *kinship* nature of obligations per se that is the significant factor here? When Engels (1972 [1884]) wrote of the lowly position of the housewife, he was referring to a situation in which kinship was intensely centered in the home. A housewife's work was invisible, taken for granted. Groups of relatives did not live together, and the meaningful political, economic, and religious functions of kinship groups had largely disappeared. Perhaps kinship obligations demean women the most when significant aspects of kin-based work are hidden from public view.

Women may perceive that their autonomy is threatened if family relations are acted out in a nuclear family context, separated from society at large. This perception is especially likely to occur to women who are accustomed to strong community sanctions over the behavior of all group members. Its occurrence in a non-Melanesian setting is illustrated by Draper (1975:109) in an anecdote drawn from her work among the foraging !Kung Bushmen of southern Africa. Draper asked !Kung women who had the better life—they or the settled Bantu. Her informants said that the !Kung women were better off, because they did not live in sturdy houses, as the Bantu did. A Bantu husband could lock the door of the house and beat his wife, who would be

unable to escape. Furthermore, the community would be powerless to inter-
vene. !Kung women's vision of the married couple cut off from the view and
reach of the community may be a kind of nightmarish metaphor for the
demeaning possibilities of domestic privacy between husband and wife.

A comparison of Nagovisi with other Melanesian groups has implications
for relating female work to status in various societies. Whyte's (1978a:169)
extensive cross-cultural study concludes that there are "no grounds for assum-
ing that the relative subsistence contribution of women has any general status
implications." From my examination of the Nagovisi data, Whyte's failure
to find a consistent cross-cultural relationship says as much or more about
the problems of cross-cultural comparison as it does about the relationship
of work to status. In fairness to Whyte, he readily admits the difficulties of
measuring work and the inconclusiveness of his findings. However, if work
is measured by such criteria as hours spent in the garden or the number of
calories each sex produces, one finds that variation in these factors may not
be the ones that produce differential status, even in historically related
societies. As Friedl (1975) argues, one must first understand cultural evalua-
tions of the kind of work each sex does, before measuring how much or how
little each sex produces.

It may be that subsistence work in preindustrial societies does not resem-
ble a job, a career, or an occupation, as is often assumed. Ideas about work
in preindustrial societies have, perhaps, been overly influenced by factors
such as occupational rankings, measures of productivity, and differential
income—concepts appropriate to advanced industrial societies. Indeed, ac-
cording to Hawlyryshyn's formulation (quoted in Wallman 1979:9), if work
can be identified by the "third person criterion" (i.e., work is whatever I can
pay someone else to do), gardening is not work for either Nagovisi women
or men—only cocoa production is work.

Oliver's (1955:131) comment on Siwai men's and women's views of
garden work illustrates other difficulties: "It always seemed to me that most
women regard gardening as a fixed part of every day's life routine, an end
in itself; whereas for many men it is a rather onerous but necessary job to
be completed as quickly as possible in order to move on to other activities—or
lack of activities." Thus, for Siwai men, work is necessary but unpleasant,
and the distinction between work and play or work and leisure is evoked.
Perhaps men would gladly evade work if they could do so. For women, work
is necessary and routine—work is a way of life. Thus, there is no agreement
on the place of work in life, even within a single society (although it must
be admitted that different tasks constitute garden work for men and women).
How can we possibly expect any agreement, then, between societies that are
far removed from each other in space and time?

The history of the introduction of cash crops to the Nagovisi de-
monstrates once again that, along with a new crop and its associated technol-
ogy, colonial policies import an ideology that assumes that men naturally
take priority over women. The biases brought to developing countries are
those of the colonial powers, and as several writers have shown, colonialism
is not particularly interested in women (e.g., Boserup 1970; Bossen 1975;
Etienne and Leacock 1980; LeBeuf 1963). From the perspective of a matrilineal
Papua New Guinean society, small and large biases toward patri-institutions
were evident in much that issued from the colonial administration.[4]

> Nagovisi women have not been encouraged to enter modern institutions: although
> women regularly vote in various government elections, there have never been any
> female local government councillors in Nagovisi, nor, in fact any female candidates.
> Although land and cash crops are the property of women, the officers of the marketing
> society are all men. Bright female students have the opportunity to receive training
> to become nurses, teachers, clerks, and so on—but most of them are posted by their
> employers, whether mission, government, or private business, to areas other than
> their Nagovisi homes. Sporadically, a woman may sew clothing or hem loin cloths
> for sale, but not as an on-going concern. Women play no central roles in locally
> owned businesses, such as trade stores or transport schemes, although they are not
> barred from doing so. Nor do they have important positions in the development
> societies of recent times. Women do not hold positions of leadership in mixed-sex
> Christian activities; catechists are all men. The church-sponsored credit union was
> also an exclusively male enterprise. (Nash 1978:124–125)

Cash crop policies of the DASF encouraged a man to register "his" crops
individually and then to pass them on to his children (i.e., sons) at his death.
Gardening technology, insofar as it has been taught at all, has been directed
toward men, an inappropriate and, by and large, unreceptive audience in
Nagovisi. Men have never regularly maintained crops, and, of course, most
tree crops have not been maintained in any significant way at all.

Nor have men responded wholeheartedly to the challenge of cash crop-
ping. To be sure, people want and need some cash income, but male interest
is limited to only a part of the cocoa farming process. Male participation in
cash cropping consists of planting a stand of trees and regularly harvesting
the pods. There is little interest in becoming a "good" cocoa farmer, despite

[4]One example of this is the introduction of the patronymic, such that most Papua New
Guineans are known in modern settings by a baptismal name (which in Nagovisi, at any rate,
has very little significance) and their father's "native" name, which is supposed to take the place
of the family name. Thus Nagovisi end up being known by two names, neither of which is
really their own. Furthermore, since the patronymic changes each generation, no family name
in the sense it is known in Western countries has been added. The practice serves to heighten
the disparity between the indigenous and modern settings in which an individual must act.

the possibility of increasing yields that could be financially beneficial. A few individual growers are willing to go to the trouble of selling cocoa directly to buyers in Kieta, the provincial capital, for a slightly higher price than the Producers' Cooperative Society pays, but they represent a small minority of growers. Insofar as Western capitalist marketing systems ignore women, the effect of cash cropping in Nagovisi has been minimal, since both sexes have failed to embrace these systems.

The paradox of the Nagovisi experience is that cocoa cash cropping has strengthened matrilineal descent and uxorilocal residence. Certainly this has not been the intent of colonial policy, nor is this what would be expected to happen. Any form of increased cultural complexity has been said to destroy matrilineal institutions (Martin and Voorhies 1975:220–241; Murdock 1949:205–207). Gough (1961:652), while noting that influences from capitalist market systems are destructive to any form of unilineal kinship system, writes that disruptions appear earlier and are more devastating in matrilineal ones. In Melanesia, the Tolai of Papua New Guinea are frequently mentioned in this regard. The incompatibility of their matrilineal institutions with economic development and cocoa cash cropping has been the subject of several publications (e.g., Distroff 1971; Epstein 1968; Hogbin 1967; Salisbury 1970).

Before cash cropping times, Nagovisi social organization was matrilineal and tended to be uxorilocal; however, there was greater flexibility in residence, garden land use, and, perhaps, in the operation of matrilineal descent than we see today.[5] The acceptance of a cash cropping system encouraged uniformity to a degree heretofore unknown. Leacock (1978) notes that a similar loss of flexibility took place among the bilateral Montagnais of Labrador in response to the fur trade. Quoting from her 1955 work, Leacock (1978:248) states that dependence on the fur trade did not destroy formerly stable social groups: instead, "changes brought about by the fur trade have led to more stable bands with greater formal organization." In both cases, colonial forces caused formerly flexible and fluid situations to harden. Matters that previously had been left to individual decisions yielded to fairly circumscribed rules, and one option became overwhelmingly attractive to most people.

We are mistaken if we assume that the forces of cultural change simply obliterate one particular kind of social system. The two examples I have cited show that change may remove the flexibility of choice in some areas; however, it is also likely that options in other areas of social organization may be increased. A case in point concerns the effect of cash cropping in Buin, located on the south coast of Bougainville. Keil (1975:157) reports that in this traditionally patrilineal society, "increased population pressure and in-

[5]People mentioned occasional instances in the past in which lineages changed their moiety affiliation if circumstances favored such a change.

creased cash cropping have led to a *decrease* in strict patrilineal inheritance of land rights" (emphasis added). Keil (1975:153) continues with the observation that in areas where land is more abundant, "some men are attempting to entice their daughters' husbands to settle in their own [i.e., the older mens'] villages." Furthermore, "people try to activate all the land rights they can, whether from the father's side or the mother's side" (Keil 1975:158).

The increased flexibility in Buin and the increased uniformity in Nagovisi, resulting from cash cropping, appear at first sight to be contradictory. What general effect does cash cropping have? The contradiction disappears if we designate the areas in which either flexibility or uniformity have occurred. In Buin, strategies to obtain land and labor have become less formalized. In Nagovisi, too, attempts to obtain land wherever it can be gotten are seen in the modern escalation of gift giving at funerals. For Nagovisi, generous donations of pigs are the means by which land can be transferred from a dead father's matrilineage to the daughter's matrilineage. Funerals, of all traditional ceremonial activities, have flourished and, indeed, surpassed in scale those of the past. However, strategies to gain land have taken place in a structural framework that is matrilineal and uxorilocal.

Categories of matriliny and patriliny are thus inappropriate for these kinds of analysis, as Leach (1966) suggested some time ago; we cannot simply state that one decreases or the other increases under conditions of social change. What Gough (1961) suspected to be evidence of the demise of matrilineal institutions may have been adjustments to new conditions. Schlegel (1972:143–144), for example, speaks of Minangkabau matrilineages in Indonesia as intensified by modern conditions and of Hopi matrilineages in North America as remaining strong, although matriclans may well be in decline. As Douglas (1969) reminds us, people have been too quick to write off matriliny.

Cash cropping in Nagovisi has assured the place of women in the village and community by strengthening matrilineal institutions. The advantages that women enjoy in these systems have thus been perpetuated. For Nagovisi, the mother-children group is the structural basis of modern villages as well. As long as matriliny prevails, there will be no sharp separation between domestic and public spheres of activity; one is the source of the other. As such, the continuing recognition of the importance of women and their contributions is enhanced.

Conclusion

I have tried to resist the anthropological sin of Bongobongoism, that is, of rejecting the work of others by saying "my group is different." Yet I have

presented material that is, to some extent, at odds with the conventional
wisdom.

Work, as it comprises effort, production, duty, routine, and more, is
not a unitary activity in nonindustrial societies. To concentrate on hours
spent in specific tasks or to measure calories produced or expended produces
interesting data that are misleading if one tries to make them a definition of
work or an index of work in more general terms. Thus, efforts to relate
changes in subsistence work ratios of men and women are doomed to be
exercises in spurious accuracy—the meaning of work does not emerge from
such quantification. Whyte (1978a) reaches a similar conclusion when he
states that subsistence work (as measured by such factors) does not have any
general implications for female status.

Probably even in industrial societies, work is not a unitary thing. The
repeated socialist failure to upgrade women by bringing them into the wage
economy shows this. Economists are probably right to consider housework
as basically different from wage earning labor; they are, of course, wrong in
denying or ignoring its significance.

Work embedded in kinship relations presents conceptual problems. The
standard attempts to understand this kind of work through quantification are
not satisfying. Of course, in human history, all work, whether done by men
or women, was probably once kinship obligation; however, women's activities
continue to include large amounts of such obligation, no matter what society
we consider.

I have argued in this chapter that the Marxist idea that kin-based work
is a source of women's devaluation may be assigning blame to the wrong
element. Women are relegated to this work in industrial societies, and they
may be excluded from male-dominated, public, wage earning work. These
factors do not mean, however, that in societies in which there is no clear-cut
male-dominated wage earning work, women's kinship obligations are also
demeaning.

This point raises the question of distinguishing between public and
domestic domains. In peasant and industrial societies, the distinction may
be a fruitful one. However, in horticultural societies, especially in the area
of subsistence, this dichotomy loses its explanatory power. Food production
in Melanesia is the basis of all wealth and, in addition to its obvious life-
sustaining nature, its connection to the small family group, its political uses,
and its connection to conspicuous display and consumption at large political
gatherings cannot be ignored. Women, of course, dominate in food produc-
tion. When we consider Melanesian subsistence, Rosaldo's (1974:34) state-
ment that "products of female labor tend to be directed to the family and
the home" is refuted. This brings us back full circle to the vexing question
of work.

This chapter has reaffirmed Boserup's (1970) point that importing a new crop or production method involves many complex factors. A bundle of Western cultural patterns are simultaneously imported as well. This may be unintended, unconscious, or calculated. The important point is that imported cultural baggage gives priority to men. However, we must give indigenous peoples some credit; they do not always accept what is offered in the form in which it has been exported. There is a reinterpretation that makes it difficult to predict what the ultimate effects will be on the indigenous system. Thus, in Nagovisi, Western innovations have not simply obliterated traditional social institutions. The results are surprising. Matrilineal institutions have actually been strengthened.

Finally, with some trepidation, I bring up the term *status* again. Why do we cling so firmly to this concept? Why do we want to know about the status of women so much? What do we think it will tell us? I have suggested that, insofar as the term suggests comparisons between men and women, it may be inappropriate in nonindustrial societies. But how else can the relations between men and women be assessed? If all we want to know is that women in some societies are not under the oppressive control of men, that they can own property and exercise their rights over it freely, and that they can enjoy their work, even when it is not an exciting career, I can do no more than offer the evidence of Nagovisi women, for whom, I believe, all of this is true.

7

Pigs, Pearlshells, and 'Women's Work': Collective Response to Change in Highland Papua New Guinea

Lorraine Dusak Sexton

The entrance of Australian gold prospectors into the high central mountains of the Territory of New Guinea in 1930 was a turning point for the people of the region. In the intervening fifty years the small-scale, isolated tribal societies of the Highlands have been drawn into the independent nation of Papua New Guinea as well as into the international market economy. Highlanders continue to cultivate sweet potatoes, raise pigs, and engage in prestigious transfers of wealth, confirming social relationships between groups. But stone technology has been superseded by steel, warfare has been outlawed (although there have been serious eruptions in recent years), and Christianity has been adopted. Money earned from coffee cash cropping, wage labor, and commercial activities has become necessary for traditional exchanges and newly created needs and obligations.

My research on *Wok Meri* from October 1976 through February 1978 was funded by a National Institute of Mental Health Predoctoral Research Fellowship no. 5 F 31 MH 05366. I thank the Yamiyufa people with whom I lived in the Daulo region, and the neighboring Manto, Zoita, and Korepa peoples for their gracious assistance and patience. I gratefully acknowledge the assistance I received in my research on Wok Meri in conversations with David Anggo and his family; Judith Munster; James Knight, S.V.D.; Peter van Oostrum, S.V.D.; Dorothy James, and Denise Potts; and in correspondence with Robin and Carolyn Hide and Robert Smith. I would also like to thank Denise O'Brien, Cathy Small, Regina Oboler, Diane Freedman, Sharon W. Tiffany, Andrew Strathern, Terence Hays, and participants in the Women in Oceania Symposium for comments on previous drafts of material presented in this chapter. I am, of course, solely responsible for any errors of description or analysis.

In response to changes that adversely affected their economic rights, women in the Chuave District, Simbu Province, and the neighboring Goroka District, Eastern Highlands Province, have, since about 1960, developed a savings and exchange system called *Wok Meri* 'women's work' in the Neo-Melanesian lingua franca (fig. 5).[1] Small groups of women collect and save their earnings from selling vegetables, small amounts of coffee, or their labor. Each group also enters into two kinds of exchange relations with similar Wok Meri groups. The first type of exchange mimics the payment of bride-price and entails the reenactment of birth and of marriage rituals. The second type of exchange is described by informants as a banking system in which Wok Meri women from a wide area make small loans to one another.

Female and male informants have a standard reply when queried about the reasons for Wok Meri's development and for the goals of the movement. Wok Meri began because women disapprove of men's expenditure of money for playing cards and drinking beer. In response to what they describe as men's negligence, women save a portion of their own money. By doing so they hope to safeguard their small incomes from importunate husbands, to demonstrate their competence as money managers, and to show how much money could be accumulated if men were more provident with the bulk of the household income that they control.

Beyond these modest aims, however, I perceive broader goals embedded in the financial and ritual activities of Wok Meri. Men's control of most money has enabled them to continue monopolizing prominent roles in cere-monial transactions and business enterprises, which are primarily financed by investment of income from coffee sales. In Wok Meri, women have de-veloped their own exchange system in which they play all the roles, and they have established a modified Western-style banking system. The capital that Wok Meri women accumulate through savings, loans, and exchange payments (in effect a customary type of loan) is usually invested in the same kinds of businesses that have attracted Highland male entrepreneurs since the early 1960s.

[1] Terms from the Neo-Melanesian lingua franca spoken in Papua New Guinea and from the Kuman and Kâte languages are identified as such. The other non-English terms are from the Siane language, one of the three vernaculars spoken in the Daulo region.

The collection and exchange system described here is known by several names. I have decided to use the term *Wok Meri* because it is widely recognized in Goroka District by speakers of different Highlands languages and is the Neo-Melanesian translation of the most common vernacular name. For example, the Siane speakers of the Daulo Pass region call the movement *rono vena* 'women's work' in their own language and *Wok Meri* in Neo-Melanesian. Some people in Goroka District use the term *Wok Maria* 'Mary's work', probably referring to the mother of Christ. Within the Unggai Census Division of Goroka District people say *Wok Ifayina* '[gloss unknown] work' (Munster 1975). The name used in Chuave District, Chimbu Province is *kafaina*. David Anggo (1975), a Siane who has written about *kafaina* in his natal region, says the term has no meaning in the Siane or Kuman dialects spoken in the region.

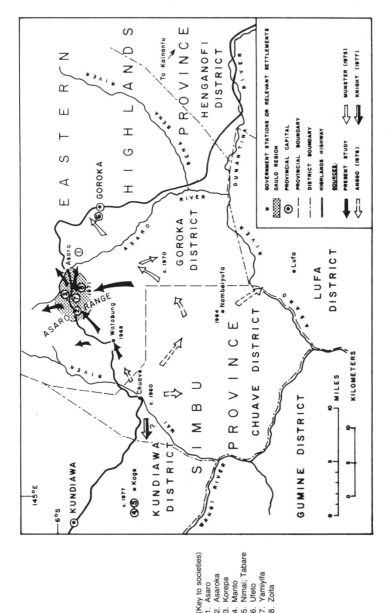

FIGURE 5: Chronology and Directions of *Wok Meri* Growth

(Key to societies)
1. Asaro
2. Asaroka
3. Korepa
4. Manto
5. Nimai; Tabare
6. Ufeto
7. Yamiyifa
8. Zoita

In this chapter I describe Wok Meri's organization and financial trans-actions, based on my research on the movement in Goroka District, and analyze the socioeconomic conditions that motivated the development of this movement.

Wok Meri

Wok Meri is a network of autonomous groups ranging from two to thirty-five women. Members are recruited from the wives of lineage or sublineage mates who live in the same village.[2] Thus, the organizational unit of Wok Meri is based on a kinship unit already carrying out important social functions. The wives of older lineage or sublineage mates have worked together for many years to organize a variety of events, including exchange payments and rites to mark the members' passages through different stages of the life cycle. The women in a Wok Meri group are able to embark on their new social and exchange activities by building on the firm structural foundation of an existing kin group. They also draw on the personal friendships and cooperative experiences that they have shared over the years.

Each group engages in savings and exchange activities under the leadership of one or two *vena namba* 'big women', a new title for women used only in Wok Meri. The term and its duties are modeled on the traditional role of the *ve namba* 'big man', who attains his status through leadership in exchange, politics, and (previously) warfare.[3] There may be more than one 'big man' in a lineage, as there may be more than one 'big woman' in a Wok Meri group. Both 'big men' and 'big women' achieve and maintain their positions through their ability to recruit supporters and to motivate their cooperation. Neither 'big men' nor 'big women' have the authority to coerce people to follow their dictates.

Successful male entrepreneurs have become known as *bikpela man bilong bisnis* 'business leaders', literally 'big businessmen' in Neo-Melanesian. These entrepreneurs have been able to adapt traditional skills to modern business conditions by enlisting their kin to invest labor and money in their business activities.[4] The Wok Meri movement is concerned with women's participation

[2]Lineage members trace their descent patrilineally from a common male ancestor. Members of a lineage branch, which I call a sublineage, may act as a unit, but the sublineage is not a kinship group recognized in this society. Several lineages who claim but cannot demonstrate patrilineal descent from a common male ancestor, form a clan. The phratry is an exogamous unit within which war is forbidden. Two or more phratries constitute a tribe, the largest sociopolitical unit.

[3]The title of the premier 'big man' of a clan is *giambave* 'man who looks after'. This term has not been incorporated into Wok Meri.

[4]See Finney (1973) for a discussion of male entrepreneurs in the Goroka Valley.

in both traditional exchange and modern business activities, and the role of the Wok Meri 'big women' encompasses the task of the old and new style 'big men'.

The 'big woman' is the prime mover in organizing a new group. She establishes and maintains ties with 'big women' from other groups, organizes meetings and ceremonies, and leads the rituals. Wok Meri 'big women' encourage their group members to save money and to participate in exchanges with other groups by exhortation and by their own example. 'Big women' compete with their opposite numbers in other groups to accumulate large sums of money. The reputation of a 'big woman', like that of a traditional 'big man', depends not only on her personal wealth but also on the group's successful completion of the cycle of exchanges and on the amount of money controlled by the group.

Women most active in Wok Meri tend to be at least forty years old. The participation of younger women is sought when the group's activities become public and large numbers of workers are required to hold ceremonies. Age is an equalizer that breaks down some of the barriers to female participation in social life. By the time a woman has reached middle age, she has established a solid relationship with her husband and has earned a place in the community, having proved her loyalty by bearing children, caring for gardens and pigs, and participating in kin-based activities. Older wives have greater autonomy and access to more money than younger wives. For example, mature women tend to cultivate larger gardens with ample produce for market sales. Younger women who are raising families may lack the time required for market gardening, and they also appear to have less input into decisions about family income. Furthermore, young people, both men and women, continue to play a subsidiary role in social activities until they are well into their thirties, so it is not surprising that younger women are peripheral to Wok Meri. Older women command respect and share responsibility with male elders for the well-being of the community. In the past, a few outstanding elderly women were even inducted into the male cult, one of whose basic tenets was the exclusion of women.

Most 'big women' are at least in their middle fifties, although a few are in their forties. Respected elderly women coordinate lineage women's Wok Meri activities, just as they organize women's efforts for the kin group's social undertakings. The few younger 'big women' are widows with young children, who can operate more independently than other women in financial and social matters, and an occasional married woman. The attainment of 'big woman' status is not dependent on the position of a woman's husband; that is, 'big women' are not generally the wives of 'big men'.

Men play important supportive roles in Wok Meri as women do in traditional exchange. Each group has a male *kuskus* 'bookkeeper' and a *siaman*

'chairman' (both Neo-Melanesian terms) selected from the lineage or sub-lineage. Most women have had no formal education and find it difficult to count large sums of money. A young man in his late teens or early twenties with a primary school education is appointed bookkeeper and is responsible for keeping written records of money accumulated by members and money exchanged with other groups.

The chairman accompanies women on visits to other Wok Meri groups, acts as their spokesman at these meetings, and serves as a general adviser. The chairman, in his late thirties or early forties, is usually not the 'big woman's' husband and is generally younger than the 'big woman'. Younger men have a patina of sophistication acquired through first-hand experience with the world beyond the village. Most men under forty-five have spent several years as contract laborers on the Papua New Guinea coast or islands. They speak Neo-Melanesian fluently, are well-acquainted with money, and have had the opportunity to observe foreigners closely. The older woman's status as classificatory 'mother' (*orabo*) to the younger chairman helps her to maintain her status as group leader. She can enjoy the chairman's assistance but can also ignore his advice if it suits her to do so.

A group meets sporadically in the 'big woman's' house to collect money and bring members' accounts up to date. These meetings generally take place on Friday evening, which has come to mark the end of the work week and the beginning of the more leisurely weekend. A woman can deposit her earnings from Friday morning's village market before she spends it on tobacco or before her husband or children ask her for spending money. Each woman retains individual ownership of the money she saves. Her deposit of one or two *kina* 'unit of Papua New Guinea currency' (abbreviated as K) is added to her previously collected coins.[5] Her money is tied up in a separate cloth bundle or mesh bag, placed in a common suitcase or box, and stored in a locked room built into the back of the 'big woman's' house. As well as recording amounts in a ledger, the bookkeeper also writes each woman's contribution in her own small notebook with the word *passbook* inscribed on the cover. Many villagers have passbook savings accounts at the savings and loan society or banks in Goroka town, the provincial capital. Wok Meri women understand that a passbook is a record of the amount deposited, and they look upon their groups as a kind of banking system.

Each new Wok Meri group is formed under the aegis of an existing group whose members teach neophytes the movement's ideology, rituals, and financial practices. Members of the more experienced group are known as 'mothers' of participants in the new group, who are called their 'daughters'.

[5] During my fieldwork in 1976–1978, the value of the Papua New Guinea *kina* ranged from $1.27 to $1.37 in American money.

The term *oraho* has the dual meaning of 'mother' and 'owner', and both denotations are drawn upon in Wok Meri. The two meanings are related. As a mother cares for her child, so ideally does an owner look after her property; as a child grows, so ideally does property. Pigs grow and reproduce; coffee trees mature and bear fruit; money is invested to earn a profit. By the use of the term *oraho* 'mother, owner', Wok Meri women not only base their relations with other groups on fictive maternal ties but also claim control of money by describing themselves as its owner.

The bond between Wok Meri 'mothers' and 'daughters' is described as similar to the relationship between real mothers and daughters. A mother cares for her offspring's growth and well-being by feeding, socializing, and, later in life, advising her child. She is gentle and loving, but she can also be stern when correcting a misbehaving child. In place of food, Wok Meri 'mothers' loan their 'daughters' small amounts of money to stimulate saving by the daughter group, to make the work of the daughter group grow. They teach 'daughters' Wok Meri ideology and rituals and admonish them if they become lax in saving money. Eventually the 'daughters' become knowledgeable enough to sponsor their own daughter group, described as 'bearing a child' (*yahipa gendaiye*). Shallow genealogies of group relationships are kept, and members of related groups refer to each other by the appropriate classificatory kin terms: *auneho* 'my grandparent, ancestor'; *oneho* 'my mother'; *aruneho* 'my daughter'; *nakuneho* 'my grandchild'. 'Mothers' urge their Wok Meri 'daughters' to become 'mothers' in their own right and chastise them if they are slow to find a daughter group for themselves. 'Mother'-'daughter' ties are not developed at random; rather, they are based on agnatic or uterine kin links between women. For example, a woman from a potential Wok Meri 'mother' group visits her natal village to encourage her classificatory mothers to form a Wok Meri group and become her Wok Meri 'daughters'.

Birth and marriage are major themes of Wok Meri rituals, and both are reenacted at nocturnal conclaves of mother and daughter groups. Fictive affinal as well as fictive consanguineal ties are established between mother and daughter groups, by the 'daughters'/bride-receivers paying a cash bride-price to the 'mothers'/bride-givers for the knowledge of Wok Meri, metaphorically described as the *noiri* 'girl'. The 'girl' is represented by a Western-style rubber doll and/or a mesh bag filled with coins given to the 'daughters'/bride-receivers at a private meeting between the two groups. The doll and/or mesh bag is decorated like a bride and, after an all-night gathering patterned after the eve of a betrothal, the symbolic bride is given in marriage and the 'mothers' ritually give birth to their 'daughters'. The payment of bride-price and marriage of the Wok Meri bride are later repeated at the 'washing hands' ceremony (*aneno kuiyono* 'we wash hands'), the climax of the group's participation in Wok Meri.

Three major events take place during the 'washing hands', a public ceremony jointly organized by two or more groups from the same clan or phratry after they have been saving money for five to nine years.

First, the sponsors announce the amount of money each has accumulated, which thereby ends a prohibition on spending money totaling up to K2,500 per group.

Second, bride-price is paid again and the symbolic 'girl' is married once more, a sign that the 'daughters'/bride-receivers are empowered to hold their own 'washing hands' ceremony in a year or two.[6] The largest exchanges of cash in Wok Meri are those between the 'mothers'/bride-givers and the 'daughters'/bride-receivers, which approximate the cash component of a real bride-price, about K200 to K250. Unlike a real marriage, however, in Wok Meri the bride-price is a loan and must be repaid to the 'daughters'/bride-receivers when they hold their own 'washing hands'.

Third, women from Wok Meri groups throughout the region attend the 'washing hands' to make small loans, from K2 to K20, to the ceremony's sponsors. At one 'washing hands' in 1977, attended by over 2,000 people, 140 loans were made. Informants say that the sponsors are like banks, and loans made to them are like bank deposits. The debts are repaid when the creditor's group 'washes hands'.

Investment

The money saved by a group, added to the bride-price and loans received at the 'washing hands', totals a substantial amount of capital, ranging from K1,000 to about K4,500 for the seven groups whose records were made available to me. Most Wok Meri groups for which I have data invested their capital in business enterprises. Of these, the majority invested in trucking, which along with storekeeping, have been the most popular businesses for Highlanders since the early 1960s. Money from groups that sponsored ten of fifteen 'washing hands' ceremonies (table 1) was used to buy pickup trucks licensed to carry passengers and freight.[7] These trucks, called PMV's (for "passenger motor vehicle"), are the only form of transportation available to most people in the Highlands.

These data must be interpreted cautiously because they were collected by ceremony, and all the 'washing hands' I attended were sponsored by more

[6]The second payment is described by informants as a second bride-price, but it is structurally similar to a child-wealth payment because the symbolic bride has borne a child, since the daughters now have their own daughter group. I am indebted to Andrew Strathern (1979:personal communication) for suggesting this possibility.

[7]Table 1 includes all the ceremonies for which my informants knew exact locations and an additional 'washing hands' ceremony attended by Munster (1975).

TABLE 1 Disposition of Money After Fifteen 'Washing Hands' Ceremonies

Disposition	Ceremony
Investment	
Passenger truck	10
Fuel truck	1
Trade store	1
Wholesale store	1
Corporation shares	1
Distributed among members	1
No data	3
Total	**18**[a]

[a]More than one investment was reported following two ceremonies. The ceremonies occurred in Goroka District before and during 1977.

than one Wok Meri group. Each group can operate independently after the ceremony, as they did before it. The data in table 1 may underrepresent the financial activities of all those who jointly organized the fifteen 'washing hands'. Some groups that sponsored the ten ceremonies after which trucks were purchased may have used their capital for other purposes as well. For example, one established a trade store in addition to buying a vehicle.[8] Trucks are highly visible, and their existence is recognized by people far beyond the boundaries of the owner(s)' village, whereas trade stores may not be as widely known. A Toyota Scout pickup truck cost almost K5,000 in Goroka by early 1978. I knew of only one Wok Meri group with money approaching that amount. A group may take out a bank loan to finance the purchase, or encourage outside investors from among their kin.

I have no data on the use of money after three of the fifteen 'washing hands'. Since people know the place of origin of almost every vehicle that plies the Highlands Highway, it is unlikely that money from these ceremonies was used for trucks.

After one of the fifteen ceremonies, the money was distributed among the women. Each member of the sponsoring groups received her own money and share of the loans to do with as she pleased. The bookkeeper for one of

[8]The fact that trade store operation has been noted only once in the data in table 1 is puzzling. It is not clear whether women have refrained from this popular type of business, or whether it does not appear in my data because the existence of these stores is not known beyond village borders, unlike trucks that travel the Highlands Highway. If women have consistently chosen trucks over trade stores, this indicates that the desire for prestige enters into their decision making. Like pigs, plumes, and shells, but on a grander scale, trucks are relatively scarce, expensive, tangible markers of wealth, the control of which enhances the owner's reputation. The name of the women's group that bought the truck is painted on the door for all to see.

the groups involved in this ceremony reported that the women used this money to meet financial obligations included under the heading of *trabel* 'trouble' in Neo-Melanesian, which encompasses court fines and bride-price payments.

Some Wok Meri women have chosen to invest their money in businesses other than trucking. These decisions suggest a new trend in Wok Meri investment that parallels directions taken by the more successful Highlands businessman in the 1970s.

One of four groups cosponsoring a 'washing hands' ceremony in October 1977 opened a wholesale store where village trade store owners could buy stock, and women from two of these groups bought shares in investment corporations. A wholesale establishment is a more capital-intensive and complex venture than a retail operation, and it is an example of women becoming involved in larger-scale businesses, as is their purchase of shares.

One of the three groups that 'washed hands' together near Watabung (fig. 5) in August 1977 had also considered establishing a bulk store, and the second discussed the possibility of opening a movie theater in cooperation with an expatriate businessman. Neither of these plans was adopted, and the money has not yet been invested. In 1978, the third group bought a ten-wheel fuel truck, which they leased to a transport company in Goroka to haul gasoline from the coastal town of Lae through the Highlands (table 1).

Daulo women (fig. 2) who 'washed hands' in 1978, after the data in table 1 were collected, invested their money, with other shareholders from their tribe, in a bid to buy an expatriate-owned coffee plantation. Women from another tribe in the Daulo, who also 'washed hands' in 1978, formed a partnership with a businessman, a lineage mate who was already a coffee buyer. After losing money, they withdrew from the business and distributed the capital among themselves.

It is not surprising that women have decided to make the same kinds of investments as men. They have access to the same information, usually filtered through men's direct contact with government or business agents, and they observe the type of investments men have made. Although trucks remained attractive in the late 1970s, women began to consider and adopt alternative investments in large-scale and potentially more lucrative enterprises, such as buying coffee for resale to processors, wholesale trade, plantation ownership, and truck leasing for fuel transport. In the 1970s successful Highlands entrepreneurs diversified businesses they had built on trucking and storekeeping; the most outstanding formed million dollar holding companies. Wok Meri women have not escalated their investments to this level; women have, however, kept current with trends in rural businesses.

Wok Meri women collect a substantial amount of capital, but until recently they perceived a severely limited number of investment options.

Trucking is rarely lucrative for small operators. The rugged terrain and rutted dirt roads necessitate frequent repairs, made at high cost by expatriate mechanics in town. Only a few village men know the rudiments of automobile repair or maintenance, which is crucial under difficult Highlands road conditions. A vehicle deteriorates rapidly unless dusty oil filters are changed, and radiators are frequently filled with water.

Added to this are the hazards of hiring often inexperienced young male drivers, who have a justified reputation for recklessness. Most owners employ male drivers rather than driving themselves; it is unthinkable for a village woman to drive, although people have seen expatriate women and a few urbanized Papua New Guinean women at the wheel. Since none of the Wok Meri vehicles were bought by women in the Daulo region where I lived, I have no data on their day-to-day operations. Undoubtedly the women employed male operators (the oddity of women drivers would have been known far and wide), and it is likely that male bookkeepers kept the accounts. Some vehicles bought by women's groups in the Chuave District have been turned over to local businessmen for management, with the expectation that the women will share the profits (Anggo 1975:221).

Women have become entrepreneurs and ceremonial transactors through Wok Meri, participating in the evolving economy and responding to changes in the last fifty years which have, on the whole, adversely affected their economic status. The sequence of events since contact with Europeans has been broadly similar throughout the New Guinea Highlands. However, there have been regional variations due to timing of contact and differences in local ecological and social conditions. After discussing the effect of socioeconomic change on women in the Daulo region in Goroka District (fig. 5), I consider economic and historical factors that contributed to the emergence of Wok Meri in Chuave District.

Socioeconomic Change and Women's Roles

Gold prospectors and government patrol officers skirted the Daulo region in the early 1930s, but the presence of Australian administrators and Christian missionaries was soon felt in the area. The first European to settle nearby was Georg Hofmann, a German missionary who established the Asaroka Lutheran Mission east of the Daulo in 1935. Because early contacts between foreigners and Highlanders were not always peaceful, the Australian administration restricted European movement in the Highlands. Although Hofmann was forced by the administration to withdraw periodically from Asaroka, he and other German missionaries at the station were the Europeans with whom people in the western end of the Goroka Valley had the most

regular contact. During the late 1930s, government patrols in the western end of the Goroka Valley were sporadic because the Highlands were then administered from two governmental centers relatively far to the east and west.

The administration did, however, continue its efforts to pacify the area. A government expedition to punish recalcitrant warriors resulted in the deaths of men from the Daulo and surrounding areas. Members of one tribe, who blamed the missionaries for government intervention, attempted to burn the Asaroka station buildings in retaliation (Hofmann 1938). When relations between the Lutherans and their neighbors were less antagonistic, the missionaries bought food from local women and quickly became enmeshed in other kinds of transactions with the local people.

Both missionaries and government officials paid Highlanders for goods and services with trade items, including shells and steel axes. Before the advent of Europeans, shells and plumes (which along with pigs were the major valuables in ceremonial exchange) were acquired by participating in exchanges or by trading pigs to the Waitsan people across the Bismarck Range. Some shells were also acquired through trade with Simbu peoples to the west.[9] Since men traditionally controlled shell valuables, it would be interesting to know more about what happened when women received shell. I can only speculate, since I did not interview extensively on this subject. I suspect that shell ownership became a source of conflict between women, who claimed the right to dispose of garden produce, and men, who claimed control over valuables used in ceremonial exchange. Contradictory answers received from older informants about the possibility of women possessing shells lend some support to my speculations. Their differing opinions may reflect the unsettled nature of rules for shell ownership dating from the early 1930s.

In addition to providing food for sale, local people brought unsolicited articles to the mission station, expecting return gifts, sometimes of greater value than the staff deemed appropriate. At one point, local people and coastal evangelists working with the German missionaries came to blows about these unsatisfactory exchanges. The missionaries also participated in compensation payments for injuries. For example, evangelists received a small pig after local boys shot arrows at them. Hofmann (1937) made a compensation payment when the missionaries were held responsible by the

[9]Egg cowrie shells (*Ovula ovum*), small cowries (*Cypraea moneta*), and nassa shells (*Nassa* sp.) were used most frequently in exchange, the egg cowrie being the most highly prized. The small number of gold lip pearlshells (*Pinctada maxima*) found in the Daulo region were obtained by trading pigs with the Simbu. When government officials, prospectors, and missionaries began to use shells and other trade goods to buy food from villagers and to pay for their labor, pearlshells were eagerly sought. They became a regular component of bride-price payments, called *lulu* 'shell', and maintained their importance until the early 1960s (Finney et al. 1974).

Asarokas for the deaths of several women and girls. Shortly after leaving the mission where they had received medical care, Ufeto warriors ambushed and killed Asaroka females who had brought sweet potatoes to sell at the mission. Hofmann (1937) gave the Asarokas one ax for each woman and girl killed.

The influx of large numbers of shells and the introduction of steel axes had far-reaching effects on Highland economies. Salisbury (1956, 1962a, 1962b) has documented their impact on the Siane west of the Goroka Valley, who had indirect contact with Europeans through World War II. The changes Salisbury discusses were probably swifter in areas closer to European settlement, such as the Daulo. Steel axes and increased numbers of shells made their way to Siane territory through traditional trading networks (see Hughes 1973). By 1936, steel axes, used as ceremonial valuables as well as tools, were no longer unusual among the Siane. The Siane 'big men' who first received the axes lent them to other men for gardening. Gradually, as more men obtained them, the axes lost their cachet as valuables. By 1953, steel axes were no longer used in ceremonial transactions (Salisbury 1962a:118). The substitution of steel axes for stone reduced the proportion of time men spent on subsistence production from 80 percent to 50 percent. The time men gained was spent on more frequent tribal fighting and on more and larger exchanges accompanied by increasingly elaborate ceremonials (Salisbury 1962a:118–119). Higher payments were made possible by the flow of shells from people closer to European settlement.[10] By 1940, the value of bride-price payments had doubled (Salisbury 1962a:116).

World War II interrupted government, business, and mission activity in the Highlands. The Asaroka mission station, with its ninety male students, was shut down (Hofmann 1938). The Highlands remained on the periphery of the war, but airstrips in North Goroka town and Asaroka were bombed in 1943 by the Japanese (Finney 1973:27). Many Daulo people remember the bombing of the mission station, and a few young men served as carriers for the Allied forces. But the Daulo people stayed apart from war activities, such as building the present Goroka airstrip and growing food for Allied forces. Simbu laborers were brought to Goroka to work on construction.

The end of World War II marked a turning point in the Daulo region and throughout the Highlands as European-instigated changes resumed at a faster tempo. Daulo people were soon in regular contact with missionaries

[10]The northeastern Siane's favorable location on customary trade routes for shells placed them in an advantageous position for obtaining wives from the southwestern Siane, who had fewer valuables. Asymmetrical marriage patterns favoring the northeastern Siane had already developed before Europeans entered the Highlands. The imbalance between wife-taking and wife-giving clans was exacerbated after European contact, as the northeastern Siane had greater access to wealth introduced by Europeans and from traditional sources closer to the north coast of the island (Salisbury 1956).

and government officers and were introduced to a cash economy. By 1947, enrollment at the Asaroka school had increased to two hundred young men being trained to teach Christianity to their people (Goldhart 1947). European missionaries at the station periodically visited outlying communities, but coastal evangelists from Lae and Finschaffen lived in the villages and were responsible for the daily work of proselytizing. The first baptisms were held in 1951 (Goldhart 1951). Acceptance for baptism required individual and group commitment to the new way of life, certified by relinquishing male cult rituals and other institutions contrary to Christian teaching, such as polygyny (Read 1952:234). In some villages, converts were required to display the sacred *nema* 'bird' flutes to the women from whom they had been hidden. The revelation of such an important secret and sacred symbol created a great deal of unrest among adherents of the traditional religion (Goldhart 1951, 1952, 1953).

Secular as well as religious life was changing rapidly. The government appointed a leader and an assistant for him in each clan, called *luluai* and *tultul*, respectively.[11] The *luluai* 'government-appointed leader' was responsible for organizing participation in public works projects, such as road building and constructing rest houses for visiting patrol officers, negotiating conflicts or referring disputants to government headquarters, and administering government regulations, such as sanitation rules. Tribal warfare had ceased, except for occasional outbursts.

Money was introduced into the Goroka Valley in 1947, although there were at that time no stores in which to exchange it for goods. Jim Taylor, then district commissioner, recalls the unfavorable reaction when money was first substituted for trade goods in payment to laborers. Some of the men "burst into tears, threw the money on the ground and demanded shell instead" (quoted in Finney 1973:40). Daulo people were at first puzzled about the use of money; some used bills to roll up their tobacco into cigarettes. But they learned quickly. Daulo men were paid A$2,880 in late 1947 and early 1948 for working on the Highlands Highway. After the first trade store opened next to the Goroka airstrip in 1947, Jim Taylor saw these men run into town en masse to make purchases. They carried their pound notes attached to long sticks which they waved in the air (Finney 1973:41). Money is still displayed this way at certain ceremonial exchanges.

In 1950, young Highland men were first recruited to work on coastal plantations through the government-regulated Highlands-Labour Scheme. Youths contracted for an eighteen-month period and were allowed to sign up again after spending six months back in the Highlands. Large numbers

[11]These titles were taken from the Tolai of the Gazelle Peninsula on New Britain. Originally *luluai* meant 'leader in battle' and *tultul* was the name for his 'messenger' (Mihalic 1971:125, 129).

of young men from Daulo and throughout the Goroka Valley went to the coast on the Highlands Labour Scheme until local possibilities, such as tending their own coffee, became more attractive (Howlett 1962:261–263, 266). While on the coast they learned the Neo-Melanesian lingua franca, met people from other areas in Papua New Guinea, and gained a certain sophistication with European technology and *pasin* 'customs' in Neo-Melanesian. The first Siane laborers who returned in 1953 spent most of their wages on luxury items and shells for themselves and their kin and reserved the rest for future purchases, often of shells (Salisbury 1962a:127–130). Soon a pound note became accepted as a valuable, and money became an expected component of bride-price and other payments (Downs 1953:20; Salisbury 1962a:126).

Experimental coffee gardens were planted in various places by missionaries and government officers during the 1930s. However, the establishment of the coffee industry dates from the early 1950s when expatriate planters were allowed to buy land in the Goroka Valley (Finney 1973:42–43).[12] Thirty plantations were established by 1962 (Howlett 1962:87). Most purchases were completed between 1952 and 1954, when the government halted land sales as a precaution against future shortages (Finney 1973:45–46).

European-owned plantations set an example of how coffee trees should be grown and harvested. In 1954–55, the Department of Agriculture, Stock, and Fisheries began to instruct villagers about raising arabica coffee on their own lands. Government officers visited villages to train people in coffee production, set up demonstration nurseries, and distributed seedlings (Howlett 1962:92–93). People quickly took to the new crop. By 1959 the government no longer encouraged villagers to plant coffee because of the difficulty of selling all of it on the world market. Villagers continued to plant trees on their own initiative; thus, the early and mid-1960s became "the period of greatest growth" in Goroka Valley coffee holdings (Finney 1973:66–67). During the 1960s and 1970s, villagers continued to grow coffee, although their enthusiasm waxed and waned as prices fluctuated on the world market. Today smallholders (i.e., persons growing coffee on their individual plots) account for 70 percent of Papua New Guinea's coffee production (Barry Beil 1977:personal communication).

The last three decades saw the elaboration of patterns already formed by the early 1950s. Villagers have become ever more enmeshed in the world economy. Money has become integral to the ceremonial exchange system and necessary for taxes, school fees, clothing, imported foods, beer, gambling, and business investment. People are involved in more inclusive units of

[12]Pyrethrum and passion fruit were also introduced as cash crops during the 1950s, but they were not accepted like coffee because of difficulties in marketing and greater labor intensity required in growing them.

government (Area Community, Local Government Council, Province, and the nation of Papua New Guinea), which provide services such as education and medical care, as well as exact taxes and enforce obedience to laws. Although Daulo people exert most of their effort on domestic and tribal affairs, they are conscious of the world beyond their tribal boundaries and often discuss their relation to this wider world.[13]

A few farsighted men were quick to invest their coffee incomes in other ventures. Trucking and trade were the first businesses to attract Highlanders for two reasons. First, they were the most tangible enterprises at the time. Highlanders could see the utility of trucks and stores and understand their basic operating procedures. Vehicles were desirable for hauling freight, transporting coffee to factories, and carrying passengers to and from town. The establishment of village trade stores gave rural people easier access to imported food, tools, and consumer goods. Other commercial activities were less easily observed. For example, arrangements necessary for the wholesale importation of trucks and of other goods were not apparent to the ordinary consumer. Second, trucking and storekeeping required relatively small amounts of capital which Highlanders could accumulate, in contrast to analogous, more capital-intensive businesses, like airlines. In 1963, there were five commercial vehicles owned by Highlanders in Goroka District; by mid-1967 there were sixty-eight. The number of licensed trade stores operated by Highlanders in Goroka District jumped from 5 in 1963 to 447 in mid-1967 (Finney 1973:72–73).[14]

Like the traditional political leaders known as 'big men', the 'business leaders' who seized the opportunity to become entrepreneurs, recruited labor and money from their kin to begin their ventures. However, these 'business leaders' tended to maintain individual control over the enterprises (Finney 1973:77). These entrepreneurs were attracted to business, not only by the profit motive, but also by the desire to help their kin and to enhance their own and their kin's reputations, traditional goals that "preadapted" Gorokans to commercial activities (Finney 1973:80, 124). Trucks and stores provide needed services in rural societies introduced to the market economy. However, the traditional emphasis on manipulation of wealth as a means of achieving status made entrepreneurship doubly attractive.

Transport and retail trade continued to be popular among Highlanders into the late 1970s, but the most successful of the early business leaders have moved on to more complex operations. Several large corporations controlled by Highland businessmen were established in the 1970s. The Gouna Corporation based in Goroka town has fixed assets of about K700,000 and owns

[13]Howlett (1973) and Meggitt (1971) have discussed the peasantization of Highland Papua New Guinea societies.
[14]Goroka District was then known as Goroka Sub-District and is cited as such in Finney 1973.

or holds shares in a helicopter manufacturing company, a soft drink company, coffee plantations, and other concerns (Donaldson and Good 1978).

Many of the changes since 1930 affected men more directly than women, such as the replacement of men's stone axes with steel and the recruitment of males for wage labor. But these and other changes have reverberated in the lives of women as well as men. When we examine events since 1930, we see that changes in the economy have, on the whole, had a detrimental effect on women's economic rights, while the relative weakening of male authority brought about by pacification and missionization has allowed women to take steps to respond to the deterioration of their economic rights.

The introduction of steel axes reduced the amount of men's time required for subsistence labor; it also upset the previously balanced contributions to production made by both sexes. Comparison of data I collected in the Daulo region during 1976 to 1978, with those previously gathered by Salisbury (1962a:108) among the Siane, indicate that in precontact society both men and women spent about 80 percent of daylight hours on gardening, pig husbandry, and household work. By 1976 to 1978 men spent 18 percent and women 43.5 percent of their time on these subsistence tasks. When cash-generating activities were introduced, including coffee production, wage labor, and commercial activities, men spent 35.4 percent and women spent 53.1 percent of their time working.

Although women earn income, in addition to their greater work load in subsistence production, they do not control the products of their labor. Property rights are the key to understanding the genesis of Wok Meri. Women's dissatisfaction with their restricted access to and control of money has been the major motivation for the movement.

Property Rights

There is a history of intersex conflict over property rights in the Daulo region and areas bordering it—the Upper Asaro to the north, the Gahuku to the east, and the Siane to the west and southwest (Newman 1965:38; Read 1965:89–90; Salisbury 1962a:62). Moreover, this type of conflict is not limited to the vicinity of Daulo. Marie Reay (1980:personal communication) notes that Minj women in the Wahgi Valley west of Chimbu have engaged in similar struggles since before contact with Europeans.

Western notions of ownership are inadequate for discussing property rights in Highland Papua New Guinea. In Western culture the term *ownership* implies individualized and absolute control over the acquisition and disposal of property. In the Daulo, ownership is more complex. There are two types

of ownership, also identified by Salisbury (1962*a*:61) among the Siane, with qualitatively different kinds of control over property:

> *Merafo* is the ordinary word for 'father', and the *merafo* of property looks after it (*bentaiye*) just as a father looks after his son, acting in his best interests, and being responsible for his well-being to the community, to the ancestors, and to posterity. The property an individual *merafo* looks after is thus comparable with an entailed estate, while his position is that of a trustee. Estates usually consist of land, sacred flutes, and incorporeal property such as pigs' souls, *gerua* [decorated boards used in the pig feasts] designs, ritual knowledge, and rights to make speeches.

The other type of owner is the *amfonka*, a term linguistically derived from the word 'shadow'. The *amfonka* is the owner of *personalty*, a legal term Salisbury uses for personal property, including pigs, trees, crops, houses, ornaments, tools, and clothing. Only a Siane man can be a *merafo* 'father'/ 'trustee', but men and women can be *amfonka* 'personal property owner' of certain items (Salisbury 1962*a*:62). The contrast is between trusteeship and ownership of personal property with rights of disposition.

Although the different kinds of ownership described by Salisbury (1962*a*) are also found among Daulo people, the same linguistic distinctions do not prevail. Unlike the Siane, Daulo people use the words 'father' (*merafo* among the Siane Salisbury studied, *meraho* in the Siane dialect used in the Daulo) and 'mother' (*orafo* among the Siane, *oraho* among the Daulo) to designate both 'trustees' and 'personal property owners' of the appropriate sex. The Daulo term *ambonga*, a cognate of the Siane *amfonka* 'personal property owner', can be used interchangeably with *meraho* 'father/male trustee/male personal property owner' and *oraho* 'mother/female trustee/female personal property owner' to refer to a 'personal property owner', although the word was uncommon and was not even recognized by some informants. Men, with a few exceptions, are the *meraho* 'trustees' of land, the remaining type of estate property. Flutes and "incorporeal property" lost their value with the demise of traditional religious rituals. Both women and men can be 'owners' (*oraho* for women and *meraho* for men) of specific kinds of personal property.

In the following discussion of ownership, the term *jural property rights* refers to formal, publicly recognized claims to property sanctioned in village courts and in traditional moots led by male elders. A major point to be made about ownership is that an individual's formal right to dispose of property is often restricted by the rights and desires of others. This holds true whether we consider trusteeship of land or disposition of minor personal property such as betel nut or cut tobacco, which people routinely demand from each other in bantering tones. An owner is hard pressed to maintain absolute control over personal property, and few would want to do so. In a society in which a person's long-term well-being depends on mutual assistance and

exchange, it would be shortsighted to consistently refuse the demands of kin. This point should be kept in mind, particularly in reference to men's and women's property. For example, while men have jural rights to most coffee income, women often make informal claims to this money based on the labor they contribute to production.

The most valuable resources in the current mixed subsistence and cash crop economy are land, coffee trees, pigs, and money. Consideration of each of these kinds of property shows that men's trusteeship of land placed them in a favorable position to claim ownership of introduced coffee trees and of the major share of their crop.[15] Although men have begun to acknowledge women's claims to pigs within the last generation, on balance, women's economic rights remain inferior to men's.

Land and Coffee Trees

Individual men are trustees of land that is owned by the phratry as a corporate group. Each patrilineal clan has rights to separate land within the boundaries of the phratry territory. A man generally works the ground his father used, but there are informal land reallocations within the lineage or sublineage as older men die, as younger males set up households, or as people move to other villages. Each man has rights to arable land and to bush for planting and cutting timber and for cultivating nut pandanus trees. Members of clans constituting a phratry can exchange land among themselves, but they cannot alienate it outside the phratry without approval of leaders from all the clans. Alienation of land for coffee plantations sets the precedent for land sales, which are rare.

A person usually acquires clan membership by birth. In this patrilineal, virilocal society with phratry exogamy, a man normally remains with his natal clan, while a wife takes up residence in her husband's village. However, an adult male immigrant can be incorporated into a clan, usually if he has married a woman from the clan. With many years' residence and the avowed intention of remaining, he is known as a clansman and his children are said

[15]My analysis of property rights is based on observations and informal conversation, in addition to data collected through interviews and a budget survey. I conducted interviews on property rights with currently married men and women in nineteen randomly selected households in Kiyamunga village in the Daulo region. Spouses were interviewed separately, except for two couples. Twenty-two women and twenty men participated, providing data for twenty couples. (Two elderly husbands with hearing impairment could not be interviewed.)

Adults from eleven randomly selected households (included in the above nineteen) took part in a budget survey. Data on income and expenses were collected by research assistants in a daily interview with each adult during the last weeks of nine months, June 1977 through February 1978. The purpose of the budget survey was to estimate how much money people made from various sources, how this money was used, and how much of it was controlled by members of each sex.

to have the same rights as those of men born into the clan. An immigrant is described as living on his wife's or mother's land; this was the only context in which I heard women described as landowners. Male immigrants behave no differently from other men and have access to the same kinds of resources. None of the immigrants could be strictly described as 'big men', but they actively participate in exchange and other community activities.

Although land is controlled by the phratry as a corporate and, ideally, patrilineal kin group in which men retain permanent membership, a woman can maintain or reactivate her membership and title to land and pass both down to her children in three situations. First, a married woman may return to her natal clan with her husband and children. Today, people are aware of possibly overcrowding their land, and some say they would not welcome a married daughter and her family. Second, a divorced woman can return to her clanspeople. Her children should stay with their father (or return to him after weaning) if bride-price has been paid, but informants' biographic data reveal that it is not uncommon for children of divorced parents to reside with their mother's patrikin. If the mother later remarries, she is likely to leave her children with her clan because men are said to be reluctant to raise another man's children. (I do, however, know of households including children from the wife's previous marriage.) Third, an unmarried girl who bears a child is likely to leave the child with her patrikin when she marries.

In summary, title to land is held collectively by the corporate patrilineal kin group. Usually women give up their ownership rights to land at marriage, but they can maintain or renew them in certain circumstances. A few young married women who live near their natal villages garden on their fathers' land without claiming permanent title or inheritance rights for their children. A wife, however, generally activates her use rights only to her husband's land.

It is the relationship of coffee trees to the land on which they are planted that has facilitated men's possession of them. Ownership of coffee trees follows the same rules as those for nut, red pandanus, and timber trees valued in the subsistence economy. A son owns or inherits the trees he or his father planted. A married daughter or sister may be given pandanus nuts or fruits at her request or when she visits her family, but she cannot take them without asking. Young married couples sometimes pick coffee from trees that they or the wife's parents planted on her father's land. This practice usually tapers off when the couple establish their own coffee gardens on the husband's land, but some older women still pick coffee on visits to their parents. People may lay claim to coffee trees they planted and tended on someone else's land, but a claim based on work alone is tenuous and usually does not prevail over the landowner's title. As one young married man said, it was not worth the effort to plant coffee trees on his father-in-law's land because there would only be trouble later about their ownership.

Labor contributions to coffee gardening give a wife restricted rights to the crop produced by her husband's trees, but not to the trees themselves. Informants unanimously state that these limited rights are canceled by divorce. A divorcée is expected to grow coffee, often called *wokim bisnis* 'make business' in Neo-Melanesian, with her new husband.

The introduction of coffee trees may in the long run contribute to changes in the land tenure system. The trees' extended life and the amount of land devoted to them complicates the reallocation of land among different phratry segments as they grow or diminish in size. Men's (and women's) desire to bequeath to their own sons the coffee trees they have planted and nurtured may develop into support for individualized land tenure in the future.

Pigs

Today spouses share ownership of their pig herd. Some earlier researchers claimed that men had sole rights to pigs, but there is evidence suggesting that the situation was more complex. Women's rights to pigs were in dispute up through the post-World War II period, as women individually and collectively demanded that men acknowledge their title to pigs.

The shift in women's rights to pigs over the last generation is important for several reasons. As a focal point for conflict between the sexes, disputed pig ownership provided the impetus for women's individual and collective action since before European contact until at least 1960. Women's recognized rights to pigs increased as the significance of the animals declined in relation to money.

Only men are reported as pig owners among the Siane in 1952–53 (Salisbury 1962a:61) and the Gururumba in the Upper Asaro in 1959–60 (Newman 1965:38). By contrast, Howlett (1973:255), writing about traditional society in the Goroka Valley as a whole, says, "All men, many women, and even children owned pigs." Read's (1952) statements about pig ownership among the Gahuku in 1950–51 are not so clear-cut; I infer from them that men were the jural owners of pigs, but that women had limited informal rights to them. In his discussion of preparations for the pig feast, Read (1952:21) notes that

they [women] are acquainted with the decisions taken by their menfolk. Pigs are regarded as their special charge, and it is understood that a husband will consult his wife before he undertakes to kill an animal. Social recognition is also accorded the wives of those who supply the largest pigs. Such women are permitted to decorate themselves with male ornaments and to dance with the men on the concluding day of the festival.

Read (1965:89–90) also reports the case of a Gahuku woman who refused, under duress, to allow her 'big man' husband to use one of the pigs she had reared to pay bride-price for another wife.

Clearly, women's involvement in pig production was recognized by the Gahuku, as was their ability to influence the provision of pigs for ceremonial events. Although Salisbury (1962a) and Newman (1965) maintain that only men owned pigs, they present data indicating that pig ownership was a far from settled issue among the Siane and the Upper Asaro. Salisbury (1962a:62) reports:

> When a man wishes to kill his pigs, his wife will commonly wail and weep, saying the pigs are her personalty [personal property], until her husband gives her a small gift to prevent further argument.

The presentation of a gift to the wife can be interpreted as compensation and acknowledgment of her claims. Newman (1965:38) describes group protests by Gururumba women:

> Men own pigs, but women carry out the day-to-day tending of them. A woman is spoken of as the 'mother' of the pigs she tends, and when they are killed she mourns them. If large numbers of pigs are killed for exchange purposes, there may be an organized stickfight between all the women and the men who have become 'killers' of their 'children'.

Since the term for 'mother' means 'owner' as well, the fact that Gururumba men and women refer to women as 'mothers' of pigs also indicates some level of male acceptance of female claims to the animals.

Daulo women used to wail when pigs were killed, crying "Why are you killing my pigs? You've killed my pigs!" Today, women no longer cry when pigs are killed. On the contrary, I was struck by the lack of emotion displayed by women when their pigs were slaughtered. Perhaps they no longer need to express ritually their rights to pigs because they are more secure in them.

When asked about pig ownership, the majority of respondents said that pigs belonged jointly to them and to their spouses and that couples discuss the distribution of their pigs before a gift is pledged.[16] Most of those who consult with spouses about gifts of pigs stated either that they never disagree

[16]Seventeen of 20 men, 18 of 22 women, and 15 of 20 couples said pigs were jointly owned with their spouse. Of the remaining 3 men and 4 women: 2 men said pigs were theirs alone; 1 man said pigs were his wife's alone; 1 woman said pigs were her husband's alone (because the pigs she had brought at marriage had been killed, leaving no offspring); 1 woman said the pig currently in her household was hers alone, but previous pigs had belonged to her and to her husband together; 1 woman said pigs were hers; the response of 1 woman was not codable.

One couple said the pigs belonged to the wife alone. In 2 of the 3 cases where the couple disagreed, the men said the pigs were theirs, while the wives said the pigs belonged to both of

about these contributions or that neither spouse dominates the decision when there is a disagreement. Sometimes the husband, or sometimes the wife, persuades the other spouse to his or her point of view.[17] As one elderly woman said, she and her husband do not compete with each other; each spouse listens to the other's opinion.

Of course, what people say and what they do are different matters. However, I was impressed by the dearth of marital quarrels about pigs. I heard of and witnessed spirited arguments between husbands and wives about money, but not about pigs. Women commonly complain about men's misuse of money, but no woman ever told me that she or other women were dissatisfied about the distribution of pigs.

In summary, a husband and wife share ownership of their pigs for the duration of the marriage. Neither spouse has the unilateral right to dispose of a pig. Most couples at least cursorily discuss the distribution of pigs, which are not a major source of tension between spouses. Upon divorce the herd is split, each spouse claiming the pigs or the descendants of pigs she or he brought to the marriage.[18] (Several mothers in long-standing marriages said they would leave their pigs behind for their children.) If the husband has initiated divorce after a lengthy marriage with children, the wife may also

them. In the third case the man said pigs belonged to both, while the wife said they were his alone. The responses of one couple could not be coded.

Seventeen of 20 men, 18 of 22 women, and 15 of 20 couples said they confer with their spouses before a pig is used for exchange purposes. Of the 3 men who said they do not discuss the disposition of pigs with their wives, 2 said they make the decision themselves and 1 man said his wife makes the decision. Of the 3 women who said they do not discuss the giving of pigs with their husbands, 2 claimed they decided themselves and 1 said her husband makes the decision. One woman's response was not codable.

Two couples agreed that they did not discuss contributing pigs. Of the two couples who disagreed, both wives said they discussed the giving of a pig with their spouse and both husbands said they did not. One couple's response was not codable.

It is not surprising that there are disagreements between spouses in responding to these questions about decision making. A study of American couples indicated a high rate of disagreement between spouses' responses to questions about each other's role in making decisions on a variety of topics, including financial decisions (Granbois and Willett 1970).

[17]Thirteen of 17 men, 11 of 18 women, 7 of 15 couples (all respondents who reported they discussed contributions of pigs with a spouse) said they never disagree or that neither spouse dominates the decision to dispose of a pig. Three men and 3 women said the husband usually prevails when they disagree about giving a pig; 1 man and 3 women said the wife had more power in such a dispute. There was no response from one woman.

One couple agreed that the wife prevailed in disagreements over pig giving. Almost half the couples disagreed: the wives of 3 couples said they and their spouses never disagree, while the husbands said they do sometimes disagree and they, the husbands, prevail; the wives of 3 couples say the husbands prevail in such disagreements, while the husbands say they and their spouses never disagree about giving pigs; the wife of the remaining couple says that she prevails, while her husband says they never disagree.

[18]Fifteen of 20 men and 17 of 22 women said a divorceé has the right to take some pigs with her. Six of these men and 3 of these women specifically said a wife has the right to take the pigs (or descendants of the pigs) she brought to the marriage.

be awarded compensation for her labor in the form of cash and/or additional pigs.

Today women appear satisfied with their rights to pigs. Previously, women's claims to the animals were disputed by men and were a source of conflict between spouses, as well as between men and women in the public sphere. I can only speculate on the process through which women's title to pigs was acknowledged by men. I suspect that men became more willing to acquiesce about sharing control of pigs with women as money became more important. Limiting female rights to pigs became less crucial to men as they consolidated their control of cash.

Women's recent gains in pig ownership may be illusory. Data on nuptial transactions for ten of the eleven Yamiyufa men from Daulo who married during my fieldwork suggest that pigs are losing their cachet. In two of ten cases, the bride's family did not bring pork to the betrothal feast for the customary exchange of cooked pork with the groom's family. Even more striking is the absence of live pigs in four of the ten bride-prices, while money was a component of all of them. At one of these four betrothal ceremonies, speeches were made supporting the elimination of live pigs from future bride-price payments. These four brides did not bring live pigs with them for their marital herds, an omission that traditionally enabled a husband to belittle his wife during arguments. If further investigation supports this trend, pigs are undergoing the same process of devaluation as shells and plumes did beginning in the 1950s, which would leave only money in the cycle of marriage exchanges and women with short-lived economic gains.

Money

The major sources of income in most households are coffee and vegetable marketing. A few entrepreneurs, almost all men, engage in commercial activities, including middleman coffee buying for resale to processing factories, truck operations, and storekeeping. Initial questions about control of money elicited the common response that women earn cash by selling produce and small amounts of freshly picked cherry coffee. Men's much larger income is derived from selling the bulk of the crop after it is processed into higher priced parchment coffee. In fact, the relative sources, control, and use of money by women and men are more complex than these responses reveal.

Marketing. Women benefited economically from their early experiences with missionaries, explorers, and government officials. In 1930, Mick Leahy bought vegetables from women on the first exploratory trip by European prospectors through the Gahuku and Bena Bena areas of the Goroka Valley. Leahy remarked that "women appeared to be the gardeners and traders, and

when we bought food, we traded with the women" (Leahy and Crain 1937:109). A few years later missionaries at Asaroka Lutheran Mission provided a steady market for women near the Daulo region (Hofmann 1937, 1938). By 1952, the government was regularly buying vegetables for its staff and hospital patients in Goroka: "Each day a native orderly waited at a large shed near the hospital with a huge spring balance (*klok* in pidgin), weighing bags of produce which women brought, and paying for them in cash" (Salisbury 1962a:164). Siane women seem to have controlled their early earnings. When Salisbury (1962a:134), who regularly purchased vegetables from them, started to buy their firewood as well, the government-appointed leader urged him to buy firewood from the men so that they also would have a regular source of income.

The early payments of shell valuables and other goods for food confounded the categorization of objects in Highland societies (Salisbury 1962a:124, 134). Garden produce, most of which women harvested and distributed, was of obvious importance but of low value in trade. Cultivated crops could not be converted into valuables like shells, which were ordinarily controlled by men. Although men were trustees of land, Salisbury (1962a:63) reports that food was a woman's personal property among the Siane in 1952 to 1953. A husband had no right to take food from his wife's garden without permission:

Thus if a man enters a garden on which there are growing crops, the personalty [personal property] of a woman, he must first obtain the permission of that woman, even though she be his wife. Otherwise he is assumed to be stealing crops, and the woman may punish him by beating him with a digging stick or scratching him with her nails. Other men do not intervene as they normally do in male-female quarrels, but laugh at his discomfiture. (Salisbury 1962a:63)

In contrast, Daulo respondents in 1976 to 1978 unanimously replied that both spouses have the right to harvest food, although men usually do not because they consider it women's work. Spouses share ownership of garden crops, and no informant admitted the possibility of spouses fighting if the husband took vegetables from the gardens. It is likely that there has been a shift toward joint ownership of produce (in addition to pigs) in the Daulo region as crops became commodities. It is relevant to note that, although vegetable marketing is women's work and demeaning for men, large-scale truck gardening is considered appropriate for men.

Today vegetable marketing is the source of small but steady earnings for women, providing a mean estimated annual income of K51 for fifteen women who participated in a budget survey. Although this income is said to be women's money, half the respondents who market said they regularly

share their earnings with their husbands.[19] Because this money is earned in small amounts, it is likely to be used for purchases of imported foods, kerosene, and soap for the household, and for personal pleasures such as tobacco and card playing. Since women are the food providers, they buy as well as sell at the market. A woman who vends on one week may buy on another, or she may sell one kind of food and use her earnings to purchase another type vegetable the same day. Crops and small amounts of money recirculate among vendors in the local markets. However, women do manage to save some of their money in their Wok Meri accounts. One woman, for instance, was credited with contributing K120 to the bride-price for her son's wife, earned from selling sweet potatoes.

Coffee Production. A small portion of the coffee crop is sold as soon as the ripe cherries are picked, but most of the harvest is pulped, washed, and dried into the more profitable parchment coffee, which jurally belongs to men.

Fifteen women surveyed earned a larger mean annual income from cherry coffee sales (K62) than from produce vending, but neither their source of income nor their total compares favorably with men's parchment earnings. The majority of women queried about control of resources reported they do not share cherry coffee income with their husbands, although most noted that they use some of this money to buy food and sundries for household consumption.[20] Women are less likely to share their cherry coffee income than their proceeds from vegetable vending, because their access to cherry coffee is considered remuneration for their labor in cash crop production. Wives are more willing to share their market earnings with spouses because husbands own the land and participate in establishing gardens. Daulo women's rights to dispose of vegetables seem to have become more limited, compared with Siane women in the early 1950s (Salisbury 1962a:63), after food crops became commodities sold for cash.

Children and men may also sell freshly picked cherry coffee. Ten of sixteen men surveyed earned a mean annual income of K40 from cherry coffee sales. However, men obtain most of their income from sales of processed parchment coffee. For example, sixteen men earned a mean of K321 in 1977.[21] A husband should ideally share a portion of this money with his

[19]Nine of 18 women respondents who market vegetables said they regularly share their earnings with a spouse. Seven of 14 men whose wives market reported their spouses shared this income with them.

[20]Twelve of the 16 women responding to this question said they do not share cherry coffee income with spouses, and 11 of 20 men reported the same for their wives. Seven of these 12 women said that a portion of this money is used for household expenses, and 3 of the 11 men reported the same.

[21]Mean annual parchment coffee income per male is presented as a means of roughly comparing the monetary resources that men and women control. However, it must be noted that 4 of the 16 men live in extended families in which parchment coffee money is pooled, and that one man is a bachelor living with his parents.

wife, but she cannot legally claim it nor money he may earn from wage labor or entrepreneurial activities. Fellow villagers sympathize with a wife whose husband squanders money, but the elders and the Village Court magistrates have no authority to compel him to change his behavior. Should a couple with children divorce at the husband's initiative, a wife receives a standard compensation for her years of labor and child care that does not reflect the particular couple's current parchment coffee income or their savings.

Of course, few men spend most of their income on beer and cards. There are, in fact, few choices involving parchment coffee income. Informants agree that it should be used for certain purposes: to make exchange payments; to save for future ceremonial needs; to pay tuition fees; and to make investments, such as buying a coffee pulper or a truck. Women support their husbands' use of income for ceremonial payments and enthusiastically fulfill their limited roles in the organization of payments and in the rituals marking them. Women also approve of business investments. But wives do object to large sums spent for personal pleasures, such as card playing, drinking beer, and buying truck fares for frequent trips to town.

An individual's right to dispose of property is constrained by other people's often conflicting rights and desires. This is especially true within marriage. Spouses informally negotiate the allocation of money and pigs. At times, however, negotiations fail and fights ensue. Money appears to have replaced pigs as the cause of many marital conflicts. As early as 1959–60, for example, disputes over money arose as Gururumba women in the Upper Asaro were occasionally employed to pick coffee on an expatriate-owned plantation. Husbands tried to force their wives to quit work after the women refused to give them their earnings (Philip Newman 1979:personal communication).

The absence of women's jural rights to the main source of income is the motivation for the development of Wok Meri. Through this movement women attempt to redress the imbalance they perceive between their labor contribution and their lack of control over the products. Wok Meri women call themselves the *orabo* 'mothers'/'owners' of money. By using this term, women not only claim ownership but also emphasize their role in producing wealth. As mothers nurture their children, so do women tend crops, pigs, and coffee trees. Wok Meri women act on their expressed claims to money by depositing portions of parchment coffee income as their 'washing hands' ceremony nears and by investing their capital in business enterprises.

Origins of Wok Meri

The economic foundations of women's discontent are clear. Two questions about Wok Meri's origins remain. How did such a women's movement,

unparalleled in the ethnographic literature on Highland New Guinea, develop? Since a similar sequence of economic changes is taking place throughout the Highlands, why did a women's movement arise in a particular area?

A major underpinning for long-term group action by women in the eastern end of the Highlands where Wok Meri is found is the regular informal and structured cooperation of female coresidents married to patrilineally related males. Marilyn Strathern (1980:personal communication) suggests that nucleated villages, in contrast to the dispersed settlement patterns in the western Highlands, allow daily interaction among women that supports a cooperative undertaking like Wok Meri. Women in Chuave and Goroka districts also have a tradition of working together to organize menarche rites and to play a limited part in the now discontinued male initiation ceremonies.

Women customarily protested against their limited property rights. I have noted that Upper Asaro women decried the slaughter of "their" pigs for ceremonial occasions in ritualized stick fights against men (Newman 1965:38). Women were also galvanized into action by noneconomic issues. Read (1965:136–137, 196–198) documents two occasions when Gahuku women's stylized protests against men's social arrangements erupted into brawls. In one case, women reacted against men's harsh treatment of young male initiates. In the other, women expressed anger at the marriage of a prepubescent girl.

Women's larger-scale collective activities were responses to colonial policy. H. F. W. Bergmann, a missionary in the Ega Lutheran Circuit in the Chimbu region, notes the existence of a women's movement in his annual report for 1955:[22]

In the beginning of this year there appeared a queer new movement. I called it the women's movement. It was going on already when we arrived here.[23] First we noticed the women, not only the girls, dressed up, singing and dancing when we travelled from one place to another. Soon we heard that the men were bitterly complaining about the behaviour of their womenfolk. They did not work in the garden, they did not prepare the meals properly, etc. The men kept quiet, but they said, We have still our axes. . . . All that I could find out about how this movement started concerned a misunderstanding about the English Queen. As she is a woman, the women here thought to play a big role in the native life now too. They wanted to be appointed Luluais . . . etc., etc. When I heard about it, I suggested to the [Lutheran] teachers to quiet the men down and told them this movement would die out soon. And so it did. I have not heard anymore about it now for several months.

This tantalizingly incomplete description suggests that women were well organized and articulate in expressing their grievances. Bergmann says that

[22]I am grateful to Robert Smith (1978:personal communication) for sharing this information collected during his research on missionization in the Highlands.
[23]Bergmann is alluding to his return from leave in 1954.

women wanted to hold office of 'government-appointed leader'; unfortunately, he does not specify their other demands. Women apparently were relying on Queen Elizabeth II, crowned in 1953, to intervene on their behalf or to set an example as sovereign that would induce men to meet their demands. The location of the movement in the Chimbu region, along with similarities in self-decoration, singing, and dancing suggest this may have been a forerunner or an early stage in the development of Wok Meri.

Another example of collective response is a 1964 strike in the Minj area in the Wahgi Valley west of Simbu. Reay (1975) describes this incident as a successful group action resulting in changes in property ownership. After World War II, roadwork became corvée labor for Highlanders. Men's and women's participation in unpaid highway maintenance was required. The government did, however, remunerate groups for heavier tasks and road construction. This money was distributed among the men by local government councillors or committeemen, despite female participation in the work (Marie Reay 1980:personal communication).

In an apparent bid to win women's votes in future elections, a newly elected House of Assembly member set aside women's obligation to take part in roadwork. Although all adults are eligible to vote in Papua New Guinea, Minj men perceived their wives' votes as extensions of their own. Thus the men interpreted the ban on women's forced labor as a political ploy to gain their votes (Reay 1975:6–7):

> The Minj men were outraged by what they saw as a move to alienate the votes of their womenfolk. . . . Most of the women continued for a time to help their husbands with routine [unpaid] road maintenance, but the loud protests at 'Kaibelt's [the House of Assembly member who issued the ban] law' had drawn their attention to it. Excluded from the men's discussion, they talked about it eagerly among themselves and reached informal agreement on what they should do. When the roadwork included tasks for which the men received payment, the women of several groups near Minj insisted that they should receive their share of the pay. The men tried to assert their authority and ignore the demand, but the women went on strike. They told the men that if they wanted to take all the pay for themselves they could also do all the work, since they themselves were not legally obligated to help them. The successful strike of the Minj women marked the beginning of a new era. It was no longer completely true that a woman had no possessions that her husband could not appropriate and count as belonging to him. From this time it was easier for women to keep for themselves at least some of the money they earned from marketing vegetables. Now some of the women have a modest income from growing their own coffee, though the men make constant demands on the use of it.

Minj women protested their exploitation by men, who profited by using female labor as a substitute for their own and by pocketing the money women

earned themselves. After successfully acquiring their share of cash for road-work, some women pointed out that they also took part in coffee production. Men perceived women's statements as an ultimatum before another strike, although it is not certain that women intended a similar action. As compensation for their wives' labor, some husbands began sharing coffee income with their spouses, and others gave their wives use rights to specified coffee trees (Marie Reay 1980:personal communication). Similarly, Wok Meri women protest against their lack of access to income they help to generate.

The immediate impetus for Wok Meri was the establishment of Lutheran women's fellowships in Simbu. In 1957, local male teachers were trained to conduct women's Bible study groups (Theile 1957) and were encouraged to establish them in their own villages (Bosanu Habu 1981:personal communication). Members usually made an offering at their weekly meetings to pay church expenses or the evangelist's support. Lutheran women's clubs are still referred to as 'women's work', although they have also been called *Sande skul* 'Sunday School' in the area between Chuave and Nambaiyufa (fig. 5). In the early 1960s, women there tired of donating their earnings to the church and withdrew to form savings associations of their own (Anggo 1975:209).[24] The structure of these new organizations and their relations to other groups appear to have gone through at least two transformations before arriving at the form described in this chapter (Wayne Warry 1981:personal communication).

Lutheran women's groups, never prominent in rural Goroka District, did not precede Wok Meri there. The movement arrived in the district in its mature form in the late 1960s. However, religiously affiliated savings groups may be in the process of change around Koge in the Sina Sina area in Kundiawa District west of Chuave District (fig. 5). By 1971, Nimai-speaking Lutheran women at Koge had formed work groups to collect thatch or to weed coffee gardens. Money earned in this fashion was contributed to the church.[25] In 1975, work parties were still organized, in addition to several women's and men's rotating credit associations called *magai*, a Kuman word for 'meeting'. The first of these was organized by a male *songan* 'pastor's assistant' (Kâte language) who encouraged people to form additional associations in which Catholics and Lutherans were members. After a worship service and collection, men or women gathered for the 'meeting' contribute money which is immediately given to one person. The recipient is expected to use the funds for a secular purpose, such as buying merchandise for a trade store (Carolyn Hide and Robin Hide 1977:personal communication;

[24]Rotating credit associations among workers in towns or on plantations are often called *sande* 'Sunday' in Neo-Melanesian (Howlett et al. 1976:257).
[25]Wok Meri groups are also said to earn money by forming work parties, but this practice had declined in the Daulo region by 1976–1978.

see also Howlett et al. 1976:257). These 'meeting' groups are also found south of Kundiawa District below the Wahgi River. In some cases 'meeting' groups are viewed as Christian charities. Recipients, who may be widowed or needy, are not expected to repay the money.

By 1977, 'meeting' groups among both Nimai- and Tabare-speakers near Koge had been influenced by Wok Meri (fig. 5). At least two Nimai groups and one Tabare group had dolls representing the symbolic bride, and the Tabare group used the marriage idioms found in Wok Meri (James Knight 1977: personal communication). It is not clear whether women's and/or men's 'meeting' groups assumed aspects of Wok Meri, or whether collecting activities were modified from a rotating credit association to an extended savings and exchange system like Wok Meri.

It is clear that church-affiliated groups in Chuave District provided a significant infrastructure for women and taught them important skills put to use in Wok Meri (see also Forman, chap. 8). Women learned how to sustain and work in all-female groups for nontraditional purposes. Members also gained experience in collecting and saving money.

The limited economic potential in Simbu Province, contrasted with earlier experiences of abundance, may have led men to maintain their control of scarce money more stringently, accentuating differences between men's and women's property rights and motivating women to react. The rugged and densely populated Simbu Province lies between the broad plains of the less crowded Goroka Valley to the east and the Wahgi Valley to the west. Access to more arable land in the valleys for the establishment of European-owned plantations led to the growth of Goroka town in the Goroka Valley and Mount Hagen in the Wahgi Valley as commercial centers, leaving Simbu Province on the sidelines of economic development in the Highlands (Howlett et al. 1976:14). Villagers in the two valleys have larger landholdings and better terrain for cash crop production (including tea and coffee in the Wahgi Valley); therefore, they have higher incomes than villagers in Simbu Province. Lagging economic development may have come as a harsh blow to Chuave people because their expectations had been heightened earlier. During World War II, men from eastern Simbu Province worked as porters and laborers on construction of the Goroka airstrip (Howlett et al. 1976:14), carrying back to their villages knowledge of the Europeans' cornucopia of material goods, in addition to their modest earnings which were quickly absorbed into the traditional system of exchanges. Long after Goroka Valley people relied heavily on coffee cash cropping, the Simbu continued to participate, in disproportionately large numbers, in short- and long-term labor migration to the coast and islands.

Research is needed to test the hypothesis that intersex conflict over money has been more severe in Chuave District than elsewhere in the High-

lands. It seems likely that the conjunction of particular economic factors with the establishment of Lutheran women's groups in Chuave District catalyzed the development of Wok Meri.

Conclusion

I have described Wok Meri, a twenty-year-old exchange system and network of savings associations. Wok Meri is a collective response by women to the restructuring of their economic rights over the last fifty years, since Western contact. Both sexes claim that women developed Wok Meri to register their disapproval of men's expenditures on cards and beer. Women save their own small earnings in Wok Meri, demonstrate their capability, and set a good example of what can be accomplished if money is prudently saved. Women's actions belie their modest words. In Wok Meri women have established quasi-Western banks and a series of exchanges patterned after customary transactions initiated by marriage. By investing their capital in business ventures, women increase their participation in both the modern and traditional sectors of the economy.

The long-range implications for gender roles remain to be seen, but Wok Meri has the potential for bringing about radical change in relations between the sexes. As its 'washing hands' ceremony approaches, members make larger deposits in their accounts to enhance their personal renown and their group reputation when their savings are announced publicly. At this point women draw on the parchment coffee income, which jurally belongs to their husbands, as well as on their own modest earnings from the sale of produce and cherry coffee. This indicates male support of Wok Meri activities, which reflect favorably on lineage and clan; moreover, it also establishes women's claims to increased rights in parchment coffee income. It is easier to build on such precedents than it is to retreat from them, once established. If women collectively, or even individually, invoke these rights outside of Wok Meri, they could have a dramatic social impact.

Only if certain conditions are met will women's augmented rights to parchment coffee income transform property relations between the sexes. Individual males own coffee trees because they are planted on land controlled by men as members of corporate patrilineal descent groups. While women's access to land, the major means of production, depends on their relations to fathers, brothers, and husbands, men remain dominant economically.

However, an alternative route to achieving control of the means of production that bypasses land ownership could be created by Wok Meri investments in profitable businesses and capital accumulation. In this way women could parlay rights to parchment coffee into their own means of

production. In the late 1970s, Wok Meri groups began to expand investment choices beyond marginally profitable trucking and storekeeping. They became involved in potentially more lucrative, complex, and longer-term ventures such as coffee plantations and fuel-truck leasing. If their businesses are successful and expand, Wok Meri groups could conceivably control extensive capital investments.

Greater control of capital investments would allow groups of women to achieve increased economic autonomy. It seems unlikely, however, that women will opt for economic independence from men. Through Wok Meri, women strive to participate alongside males rather than to cut themselves off from men. Wok Meri is not a separatist movement; women express a desire for greater, not less, cooperation between the sexes. The collective nature of the movement and the organization of units based on established ties of kinship support the traditional value placed on cooperation. Wok Meri is significant because it institutionalizes collective female action and enables women to redefine property rights vis-à-vis men, and thus to enchance their participation in the ceremonial and commercial sectors of the economy.

8

"Sing to the Lord a New Song": Women in the Churches of Oceania

Charles W. Forman

In 1971, the churches of the Pacific Islands chose a leader for their central organization, the Pacific Conference of Churches. Previously this body had been chaired by males, and the general secretaries had always been men. However, at the assembly held in 1971, Fetaui Mata'afa, wife of the (then) Prime Minister of Western Samoa, was selected to chair the organization. Six years later the general secretaryship passed to Lorine Tevi, a Fijian woman. These two elections reveal a transformation of women's roles in the South Pacific churches. At the first gathering of the Pacific Conference in 1961, women played little part in deliberations, and they were not considered

This chapter is based on archival research in the headquarters of the relevant missionary societies and churches. The author wishes to thank the following libraries and church and mission offices for permission to use their collections: the Council for World Mission, London; the United Society for the Propagation of the Gospel, London; the Société des Missions Évangéliques, Paris; the Padri Maristi, Rome; the Congregazione dei SS Cuori, Rome; the Neuendettelsau Mission, Neuendettelsau, Bavaria; the Division of World Missions, American Lutheran Church, Minneapolis; the Society of the Divine Word, Techny, Illinois; the Jesuit Missions Collection of Fordham University, New York; the United Church Board of World Ministries, New York; the Mitchell Library, Sydney; the Australian Board of Missions, Stanmore, N.S.W.; the Australian Council of Churches; the former mission boards of the New Zealand Presbyterian and Methodist churches, Auckland; the Houghton Library of Harvard University; the Divinity Library of Yale University; the Roman Catholic bishops of Port Moresby, Madang, Rabaul, Honiara, Port Vila, Noumea, Tarawa, Suva, Nuku'alofa, Apia, and Papeete; the United Church of Papua New Guinea and the Solomon Islands; the Evangelical Lutheran Church of Papua New Guinea; the Anglican Province of Papua New Guinea; the Anglican Province of Melanesia; the Presbyterian Church of Vanuatu; the Kiribati Protestant Church; the Methodist Church of Fiji; the Free Wesleyan Church of Tonga; the Congregational Christian Church of Samoa; and the Evangelical Churches of New Caledonia and of Tahiti.

for formal positions. Women were more active in the second assembly in 1966, and the planners of the conference advised each church to include a woman in its delegation (Mata'afa 1966). However, when one woman was outspoken in the debates, she was taken aside and privately reprimanded by the other delegates from her country. In contrast in the 1970s, women held the top positions.

This reversal is only one conspicuous and recent development in a long process of sociohistorical change involving women of the Pacific churches. Initially the churches were completely in the hands of men. Gradually women broke into these male-dominated institutions, created their own spheres of influence within them, and eventually achieved a share in their leadership. This chapter examines the course of that change. There will be no attempt here to examine the wider role of the churches in relation to the position of women in island societies. Rather, effort is focused on the roles of women in the churches themselves. Exploration of this question is undertaken more from a historical than an anthropological perspective. In matters of this kind, however, history and anthropology overlap to a considerable extent, and historical analysis may well yield anthropological insights.

The Churches

A brief historical overview of the major South Pacific churches will provide some background. Christianity came to the South Pacific at the beginning of the nineteenth century through the work of missionaries from Europe and, later, Australia and New Zealand. Tahiti was the first island where missionaries preached and established Christianity. The national church there was organized by the London Missionary Society (hereafter referred to as LMS), a body in the Congregational tradition. This same mission also began the major churches of Samoa, the Cook Islands, Tuvalu (Ellice Islands), Kiribati (Gilbert Islands), Niue, the Loyalty Islands, and the south coast of Papua. A second congregational organization, the American Board of Commissioners for Foreign Missions, which worked out of Boston, came to the Pacific in 1820 and was responsible for the creation of churches in the islands north of the equator.

Next on the scene were the Methodists, who developed what were, in effect, the national churches of Tonga and Fiji, as well as the major churches in the western Solomons and the islands east of New Guinea. The Catholics arrived a little later and, therefore, had to be content with minority status in all of the countries thus far mentioned. However, they were the first arrivals in New Caledonia and Wallis, where they remain dominant. They also became the largest church in the former Territory of New Guinea and

in present-day Papua New Guinea. The last major denominations to arrive were: the Presbyterians, who predominated in Vanuatu (the New Hebrides) from 1848; the Anglicans, who concentrated in the Solomons (1851) and eastern Papua (1891); and the Lutherans who began, appropriately enough, in German New Guinea (1886) and continued exclusively in that area, developing a large and influential church.

These are the major churches of Oceania, and the only ones considered here, although there are others of more recent origins and of smaller size, which would only add to the already complex picture.[1]

Beginnings

The churches initially projected a strongly masculinist image. The first missionaries were men, some of whom were accompanied by their wives. The early Congregational and Methodist missionaries, as well as the Presbyterian and Lutheran missionaries who came after them, were usually married men who brought their wives with them. Some of these women, such as Mrs. William Ellis, a member of one of the earliest LMS contingents in Tahiti, were committed to missionary endeavors of their own and met their future husbands as a result of their desire to work in overseas missions (Ellis 1836). Other women came primarily as companions for their husbands. Anglican missionaries who happened to be married brought their wives, in the years before 1895, only as far as Norfolk Island. There the wives were left while their menfolk traveled by ship through the Solomons and New Hebrides. The early Catholic missionaries, the most numerous group, were unmarried priests and brothers. The Catholics thus presented the most male-dominated image, but what they exhibited in an extreme form was characteristic of all the missions. As churches began to develop in the islands, male missionaries were in charge, and their wives held no formal positions. None of the churches permitted women to be ordained to the ministry. Hence, island women had few role models as far as female participation in church leadership was concerned.

Participation of another kind, however, was allowed to indigenous women. From the beginning women shared in the weekly rituals of the Christian converts. Female participation in Christian worship had been taken

[1]The principal churches of smaller size are the Mormons and Seventh Day Adventists, both of which began Pacific missions in the nineteenth century and spread to many islands. Others include: the Assemblies of God, which began work in the Pacific in 1926; Jehovah's Witnesses who came in 1939; and the Baptists, the Nazarenes, and several nondenominational evangelical missions that entered the New Guinea Highlands after World War II. For discussion of the work and policies of twentieth-century Pacific missions, see Forman 1978.

for granted in other parts of the world, yet it could not be assumed in Oceania. Pacific Island women, for the most part, had been excluded from the religious rituals of their communities prior to the advent of Christianity. Tahitian women, except those who were rulers, were not allowed to enter the *marae* 'sacred enclosures', where rituals took place.[2] The same was true of Hawaiian women, except in periods of national mourning when certain social restrictions were suspended and elite women were permitted in holy places (Ito 1980:23–25). The four sacred maids of Pukapuka in the Cook Islands entered the sacred enclosures, but only after initiation rites had taken them from the female domain to a sacred status in the male domain, and on the understanding that they would never fulfill the female role of marrying and bearing children (Hecht 1977:195–199). In the western Pacific, Melanesian women were commonly excluded from religious rituals (Lawrence and Meggitt 1965:15). The men of the community conducted rituals on behalf of the whole population, including the women, but women were not allowed to be present (see M. Strathern, chap. 2).

There were important exceptions. Tongan women held higher sacred status than their brothers, so that the highest and most sacred rank was held by the eldest sister of the ruler. Mystical power was inherited through the female line, rather than the male (Rogers 1977:177–178). Hawaiian women had household deities of their own to worship (Gething 1977:193). Samoan women, like Tongan women, held higher rank than their brothers. Samoan women also assumed chiefly titles, served as family priests, and held formal ritual offices (Goldman 1970:253; Schoeffel 1977:11). In some Melanesian societies, women performed religious rituals as, for example, among the Nagovisi of Bougainville in the Solomons (Nash, chap. 6).

These exceptions do not alter the general picture of female exclusion. In most Oceanic societies, women were not normally accepted as participants in religious ritual. Hence, the presence of women in Christian services marked a significant change for most island women. It must be recognized, however, that Christian ritual was not equivalent to the rituals of island societies. Christian ritual, which made no claims to the control of supernatural powers as did indigenous rituals, was a tamer affair of praise, thanksgiving, and

[2]Williamson (1937:132) notes that Tahitian women were required to attend certain ceremonies, but these were exceptions to the general rule of exclusion. Female exorcists and healers, because of being spirit-possessed, were another exception and, according to Henry (1928:145), had their own *marae* 'sacred enclosures' where they dedicated their herbs and recited their charms. Henry (1928:143) also says that women were allowed to make offerings at the back of the family *marae*. But, in general, *marae* were closed to women, whose presence was disallowed, even during the construction of the enclosure (Henry 1928:143; London Missionary Society 1966:329). One advantage of this, as far as the women were concerned, was that they were not normally acceptable as victims of the sacrifices made to the gods (Henry 1928:228; Williamson 1937:123). I am indebted to Talitha Arnold for these references.

ritualistic sharing in freely given divine gifts. But in these more limited areas of operation, it did provide for female attendance.

Island women did not always relish these new opportunities. In the Solomons, there was embarrassment and reluctance on the part of women and only grudging acceptance among the men. When Catholics began work at Kieta in Bougainville, the priest had to use his influence with the local chief to permit women to attend church services. Even so, women had to sit at a distance (de Bigault 1947:97). During the early years of this century, Anglican services in the Solomons were commonly attended by large numbers of men, who collected on one side of the church, and by four or five women, who stood during the service on the other side "with their faces turned towards the wall, from shame at being in a house with men" (Hilliard 1966:143). During the first decade of Methodist work in the Solomons, churches maintained a *tabu* 'prohibition' against the presence of married women at services. In 1913 the first village removed this prohibition, and others rapidly followed suit (Luxton 1955:79).

Limitations were placed on female participation, though their presence was allowed. Until the early twentieth century, women could not sing in church choirs, even in the longer established churches of Fiji and Samoa. However, one or two Samoan women were used in the choir to "set off the male voices" (Hough 1931:147; McHugh 1965:55–56; Schultze 1910). Tongan women, when they prayed aloud in church, always did so before any man. The men then followed in order of ascending rank, indicating the inferior place of women in the church. In the Lutheran churches of New Guinea, women were not permitted to pray aloud in church until the 1960s (I. Bergmann 1969:9).

Religious participation other than in worship developed slowly for island women, with the assistance of missionary wives. As theological schools were created to train pastors for the Pacific churches, wives of missionaries provided special training to the wives of future teachers and pastors. This work was started in Tahiti from the early years of the LMS mission and was taken up in other island groups as fast as seminaries could be established. These schools, then, may be seen as the first centers for women's work in the church, and the dates of their establishment reflect the beginnings of female leadership. They appeared, after Tahiti, in Rarotonga 1839, Samoa 1844, Tonga 1849, Fiji 1857, Lifu 1862, Norfolk Island (for the Solomons) 1867, New Britain 1878, Papua 1894, the New Hebrides 1895, and Kiribati 1900 (Forman 1969:151–152; Marchand 1911:148; Randell 1975:120; Turner 1917:162–163).

The training offered to island wives in these schools was simple. Bible study, domestic arts, child care, and methods for leading women's church meetings were usually all that was provided. A female missionary commented

regretfully on the fact that, with this training, the pastors' wives could improve home life, but they could not spread any wider "new enlightment" (E. A. Downs 1948:2–3). Greater enlightment was achieved, however, through the creation of special girls' schools. Founded and operated by single female missionaries, girls' schools, discussed later in this chapter, offered new opportunities for women of the island churches.

Female Missionaries

Single women arrived in small numbers in Oceania shortly after the pioneer period of mission endeavors. The first Catholic bishop in Tahiti secured the services of the Sisters of Cluny, who had originally come in 1844 as nurses for French soldiers in the military hospital rather than as missionaries. The sisters started teaching the French language, and in 1857 they began a school for Tahitians (*Centenaire* 1966:19; Lesourd 1931:137; O'Reilly 1969:6). The first single female missionary to arrive in the Pacific was Françoise Perroton, a middle-aged French Catholic of independent character, who came to Wallis Island in 1845. Thirteen years later, members of a French religious order arrived to help her, and by 1864 two of these nuns had moved on to Samoa to begin the first mission work by unmarried women in that archipelago (Darnand 1934:166; *Missions des Îles* 1964 [April]:58–59).[3]

 These early arrivals were exceptional. It was not until the late nineteenth century that women started mission work in significant numbers, which was as true of Oceania as it was elsewhere. Foreign missions emerged during this period as one of the few fields in which women could take positions of leadership (Beaver 1968; Montgomery 1911). In 1882, the first Catholic women arrived in Fiji, and in 1891 the first Protestants in Samoa (Blanc 1926, 2:67; cf. Goodall 1954:359, who gives a slightly different date for Samoa; Lovett 1899, 1:395). In 1891, the Australian Methodist Church decided to send single women; thus, missions in Fiji, Tonga, Samoa, Papua, New Britain, and the western Solomons received female workers shortly thereafter. At first this was seen as a rash experiment, but soon these areas were clamoring for women, particularly for educational work (Hilliard 1966:292; *Missionary Review* 1917 [July]:1).[4] Greater female participation oc-

[3]The *Missions des Îles* ([April] 1964:58–59) reference gives her name as Marie-Francoise Perroton. Single women in Tahiti opened two Protestant schools in 1868 and 1870, but they seem to have been already living in the island, rather than women sent out for mission work (*Centenaire* 1966:10).

[4]Citations from the *Catholic Mission New Britain, Centenaire, Fiji Times, Missionary Review of the Methodist Church of Australasia, Pacific Islands Monthly, PCC News, Mission des Îles, Melanesian Messenger, Annales des Sacrés-Coeurs, Vie Protestante, Souvenir,* and *Word in the World* refer to news items, editorials, and letters; hence, they carry no author or article names. The issue of *PCC*

curred during the early twentieth century, the most notable event being creation of a new mission by a woman. The South Sea Evangelical Mission, one of the major religious bodies of the Pacific, was established in 1904 by Florence S. H. Young, a buoyant, indefatigable Australian who dominated her mission in the Solomon Islands for thirty-six years (F. S. H. Young 1925; see also Boutilier, chap. 9).[5]

The work of female missionaries was primarily in women's education. Prior to their arrival, island girls received elementary education in village schools started by the missions. Female missionaries established schools for girls at a more advanced level, and these became important institutions in island societies. Outstanding educational centers include the Collège Javouley of the Sisters of Cluny in Tahiti, the Marist sisters and the LMS schools in Western Samoa, and the Methodist Queen Salote School in Tonga. Girls' schools were established later in the western Pacific, as single women arrived later. The Anglicans in the Solomons, for instance, did not have boarding schools for girls until the mid-1930s, while the Lutherans in New Guinea waited until after World War II to start these schools because their congregations resisted the idea of letting girls live away from home (Inselmann 1948:20; Pilhofer 1961–1963, 2:59–60; Wilson 1936:41–50).

The impact of these schools and of the single female missionaries on the place of women in the church was more indirect than direct. Island women did not immediately acquire a larger voice or greater responsibilities in the churches. Island women, however, were educated to greater capacities and new opportunities. Moreover, girls who attended the Protestant boarding schools were sought after as wives for aspiring pastors and teachers.

Female Leaders

Pastors' wives were expected to provide leadership for women of the church. In the Protestant churches they were counterparts to the pastors, serving the women's side of the congregation. The wives of pastors were expected to organize women's meetings for Bible study, prayer, and hymns. Sometimes they gave instruction in child care, hygiene, and handicrafts. The important responsibilities of pastors' wives were most noticeable in Tahiti, the Cook Islands, Samoa, Kiribati, Tuvalu, the Loyalty Islands, and the south coast

News refered to as of March 1979, it should be explained, carries no month in the actual publication; March is inserted as an approximation of its date of issue.

[5]Missions in the Solomon Islands received their first Catholic nuns in 1901, their first single Anglican women in 1906, and the first single Methodist women in 1907. The first nuns arrived in the Caroline Islands in 1906. The London Missionary Society in Papua did not have any single female workers until 1921 (Goodall 1954:436; Hilliard 1966:293; H. M. Laracy 1969:420; Wilson 1936:41–50).

of Papua, areas where the LMS started churches. Most of these were also
islands where the importance of women in Polynesian social institutions
prevailed. In the case of Papua, Kiribati, and the Loyalties, which were not
Polynesian, organizational patterns for the churches were the result of the
earlier experiences of the LMS in Polynesia and of the Polynesian workers,
who played major roles in starting their churches. In Samoa the LMS also
had significant influence on the Catholic Church, which appointed married
catechists whose wives followed the model of LMS pastors' wives.

Perhaps the most exalted position for pastors' wives occurred in Tuvalu
and in southern Kiribati, where Samoan Island missionaries began churches
and continued to lead them as their pastors until the middle of this century.
The Polynesian-LMS pattern of importance for the pastor's wife was elabo-
rated by the wives of these men as the couples moved from what appeared
to them as the central Samoan culture to less advanced, peripheral societies.
The Samoan wives would lead the women's meetings, but they also received
many services from the church women. Their babies were nursed, their
gardens tended, and their food cooked by women of the congregation. Living
as "queens" in finer houses than the local elites, these women were waited
on hand and foot, so they could sit and take their ease (David 1899:27).

The experiences of these women, however, should not be considered
typical of pastors' wives who went abroad as island missionaries in the ser-
vice of their churches. The lives of these women were usually hard and
demanding. The first to go abroad were the wives of Tahitian and Raiatean
teachers, who accompanied their husbands to the Cook, Austral, and Samoan
Islands. Women in the initial contingent who reached Rarotonga in 1823 had
to fight off, with tears, words, and blows, an attempted abduction during
their first night by the same chiefs who had promised their husbands protec-
tion for them (Beaglehole 1957:19–20). This experience foreshadowed many
difficulties to come.

The great period for indigenous missionary wives was the last quarter
of the nineteenth and first quarter of the twentieth centuries. In those years,
close to one thousand men, many with wives, left Samoa, Fiji, Tonga, the
Cook Islands, and the Loyalty Islands. Working principally in New Guinea
and the Solomons, they started schools and churches in new areas. Their
wives shared fully in the hard work involved. In places where women had
little voice in society, missionary wives showed new possibilities. They taught
new arts and craft production brought with them from their homelands; they
introduced new crops and helped improve local nutrition; they taught new
songs and games, which became popular, and new styles of music that were
established in the church life of their adopted lands. They provided religious
instruction to women while their husbands taught the men. The husbands
of these strong women were usually called "teachers," although they, like

their wives, were missionaries, just as much as those who came from Europe or Australia (Forman 1970).

Many of these missionary wives died young because of inadequate housing, poor food, or malaria, which was unknown in their homelands. Those who returned to their homes in Samoa, Fiji, or Tonga were treated as heroines by the women of their churches and spoke about their work and adventures. These endeavors advanced the importance of women in the churches and opened new vistas on what women did and could do.

Pastors' and missionaries' wives were not the only women who developed significant roles in the church. The wives of deacons, men of great dignity in the LMS Churches, acted as female counterparts to their husbands. Deacons, with the pastors, administered church organizations (e.g., Tiffany 1978c:437). Deacons' wives often shared with the pastor's wife responsibility for conducting meetings of female members. They also made sure that the pastor's house was suitably appointed for entertaining village guests. This was true in the Society and Cook Islands as well as Samoa. In the case of Samoa, it should be noted that in pre-Christian society there had been similar structuring of the women's side of the village in correspondence with the men's side, but in those days it was the sisters, not the wives, of important men who assumed leadership (Schoeffel 1977:4–6). Giving importance to wives was a mission-induced change that reduced, rather than enhanced, the roles of Samoan women. The status of Samoan women, rather than being inherent in their birth, was subsequently derived from their husbands' status.

Unlike their LMS counterparts, women in the Methodist churches of the Pacific took offices in the church that were theirs by right and not derived from their husbands. The Methodist pastor's wife seemed to have less prestige by comparison, and there was no office of deacon. However, the Methodist institution of the class meeting lent itself well to female leadership. From its early years in England, Methodism convened its members weekly in small groups to pray, study the Bible, and discuss what God had done for them during the week. This institution was transplanted to the Pacific, and by the early 1900s women were accepted as class leaders. This occurred in the older churches of Fiji, Tonga, and Samoa and in the newer churches of New Britain.

Methodist organizations in Fiji and Tonga also introduced indigenous positions for recognizing female leaders. In Fiji these women were the *Duase ni Siga* 'Senior Members', appointed by lay leaders of the congregation. 'Senior Members' arranged church festivals and functions, provided food, and danced. They alone were allowed to sing psalms and chant the catechism before the opening of Sunday services.

Tongan Methodism had a corresponding rank called the *Akonaki* 'those who can teach.' *Akonaki* 'teachers' did not bear any particular responsibility; they were simply honored and recognized by the red scarf they wore. These

ranks in Fiji and Tonga, and the special rank given to deacons' wives in other Polynesian societies, were unknown elsewhere in the world. They were indigenous creations of Pacific churches, responding to local values and needs of island societies. Fiji and Tonga had ranked societies with deference paid to those of higher status. Considerations of rank, combined with the level of respect enjoyed by women in Polynesia, may explain why honorific positions were created in the churches. In the islands farther to the west, with their more egalitarian Melanesian traditions and with their more limited place for women, no locally created positions of these kinds appeared.

Women's Organizations

Women carved out their places in the churches through their organizations as well as their offices. In traditional island societies, women worked and socialized together, so women's groups were not unknown to them. However, church groups tended to be more formally organized than traditional ones. All-female groups started by the wives of European missionaries were the first local organizations for church women. For example, Vanuatu, which has not figured in our examination of church offices, had these missionary-led groups from the early years. The groups led by the pastors' wives were the next form of organization and developed early, as I have shown, in the eastern and central Pacific Islands and the south coast of Papua. A manual for the meetings and services of Protestant women led by pastors' wives was published in Kiribati as early as 1896.

Women's organizations developed later in the western Pacific Islands. It was not until the 1930s that local women's groups led by missionary wives began among the Anglicans of the Solomons and Papua and among the Lutherans of New Guinea Territory (Diocese of New Guinea 1935:5; Hilliard 1966:532–533; Strong 1947:144).

Out of local women's groups came national women's organizations in the churches. These marked a great advance, since national women's organizations paralleled and influenced the national church structures. The first women's national organization was, not surprisingly, in Samoa. Immediately after the General Assembly of the LMS Church was established in 1875, there developed a general assembly for women, held annually at the same time and place as the church's assembly, who were primarily the wives of pastors and deacons. The wives of Elder Pastors, men who were the principal administrators of the church, were the leaders of this assembly. Among their actions the women's assemblies annually appointed a committee to inspect pastors' houses to ensure that they were properly maintained and equipped (Samoan Church 1958:24; Tiffany 1978c:442). A national women's assembly

was also organized in Tuvalu. Doubtless this resulted from the fact that LMS pastors in Tuvalu were Samoans. Other churches founded by the LMS but lacking as much Samoan participation, such as those of Kiribati, the Society Islands, and the Cook Islands, had no comparable national women's assemblies.[6]

The largest women's organization outside of Samoa was founded considerably later in Fiji. In 1924, the wife of a missionary, Mrs. Ronald Derrick, began a local women's organization at the main Methodist educational center of Davuilevu. Though it was not strictly a church group (being devoted to home economics and child care), it spread through church connections and was quickly established throughout the archipelago. It became entirely indigenous in its leadership when Mrs. Derrick retired after twenty years as president, and it also changed its name at that time from the Qele ni Ruve to the Soqosoqo Vakamarama (Baro 1975:34–35). As a national organization, it has moved beyond home economics to a concern for public affairs; it has become quite influential, though adopting a fairly conservative stance.[7] A second national organization, for more strictly Methodist church purposes, was started in 1949 by another missionary's wife, Mrs. Stanley Cowled. This group also spread throughout Fiji under largely indigenous leadership (*Souvenir* 1964:49). As a result of these organizations, the women of Fiji have emerged as influential leaders in the Pacific.

In the western islands, where local women's groups came later, national organizations for church women did not appear until after World War II; however, these apparently had less indigenous participation than those of Samoa and Fiji. The Presbyterian Women's Missionary Union was launched in Vanuatu in 1957 with regular national meetings. Its name and structure were copied directly from the Presbyterian women's organization in New Zealand. The Anglicans of the Solomons and of Papua New Guinea also developed national meetings copied from foreign models. In fact, they were national branches of a worldwide Anglican women's organization known as the Mothers' Union. The Papuan section was not established until the late 1940s. Although there were beginnings in the 1930s, foreign leadership in the Solomons branch remained predominant as late as the 1960s. The national meetings of the Mothers' Union were made up of groups of local women, each accompanied by a foreign missionary (*Melanesian Messenger* December 1964:26; Tomlin 1957:131; Wilson 1936:47). Strong indigenization had not

[6]One eventually began in the Cook Islands, but not until 1979 (*PCC News* [March] 1979:3–5).

[7]For example, in 1965, when representatives of the Soqosoqo Vakamarama met with a delegation from Britain that was planning the constitution for independent Fiji, they advocated separate electorates for the racial groups and maintenance of all special Fijian rights. A group of YWCA representatives at the same time urged a single electorate and a gradual end to Fijian privileges (*Fiji Times* [April] 1965).

yet developed. Methodists in Papua New Guinea and the Solomons did not start their national meetings for women until 1952 and 1962, respectively. These groups subsequently merged with the Women's Fellowship of the LMS church after the Methodists and LMS united in 1968.

The United Church Women's Fellowship which resulted from this merger was politically more important and more indigenized than other churchwomen's groups of the western Pacific. Perhaps it had inherited some of the sense of women's importance and responsibility brought a century earlier by the Samoan and Rarotongan missionary wives who had started the first women's groups for the LMS in Papua. The United Church Women's Fellowship held national meetings triennially and took a lively interest in national affairs. In 1974 it organized a march on the House of Assembly in Port Moresby to protest the high cost of living. By that time, all its officers at every level were indigenous women. One recent study of Port Moresby showed that the United Church Women's Fellowship had a higher level of local leadership and participation than any other women's group in that town (Randell 1975:120–123).

The churches were not alone in organizing women. Pacific governments began to take an interest in organizing women's groups, creating alternative organizations that sometimes competed but usually cooperated with established church groups. The first of these began in Samoa in the early 1920s, when a government health officer, along with the wife of the American vice-consul, organized women's committees in the villages to work on child health. Samoan women's health committees merged with local women's church groups in villages where there was only one denomination or cooperated with those groups where there was more than one. Close relations between church and health groups have continued to the present. In many cases the pastors' wives have been the leaders for both groups. The government of Fiji started similar work shortly thereafter, but since no separate government-sponsored groups emerged, the work was presumably done in conjunction with the Methodist women's group, the Soqosoqo Vakamarama.

Other governments inaugurated women's programs and organizations during the 1950s and 1960s. These include the governments of Kiribati and Tuvalu, New Caledonia, Papua New Guinea, and the Solomons, Vanuatu, and Cook Islands. They were assisted by the South Pacific Commission (hereafter, SPC), established after the war as an intergovernmental organization for the Pacific Islands. The SPC became interested in women's groups

[8]Keesing (1945:221–222), Monoghan (1955:22–23), Schoeffel (1977:12), and Tiffany (1978c:442–443) variously state the beginning of government work in Samoa as 1921, 1924, and 1925. Keesing (1945) writes that the pastors' wives led the women's health committees, while Monoghan (1955) claims they were usually led by the wives of chiefs.

in 1953. Funds for its first women's interests officer, who traveled around
the islands, were provided by the United Church Women of America (South
Pacific Commission 1967). In most cases, government workers have helped
church organizations almost as much as their own groups and, as in the early
days in Samoa, there has been considerable overlap in membership between
the two bodies (Penelope Schoeffel 1979: personal communication).

Female Orders

Little has been said thus far about Roman Catholic women, whose organiza-
tions were smaller and less influential than Protestant ones. Local groups
were most noticeable in Wallis and Samoa, where the Children of Mary
provided for younger women and the Ladies of Saint Anne for older
women. These groups held devotional meetings in the local parishes but
lacked strong national organization or indigenous leadership such as the
Protestant women developed. Indeed, the outspoken leadership of Protestant
women was at times shocking to Catholic priests, who felt Saint Paul's
teachings about women keeping silent in the church were violated (Suárez
1921–1922:426–427).

Female participation in the Catholic church occurred mainly in the
religious orders, and island women gradually began to take their place in
them. All female Catholic missionaries had come to the Pacific as members
of religious orders, such as the Marist Sisters or Maryknoll Sisters, and they
watched eagerly for signs of the first vocations to the religious life in the
islands. It was not easy to develop an interest in this kind of life among
islanders who were not accustomed to such a highly regulated existence and
for most of whom celibacy had not been an ideal.

Missionary sisters who conducted boarding schools for island girls were
in the best position to influence young people, and it was almost invariably
from their work that indigenous orders began. Girls who had spent years
living with the sisters began to express a desire for emulating the kind of life
they had observed. Requests for admission to an order would be repeated

[9]In the one island of Pukapuka, celibacy had indeed been an ideal and a requirement for
female participation in worship of the gods. The four *mayakitanga* 'sacred maids' of the island
remained virgins all their lives (Hecht 1977:195–199). The 'sacred maid' provides a close parallel
to the celibacy required of Catholic nuns, and it might have supported development of a strong
female order if there had been any Catholics on Pukapuka. Unfortunately, in terms of this
conjecture, Pukapuka never had any church but the LMS. The other area where celibacy for
women might be seen as a traditional ideal was Samoa, where certain chiefly titles had rights
to a *tāupou* 'ceremonial maiden'. However, a *tāupou* was required to maintain her virginity only
until marriage. Furthermore, as far as can be discerned from Keesing's (1937) description of her
role, she does not appear to have carried out any religious functions.

until the bishop felt satisfied that there was reason to hope for a continuing group. Bishops then established native orders or admitted island girls by special arrangements to orders of missionary sisters. In the 1870s girls who attended the sisters' school in Apia, Samoa, were brought into the same order as the missionaries, although the rules for their observance were modified. Shortly thereafter a separate, subsidiary order, Helpers of the Sisters, was established in Fiji. Other islands followed suit: in the late nineteenth century, New Caledonia, Wallis, and Tonga; between 1910 and 1920, Vanuatu, New Britain, and Papua; during the 1930s, the Caroline and Solomon Islands; and soon after World War II, Kiribati and New Guinea Territory. The only island groups lacking this kind of development were, until very recently, French Polynesia and the Cook Islands, in both of which the Catholic mission was notoriously slow about fostering indigenous leadership of all types.[10]

The orders that were thus established—or the indigenous parts of existing orders—were small prior to World War II, usually ranging between ten and twenty-five members.[11] By contrast, two territories, New Caledonia and Fiji, had flourishing organizations with nearly fifty and one hundred members, respectively. An early start in these two areas may explain the greater size of their orders. Not only were most orders small, but indigenous sisters were also given menial work. Washing, cooking, gardening, and care of church buildings were their assignments under the supervision of European superiors.

In the years following World War II, however, the size and significance of these groups changed. Indigenous sisters in war-devastated areas revealed

[10]Dates for the first island nuns are: New Caledonia, 1875 (P. Martin 1960:19); Samoa, 1877 (Darnand [1934:174] gives a quotation of 1877, calling the Samoans the first native sisters of the Pacific, which throws some doubt on Martin's date for New Caledonia. Informants on New Caledonia report that their native order began about 1920 or 1925, and thus it may be that the 1875 date refers to French women domiciled in New Caledonia who became sisters); Wallis, 1887 (Landes 1931:612); Fiji, 1890 (Streit and Dindinger 1955:694); New Hebrides, 1910 (Douceré 1934:319); New Britain, 1912 (*Catholic Mission New Britain* 1962:14); Papua, 1918 (Goyau 1938:128); southern Solomons, 1932 (H. M. Laracy 1969:251); Carolines 1935, for one part-Japanese islander, and 1949 for the first indigenous group (Sister Patricia Cody 1973: personal communication); northern New Guinea, 1952 for the Wewak area and 1953 for the Madang area (*Word in the World* 1969:56); Tahiti 1964 (*Pacific Islands Monthly* 35 [March] 1964:117). According to the *Annales des Sacrés-Coeurs* ([June] 1932:457), there had already been sisters from Tahiti, though there is no claim they were Tahitians. Training for the indigenous sisterhood began in 1940 in Kiribati, but the first seven members took the habit in 1950. Most of these nuns, and all later recruits, eventually entered the Order of the Sacred Heart rather than staying in the indigenous order (Bishop Pierre Guichet 1973: personal communication).

[11]Dubois (1928:405–406) reports thirty-four island sisters in the Vicariate of Central Oceania, which means that nearly all of them would have been in Wallis-Futuna, since Tonga, the other part of the Vicariate, had no large Catholic population. Dubois's figures may be exaggerated, since Landes (1931:612), writing at a later date, claims there had been only twenty-four professions in Wallis up to that time, while Courtais and Bigault (1936:68) report only twenty-six indigenous sisters in Wallis and very few in Tonga. Though the smaller figures may be more correct, it is evident that for the size of its population Wallis had a large female order.

faithfulness and strength that led to greater recognition of their abilities. This was most evident in embattled New Britain, where indigenous sisters single-handedly maintained their communal religious life outside the concentration camp. They smuggled food to the interned missionaries and kept them informed about church life outside. They were thrown out of their house by the Japanese authorities, but held together, living for a time in temporary shelters in their gardens. After the war the missionaries realized that greater training and responsibility should be given to women. Throughout Oceania new avenues of education and work were opened to women, chiefly in teaching and nursing. Older sisters, who were still the majority, continued in their menial occupations, but the new recruits advanced rapidly. When the University of Papua and New Guinea opened its doors in 1966, three students out of the fifty-eight in its first class were members of the Papuan women's order.

Indigenous orders also experienced substantial growth, and they began to emerge from under European leadership. Those of New Britain and Papua each rose to over 100 members, Fiji to over 150. Smaller groups doubled their numbers. The first order in the Pacific to elect an indigenous mother superior was the Papuan women's order, the Handmaids of Our Lord, in 1966.[12] Other orders with expatriate leaders at their headquarters established new houses where there were no Europeans. Permanent vows for indigenous sisters gradually replaced annual promises made to the bishop. The Dioceses of Samoa, Tonga, and Fiji adopted a common order, the Sisters of Our Lady of Nazareth, to work in these three regions, and in 1965 made that order fully autonomous (Kent 1966:27–28).

With these developments, Pacific Island women participated significantly in the life of the Catholic church. Indigenous women, more so than island men, moved into the educational and medical services of the church. The orders of indigenous brothers, who provided similar kinds of services, never took hold in Oceania. Part of the reason may be that island men who wanted to devote their lives to the church had the opportunity of becoming priests rather than brothers. Hence, while women became sisters, men bypassed what seemed like the more mundane work of brothers to become priests. Yet, oddly enough, there were far more sisters than there were indigenous priests. This is harder to explain. The difference may reflect the fact that the qualifications demanded of priests were higher than those required of sisters. Priests had to pass one of the most rigorous educational programs in

[12]The rapid advance of the Papuan order to indigenous leadership was due to the work of two French women. Marie Thérèse Noblet began the order, working from 1921 to her death in 1930, and Solange Bazin de Jessey continued for ten years until her death at age thirty-six. There is a large literature on both these women. For their biographies, see Pineau 1934 and Villeroy de Galhau 1967.

the Pacific Islands, while some sisters had little education. The difference in numbers is also explained in part by the wider range of opportunities available to young men for village leadership and for outside work and travel. A restricted and subservient position in village life was all that was open to women in many islands. Therefore, women found church vocations more attractive than did men. This explanation is given credence by the fact that women's orders grew more rapidly in Melanesia, where traditional cultures tended to be more restrictive for women. The largest female orders were in Papua, New Britain, New Caledonia, and Fiji, while the Polynesian Islands had substantially smaller orders.[13]

The fact that women were more numerous than men in the service of the Catholic church does not mean that women assumed greater responsibilities. The few indigenous priests were elevated to the episcopacy as quickly as possible. Thus, island men have determined the directions and policies of the church, while women have continued to play supportive and secondary roles. After the reforms of the second Vatican Council, women joined with laymen in taking a more active part in the liturgy. They were allowed, along with men, to read the scripture and carry forward bread and wine for the Eucharist. Women now sit on school boards of Catholic schools in Papua New Guinea and participate in planning committees of local congregations. A few have been appointed as catechists, a position previously reserved for men. These women now teach catechism in school and lead morning and evening prayers in the village church (MacDonald 1975:105). Thus, many changes have occurred, and Catholic women may be catching up with their Protestant sisters in their influence on the church.

Church Offices

Recent years have brought Protestant women into expanded fields of work and more central decision-making positions. Younger, educated women are no longer content to remain in separate female organizations, important as these may have been (Randell 1975:129). Professionally educated pastors' wives are not satisfied with leading churchwomen's groups, especially since many functions of these groups, such as health care and craft work, are being assumed by government programs (Penelope Schoeffel 1979:personal com-

[13]Wallis Island, admittedly, is Polynesian, and in relation to its small population, has had a large women's order. However, this may be attributed to the fact that in Wallis, Catholic life was more all-encompassing than anywhere else. Mention should also be made of female orders in some Protestant churches. Methodists in the Solomons began an order of deaconesses in 1964, and the Fijian Methodists did the same in 1966. These orders primarily serve women and children.

munication). Tahitian pastors' wives, for example, have been given permission by the church to drop their congregational activities and to enter professions for which they are trained, such as nursing or teaching (A. Schneider 1976:152–153). In the governing of the churches, female deacons have been elected in limited numbers in Kiribati, Tahiti, the Cook Islands, and Samoa, among others. Female elders have been chosen to participate in the rule of congregations by the Presbyterians in Vanuatu and the Lutherans in New Guinea. Methodist women have been accepted as lay preachers, a considerably more influential position than that of class leader. Female class leaders had occasionally preached in earlier days, but only when a suitable man was unavailable. The first time this occurred in New Britain, the woman was required to dress like a man when preaching. The right to preach and lead worship has been won by some of the more active Papuan branches of the United Church Women's Fellowship, which take responsibility for one church service each month (Randell 1975:124).

For the first time women have also been elected to the central governing assemblies of some denominations. This occurred, for example, in the LMS-founded church of Samoa in 1956 and in the LMS-founded church of Papua in 1963 (Randell 1975:121; Samoan Church 1958:25). It also happened among the Methodists of the Solomons in 1953 (Williams 1972:264) and of Tonga in 1966 (George C. Harris 1967: personal communication). The Protestants of New Caledonia and the Loyalty Islands seated their first female delegates to their central governing body in 1966 (*Vie Protestante* [May 22] 1966). In 1978 the Church of Tuvalu finally agreed to the inclusion of women in its Church Assembly (*PCC News* 1979 [March]:3).

Some Pacific Island women have been ordained to the ministry, though this has proven to be the hardest position to open up. The first two ordinations of Pacific Island women were carried out in 1976 by the United Church of Papua New Guinea and the Solomon Islands, a new church formed in 1968 from the previously mentioned merger of the Methodist and LMS bodies. It is striking that Papua New Guinea, particularly the Papuan part of this nation, has often taken the lead in opening positions for women. Papua produced the first indigenous superior for a Roman Catholic religious order. It has also had one of the strongest women's organizations in the Pacific. It was the first to organize mass action and to take monthly responsibility for church services; now Papua is also the first to ordain women. The reasons for this leadership role are obscure. No doubt the contribution of the Polynesian missionary wives must be part of the explanation, although that hardly accounts for Papua's advancement ahead of the Polynesian islands themselves. Innovation in a newly united church may be a more likely explanation of the Protestant advance. Moreover, the fact that two successive female organizers of the local women's Catholic order dedicated their lives to developing

indigenous leadership may be the best explanation for the precedence there. Whatever the reasons, Papuan achievements have been notable.

Although Pacific Island women have been accepted for ordination, the local congregations are seldom prepared to accept them as pastors. The men who objected strenuously to women singing in the choirs, leading in prayer, or having better educational facilities, are not likely to support female ministers (I. Bergmann 1969:9; Deane 1921:10; McHugh 1965:55–56; *Melanesian Messenger* 1964 [August]:15–16). Women who presently receive theological training or ordination are not often expected to lead congregations but rather to work in specialized ministries such as Christian education and youth work, areas regarded in the West as women's work. The Central Protestant Theological College, located in Fiji and serving the major Protestant denominations, launched an ambitious program in 1978 for training women. Funded in part through the United Nations, the program is, however, designed primarily for pastors' wives and women in specialized ministries (*PCC News* [June–September] 1978:12).

Conclusion

The most recent changes that have brought women into the governing bodies of churches seem to be inspired more by external than by indigenous influences. These changes would hardly have been suggested by Pacific traditions. Traditionally, Melanesian women did not hold formal positions of leadership in religious institutions, and Polynesian women emphasized their hemisphere of activity complementing that of the men. Separate church organizations, created in the past for island women, fitted in with that kind of emphasis. More recent decisions to bring women into the governing bodies with men have fitted better with influences coming from the West. The decision made by the Cook Islands Christian Church to elect women as deacons was suggested by an English missionary. The idea had not occurred to the islanders because, as they said to the missionary, they already had female deacons, referring to the special rank and responsibility of deacons' wives in the women's half of the church.

It may appear anomalous that foreign attitudes should be so influential at a time when churches of the Pacific islands are moving toward increased autonomy from foreign control. Since World War II, all the major Pacific churches have replaced foreign missionaries in positions of authority with local leaders. Even the Catholics have replaced European bishops with indigenous ones as fast as the limited numbers of island priests would allow. However, church autonomy has not reduced foreign influences. There has, in fact, been greater foreign impact on island churches after the withdrawal

of foreign controls. Worldwide communications and travel are largely respon-
sible for this. In recent years the churches of Oceania have been drawn into
a broad range of global ecumenical relationships. In increasing numbers
visitors come from abroad. The World Council of Churches has sent a
specialist to raise women's awareness of their condition. Island women have
served on international committees where they communicate with men and
women from all continents. Experiences of this kind have led Pacific Islanders
to adopt attitudes and goals common to other parts of the world.

The increasing impact of the outside world has brought, of course, some
loss of those qualities that made the life of Pacific churchwomen unique. In
past years, women's church roles, though they owed much to foreign influ-
ence, often reflected a peculiarly Pacific style. Nowhere else in the world
did women's groups have the particular responsibilities that have been de-
scribed here. Nowhere else did pastors' wives and deacons' wives have such
clearly assigned, hierarchic teaching and leading roles, as they had in the
Pacific. Nowhere else were women given such prestigious ranks in the church
as was afforded to the *Duase ni Siga* 'Senior Members' and the *Akonaki*
'teachers'. Some of this distinctiveness remains. Recent developments, how-
ever, suggest little that is peculiar to the Pacific. As the islands have been
drawn into the currents of modern life, the unique features of island church
organizations have given way to more universal patterns.

The adoption of universal patterns is evident in the varying rates at
which denominations have opened positions of governance and ministry to
women. Churches that emphasize sacrament and hierarchy provide fewer
leadership roles to female members than do the other churches. This is a
universal pattern followed in Oceania. Pacific Congregationalists, with their
lack of emphasis on sacraments and concern for locally based governance,
and Methodists, who emphasize religious experience and nonhierarchical
structure, are the denominations most readily accessible to female leadership.
Conversely, Anglicans and Roman Catholics, both of whom see the church
more as a sacred body and govern their people in a more hierarchical manner,
have been the slowest to open leadership to women. Because these denomi-
nations are dealing with offices that have sacred powers, they hold back from
admitting women. It is more dubious, or even dangerous, to make changes
in the sacred than in the ordinary, secular matters. Likewise, ancient hierar-
chical structures, which are very important in these two churches, carry a
heavy weight of tradition and are, therefore, less accessible to women.

Presbyterians and Lutherans are not as sacramental or hierarchical as
the Anglicans and the Roman Catholics, but they are perhaps more so than
the Methodists and the Pacific Congregationalists. Presbyterians and Lu-
therans certainly place greater emphasis on traditional doctrine and procedure
than do the Congregationalists and Methodists. Hence, Presbyterians and

Lutherans fall somewhere in the middle, and it is probably also fair to say that they have also fallen in the middle in the extent to which women have been given authority. The slower pace of these two groups, as well as of the Anglicans, might at first sight be attributed to the fact that none of these denominations had missions or churches of any size in Polynesia, where changes in women's roles first appeared. But this is not an adequate explanation, because these denominations in Melanesia have also lagged behind the Congregationalists and Methodists.

Developments in the United States parallel those of the Pacific churches. In America women moved forward most rapidly in the Congregational and Methodist churches, most slowly in the Anglican and Roman Catholic, with the Presbyterians and Lutherans falling somewhere in between. The Congregationalists of America had nearly forty ordained women by 1900; the Methodists first ordained women in 1924. The Presbyterians, however, did not reach this decision until 1956, and the Lutherans not until 1970. The Anglicans (Episcopalians) have been last to accept women's ordination, coming to that agreement in 1976 after a bruising struggle. The Roman Catholics still refuse to take this step (Brereton and Klein 1979:302, 316, 319).

Thus it is evident that worldwide forces and global patterns are the principal agencies of change presently affecting women of the Pacific Island churches. In earlier years there were also foreign missionary women who represented an outside influence. However, it must not be forgotten that Pacific Island women have always been active themselves in helping bring about change. In previous generations, they put the distinctive stamp of their own societies on many of the new features they adopted. In recent years, island women are following cosmopolitan ways that are entirely of their own choosing and preference. The history of their innovations is obviously far from finished.

9

European Women in the Solomon Islands, 1900– 1942: Accommodation and Change on the Pacific Frontier

James A. Boutilier

This chapter is not about indigenous women in Oceania. Rather, it is about that small and forgotten community of European women who lived in the Solomon Islands prior to World War II. Theirs was a frontier experience on the fringes of the empire. They were members of an alien and imported culture living on suffrance in a world dominated by males and Melanesians. An analysis of their lives reveals that in many ways they fulfilled nineteenth- and twentieth-century expectations with respect to female roles. And yet there were important exceptions, exceptions that suggest that prevailing paradigms of womanhood were inapplicable to their experiences and must now be reconsidered.

Other authors in this volume (O'Brien, chap. 4; M. Strathern, chap. 2; and Tiffany, chap. 1) highlight the way in which anthropological studies reflect contemporary values and concerns. Moreover, they show the extent to which those studies have devalued women, depicting them as either marginal or invisible. History is guilty of these shortcomings as well. It too has

This chapter would not have been possible without the detailed and sympathetic assistance of the eight women whose experiences are described above. I owe them an enormous debt. I am also deeply indebted to those Solomons "old hands," listed in footnote 3, who corresponded repeatedly with me, and to Mr. Bruce Burne, the director of the Western Pacific Archives in Suva, Fiji, who gave so often and so freely of his expertise and his sage advice. And lastly, I owe the warmest of thanks to the editors of this volume, who brought to bear their great knowledge and editorial skill in the development and revision of this chapter.

a weakness for reflecting contemporary (and frequently fashionable) visions. It too has consigned women to obscurity; though it might be argued that this is less a question of sexual bias than a larger issue of ignoring all those—whether men or women—who were not wielders of power. While anthropology has been largely the work of males intrigued—some might say mesmerized—by the public power of males in microcosmic settings, history has been its macrocosmic counterpart. This chapter is a historical rather than an anthropological account. In it I seek to rescue the expatriate women of the Solomons from what M. Strathern (chap. 2) has called a status of "partial humanity."

The term *expatriate women* simplifies and disguises the complex nature of the female community in the Solomons. There were many different categories of European women present: transients; wives of planters, traders, missionaries, administrators, and commercial men; single female missionaries; and women on their own who acted in male roles. In many cases the status of European women was derived from their spouses' positions. In other cases it was dependent on such variables as the mission to which they belonged, their geographical location, and happenstance. The expatriate women's community was less homogeneous and more stratified than the social systems of indigenous females. What is more, European women were conferred, en masse, an elevated status by virtue of their presumed and enforced superiority on racial grounds. While they were seen as subject to their husbands' domination, the expatriate women were, in turn, able to act in dominant roles vis-à-vis the islanders.

European women who came to the Solomons found themselves in an isolated, imperial backwater. Expatriate society was ultraconservative in character. Cut off from metropolitan centers of change and subject to a degree to siege mentality, European residents sought psychological reassurance in maintaining traditional social patterns. Nor was this phenomenon unique to the Pacific. As Woodcock (1969:163) has pointed out, racial and class distinctions became more sharply defined within British communities in the Far East during the twentieth century, while routines accorded ever more closely "to those of the temporarily lost homeland." The same was true of India, where British social life was "twenty years behind the times" (C. Allen 1975:77).[1] As a consequence, Victorian values prevailed throughout much of the period—values characterized by pseudoscientific generalities and assumptions about the nature of women. Biological determinism, the accepted wisdom of the age, argued that women were childbearers, nurturers, and civ-

[1]There is a substantial body of comparative literature relating to the nature of European society in tropical dependencies that supports the principal points made in this chapter. The reader's attention is drawn to accounts by C. Allen (1975), Kiernan (1972), Woodcock (1969), and Wright (1980) listed in the references section of this volume.

ilizers. The indisputable procreative distinction between men and women was seen as a justification of a sexual division of labor whereby women were pictured as childraisers and guardians of purity. Indeed the Plunket Society in New Zealand went so far as to argue that girls who worked too hard in school would become "flat-chested and unfitted for maternity," while educating women in domesticity would give "an enormous benefit to . . . women, and . . . to the race" (Olssen ca. 1978:4). Frontier conditions, however, challenged these naive assumptions about women as monuments to motherhood and morality.

There are some interesting parallels between the male/female, white/ black, and civilized/savage cleavages. The unquestioned exercise of imperium by white males of a reputedly superior civilization over black races of "savage" character mirrored the "natural" dominion that Victorian males exercised over females. Males occupied public domains as colonial administrators and heads of households. Their vision was patrician. The burden of responsibility merited privileges of power. Women and colonial subjects occupied restricted "colonized" domains, lacking in public power. To be a male was to be active, creative, and of high status. To be white was, in the parlance of the day, "to be right."[2] To be female was to be passive and of low status, conditions felt to pertain to the nonwhite subjects of British imperialism. Thus, while set apart from (and above) the Solomon Islanders by an almost unbridgeable gulf of culture and habit, European women shared, no doubt quite unknowingly, common ground with them.

Sources, Methods, and Questions

This chapter is based on interviews and correspondence with eight European women who lived in the Solomons prior to the Second World War: Christine Woods, a nursing sister and hospital matron interviewed in Bexley Heath, Kent; Gladys Deck, a member of the South Sea Evangelical Mission (SSEM), of Toronto, Ontario; Joan Deck, Gladys Deck's sister-in-law in the SSEM of Sydney, Australia; Georgina Seton, author and wife of an Australian plantation manager of Brisbane, Australia; Frances Blake, wife of an English treasury clerk, of Walburton, Sussex; Eleanor Hetherington, wife of a Canadian doctor, of Brantford, Ontario; Vera Clift, wife of an Australian plantation owner-operator, of Toowoomba, Australia; and Mrs. F. Noel Ashley, wife of a resident commissioner, of Guildford, Surrey.

[2]"White supremacy was accepted as the fundamental basis of the emerging society [in Papua New Guinea]" (quoted in Jinks, Biskup, and Nelson 1973:286). Bolton (1970:89) refers to the "ugly contempt for non-white races" that was part of the north Queensland scene at the turn of the century. It was this attitude that many of the white settlers carried with them to Melanesia.

The interviews (tape recorded or stenographic) were conducted during the 1970s in connection with the writing of a history of the Solomons. They were not undertaken specifically for this chapter, although a large portion of the correspondence that followed was developed for use here. Unfortunately, it was not possible to reestablish contact with all of my informants or to eliminate all of the lacunae in their recollections.

The sample is small. Consequently, while the individuals interviewed cover the plantation, administration, and mission spectrum, they may not be entirely representative, though generally I feel that they are a good sampling. Certainly, there is need for more research on these early Pacific frontierswomen, and it is a matter of great urgency. All of the women interviewed, with two exceptions (Woods and Seton), were in their eighties, and the number of survivors from this tiny prewar sorority is dwindling rapidly. Indeed, it will soon become impossible to reconstruct that era of expatriate society in the Solomons using oral history techniques. The matter is further complicated by the relative paucity of primary documentation relating to expatriate women in the Solomons.

What is needed is a concerted effort to locate the surviving members of that sorority, to determine their class and social backgrounds, to examine the ways in which their presence altered expatriate society and the relationship between that society and indigenous societies, to analyze the way in which early twentieth-century views about femininity, domesticity, and women's "place" were altered by the frontier experience, and to establish the degree to which gender distinctions and class considerations became confounded in that setting.

Background and Class

Because the number of women interviewed was small, it is difficult to draw firm conclusions about their backgrounds. Moreover, my biographical data are frustratingly incomplete. Vera Clift was born in Brisbane, Australia, in 1892, the daughter of Muriel Vera Thorn, an English woman, and John McElhone Clift, a member of the New South Wales landed gentry. Gladys Deck was born in New Zealand about 1890, the daughter of Henry O'Brien Deck, a doctor, and Ethel Watts, the part-Welsh daughter of William Calley Watts, the Melbourne city architect. Frances Blake was born on 13 May 1898 in Yorkshire. Her father, Perceval Muschamp, was a mining engineer in charge of five coal mines. Her mother, Alice Bayne Foulds, spent her life bringing up five daughters and three sons. Frances went to school in Mansfield, Nottinghamshire, studied at the University of Nottingham, qualified as a pharmacist, served in an army field hospital during World War I,

and met her future husband, an Australian army major named William Vere Jardine Blake, there. They married and moved to the Solomons in 1921, the same year that Vera Clift was leaving Queensland as a new bride bound for Guadalcanal.

Georgina Seton was born on 30 August 1900 at Tenterfield Station in western New South Wales. Her father, Donald McLeod Cameron, was the manager of Welltown Station forty miles west of Goondiwindi near the New South Wales border. His father had been a Presbyterian minister, "the first in the north," while his mother, a McLeod from Skye, had seen the bushranger who "bailed up" (i.e., robbed) the mail coach bearing her husband's meager stipend.

Georgina was brought up at Welltown, under the watchful eye of her mother, Kate Walker Cameron, and sent to boarding school when she was fifteen. Three years later she enrolled in the Women's College in Sydney to study medicine but, since places in medical school in 1918 were being awarded to demobilized servicemen, she decided to go home. During the early twenties, she worked for a doctor in Sydney and began writing books and short stories. She had no intention of marrying. Marriage, she recalled, seemed "dull" and she wanted to go to England instead. But when Carden Wyndham Seton appeared on the scene, all that changed, and they were married in May 1929, three weeks before setting sail for the islands.

Of the other women I know very little. Eleanor Hetherington was born in Canada about 1890 and went to the Solomons in 1926 with her husband, Dr. Harry Brown Hetherington. Christine Woods arrived in the archipelago in the mid-1930s and did not leave (with the exception of enforced absences during World War II) until forty years later in 1975.

The majority of the women interviewed were middle-class—the daughters of landed gentry, doctors, engineers, and sheep station managers. The determination of class, however, was not without its difficulties, as my informants had conflicting opinions about this matter. Frances Blake, for example, saw herself as middle-class and maintained that all of the expatriate women that she knew in the Solomons were of the same class. By contrast, Vera Clift considered herself upper-class because her husband was the owner-operator of a plantation, as distinct from an employee like Carden Seton. Moreover, her upper-class status seemed confirmed (in her eyes) by the fact that she and her husband were invited to important social functions by the senior civil servants in the Solomon Islands' administration. These men, even though she described them as "the dregs from Fiji," constituted (with their wives) the elite of expatriate society. Beneath them she ranked (in descending order of social standing) the company managers of the big coconut plantations, the owner-operators of smaller estates, the hired managers of plantations, and (at the bottom) the Solomon Islanders.

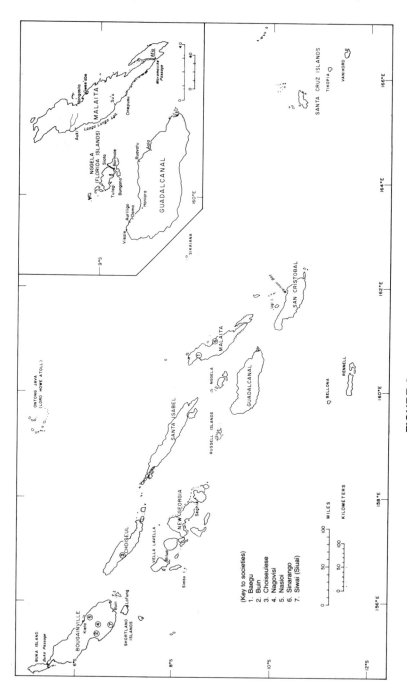

FIGURE 6: The Solomon Islands

Clift and Seton expressed a concern, common in Britain's tropical dependencies, about the influx of unfit whites who lowered the tone and threatened to undermine white prestige. "The upper middle-class," the latter noted, "was represented in the Solomons by a good many of birth and breeding from England and Australia with titled relatives and good education" (Georgina Seton, 5 August 1980: personal communication).[3] But at least half the expatriate women were, in her opinion, "very unsuitable" (Georgina Seton, 5 August 1980: personal communication), the sort who, in Vera Clift's words, were "so ordinary" and "played poker and didn't pay their debts" (Vera Clift, 24 October 1980: personal communication).

"Poor types should never [have been] sent amongst natives," Georgina Seton wrote, because the islanders were "very conscious of the difference between ladies and something-nothings [low-class white women]" (Georgina Seton, 5 August 1980: personal communication). What counted, Seton maintained, was character. "The right sort of woman of whatever status got the reputation she deserved. In the islands, class distinctions disappeared and recognition of character took over" (Georgina Seton, 5 August 1980: personal communication).

The Setting

What sort of world did European women enter when they stepped ashore in the Solomons? The islands—mountainous, jungle-clad, reef-girt, and pestiferous—had been declared a British protectorate in 1893. Three years later the first resident commissioner, Charles Woodford, established a colonial capital at Tulagi.[4] The European population at the time totaled fifty males. Four of them were members of the Melanesian Mission of the Church of England, while the remainder were planters and traders scattered throughout the archipelago.

Twenty-three years later, in 1919, the number of expatriates had risen to 349, of whom 95 were women. It is difficult, in the absence of more complete evidence, to classify their activities with precision, but an analysis

[3] All of the personal communications cited in this chapter, other than from the eight female informants described in the "Sources, Methods, and Questions" section, are from: Mrs. Ken Calvert, wife of a Presbyterian missionary at White Sands, Tanna, New Hebrides; Mr. Tom Elkington, a trader, labor recruiter, and boat-builder for over fifty years in the Solomon Islands; the Reverand Richard Fallowes, a Church of England clergyman who served as a member of the Melanesian Mission in the Solomons prior to World War II; Mr. Robin Low, a district officer for more than twenty years in the Solomons after World War II; and Mr. Dougal Malcolm, who served in the British administration in Tanganyika, Fiji, and the Solomons.

[4] For details of the annexation, see Boutilier 1978:160.

of *Stewart's Handbook of the Pacific Islands* (P. S. Allen 1919:256–259) suggests
the following categories, based primarily upon their husbands' employ: mis-
sion 32, planter 14, administration 2, trader 2, commercial 2, plantation
manager 39, and seaman and miscellaneous 4.

One obvious feature of the 1919 (and 1931 census) figures is the disparity
between males and females, a disparity common to frontier conditions. Savage
(1976), for example, discovered that almost two-thirds of the 900,000 people
who moved into western Canada between 1900 and 1911 (the period of
greatest immigration) were men. Similarly, North Queensland was a man's
world, and the 1876 census revealed that there were "over twice as many
men as women" in that part of Australia (Bolton 1970:174).

Dwarfing the European community was a Melanesian population of
roughly 100,000. The Solomon Islanders were swidden agriculturalists who
lived in small coastal villages and upcountry hamlets. Warfare was endemic,
although it was usually on the scale of skirmishing. Head-hunting activities
were common in the western Solomons, and the islands were considered
dangerous and unpacified. As late as 1913 a Western Pacific High Commission
(abbreviated hereafter as WPHC) minute noted that there were still "plenty
of murders . . . reported by every other mail" (Minute by Davis, 24 May
1913:WPHC, IC 942/1913).[5] The Sorrowful Solomons, as they were some-
times called, were deemed—with their murder, malaria, and monotony—to
be no place for women.

The European residents, most of whom were from Great Britain, Aus-
tralia, and New Zealand, were divided into two groups: those who lived in
Tulagi, and those who lived elsewhere. The latter were principally planters,
traders, and missionaries. Only about 100 acres of land were being worked
as coconut plantations in 1896, but by 1907 Levers' Pacific Plantations Limited
(encouraged by Woodford) had leased 90,000 acres and brought 4,000 acres
under cultivation on New Georgia, Guadalcanal, and the Russell Islands
(P. S. Allen 1919:244). At the same time, individuals such as Darbyshire
and Harding at Aola on Guadalcanal, and companies such as the Malayta
Company on Malaita, began to establish their own plantations. Accompany-
ing the growth of plantations was the recruitment of labor within the islands
and the appearance of European plantation managers from overseas. Copra
became the mainstay of the protectorate's economy, financing the administra-
tion and encouraging Australian firms such as Burns, Philp and W. R. Car-
penter to open outlets at Tulagi. Burns, Philp inaugurated a steamer service

[5]The Western Pacific High Commission, Inwards Correspondence (WPHC, IC) files are
located in the National Archives, Honiara, Solomon Islands. These files relate to the British
administration of the Solomons. The date of each piece of correspondence and the appropriate
file number are included in the in-text references.

every six-weeks from Sydney, via Brisbane, to the Solomons. These steamers provided the European community with its one tenuous link with the outside world.[6]

The plantation world duplicated, in many ways, conditions on the Queensland sugar estates and sheep stations. Plantations were stratified, racialist, and self-contained social structures. Planter paternalism prevailed. It was a rough, physically demanding, masculine world in which white men exercised their "right" to exploit the cheap labor of backward races while imagining that they were bestowing the benefits of civilization on the islanders (Bolton 1970:89). "We expected to be respected, have privileges, feel superior," Judy Tudor (1966) observed, describing her time in neighboring New Guinea. "In return, we were the Rock on which such frail structures as honesty, fair play, protectiveness, obligation were to be erected. Generally, we lived a life of natural *apartheid*, in which the native inhabitants went their way and we ours, meeting at such points as were mutually advantageous—but where we called the tune. This, anyway, was the theory" (Tudor 1966:67).

Into this world—a rather penniless, shopworn, lower-middle-class version of British India—came an increasing number of European women after 1900. Their experiences and the character of expatriate female society in the Solomons are the subjects of this chapter.

Missionary Labors

The first European women to come to the Solomons were missionaries. As Forman (chap. 8) has pointed out, women initially entered the mission field in large numbers during the late nineteenth century as the frontier was opening in the Solomons. The first Roman Catholic nuns arrived in 1901. They were followed by the redoubtable Florence Young, who established the Queensland Kanaka Mission (known after 1907 as the South Sea Evangelical Mission or SSEM) outpost at Onepusu on Malaita in 1905 (Boutilier 1978:145). A year later Anglican women began arriving, and in 1907, five years after the Methodist Mission was established in New Georgia, the first Methodist female missionaries came to the Solomons. It should be noted in passing that these were not the only female expatriate missionaries. A good deal of mission work was carried out by Polynesian missionaries and their wives, who saw service particularly in the western Solomons (Forman, chap. 8; Lātūkefu 1978:91).

[6]A radio transmitter was brought into service at the time of the First World War, but its range, even during maximum nighttime conditions, was barely sufficient to reach Australia.

Female missionaries made perhaps their greatest contribution in the field of education (Forman, chap. 8). The Melanesian Mission accepted young women from the Solomon Islands in the latter part of the nineteenth century for education at the mission school on Norfolk Island. "Splendid results" were achieved in training them to be the wives of islanders being prepared for the ministry (Wilson 1936:41). These island women were given simple instruction in cleanliness, hygiene, child care, and homemaking.

On the one hand, it could be argued that these activities were universals that were not only beyond criticism but also accorded closely with the traditional pursuits of young women in the Solomons. On the other hand, it can be seen that expatriate female missionaries, by their tutelage and example over the years, imposed Western values of womanhood predicated on the idea that men and women had fundamentally different natures and abilities. In this way female missionaries and European mothers were, paradoxically, active agents in the perpetuation of the devalued and invisible status of expatriate and indigenous women.

The number of women recruited from the Solomons for training at Norfolk Island was small, and they had, in the eyes of the church fathers, a high incidence of death in childbirth. Accordingly, it was decided to establish schools for girls in the protectorate itself. The first one was established on Nggela in 1906 with Miss Kitchen in charge (Wilson 1936:42). A little over a decade later a second boarding school for girls was established on Nggela at Boromole and moved in 1918 to nearby Siota. Later still, Saint Hilda's, as the second boarding school was called, was transferred to the neighboring island of Bungana (Boutilier 1978:160). There, as elsewhere, young women were taught, in the words of Ellen Wilson's 1936 mission report, "to help others in times of sickness and trouble, instead of ignoring them as is the manner of the heathens" (Wilson 1936:43).

The South Sea Evangelical Mission was also engaged in educating young women. One of Florence Young's first acts was to establish in 1906 a small coeducational boarding school at Onepusu; later a separate school for girls was established at Afio in southern Malaita.

The Deck family was closely associated with Florence Young. Indeed, the Decks constituted, in many ways, the backbone of the SSEM in the prewar days. Kathleen Deck accompanied Florence Young in 1904 on her first reconnaissance of untamed Malaita. Four years later, her brother, Dr. Northcote Deck, came to the Solomons to commence his missionary labors. He was faithfully assisted by his wife, Jesse (née Gibson). When she died of blackwater fever, he married a young woman, fourteen years his junior, from another branch of the Deck family, Gladys Deck. She arrived in the Solomons in March 1923 and recalled, over half a century later, her feelings

on that occasion. "Well, I really wasn't much use as a missionary," she observed:

I did do a little teaching, everybody took their turn at teaching the boys to read. They had to read straight from the Bible in those days. And big words were quite easy, but little words stumped them. But my job was more to look after the missionaries and make them comfortable. I loved to nurse and I loved housekeeping, and I kept things going on the ship you know. We often had sick missionaries on board [the SSEM mission vessel *Evangel*]. I had one dreadful experience with a new missionary who was [unwell and] being taken to Wanoni Bay [on the island of San Cristobal]. The missionary there had died of blackwater fever. . . . in those days there [were] no screened windows, no protection whatever from malaria. . . . We always had a service in the evenings when the mosquitoes were most lousy, sitting in a little, dark, leaf church, you know. It's a wonder that we survived as well as we did. And we suffered, I believe, from malnutrition more than any cause. It was shocking. You know, there was very little canned stuff. It was very expensive, and very unpalatable in those days. It was very poor and on the ship we had no fresh food. (G. Deck transcript: 6 July 1974)

Later Gladys Deck took passage on the *Evangel* to the south coast of Guadalcanal. "It was an awful place," she recalled:

One man we had . . . nearly went insane there. The loneliness was so tremendous. There was a long, long beach composed of nothing but boulders and landing there was a nightmare. The boat was continually smashed landing at Guadalcanal with supplies. I mean we had to take sacks of rice, all sorts of things ashore. They'd get as close in as possible and leap into the water and . . . a dozen men would . . . push her up the beach. It was a terrible business, a frightening business.

I had a very hard experience. I'm not a very courageous person, it's no good pretending I am, and I was really frightened that time. I wasn't frightened going ashore. I wasn't frightened doing anything with my husband—he was so capable. My husband and the missionary, Mr. Pettifer, went off in the launch . . . and it was overloaded. He was taking supplies, Bibles and all sorts of things to a teacher at a distance along the coast, and they went off one morning in a dreadful sea. . . . I really didn't know whether they hadn't been drowned. The natives themselves were very concerned. And I had a bad attack of fever, I expect, because I was frightened. We also had quite a severe earthquake which scared the boys very badly and I can remember I got them all together and I tried to be brave and comfort them. (G. Deck transcript: 6 July 1974)

Gladys Deck's sister-in-law, Joan Deck, also served as a missionary in the SSEM. When Jesse Gibson Deck died in 1920, Northcote asked his sister, Joan, to return to the islands with him. She was twenty-five. She lived for

seven years on Nongasila, on the east coast of Malaita, in the company of another brother, Norman. She was the only European woman there and the first European to learn of the murder of District Officer W. R. Bell and his police contingent on 4 October 1927 at nearby Gwee'abe. She recalled:

I was sitting on the verandah, mending my brother's socks, feeling pretty wretched with low fever, when one of the men . . . came up and said . . . that Mr. Bell . . . [had] been murdered and the *Auki*, the little [government] vessel, was at the wharf, and so I told my cook boy . . . "you heat a lot of water," and I grabbed all . . . the cotton blankets, and I went on board. I could hardly keep my feet for blood, everywhere on the deck. And the two Europeans [Bell and his cadet, Lillies] were in the cabin . . . and they were wrapped in a sail with their feet sticking out. And then I went on deck and there was a man . . . dead. The other man had been cut with [one of] those big knives right around the back in two huge [slashes]. They were about as wide open as that, right through the muscles to the bone. [It was a] terrible sight. Another man had a spear broken off into his ribs at the back . . . and he was writhing about.

I heard that two men from the Seventh Day Adventist station were coming up to help . . . so I covered them over with blankets . . . and I helped them. I held the light for them while they tended to these men. Then they went ashore to have the burial . . . Mr. Lillies' hand was missing and they buried the dead native and the two white men there. And I slipped away during the service and went back to the men on board to pray with them because they were all our devout Christian men. (J. Deck transcript: 28 May 1973)

Joan Deck was the first European woman to journey across Malaita after the Bell massacre. She set off with her friend, Lena Gordon, in the company of four young islanders who acted as carriers. In preparation for the journey, she nailed strips of leather onto her brogues with football brads to keep herself from slipping on the track. It poured. The undergrowth was treacherous, Lena strained a muscle in her leg, the lantern was smashed accidentally, two of the carriers were bitten by centipedes, and the party became thoroughly lost in the rugged and precipitous headwater country of the Fiu River. It was at this stage that the women had a brief exchange that illustrated there were limits to their female independence and initiative, despite the "eccentric" and "masculine" nature of their undertaking. Joan Deck suggested to her companion that they build a shelter and sleep the night in the bush. "Oh, no," Miss Gordon is reported to have replied, "My fiance would never agree to that" (J. Deck transcript: 28 May 1973).

They pressed on. "We were so excited when we got to the center [of the island] and looked across and saw the sea, we felt like Christopher Columbus," Joan Deck recalled. When they reached the coast near Auki, the district officer berated them for their apparent stupidity. "Do you realize,"

he said, "that you might have broken your leg!" "So might a man," she rejoined with amusement (J. Deck transcript: 20 June 1978).

It was Joan Deck who managed the Afio girls' school after it was established in 1934 near the Maramasike Passage. Forty girls and several married couples attended. Conditions were primitive and the soil for gardens was poor. "We had no white men [at Afio]," Joan Deck observed. "I did all the supervision of building and repair work." There were usually three or four "lady missionaries" undergoing training at Afio, and when they or the students fell ill, Miss Deck was obliged to minister to them on her own. "We had no contact with the outside world; we had no help from doctors. . . . That was perhaps the hardest part of all. We had [medical] books and we did what we could" (J. Deck transcript: 20 June 1978).

Female missionaries fulfilled not only their traditional roles as wives, housekeepers, cooks, and educators but also male roles as carpenters, overseers, and supercargoes. Joan Deck's transit of Malaita illustrated the eccentric (in male eyes) "maleness" of some female missionary activity. However, they failed to fulfill the valued female role of mother insofar as many of them never bore or raised children.

The association of female missionaries with the islanders was governed to a large extent by the missionaries' sex and religion. Their sex enabled them to interact fairly easily with pagan women but denied them access, on many occasions, to pagan males because of sexual taboos. The conversion experience, however, broke down these barriers, and female missionaries were able to deal directly with island men, as the various mission school and clinic situations illustrate.

Plantation Life

European plantation women were primarily concerned with domestic affairs. Their lives revolved around the broad-verandahed plantation house, the garden, and the labor lines. It fell to them, in a setting perceived as rough and masculine, to raise children, nurse the sick, and attend to education.

When Vera Clift met her husband-to-be in 1921, she knew nothing about the Solomon Islands and had hardly even heard of them. She was living at the time at Bellevue, an old historic station on the Brisbane River in Australia, and decided, at the prompting of the acting resident commissioner's wife (Mrs. Brodhurst-Hill), to visit the Solomons and see what conditions were like. Her close relations were unalterably opposed to the idea of her marrying on the grounds that the Solomons were unsophisticated and dangerous and that expatriate society there was socially inferior. They felt that a life in the islands was not nearly good enough for her and that she

was running the risk of marrying beneath herself. Despite these objections, she decided to marry Jack Clift. The resident commissioner in Tulagi was reportedly too drunk to marry them so they sailed to Visale, on the north coast of Guadalcanal, where they were married by a Roman Catholic priest, and continued to the Clift plantation at Auriligo eight miles away.

Auriligo was several thousand acres in extent, with five or six hundred acres under cultivation. The Clifts browsed six hundred cows throughout the estate to keep the undergrowth down and to provide a source of meat. Every Thursday they killed a bullock, kept some of the choice cuts, and gave the rest of the carcass to the sixty copra cutters and domestics in their employ.

Fresh meat was supplemented by tinned food, which arrived every six weeks on the Burns, Philp steamer. "Everything," one woman recalled wearily, "was always tinned food in those days. . . . Bully beef and rice, bully beef and rice" (Woods transcript: 24 May 1978). There was no refrigeration to begin with, although later the Clifts imported what Vera Clift thought to be the first refrigerator in the Solomons, a cranky old "icy-ball" machine that depended upon laborious heating with a primus stove. There was plenty of fish and fowl, though snakes had an annoying habit of eating the eggs. On one occasion the plantation laborers killed a snake, cut it open, recovered the eggs, and tried to sell them back to her. Fortunately, there was a "lovely garden" with mangoes, custard apples, taro, and potatoes to supplement the Clifts' diet (Clift transcript: 7 September 1978).

Their experience was a far cry from that of Joan Deck, who received tinned food twice a year. The butter, she recalled, was rancid and tasted "like black ants" (she used to beat water into it in an attempt to take the taste away). The flour was full of weevils. She didn't mind the weevils in the porridge but she couldn't abide the white grubs that went stiff when the porridge was cooked. The onions rotted and she grew to loathe stew because it always tasted tinny. "Our food was very, very poor in those days," she observed in a masterful understatement (J. Deck transcripts: 28 May 1973 and 20 June 1978).

Every morning the recruited laborers moved out through the Clift plantation to collect, cut, and bag copra. They worked on a piecework basis and were required to fill three forty-pound sacks a day. While Jack Clift supervised their activities, Vera Clift attended to household chores, maintained the plantation books, paid villagers who brought in vegetables, took stock in the plantation store, and oversaw the preparation of meals.[7]

[7]Georgina Seton on Lofung Plantation was paid £10 a month by Burns, Philp to copy the books. "Actually," she wrote, "I did an overseer's work—sometimes on the move for fourteen hours a day, as Carden [her husband] was away nearly all the time, taking supplies and bringing back copra" (Georgina Seton, 3 December 1978:personal communication).

The Clifts never employed local women or "marys" (now Neo-Melanesian *meri*) because they thought that it would be unwise with so many Malaitan men around. Instead, Vera Clift trained young boys in the kitchen, teaching them how to cook from a cartoon book that she had prepared. Cook-boys were the closest companions many European women had. Living as they were in almost complete isolation, plantation wives turned quite naturally to their cook-boys for companionship and support (Seton transcript: 18 June 1978).

This was not always the case. Georgina Seton, who came to the Solomons in 1929 to join her husband, Carden, on Burns, Philp's Lofung Plantation in the Shortlands, insisted that the houseboy leave her morning tea on the table outside her bedroom. She took the further precaution of bathing and dressing in the dark, while one of her female acquaintances was not even allowed to pull the toilet chain when islanders were in the house. To have done otherwise was to court molestation so far as most Europeans were concerned. In other cases, as Charmian London (1915:369) noted during her visit to the Darbyshire and Harding plantation at Aola (Guadalcanal) in 1908, the plantation house and its surrounds were off limits to the laborers. Most of the planters would have agreed with the jailer at Tulagi, who maintained that Solomon Islanders were a "black and almost savage race" (Gray to Woodford, 26 January 1914:WPHC, IC 648/1914).

It was not unknown for laborers to be fractious, and on one occasion twelve of them attempted to stab Jack Clift. He was saved by the fortuitous positioning of a pocket watch and by the timely arrival of a white nanny brandishing a revolver. Carden Seton was obliged to thrash some of his laborers to bring them into line, and his wife never addressed them by their Christian names lest the master-servant relationship be undermined. Firm control of the heathen was the order of the day. Georgina Seton had been well prepared for difficult situations before she came to the Solomons. During her childhood on a merino sheep station in southwestern Queensland she had learned to ride, shoot, and handle a stock whip. "I don't think," she recalled, "that I could ever have managed unless I had had such a tough upbringing. I didn't have any excuses made for me for being a girl" (Seton transcript: 18 June 1978).[8]

While labor strife was a nuisance, the depression was a disaster. Copra prices plummetted. "Planters winced everytime a coconut fell from a tree as

[8]She was alone for two months on the Lutee estate on Choiseul Island operating the plantation by herself while Carden was in Rabaul. Forty-five of the fifty-five laborers were feared Sinarango (fig. 6, alternate spellings of this place name include Sinerango, Sinalagu, and Sinalanggu) men from Malaita (the murderers of District Officer Bell), and she was certain that one of them was "cranky" or psychotic. As a precaution, she erected barbed wire barricades on the front steps of the plantation house (Georgina Seton, 19 September 1978:personal communication).

they were a hae-penny poorer. They had to cut copra but couldn't afford to" (Tom Elkington, 3 May 1977: personal communication). Copra cost seven pounds sterling a ton to produce, but the Clifts could only get three pounds a ton for it in the early 1930s. Faced with bankruptcy they sold out, like many others, and moved to western Queensland, where they began a new life pioneering "on absolute prickly pear scrub" (Clift transcript: 7 September 1978).

Tulagi Ladies

Tulagi was the protectorate's administrative and commercial capital located on an island of the same name. Very few European women lived there. Probably the first was Mrs. Woodford who visited her husband, the resident commissioner, several times in the years before World War I. There were only six European women on Tulagi in 1914, and at the time Woodford was debating whether to increase their number by appointing a female nurse to the government hospital. He was convinced that "a young and attractive nurse would very rapidly become involved in a 'matrimonial arrangement' " (Woodford to Sweet-Escott, 3 April 1914:WPHC,IC 80/1914). His fears were not altogether unfounded. The hospital came to be known as the "matrimonial bureau," and only two nurses, Sisters Zagallo and Ralph, failed to marry in a period of fifteen years. Another practical problem was whether or not the nurse in question would be required to treat male venereal patients. This was the subject of considerable correspondence between Suva and London. Eventually Woodford was able to reassure the Western Pacific High Commissioner that a female nurse would not be required to minister to anyone suffering from "the disease" (Woodford to Sweet-Escott, 7 July 1914:WPHC,IC 1912/1914). Accordingly, Edith Elizabeth Elliot, who had served previously in West Africa, was appointed as the first nurse to the Tulagi hospital staff in December 1914.

Almost all the other women residents on Tulagi were wives of administrative officers. Their status was dictated largely by their husbands' positions in the administrative pyramid. At the top (in fact, quite literally in "Top Office") was the resident commissioner. The wives of resident commissioners seldom lived in the little capital. When they did—such as Mrs. Ashley in the 1930s (who tried to see that there was "no unpleasantness" in the social life of the capital)—they became, perforce, the principal figures in female society (Ashley transcript: 18 June 1972). They kept social order and were always considered "tidy," as distinct from their less cultivated plantation sisters, who were deemed "not tidy." A number of women who lived in

Tulagi recalled that things were "terribly formal in those days," though the leaving of calling cards at the residency had been discontinued by the time Christine Woods arrived in 1935 (Woods transcript: 24 May 1978).

Hierarchical distinctions existed not only within expatriate society in Tulagi but also between that society and the European community living outside the capital. Administrative officers considered themselves above "commercials" while both, it seems (if Vera Clift is to be believed) looked upon the planters as "mud." From the plantation perspective, Tulagi was "the preserve of the 'Mink' [the upper class] with a good deal of fuss and so forth about household equipment and fashion" (Georgina Seton, 5 August 1980: personal communication). Women there appear to have been more concerned with maintaining these distinctions than men, possibly because most women enjoyed power by association rather than in their own right (C. Allen 1975:104). "The suburban type of woman married to a clerk," Georgina Seton observed, "was charmed with the idea of *servants* and soon got a photograph of [her] cook-boys in embroidered laplaps producing after-noon tea on the verandah for her" (Georgina Seton, 5 August 1980: personal communication, emphasis in original).

While Vera Clift and other plantation women were obliged to entertain themselves by picnicking and listening to the gramophone, European women in Tulagi had a considerable range of social outlets. There were "dos" at Elkington's Hotel, which one missionary described as a primitive place "where a few planters drank and wenched" (Richard Fallowes, 14 December 1971: personal communication). Mrs. Elkington was an artist, who decorated the big hotel dining room with her own paintings and a vast collection of spears, shields, and bric-a-brac from the islands. She was also a self-taught musician and had a Brinsmead piano (for which she is said to have refused an offer of £1000) in a huge asbestos case.

When not at Elkington's there was what one colonial veteran called "coffee and character slashing" (Dougal Malcolm, 7 July 1978: personal communication). Following morning get-togethers, there was always Orwell's "spiritual citadel," the Tulagi Club, for bridge, tennis, golf, and two-month-old copies of *The Times* (quoted in C. Allen 1975:116). There was also recipe swapping, perusal of the mail order catalogues (almost the only way, short of leaving, of obtaining new clothes), and dinner parties (Hetherington transcript: 1 September 1977). Everything was not on the credit side, however. European women in Tulagi faced many of the same problems that their sisters faced elsewhere in the islands, but those in the capital did have certain distinct advantages. They had the hospital, they were at the center of things in terms of news, and their husbands' jobs were more assured than was the case with planters and traders. Moreover, they had fairly regular leave.

Frances Blake, whose husband was an accountant in the government treasury, traveled to Sydney every year. The Blakes went there for three-months' leave every two years on average, and for six-months' leave to Britain approximately every five years (Frances Blake, 5 September 1978: personal communication). By contrast, some of the Roman Catholic nuns labored for decades without ever leaving the Solomons.

Transients

Over the years a number of European women visited the Solomons as writers, cinematographers, painters, and tourists. Their immediate impact was slight, but they left behind an important legacy in the form of books, films, paintings, and recollections about the Solomons. One of the earliest visitors was Charmian London, who arrived in the protectorate in 1908. Her husband, Jack, was probably the most popular American author of his day. Anxious to generate fresh ideas for stories, he set sail in 1907 with Charmian aboard the schooner *Snark*. They stayed at Penduffryn Plantation at Aola, accompanied a labor recruiting expedition along the coasts of Malaita, and visited with Harold Markham, a trader, on Ontong Java.

Charmian's account, *Voyaging in Wild Seas*, is particularly interesting in terms of her attitude toward and experiences with the local women. We find her planning "no end of good fun" with a young girl from Ontong Java whom she wished to dress up in European clothes as "one would a new doll" (C. K. London 1915:445). Another girl made her wistful, since Charmian was "sure she was more than a half soul—such as are the bulk of these evil, sub-human creatures who people her land" (C. K. London 1915:409). Sub-human or not, she soon found herself mulling over "a fascinating plan to adopt some attractive pickaninny, and take her home with me. Visions of a perfectly trained treasure of a maid lured" Charmian to ask after a young woman, but her kin refused to let her go (C. K. London 1915:407).

A young cinematographer, Martin Johnson, sailed with the Londons aboard the *Snark*. Johnson returned to the Solomons nine years later to shoot some of the earliest motion picture footage there. He was accompanied by his young wife, Osa, from Chanute, Kansas. Unfortunately, her account of their visit, *Bride in the Solomons* (Johnson 1944), is unreliable. It was ghostwritten many years later in order to capitalize on the World War II fascination with the Guadalcanal and the Solomons campaign. It seems to have been pirated in parts from *Voyaging in Wild Seas* (C. K. London 1915). Nonetheless, it contains some interesting insights. We find Osa Johnson (1944:5) speaking of District Officer Bell as "another woman-hater, like so many others out

here." Elsewhere, Martin Johnson comments that the "Malaita men have the right idea, [they] let the women do the work" (Johnson 1944:21). When they visited the Langa Langa Lagoon, Osa Johnson found herself segregated and forced to remain on the women's side of the artificial islet. She bridled when Bell treated her "like a sissy" (Johnson 1944:44) and wanted to be able to act like a man in much the same way as Joan Lackland, the heroine of *Adventure*, one of Jack London's (1911) novels set in the Solomons.

Roughly a decade after the Johnson visit, an intrepid American painter, Caroline Mytinger, traveled throughout the archipelago with a female companion. They visited a plantation operated by a lone European woman whose husband had died three years before from blackwater fever. Mytinger described how the woman had kicked a Malaitan laborer who failed to follow instructions: "So that's how frail woman [*sic*] runs a plantation," she observed. "Can every English clergyman's daughter kick like a kangaroo?" "As a matter of fact," the missus answered, "I've never kicked before. Your being with me must have given me the courage to do it [for fear that the laborer would accidentally burn down the copra shed if he were not disciplined]" (Mytinger 1942:132).

Another visitor was the prolific writer and propagandist, Beatrice Grimshaw. She came to the Solomons in 1909 and returned twenty years later, on this second occasion staying with Frances Blake in Tulagi. Grimshaw, like her contemporaries Jack London and Jack McLaren, was a proponent of Social Darwinism and its racialist corollaries. "White people," she wrote, "must not be frightened before blacks," who after all were "nearer to monkeys than to human beings" (quoted in E. Laracy 1977:164, 162). Her fictional accounts of planter life in Papua are invaluable as illustrations of colonial mythology. Moreover, they were no doubt avidly read by European women living in the Solomons, and this exposure formed new or reinforced old attitudes.

An assortment of other women came to the Solomons as shipboard tourists on the Burns, Philp steamers. Vera Clift recalled two of them arriving at Auriligo one day, having ridden up on horseback from the neighboring estate of Doma. "All the young blokes would . . . go and preen themselves" (Tom Elkington, 29 July 1972: personal communication), starved as they were for female company, when newcomers came ashore at Tulagi. One of the European women who visited the protectorate was Miss E. T. Barker. Later she reported to the students of the Central Girls School in Maryborough, Queensland, that "one could not but admire . . . the physiques" of the local stevedores in their "bright coloured loinclothes" (Barker n.d.:3). The islanders were perceived as "monkeys" and "subhuman" but intriguing nonetheless.

Illness

Illness was an ever-present concern for European women in the Solomons. The climate was considered "almost deadly" (in Thurn to Sec. of State, 8 May 1907:WPHC, IC 65/1907) and "virtually impossible for married men" or more precisely, for their wives (British Solomon Islands Protectorate [abbreviated hereafter as BSIP], Estimates, 1911–1912:WPHC,IC 18/1911). Dysentery was rife, but even worse was malaria, the "horrible sweats and shivers," as one missionary wife described it (Mrs. Ken Calvert, 24 July 1978: personal communication), and blackwater fever, the deadly corollary of uncontrolled malaria. In the Solomons, as in India, you could be "ill one day and dead the next" (C. Allen 1975:151). European residents normally took five grains of quinine a day as a malarial prophylactic, and young children were occasionally clothed from head to foot in an effort to minimize mosquito bites.[9] Norman Deck's wife, Mary, wore mosquito boots made of calico to protect her legs, but despite these precautions almost everyone suffered from varying degrees of malaria. Joan Deck had what she called simply "a lot of low fever," a temperature of about 100 degrees that lasted for eight months and made her feel wretched (J. Deck transcript: 20 June 1978). Georgina Seton found her husband gravely ill with malaria and hemorrhaging when she reached Lofung Plantation for the first time. She nursed him back to health, but he was forced to go south to Australia to recover. Shortly thereafter, Georgina herself came down with a three-month bout of malaria. "I must have been practically dying," she recalled (Seton transcript: 18 June 1978).[10]

Many did die. The death of Annie Harding, Woodford noted, made the sixth death from malaria in a year (March 1912–March 1913) out of an European population of roughly 310 (Woodford to Sweet-Escott, 12 April 1913:WPHC,IC 936/1913). A number of victims were children. Vera Clift's two-year-old son, Peter, died from suspected malaria, as did one of the children of Dick Laycock, a trader at Tulagi.

The unhealthiness of the protectorate was compounded by the absence of trained medical personnel and hospital facilities. In Vera Clift's opinion, the medical services were "the worst in the world" (Clift transcript: 7 September 1978). Christine Woods, who spent forty years in the Solomons as a nurse and hospital matron, once worked at the Melanesian Mission clinic

[9]It appears to have been a common folk belief that the application of quinine itself resulted in the onset of blackwater fever (Seton and Deck transcripts, 1978). However, there does not seem to be any connection between the two (Robin Low, 25 September 1978:personal communication).

[10]For additional details with respect to malaria see Avery 1978:942–949 and Cloudsley-Thompson 1976:76–100.

on Ugi. Almost everything there, she recalled, had to be improvised. She saved old fruit salad tins so that she would have containers when she came to bathe the patients. She fashioned forceps from bent bamboo. The remainder of the hospital equipment consisted of two towels, two sheets, a camp bed, and a hurricane lamp (Woods transcript: 24 May 1978).

The hospital at Tulagi was somewhat better, although unfortunately one of the doctors there was too deaf to use a stethoscope.[11] The real problem was access. Even if a schooner were immediately available, it might take two or three days to transport a patient through rough seas to the capital. In many instances European residents, women in particular, were obliged to act as doctors and midwives themselves. This was the case for Vera Clift when the manager of a neighboring plantation arrived at Auriligo desperate for assistance. His sister was in labor, and although Clift acknowledged that she knew nothing about midwifery, she had no other choice but to help. Armed with a medical text, a necktie pin, and a piece of tape, she managed to deliver the baby and save the mother's life. Stories of medical improvisation like this are legion on almost any frontier, and in this respect the Solomons were no exception.[12]

Children

The general consensus among European women in the protectorate was that "nobody could have a baby [in the Solomons]" (Clift transcript: 7 September 1978). The lack of medical facilities, the dangers of childbirth, and the threat of malaria rendered it imperative for expatriate women to have their babies in Australia or New Zealand.[13] Malaria was a major problem for pregnant women. The malarial parasites affected their reproductive capacity and resulted in newborn children who were delicate and particularly vulnerable to disease (Robin Low, 25 September 1978: personal communication).

What made matters worse was a virtual lack of birth control knowledge or devices. Moreover, according to the wisdom of the day, "a woman who rebelled against pregnancy was as absurd and irreverent as someone who

[11]There was one woman doctor in the Solomons prior to World War II. She was Dr. Lily McCrimmon, the wife of a planter at Su'u on Malaita.

[12]"I'll never forget it till the day I die. Here's a poor little dead baby on the banana leaf and the mary [Solomon Islands woman] nearly dying. We sat up the entire night with that woman filling her up with hot tea. We saved her life anyway. You daren't touch her. If you touched her and she died you'd be blamed" (Clift transcript: 7 September 1978).

[13]The "missus," whom Mytinger (1942:130) encountered running a plantation on her own, was trying desperately to pay off debts incurred through hospitalization in Australia for several childbirths.

railed against death" (Savage 1976:42). Thus, if women were not occupied directly in child care they were often in "a family way."

Infants were brought back to the Solomons when they were three or four months old and remained there until they were school age. While the Clifts had a white nurse to look after their children ("she wasn't much good because she got fever every week"), a nanny was an exception to the rule (Clift transcript: 7 September 1978). Georgina Seton was uncertain how she "ever managed to get [her] two children to survive" in the islands (Seton transcript: 18 June 1978). One of them nearly succumbed when the baby food she had ordered failed to arrive, and her cow died. Fortunately, a neighbor, Clara Scott, had fresh milk, and the young boy was nursed back to health.

Some European women perceived an added danger, homosexual threats to their sons. Mrs. Seton, for one, never allowed her sons, Donald and George, out of her sight when they were in the company of the laborers on Lofung. "A lot of women," she maintained, "didn't seem to realize the dangers their small children were exposed to" (Seton transcript: 18 June 1978).

Responsible supervision of children was an additional problem in its own right. The wife of the district officer in neighboring Buin (southern Bougainville Island) had a young daughter. "On golf Saturdays," Georgina Seton recalled, "she took the baby in a pram with a pickaninny [a local child] to wheel her. She also took a senior cook-boy to keep an eye on him. Her husband provided a police boy to keep an eye on them all" (Georgina Seton, 5 August 1980: personal communication).

Schooling meant separation and expense. There were no facilities in the Solomons deemed suitable for European children, and most youngsters went away to Australia or England when they reached the age of seven. In many cases they were accompanied by their mothers, who put them into or took them out of school. Passages and school fees were costly burdens to bear, particularly during the depression era. Separations were also painful, though occasionally they were a smoke screen for (or a contributing factor to) a failing marriage.

Booze, Boredom, and Adultery

"Almost every tropical settlement has its quota of lazy, bored, card-playing, spirit-drinking women," Price (1939:226) observed in his classic, *White Settlers in the Tropics*. This was true to a limited degree in the Solomons. Drinking was, if anything, a male pursuit. There was "more alcohol per head of population poured into the Solomons" Vera Clift alleged, "than any place

in the world" (Clift transcript: 7 September 1978). There were certainly some breathtakingly capacious drinkers among the men, but none of the European women seem to have distinguished themselves in this regard.

Loneliness, isolation, and boredom were problems for some. Unlike the women of Queensland and the Canadian prairies who were slowly united by the railway and telegraph, European women in the Solomons remained as isolated from the world, and from one another, in 1940 as they had been in 1900.[14] Their plight was symbolized by Frances Blake, who burst into tears when the sound of Big Ben striking in London first came crackling over her husband's primitive wireless set. Many women were starved for female company. There were "plenty of men, but no women," Vera Clift observed (Clift transcript: 7 September 1978). Only two women came to visit her during her eight-year sojourn at Auriligo. By comparison, the women of Tulagi probably saw one another too much, while members of religious communities enjoyed female companionship and the psychological reinforcement of their common calling. Gladys Deck, for one, was far too busy to be bored, while Christine Woods, who lived on her own for several years, could only recall her time as being "very exciting" (Woods transcript: 24 May 1978).

It is hard to say whether the little European community was any more adulterous than similar settlements elsewhere. "The wives of senior men inclined to be rigid even to what was looked on as 'stuffiness' and 'like missionaries' " (Georgina Seton, 5 August 1980: personal communication). Adultery certainly occurred: a number of men "sparked" the wife of a planter; a district officer was involved with the wife of a plantation manager; and the resident commissioner himself shocked Tulagi society by running away with the wife of one of his district officers. However, Tulagi was generally too small and the other settlements too scattered for adulterous liaisons to take place very often. Moreover, there was a lack of privacy. "It was like living in a goldfish bowl," Georgina Seton observed (Georgina Seton, 5 August 1980: personal communication). Although Europeans were isolated geographically and racially, the presence of domestic servants meant that the slightest peccadillo became common knowledge, the news being transmitted with disconcerting rapidity along the famed "coconut wireless" from cook-boy to cook-boy.

[14]Conditions were not much changed in the 1960s. "My wife's principal problem . . . was lack of company and lack of constructive things to do. Even the thrill of having our son . . . and attending to him as a babe had its limitations. The house was well looked after by our three rustic servants. We had no wheeled transport and our nearest white neighbors were over an hour away by boat (which we seldom had) and four hours' walk for me. Mail was irregular and not very sophisticated" (Anonymous, 1978:personal communication).

The Sexual Dimension

France (1969:40) maintained in *The Charter of the Land* that "the final and irrevocable estrangement [of white settlers] from native society came with the arrival of the European lady." Certainly there is a good deal of evidence, drawn from a variety of colonial settings, to support this view. What we need ask ourselves is two things. First, why did the racial cleavage become more pronounced? And second, to what extent were European women in the Solomons responsible for such "estrangement?"

Like their expatriate brothers in India, the Malay States, and other parts of the Pacific, planters and traders in the Solomons took local women as mistresses in the early days of settlement. One island woman, the redoubtable ZaZa from Simbo, lived with five European men, including the district officer, J. C. Barley. It is perhaps not surprising that European women, the products of Victorian morality, had strong views about these "irregular" liaisons as morally and racially reprehensible. The Colonial Office itself was moved to forbid these unions by its administrative staff on the grounds that the authority and prestige of His Majesty's Government was called into question. How, it was asked, could that great imperial essential, respect, be maintained in the face of such familiarity?

At the heart of it all was the real or imagined threat to superiority and status that miscegenation implied. The presence of island mistresses constituted a grave threat to European women, who legitimized their status by association with their husbands. At the same time, as Silverman's (1978:25) study of the frontier in Alberta suggests, the presence of expatriate women "served to define men in relation to each other." European women expressed "the fruits of [a man's] labor," elevated his status within the expatriate community, assured him superiority over local nonwhites, and constituted a possession he felt obliged to protect (Silverman 1978:25).

European men saw the threat of irregular liaisons in terms of sexual conquest and an impermissible challenge to dominant status. The segregation of white and black societies bred ignorance on the part of European males concerning Solomon Islands social systems. Island men were perceived as savage, uncivilized, and overly sexual. This vision was, as Wolfers (1975:45) has pointed out in his analysis of expatriate society in Papua, Fanonist in nature. If a Solomon Islands man were to lie with a white woman, the European man, in Stember's (1976:196) view, would not only be denied sexual pleasure but denied pleasure that the islander, by virtue of his inferior status, was not entitled to. Thus the loss was twofold: an invasion of a sexual sanctum (a double defilement in terms of the additional white purity association) and a loss of status with all that that implied with respect to master-servant relationships.

When European women arrived on the scene, island wives drifted into the background. "A fastidious reaction took place against earlier familiarities" (France 1969:40). It was suggested during symposium discussions of the chapters in this volume that European women discouraged the employment of housegirls, lest they appeal to their husbands. However, expatriate women were willing to employ houseboys. By exercising dominance over Melanesian men, they negated the possibility of a sexual relationship. Certainly the creation of European households (some would say the recreation of Leamington Spa or Toowoomba in the tropics) imposed a physical barrier between European men and local women, a fact illustrated metaphorically by the *cordon sanitaire* drawn around many plantation dwellings.

European males displayed their sexual anxiety in hostility. This hostility expressed itself graphically in Papua with the 1926 passage of the White Women's Protection Ordinance, a questionable, not to say brutal and racialist piece of legislation based more on rumor and expectation than on reality (Inglis 1974). That same hostility found expression in the Solomons in 1934, when it was alleged that several women in Tulagi had been looked in upon or molested. Frances Blake remembered Betty Laycock, the sister-in-charge at the hospital, arriving at her door, terrified and distraught. She had been resting in her room when an islander—a Fijian, not a Solomon Islander— entered her room. The European community was outraged by this and other "incidents," which appear to have been more frightening than serious. Georgina Seton, for one, maintains that there were some women "with too few clothes" who liked to swim "in the nuddy [sic]" and constituted a *"menace"* to the safety of other expatriate women (Georgina Seton, 5 August 1980: personal communication, emphasis in original). While the authorities did not legislate the death penalty as in Papua New Guinea, they introduced public flogging with the cat-o-nine-tails.[15]

While Mannoni maintains that "European women are far more racialist than men" (quoted in Wolfers 1975:55), Woodcock (1969) points out that women were not entirely to blame for widening the gulf between the races. European women, he observes, began to arrive in the colonies at a time when two forces were at work: stabilization and missionization. It was common for European men to bring women to the frontier when the fluid and danger- ous period of initial contact with indigenes was coming to an end. At the same time, missionary activity introduced an element of moral fervor that was antithetical to "unnatural" liaisons. "When the Church and the mem- sahibs were united," Woodcock (1969:167) writes, "there were very few even

[15]This punishment was provided for under the "King's Regulation to Provide for the Penalty of Flogging in Certain Cases of Criminal Assaults on Females (Cap. 4, Regulation No. 7 of 1934: 16 August 1934)" (BSIP 1950:13).

among the most powerful men in the East who were willing openly to defy them." Most Victorian Englishmen, he concludes, "had a guilty fear of clergymen which their descendants have lost, and a dread of moralistic women which has proved more durable" (Woodcock 1969:167).

Stabilization and missionization occurred in the Solomons early in the twentieth century. Though much of what has been said does damage to the deep friendships and lasting affection that many Europeans, men and women, displayed toward or felt for the islanders, there is a good deal of truth in what France (1969) says. European women were not well disposed toward island mistresses, and the arrival of European women promoted and focused hostility on the part of European males toward indigenous men. While European women were seen as civilizers who would raise the tone, they also contributed substantially to the racial cleavage. Moreover, many of them, particularly in the planter/trader community, brought with them racialist inclinations that hardened as they absorbed the popular wisdom of Europeans already living in the group.

Evacuation

Following their attack on Pearl Harbor on 7 December 1941, the Japanese swept southward, occupied Rabaul, and prepared to capture Port Moresby and Tulagi. The British decided to evacuate all European women and children from the Solomons in the face of the Japanese advance. While people from the northern part of the protectorate, such as Georgina Seton, were evacuated on the Burns, Philp steamer SS *Mataram*, the remainder were instructed to assemble at Tulagi.

Joan Deck and her colleagues at Afio were forced to close down their school for girls. Before leaving they carefully packed all of the girls' equipment in tin-lined boxes, hoisted them up with a block and tackle, and hid them in an attic space above her bedroom. (The boxes were still there when she returned four years later.) Then the *Evangel* transported Deck and the other Europeans to Tulagi, where they boarded the SS *Morinda* and sailed to Sydney (J. Deck 1975:9).

A handful of European women stayed behind. Two of them were Roman Catholic nuns whom the Japanese executed in 1942 at Ruavatu on the north coast of Guadalcanal (Lord 1977:63). Two others became coast-watchers, hiding in the jungle and reporting the movements of Japanese ships and planes to Allied headquarters. Although Mrs. Frank Jones (née Ruby Olive Boye) was not behind enemy lines, she was decorated for her work on Vanikoro, in the eastern district, during the Solomons campaign. Merle Farland was a nurse at the Methodist Mission station at Bilua in the western Solomons. She refused to leave, commenting that "it is surely not consistent

with Christian service that our medical work should be completely dropped because things are a little difficult. I am the only medical person left: therefore I stay. There is no other course" (quoted in Lord 1977:91).

Farland worked behind enemy lines for a year, undertaking perilous journeys, providing medical assistance, and helping Major Donald Kennedy, the coast-watcher at Seghi in New Georgia. While she was there in December 1942, the British administration, realizing that she was still in the Solomons, ordered her to go. They maintained that she was violating "present restrictions on white women remaining in the Protectorate" (Lord 1977:99). Like Osa Johnson a quarter of a century before, Merle Farland discovered that in some people's eyes at least the Solomons were still "no place for a woman" (Johnson 1944:16).

Conclusion

European women in the Solomons were members of and contributors to a stratified, racialist, nineteenth-century society. Prevailing social values cast them in traditional roles as childbearers, homemakers, and guardians of morality. Many of the women in question conformed to these expectations and behaviors, particularly the women in Tulagi. Moreover, Tulagi provided the only setting in which anything approaching the Victorian ideal of the "lady of leisure" was possible. Elsewhere, the environment placed a high premium on "masculine" qualities of toughness and strength. It was said that the worst thing you could have on a boat was "missionaries and women" (Seton transcript: 18 June 1978). Both implied weakness and incompetence in the male mind.

Women in the outlying mission stations and plantations had few opportunities to indulge in the "feminine pursuits" appropriate to Sydney or London. They found themselves at once constrained and liberated. During those times when their husbands (or male colleagues) were present, they performed traditionally feminine roles. However, when their menfolk were absent, women moved into the male domain, acting as surrogate males and performing "men's work." The frontier supported a strong sense of self and an ability to adapt to unusual conditions.

Some European women, such as Ida Wench and Christine Woods, came to the Solomons knowing more or less what to expect (Wench 1961:5).[16]

[16]"Full details of this experiment [Melanesian Mission women teaching in the Solomons] eventually reached me [in England], either from the lips of visiting missionaries or from factual accounts included in the Melanesian Mission pamphlets that were sent to my mother regularly. I followed the whole story with gradually mounting excitement, for at last the way to the islands had been opened up to members of my own sex" (Wench 1961:5).

Others, such as Vera Clift, were profoundly ignorant of what lay ahead. All of them brought cultural values about the nature of womanhood, values that were reinforced in the islands. Women were, in many instances, the principal authors of what contemporary feminists would call their own servitude. They learned traditional roles from other women and passed them on to their own children.

There is a danger of romanticizing these frontier women. The eighteenth century romanticized the rural rustic, the nineteenth century the cloth-capped proletarian, and the twentieth century the revolutionary, liberationist figure, whether Vietnamese or female. All of these figures share one thing in common. They served and serve as mirrors for society, highlighting its shortcomings and, in the process, escaping adequate scrutiny themselves. European women in the Solomons were tough, resourceful, and competent. They endured separation, illness, and hardship with fortitude. But so also did the European men who lived there. It is extremely important that the story of European women in the South Seas be told. Their impact was far-reaching and profound. Yet one must guard against overstating their case. What is needed is to rescue them from obscurity so that their contribution to the colonial experience, for Europeans and Solomon Islanders alike, may be fairly judged.

References

Alkire, William H.
 1978 *Coral Islanders*. Arlington Heights, Illinois: AHM Publishing Corporation.

Allen, Charles
 1975 *Plain Tales from the Raj*. London: Deutsch.

Allen, Percy S., ed.
 1919 *Stewart's Hand Book of the Pacific Islands: A Reliable Guide to All the Inhabited Islands of the Pacific Ocean, for Traders, Tourists, and Settlers*. Sydney: MCarron, Stewart and Co., Ltd.

Allison, Susan
 1976 *A Pioneer Gentlewoman in British Columbia: The Recollections of Susan Allison*. Edited by Margaret A. Ormsby. Vancouver: University of British Columbia Press.

Anggo, David
 1975 *Kafaina*: Group Action by Women in Chuave. *Yagl-Ambu* 2(3): 207–223.

Annales des Sacrés-Coeurs
 1932 Braine-le-Comte and Evreux, France: Society of the Holy Hearts of Jesus and Mary.

[Anonymous]
 1953 New and Interesting Identifications. Plant Pathogens. Phytophthora Colocasire. *Papua and New Guinea Agricultural Gazette* 8(2).

Ardener, Edwin
 1972 Belief and the Problem of Women. In *The Interpretation of Ritual: Essays in Honour of A. I. Richards*, ed. J. S. La Fontaine, pp. 135–158. London: Tavistock Publications, Ltd.

 1975 The "Problem" Revisited. In *Perceiving Women*, ed. Shirley Ardener, pp. 19–27. New York: John Wiley and Sons, Inc., Halsted Press.

Ashley, F. N.
 1972 Transcript of interview in J. Boutilier's possession.

Avery, J. G.
 1978 Malaria in the Solomon Islands. *The Practitioner* 220 (June): 942–949.

Barker, E. T.

n.d. *The Beautiful Solomon Islands.* Sydney: Burns, Philp and Co., Ltd.

Barnett, Homer G.

1960 *Being a Palauan.* New York: Holt, Rinehart and Winston, Inc.

Baro, Eta

1975 Lolohea Akosita Waqairawai. In *Women's Role in Fiji,* by Jyoti Amratlal, Eta Baro, Vanessa Griffin, and Geet Bala Singh, pp. 33–39. Suva, Fiji: South Pacific Social Sciences Association.

Barwick, Diane E.

1974 "And the Lubras Are Ladies Now." In *Woman's Role in Aboriginal Society,* ed. Fay Gale, pp. 51–63. Australian Aboriginal Studies, no. 36. Social Anthropology Series, no. 6. 2d ed. Canberra: Australian Institute of Aboriginal Studies.

Bateson, Gregory

1958 *Naven: A Survey of the Problems Suggested by a Composite Picture of the Culture of a New Guinea Tribe Drawn from Three Points of View.* 2d ed. (1st ed., 1936). Stanford: Stanford University Press.

Beaglehole, Ernest

1957 *Social Change in the South Pacific: Rarotonga and Aitutaki.* London: Allen and Unwin.

Beaver, Robert Pierce

1968 *All Loves Excelling: American Protestant Women in World Mission.* Grand Rapids, Michigan: Eerdmans.

Bell, Diane

1980 Desert Politics: Choices in the "Marriage Market." In *Women and Colonization: Anthropological Perspectives,* ed. Mona Etienne and Eleanor Leacock, pp. 239–269. Praeger Special Studies. Brooklyn, New York: J. F. Bergin Publishers.

Bergmann, H. F. W.

1955 Annual Report, Ega Lutheran Circuit. Mimeographed. Kundiawa, Papua New Guinea: Evangelical Lutheran Church of New Guinea Office.

Bergmann, Irmgard

1969 Women's Work in a Changing Rural Society. Mimeographed. Lae, Papua New Guinea: Lutheran Mission New Guinea.

Berndt, Ronald M.

1962 *Excess and Restraint: Social Control among a New Guinea Mountain People.* Chicago: University of Chicago Press.

Berndt, Ronald M., and Peter Lawrence, eds.

1973 *Politics in New Guinea. Traditional and in the Context of Change: Some Anthropological Perspectives.* Seattle: University of Washington Press.

Blackwood, Beatrice
 1935 *Both Sides of Buka Passage: An Ethnographic Study of Social, Sexual,
 and Economic Questions in the North-Western Solomon Islands.* Oxford:
 Clarendon Press.
Blake, Frances
 1977 Transcript of interview in J. Boutilier's possession.
Blanc, Joseph Felix
 1926 *Histoire Religieuse de l'Archipel Fidjien.* 2 vols. Toulon: Imprimerie
 Sainte-Jeanne-d'Arc.
Bolton, Geoffrey C.
 1970 *A Thousand Miles Away: A History of North Queensland to 1920.*
 Canberra: Australian National University Press.
Boserup, Ester
 1970 *Woman's Role in Economic Development.* New York: St. Martin's
 Press, Inc.
Bossen, Laurel
 1975 Women in Modernizing Societies. *American Ethnologist* 2:587–
 601.
Boutilier, James A.
 1978 Missions, Administration, and Education in the Solomon Is-
 lands, 1893–1942. In *Mission, Church, and Sect in Oceania*, ed.
 James A. Boutilier, Daniel T. Hughes, and Sharon W. Tiffany,
 pp. 139–161. ASAO Monograph, no. 6. Ann Arbor: University
 of Michigan Press.
 1979 Killing the Government: Imperial Policy and the Pacification of
 Malaita. In *The Pacification of Melanesia*, ed. Margaret Rodman
 and Matthew Cooper, pp. 43–87. ASAO Monograph, no. 7.
 Ann Arbor: University of Michigan Press.
Bowen, Elenore Smith [Laura Bohannan]
 1954 *Return to Laughter: An Anthropological Novel.* Reprint. Garden
 City, New York: Doubleday and Co., Inc., Anchor Books, for
 the American Museum of Natural History, 1964.
Brereton, Virginia Lieson, and Christa Ressmeyer Klein
 1979 American Women in Ministry: A History of Protestant Begin-
 ning Points. In *Women of Spirit: Female Leadership in the Jewish
 and Christian Traditions*, ed. Rosemary Reuther and Eleanor
 McLaughlin, pp. 301–332. New York: Simon and Schuster.
British Solomon Islands Protectorate (BSIP)
 1950–51 *The Laws of the British Solomon Islands Protectorate.* 2 vols. Rev.
 ed. Suva, Fiji: Government Printer.
Brookfield, Harold C., and Doreen Hart
 1971 *Melanesia: A Geographical Interpretation of an Island World.* London:

Metheun and Co., Ltd.
Brown, Paula
1972 *The Chimbu: A Study of Change in the New Guinea Highlands.* Cambridge, Massachusetts: Schenkman Publishing Co., Inc.
1978 *Highland Peoples of New Guinea.* Cambridge: Cambridge University Press.
Brown, Paula, and Georgeda Buchbinder, eds.
1976 Introduction. In *Man and Woman in the New Guinea Highlands,* ed. Paula Brown and Georgeda Buchbinder, pp. 1–12. American Anthropological Association, Special Publication, no. 8. Washington, D.C.: American Anthropological Association.
Bujra, Janet M.
1979 Introductory: Female Solidarity and the Sexual Division of Labor. In *Women United, Women Divided: Comparative Studies of Ten Contemporary Cultures,* ed. Patricia Caplan and Janet M. Bujra, pp. 13–45. Bloomington: Indiana University Press.
Burrows, Edwin Grant
1963 *Flower in My Ear: Arts and Ethos of Ifaluk Atoll.* University of Washington Publications in Anthropology, vol. 14. Seattle: University of Washington Press.
Catholic Mission New Britain
1962 Vunapope, New Britain: Catholic Mission Press.
Centenaire
1966 *Centenaire des Écoles Protestantes à Tahiti.* Papeete: "La Dépêche."
Cesara, Manda [Karla O. Poewe]
1982 *Reflections of a Woman Anthropologist: No Hiding Place.* London: Academic Press, Inc.
Chafe, William Henry
1972 *The American Woman: Her Changing Social, Economic, and Political Roles, 1920–1970.* London: Oxford University Press.
Chowning, Ann
1977 *An Introduction to the Peoples and Cultures of Melanesia.* 2d ed. Menlo Park, California: Cummings.
Clarke, William C.
1971 *Place and People: An Ecology of a New Guinean Community.* Berkeley and Los Angeles: University of California Press.
Clay, Brenda Johnson
1977 *Pinikindu: Maternal Nurture and Paternal Substance.* Chicago: University of Chicago Press.
Clift, Vera M.
1978 Transcript of interview in J. Boutilier's possession.

Cloudsley-Thompson, J. L.
 1976 *Insects and History*. New York: St. Martin's Press, Inc.
Counts, Dorothy Ayers
 1980*a* *Akro* and *Gagandewa*: A Melanesian Myth. *Journal of the Polynesian Society* 89:33–65.
 1980*b* Fighting Back Is Not the Way: Suicide and the Women of Kaliai. *American Ethnologist* 7:332–351.
Counts, D., and D.
 1974 The Kaliai Lupunga: Disputing in the Public Forum. In *Contention and Dispute: Aspects of Law and Social Control in Melanesia*, ed. A. L. Epstein, pp. 113–151. Canberra: Australian National University Press.
Courtais, E., and Guy de Bigault
 1936 *Centenaire des Missions Maristes en Océanie*. Paris: Emmanuel Vitte.
Cross, Michael S., ed.
 1970 *The Frontier Thesis and the Canadas: The Debate on the Impact of the Canadian Environment*. Toronto: Copp Clark Publishing Co.
Darnand, Joseph
 1934 *Aux Iles Samoa: La forêt qui s'illumine*. Lyon: Emmanuel Vitte.
David, Caroline Martha (Mrs. T. W. Edgeworth David)
 1899 *Funafuti; or, Three Months on a Coral Island: An Unscientific Account of a Scientific Expedition*. London: John Murray.
Deane, Reverend Wallace
 1921 *Fijian Society; or, the Sociology and Psychology of the Fijians*. London: MacMillan and Co.
de Bigault, Guy
 1947 *Drames de la Vie Salomonaise*. Namur: Grands Lacs.
Deck, Gladys
 1974 Transcript of interview in J. Boutilier's possession.
Deck, Joan
 1973 Transcript of interview in J. Boutilier's possession.
 1975 War Alarms in the Solomons. *Willandra Village News* 41 (1 March):9. Mimeograph in J. Boutilier's possession.
 1978 Transcript of interview in J. Boutilier's possession.
Diocese of New Guinea
 1935 Conference, 1935. Mimeographed. Stanmore, New South Wales: Australian Board of Missions.
Distroff [pseud.]
 1971 The Confusion of Cultures. *New Guinea* 6:39–42.
Donaldson, Mike, and Kenneth Good
 1978 Class and Politics in the Eastern Highlands of Papua New

Guinea. Manuscript. Waigani: Departments of History and Politics, University of Papua New Guinea.

Douceré, Victor
1934 *La Mission Catholique aux Nouvelles-Hébrides; d'après des Documents Écrits et les Vieux Souvenirs de l'Auteur.* Lyon, France: Emmanuel Vitte.

Douglas, Mary
1969 Is Matriliny Doomed in Africa? In *Man in Africa*, ed. Mary Douglas and Phyllis M. Kaberry, pp. 121–135. London: Tavistock Publications, Ltd.

Downs, E. A.
1948 Commission VI Report. Papers of South Pacific Missionary Conference, Morpeth, Australia, 1948. Mimeographed. Sydney: Australian Council of Churches.

Downs, Ian
1953 Annual Report, Eastern Highlands District. Mimeographed. Goroka, Papua New Guinea: Goroka District Office.

Draper, Patricia
1975 !Kung Women: Contrasts in Sexual Egalitarianism in Foraging and Sedentary Contexts. In *Toward an Anthropology of Women*, ed. Rayna R. Reiter, pp. 77–109. New York: Monthly Review Press.

Dubois, L. L.
1928 Activité Protestante en Polynésie Occidentale et Mélanésie: Réactions et Espoirs Catholiques. *Revue d'Histoire des Missions* 5:369–406.

Edgerton, Robert B.
1976 *Deviance: A Cross-Cultural Perspective.* Menlo Park, California: Cummings Publishing Co.

Edgerton, Robert B., and L. L. Langness
1974 *Methods and Styles in the Study of Culture.* San Francisco: Chandler & Sharp.

Edholm, Felicity, Olivia Harris, and Kate Young
1977 Conceptualising Women. *Critique of Anthropology* 3(9–10): 101–130.

Ellis, Reverend William
1836 *Memoir of Mrs. Mary Ellis, Wife of Rev. William Ellis . . . including . . . the Details of Missionary Life.* Boston: Crocker and Brewster.

Engels, Frederick
1884 *The Origin of the Family, Private Property, and the State.* Edited and introduction by Eleanor Burke Leacock. Reprint. New York: International Publishers Co., Inc., 1972.

Epstein, T. Scarlett
 1968 *Capitalism, Primitive and Modern: Some Aspects of Tolai Economic Growth.* East Lansing: Michigan State University Press.
Etienne, Mona, and Eleanor Leacock, eds.
 1980 *Women and Colonization: Anthropological Perspectives.* Praeger Special Studies. New York: J. F. Bergin Publishers, Inc.
Evangelical Church of New Caledonia and the Loyalty Islands
 1960– *La Vie Protestante. Journal Mensuel de L'Église Évangélique en Nouvelle Calédonie et aux Iles Loyauté.* Noumea, New Caledonia.
Faithorn, Elizabeth
 1976 Women as Persons: Aspects of Female Life and Male-Female Relations among the Kafe. In *Man and Woman in the New Guinea Highlands,* ed. Paula Brown and Georgeda Buchbinder, pp. 86–95. American Anthropological Association Special Publication, no. 8. Washington, D.C.: American Anthropological Association.
Feil, Daryl Keith
 1978*a* Women and Men in the Enga *Tee. American Ethnologist* 5:263–279.
 1978*b* Enga Women in the *Tee* Exchange. *Mankind* 11:220–230.
 1978*c* 'Straightening the Way': An Enga Kinship Conundrum. *Man* (n.s.) 13:380–401.
 1980 Symmetry and Complementarity: Patterns of Competition and Exchange in the Enga *Tee. Oceania* 51:20–39.
Fiji Times
 1965 Suva, Fiji.
Finney, Ben R.
 1973 *Big-Men and Business: Entrepreneurship and Economic Growth in the New Guinea Highlands.* Honolulu: University Press of Hawaii.
Finney, Ben R., Uro Mikave, and Akaropa Sabumei
 1974 Pearl Shell in Goroka: From Valuables to Chicken Feed. *Yagl-Ambu* 1(4):342–349.
Firth, Raymond
 1957 *We, the Tikopia: A Sociological Study of Kinship in Primitive Polynesia.* 2d ed. (1st ed., 1936.) Reprint. Boston: Beacon Press, Inc., 1963.
 1959 *Economics of the New Zealand Maori.* 2d ed. (1st ed., 1929.) Wellington: A. R. Shearer, Government Printer.
 1965 *Primitive Polynesian Economy.* 2d ed. (1st ed., 1939.) London: Routledge and Kegan Paul, Ltd.
Fluehr-Lobban, Carolyn
 1977 Agitation for Change in the Sudan. In *Sexual Stratification: A Cross-Cultural View,* ed. Alice Schlegel, pp. 127–143. New York: Columbia University Press.

Forge, Anthony
 1972 The Golden Fleece. *Man* (n.s.) 7:527–540.
Forman, Charles W.
 1969 Theological Education in the South Pacific Islands: A Quiet Revolution. *Journal de la Société des Océanistes* 25:151–167.
 1970 The Missionary Force of the Pacific Island Churches. *International Review of Missions* 59:215–226.
 1978 Foreign Missionaries in the Pacific Islands during the Twentieth Century. In *Mission, Church, and Sect in Oceania*, ed. James A. Boutilier, Daniel T. Hughes, and Sharon W. Tiffany, pp. 35–63. ASAO Monograph, no. 6. Ann Arbor: University of Michigan Press.
Fortune, Reo F.
 1963 *Sorcerers of Dobu: The Social Anthropology of the Dobu Islanders of the Western Pacific.* Rev. ed. (1st ed., 1932.) London: Routledge and Kegan Paul, Ltd.
France, Peter
 1969 *The Charter of the Land: Custom and Colonization in Fiji.* Melbourne: Oxford University Press.
Freeman, Derek
 1983 *Margaret Mead and Samoa: The Making and Unmaking of an Anthropological Myth.* Cambridge, Massachusetts: Harvard University Press.
Freilich, Morris, ed.
 1970 *Marginal Natives: Anthropologists at Work.* New York: Harper and Row, Publishers, Inc.
Friedl, Ernestine
 1975 *Women and Men: An Anthropologist's View.* New York: Holt, Rinehart and Winston, Inc.
Gething, Judith R.
 1977 Christianity and Coverture: Impact on the Legal Status of Women in Hawaii, 1820–1920. *Hawaiian Journal of History* 11:188–220.
Gewertz, Deborah
 1981 A Historical Reconsideration of Female Dominance among the Chambri of Papua New Guinea. *American Ethnologist* 8:94–106.
Gillison, Gillian
 1980 Images of Nature in Gimi Thought. In *Nature, Culture, and Gender*, ed. Carol P. MacCormack and Marilyn Strathern, pp. 143–173. Cambridge: Cambridge University Press.
Golde, Peggy, ed.
 1970 *Women in the Field: Anthropological Experiences.* Chicago: Aldine

Publishing Co., Inc.

Goldhart, the Reverend
1947, *Annual Reports, Asaroka Lutheran Mission.* Lae, Papua New
1950– Guinea: Evangelical Lutheran Church of New Guinea Head-
1953 quarters.

Goldman, Irving
1970 *Ancient Polynesian Society.* Chicago: University of Chicago Press.

Goodale, Jane C.
1980 Gender, Sexuality, and Marriage: A Kaulong Model of Nature
 and Culture. In *Nature, Culture, and Gender*, ed. Carol P. Mac-
 Cormack and Marilyn Strathern, pp. 119–142. Cambridge:
 Cambridge University Press.

Goodall, Norman
1954 *A History of the London Missionary Society, 1895–1945.* London:
 Oxford University Press.

Gough, Kathleen
1961 The Modern Disintegration of Matrilineal Descent Groups. In
 Matrilineal Kinship, ed. David M. Schneider and Kathleen
 Gough, pp. 631–652. Berkeley and Los Angeles: University of
 California Press.

Goyau, Georges
1938 *Le Christ Chez les Papous.* Paris: Beauchesne et Ses Fils.

Granbois, Donald H., and R. P. Willet
1970 Equivalence of Family Role Measures Based on Husband and
 Wife Data. *Journal of Marriage and the Family* 32:68–72.

Groenewegen, K.
n.d. *Report on the Census of the Population, 1970.* Western Pacific High
 Commission, British Solomon Islands Protectorate. South-
 ampton: Hobbs.

Handy, Edward S. C., and Elizabeth G. Handy
1972 *Native Planters in Old Hawaii: Their Life, Lore, and Environment.*
 Assisted by Mary Kawena Pukui. Bernice P. Bishop Museum
 Bulletin, no. 233. Honolulu: Bernice P. Bishop Museum Press.

Harris, Marvin
1968 *The Rise of Anthropological Theory.* New York: Thomas Y. Crowell
 Co.

Harris, Olivia
1978 Complementarity and Conflict: An Andean View of Women
 and Men. In *Sex and Age as Principles of Social Differentiation*, ed.
 J. S. La Fontaine, pp. 21–40. ASA Monograph, no. 17. London:
 Academic Press, Inc.
1980 The Power of Signs: Gender, Culture, and the Wild in the

Bolivian Andes. In *Nature, Culture, and Gender*, ed. Carol P. MacCormack and Marilyn Strathern, pp. 70–94. Cambridge: Cambridge University Press.

Hart, C. W. M., and Arnold R. Pilling
1960 *The Tiwi of North Australia*. New York: Holt, Rinehart and Winston, Inc.

Hays, Terence E., and Patricia H. Hays
1982 In Opposition and Complementarity of the Sexes in Ndumba Initiation. *In Rituals of Manhood: Male Initiation in Papua New Guinea*, ed. Gilbert H. Herdt, pp. 201–238. Berkeley, Los Angeles, London: University of California Press.

Hecht, Julia A.
1977 The Culture of Gender in Pukapuka: Male, Female, and the *Mayakitanga* 'Sacred Maid'. *Journal of the Polynesian Society* 86:183–206.

Henry, Teuria
1928 *Ancient Tahiti*. Bernice P. Bishop Museum Bulletin, no. 48. Honolulu: Bernice P. Bishop Museum.

Hetherington, Eleanor
1977 Transcript of interview in J. Boutilier's possession.

Hilliard, D. L.
1966 Protestant Missions in the Solomon Islands, 1849–1942. Ph.D. dissertation, Australian National University.

Hoffer, Carol P.
1974 Madame Yoko: Ruler of the Kpa Mende Confederacy..In *Woman, Culture, and Society*, ed. Michelle Zimbalist Rosaldo and Louise Lamphere, pp. 173–187. Stanford: Stanford University Press.

Hofmann, Reverend Georg
1937– Annual Reports, Asaroka Lutheran Mission. Mimeographed.
1938 Lae, Papua New Guinea: Evangelical Lutheran Church of New Guinea Headquarters.

Hogbin, H. Ian
1951 *Transformation Scene: The Changing Culture of a New Guinea Village*. London: Routledge and Paul.
1958 *Social Change*. London: Watts.
1963 *Kinship and Marriage in a New Guinea Village*. London: University of London, Athlone Press.
1967 Tillage and Collection in Wogeo. In *Studies in New Guinea Land Tenure*, ed. Ian Hogbin and Peter Lawrence, pp. 45–90. Sydney: Sydney University Press.

Hough, Alexander
1931 Samoa's Diapason. *Chronicle of the London Missionary Society*

96:147.

Howlett, Diana R.
1962 A Decade of Change in the Goroka Valley, New Guinea: Land Use and Development in the 1950s. Ph.D. dissertation, Australian National University.
1973 Terminal Development: From Tribalism to Peasantry. In *The Pacific in Transition: Geographical Perspectives on Adaptation and Change*, ed. Harold C. Brookfield, pp. 249–273. New York: St. Martin's Press, Inc.

Howlett, Diana R., Robin Hide, Elspeth Young, et al.
1976 *Chimbu: Issues in Development*. Development Studies Centre Monograph, no. 4. Canberra: Australian National University.

Hughes, Ian
1973 Stone-Age Trade in the New Guinea Inland: Historical Geography without History. In *The Pacific in Transition: Geographical Perspectives on Adaptation and Change*, ed. Harold C. Brookfield, pp. 97–126. New York: St. Martin's Press, Inc.

Inglis, Amirah
1974 *The White Women's Protection Ordinance: Sexual Anxiety and Politics in Papua*. London: Chatto and Windus, Ltd., for Sussex University Press.

Inselmann, Rudolf
1948 Changing Missionary Methods in Lutmis, New Guinea. Bachelor of Divinity thesis, Wartburg Seminary, Dubuque, Iowa.

Ito, Karen
1980 Historical Perspectives on the Political Power of Hawaiian Women. Paper read at the meetings of the Association for Social Anthropology in Oceania, Galveston, Texas. Mimeographed.

Jeffreys, M. D. W.
1952 Samsonic Suicide or Suicide of Revenge among Africans. *African Studies* 11:118–122.

Jinks, Brian, Peter Biskup, and Hank Nelson, eds.
1973 *Readings in New Guinea History*. Sydney: Angus and Robertson.

Johnson, Osa Helen Leighty
1944 *Bride in the Solomons*. Garden City, New York: Garden City Publishing Co.

Kaberry, Phyllis M.
1939 *Aboriginal Woman: Sacred and Profane*. London: George Routledge and Sons, Ltd.

Keesing, Felix M.
1937 The *Taupo* System of Samoa: A Study of Institutional Change.

Oceania 8:1–14.

1945 *The South Seas in the Modern World*. Rev. ed. New York: John Day Co.

Keil, Jared Tao

1975 Local Group Composition and Leadership in Buin. Ph.D. dissertation, Harvard University.

Kelly, Raymond C.

1977 *Etoro Social Structure: A Study in Structural Contradiction*. Ann Arbor: University of Michigan Press.

Kent, Patricia

1966 The Church in the Pacific. *Manna* 6:27–28. Sydney: University of Sydney.

Kiernan, E. Victor Gordon

1972 *The Lords of Human Kind: European Attitudes towards the Outside World in the Imperial Age*. 1st ed. Harmondsworth, Middlesex: Penguin Books, Inc.

Kuhn, Thomas S.

1970 *The Structure of Scientific Revolutions*. Foundations of the Unity of Science, vol. 2, no. 2. 2d ed. Chicago: University of Chicago Press.

Labby, David

1976 *The Demystification of Yap: Dialectics of Culture on a Micronesian Island*. Chicago: University of Chicago Press.

La Fontaine, J. S.

1978 Introduction. In *Sex and Age as Principles of Social Differentiation*, ed. J. S. La Fontaine, pp. 1–20. ASA Monograph, no. 17. London: Academic Press.

1981 The Domestication of the Savage Male. *Man* 16:333–349.

Lamphere, Louise

1974 Strategies, Cooperation, and Conflict among Women in Domestic Groups. In *Woman, Culture, and Society*, ed. Michelle Zimbalist Rosaldo and Louise Lamphere, pp. 97–112. Stanford: Stanford University Press.

Landes, Albert, S. M.

1931 . . . Wallis. *Missions Catholiques* 63:585–590, 610–613.

Langness, L. L.

1967 Sexual Antagonism in the New Guinea Highlands: A Bena Bena Example. *Oceania* 37:161–177.

1974 Ritual, Power, and Male Dominance in the New Guinea Highlands. *Ethos* 2:189–212.

1976 Discussion. In *Man and Woman in the New Guinea Highlands*, ed. Paula Brown and Georgeda Buchbinder, pp. 96–106. American

Anthropological Association Special Publication, no. 8. Washington, D.C.: American Anthropological Association.

Langness, L. L., and John C. Weschler, eds.
1971 *Melanesia: Readings on a Culture Area*. Scranton: Chandler.

Laracy, Eugénie, and Hugh Laracy
1977 Beatrice Grimshaw: Pride and Prejudice in Papua. *Journal of Pacific History* 12:154–175.

Laracy, Hugh M.
1969 Catholic Missions in the Solomon Islands, 1845–1966. Ph.D. dissertation, Australian National University.

Lātūkefu, Sione
1978 The Impact of South Sea Islands Missionaries on Melanesia. In *Mission, Church, and Sect in Oceania*, ed. James A. Boutilier, Daniel T. Hughes, and Sharon W. Tiffany, pp. 91–108. ASAO Monograph, no. 6. Ann Arbor: University of Michigan Press.

Lawrence, Peter, and Mervyn J. Meggitt
1965 Introduction. In *Gods, Ghosts, and Men in Melanesia: Some Religions of Australian New Guinea and the New Hebrides*, ed. Peter Lawrence and Mervyn J. Meggitt, pp. 1–26. Melbourne: Oxford University Press.

Laycock, Donald
1973 *Sepik Languages: Checklist and Preliminary Classification*. Pacific Linguistics Series B, Monograph no. 25. Department of Linguistics, Research School of Pacific Studies. Canberra: Australian National University.

Leach, E. R.
1954 *Political Systems of Highland Burma: A Study of Kachin Social Structure*. Reprint. Boston: Beacon Press, Inc., 1964.
1966 *Rethinking Anthropology*. London School of Economics Monograph on Social Anthropology, no. 22. London: Athlone Press, University of London.

Leacock, Eleanor Burke
1972 Introduction. In *The Origin of the Family, Private Property, and the State*, by Frederick Engels, pp. 7–67. Edited by Eleanor Burke Leacock. New York: International Publishers Co., Inc.
1978 Women's Status in Egalitarian Society: Implications for Social Evolution. *Current Anthropology* 19:247–275.

Leahy, Michael J., and Maurice Crain
1937 *The Land That Time Forgot: Adventures and Discoveries in New Guinea*. New York: Funk and Wagnalls Co.

LeBeuf, Annie M. D.
1963 The Role of Women in the Political Organization of African

Societies. In *Women of Tropical Africa*, ed. Denise Paulme. Translated by H. M. Wright, pp. 93–119. Berkeley and Los Angeles: University of California Press.

Leenhardt, Maurice
1979 *Do Kamo: Person and Myth in the Melanesian World.* Translated by Basia Miller Gulati. (French ed., 1947.) Chicago: University of Chicago Press.

Lesourd, Paul
1931 *L'évangelisation des Colonies Francaises. Bulletin de l'Association Charles de Foucauld.* Seventh Year (March-December). Numéro Special. . . . Paris: Association Charles de Foucauld.

Levy, Robert I.
1973 *Tahitians: Mind and Experience in the Society Islands.* Chicago: University of Chicago Press.

Lindenbaum, Shirley
1976 A Wife is the Hand of the Man. In *Man and Woman in the New Guinea Highlands*, ed. Paula Brown and Georgeda Buchbinder, pp. 54–62. American Anthropological Association Special Publication, no. 8. Washington, D.C.: American Anthropological Association.

London, Charmian Kittredge
[1915] *Voyaging in Wild Seas; or, a Woman Among the Head Hunters. A Narrative of the Voyage of the Snark in the Years 1907–1909.* London: Mills and Boon, Ltd.

London, Jack
1911 *Adventure.* New York: McKinlay, Stone and MacKenzie.

London Missionary Society
1966 *A Missionary Voyage to the Southern Pacific Ocean, 1796–1798.* Introduction by Irmgard Moschner. Graz, Austria: Akademische Druck- und Verlagsanstalt.

Long, Gavin
1963 *The Final Campaigns: Australia in the War of 1939–1945.* Army Series, no. 1, vol. 7. Canberra: Australian War Memorial.

Lord, Walter
1977 *Lonely Vigil: Coastwatchers of the Solomons.* New York: Viking Press.

Lovett, Richard
1899 *The History of the London Missionary Society, 1795–1895.* 2 vols. London: Henry Frowde.

Luxton, Clarence T. J.
1955 *Isles of Solomon: A Tale of Missionary Adventure.* Auckland: Methodist Foreign Missionary Society of New Zealand.

MacCormack, Carol P., and Marilyn Strathern, eds.
 1980 *Nature, Culture, and Gender*. Cambridge: Cambridge University Press.

MacDonald, Mary
 1975 Training for Mutual Ministry: Working with Women in the Southern Highlands. *Point*, no. 2, pp. 102–109. Goroka, Papua New Guinea: Melanesian Institute for Pastoral and Socio-Economic Service.

McDowell, Nancy
 1975 Kinship and the Concept of Shame in a New Guinea Village. Ph.D. dissertation, Cornell University.
 1976 Kinship and Exchange: The *Kamain* Relationship in a Yuat River Village. *Oceania* 47:36–48.
 1977 The Meaning of 'Rope' in a Yuat River Village. *Ethnology* 16:175–183.
 1978*a* The Struggle to Be Human: Exchange and Politics in Bun. *Anthropological Quarterly* 51:16–25.
 1978*b* Flexibility of Sister Exchange in Bun. *Oceania* 48:207–231.
 1979 The Significance of Cultural Context: A Note on Food Taboos in Bun. *Journal of Anthropological Research* 35:231–237.
 1980 It's Not Who You Are but How You Give That Counts: The Role of Exchange in a Melanesian Society. *American Ethnologist* 7:58–70.

McHugh, Winifred
 1965 Memoir of Rev. A. J. Small. Mimeographed. Suva, Fiji: Methodist Church.

Malinowski, Bronislaw
 1922 *Argonauts of the Western Pacific: An Account of Native Enterprise and Adventure in the Archipelagoes of Melanesian New Guinea*. London: Routledge and Kegan Paul, Ltd.
 1967 *A Diary in the Strict Sense of the Term*. Preface by Valetta Malinowski. Introduction by Raymond Firth. Translated by Norbert Guterman. New York: Harcourt, Brace, and World, Inc.

Mannoni, Dominique O.
 1964 *Prospero and Caliban: The Psychology of Colonization*. Translated by Pamela Powesland. 2d ed. (French ed., 1950.) New York: Frederick A. Praeger, Inc., Publishers.

Marchand, Léon
 1911 *L'évangelisation des Indigénes par les Indigénes dans les Îles Centrales du Pacifique (de Tahiti, à Nouvelle Calédonie). . . .*Montauban, France: Orphelins.

Marcus, George E.
 1980 Rhetoric and the Ethnographic Genre in Anthropological Re-
 search. *Current Anthropology* 21(4):507–510.
Martin, M. Kay, and Barbara Voorhies
 1975 *Female of the Species.* New York: Columbia University Press.
Martin, M. Marlene
 1978 Women in the HRAF Files: A Consideration of Ethnographer
 Bias. *Behavior Science Research* 13:303–313.
Martin, Pierre
 1960 Relatio de Statu Vicariatus Apostolici Novae Caledoniae A.D.
 1960. Report to Congregation for the Propagation of the Faith.
 Mimeographed. Paris: Library of the Society for the Propagation
 of the Faith.
Mata'afa, Fetaui
 1966 My Impressions of the Lifou Conference, 1966. *Pacific Journal
 of Theology*, nos. 19–20 (June–September):5–6.
Mathieu, Nicole-Claude
 1978 Man-Culture and Woman-Nature. Translated by D. M. Leon-
 ard Barker. *Women's Studies International Quarterly* 1:55–65.
 1979 Biological Paternity, Social Maternity: On Abortion and Infan-
 ticide as Unrecognized Indicators of the Cultural Character for
 Maternity. Translated by Diana Leonard. In *The Sociology of the
 Family: New Directions for Britain*, ed. Christopher C. Harris,
 with Michael Anderson, Robert Chester, D. H. J. Morgan, and
 Diana Leonard, pp. 232–240. Sociological Review Monograph,
 no. 28. Keele, England: University of Keele.
Mead, Margaret
 1928 *Coming of Age in Samoa: A Psychological Study of Primitive Youth
 for Western Civilization.* New York: William Morrow and Co.,
 Inc.
 1930 *Growing Up in New Guinea: A Comparative Study of Primitive
 Education.* New York: William Morrow and Co.
 1935 *Sex and Temperament in Three Primitive Societies.* New York:
 William Morrow and Co.
 1972 *Blackberry Winter: My Earlier Years.* New York: William Morrow
 and Co., Inc.
 1974 On Freud's View of Female Psychology. In *Women and Analysis:
 Dialogues on Psychoanalytic Views of Femininity*, ed. Jean Strouse,
 pp. 95–106. New York: Grossman.
Meggitt, Mervyn J.
 1962 *Desert People: A Study of the Walbiri Aborigines of Central Australia.*
 Chicago: University of Chicago Press.

1965 *The Lineage System of the Mae-Enga of New Guinea.* New York: Barnes and Noble, Inc.

1971 From Tribesmen to Peasants: The Case of the Mae Enga of New Guinea. In *Anthropology in Oceania: Essays Presented to Ian Hogbin*, ed. L. R. Hiatt and Chandra Jayawardena, pp. 191–209. San Francisco: Chandler Publishing Co.

Meigs, Anna S.

1976 Male Pregnancy and the Reduction of Sexual Opposition in a New Guinea Highlands Society. *Ethnology* 15:393–407.

Melanesian Messenger

1964 The Melanesian Messenger. Honiara, The Solomon Islands: Melanesian Mission.

Menninger, Karl A.

1966 *Man Against Himself.* New York: Harcourt, Brace and World.

Mihalic, F., S.V.D.

1971 *The Jacaranda Dictionary and Grammar of Melanesian Pidgin.* Melbourne: Jacaranda Press.

Milton, Kay

1979 Male Bias in Anthropology? *Man* (n.s.) 14:40–54.

Missionary Review

1917 *Missionary Review of the Methodist Church of Australasia.* Sydney.

Missions des Îles

1964 Paris: Society of Mary.

Mitchell, Donald D.

1976 *Land and Agriculture in Nagovisi, Papua New Guinea.* Papua New Guinea Institute of Applied Social and Economic Research, Monograph no. 3. Boroko, Papua New Guinea.

Monoghan, C.

1955 Women's Committees of Western Samoa. *South Pacific Bulletin* 5(2):22–23.

Montgomery, Helen Barrett

1911 *Western Women in Eastern Lands: An Outline Study of Fifty Years of Woman's Work in Foreign Missions.* New York: MacMillan Co.

Munster, Judith

1975 A Band of Hope, Wok Meri. *Point* 2:132–146. Goroka, Papua New Guinea: Melanesian Institute for Pastoral and Socio-Economic Service.

Murdock, George Peter

1949 *Social Structure.* New York: MacMillan Publishing Co., Free Press.

Mytinger, Caroline

1942 *Headhunting in the Solomon Islands around the Coral Sea.* New York:

MacMillan Co.

Nash, Jill
1974 *Matriliny and Modernisation: The Nagovisi of South Bougainville.*
 New Guinea Research Bulletin, no. 55. Port Moresby and Can-
 berra: New Guinea Research Unit, Australian National Univer-
 sity.
1978 Women and Power in Nagovisi Society. *Journal de la Société des
 Océanistes* 34(60):119–126.
1981 Sex, Money, and the Status of Women in Aboriginal South
 Bougainville. *American Ethnologist* 8:107–126.

Newman, Philip L.
1965 *Knowing the Gururumba.* New York: Holt, Rinehart and Winston,
 Inc.

O'Brien, Denise
n.d. Images of Women in the South Seas. Manuscript.

Ogan, Eugene
1972 *Business and Cargo: Socio-Economic Change among the Nasioi of
 Bougainville.* New Guinea Research Bulletin, no. 44. Port
 Moresby and Canberra: New Guinea Research Unit, Australian
 National University.

Oliver, Douglas L.
1949 Land Tenure in Northeast Siuai, Southern Bougainville, Solo-
 mon Islands. In *Studies in the Anthropology of Bougainville, Solomon
 Islands.* Papers of the Peabody Museum of American Archaeol-
 ogy and Ethnology 29(4):3–97. Cambridge: Harvard University,
 Peabody Museum.
1955 *A Solomon Island Society: Kinship and Leadership among the Siuai of
 Bougainville.* Reprint. Boston: Beacon Press, Inc., 1967.

Olssen, Erik
[1978] The Plunket Society and Its Ideology, 1907–1942. Unpublished
 manuscript in J. Boutilier's possession.

O'Reilly, Patrick
1969 *Le Tahiti Catholique.* Dossier 5. Paris: Société des Océanistes.

Ortner, Sherry B.
1973 On Key Symbols. *American Anthropologist* 75:1338–1346.
1974 Is Female to Male as Nature Is to Culture? In *Woman, Culture,
 and Society,* ed. Michelle Zimbalist Rosaldo and Louise Lam-
 phere, pp. 67–87. Stanford: Stanford University Press.

Pacific Islands Monthly
1964 Sydney.

Panoff, Michel
1977 Suicide and Social Control in New Britain. *Bijdragen Tot de*

Taal-, Land- en Volkenkunde 133:44–62.

PCC News
1978– Suva, Fiji: Pacific Conference of Churches.
1979

Pearson, W. H.
1969 European Intimidation and the Myth of Tahiti. *Journal of Pacific History* 4:199–217.

Pilhofer, Georg
1961– *Die Geschichte der Neuendettelsauer Mission in Neuguinea.* 3 vols.
1963 Neuendettelsau, Deutsche Bundeszepublik: Freimund-Verlag.

Pineau, André
1934 *Marie-Thérèse Noblet, Servante de Notre-Seigneur en Papouasie, 1889–1930.* Issoudun, Indre: Archiconfrerie de N. -D. du Sacré-Coeur.

Pospisil, Leopold
1978 *The Kapauku Papuans of West New Guinea.* 2d ed. New York: Holt, Rinehart and Winston, Inc.

Powdermaker, Hortense
1933 *Life In Lesu: The Study of a Melanesian Society in New Ireland.* London: Williams and Norgate, Ltd.

Price, Archibald Grenfell
1939 *White Settlers in the Tropics.* Special Publication, no. 23. New York: American Geographical Society.

Quinn, Naomi
1977 Anthropological Studies on Women's Status. In *Annual Review of Anthropology, Volume VI*, ed. Bernard J. Siegel, pp. 181–225. Stanford: Stanford University Press.

Rabinow, Paul
1977 *Reflections on Fieldwork in Morocco.* Berkeley, Los Angeles, London: University of California Press, Quantum Books.

Ralston, Caroline
1977 *Grass Huts and Warehouses: Pacific Beach Communities of the Nineteenth Century.* Canberra: Australian National University Press.

Randell, Shirley K.
1975 United for Action. Women's Fellowships: An Agent of Change in Papua New Guinea. *Point*, no. 2, pp. 118–131. Goroka, Papua New Guinea: Melanesian Institute for Pastoral and Socio-Economic Service.

Rapp, Rayna
1979 Review Essay: Anthropology. *Signs: Journal of Women in Culture and Society* 4:497–513.

Read, Kenneth E.
 1952 Nama Cult of the Central Highlands, New Guinea. *Oceania*
 23:1–25.
 1965 *The High Valley*. New York: Charles Scribner's Sons.
Reay, Marie
 1959 *The Kuma: Freedom and Conformity in the New Guinea Highlands.*
 Melbourne: Melbourne University Press, for the Australian Na-
 tional University.
 1975 Politics, Development, and Women in the Rural Highlands.
 Administration for Development 5:4–12.
Reiter, Rayna R.
 1975a Introduction. In *Toward an Anthropology of Women*, ed. Rayna
 R. Reiter, pp. 11–19. New York: Monthly Review Press.
 1975b Men and Women in the South of France: Public and Private
 Domains. In *Toward an Anthropology of Women*, ed. Rayna R.
 Reiter, pp. 252–282. New York: Monthly Review Press.
 1977 The Search for Origins: Unraveling the Threads of Gender
 Hierarchy. *Critique of Anthropology* 3(9–10):5–24.
Rogers, Garth
 1977 'The Father's Sister is Black': A Consideration of Female Rank
 and Powers in Tonga. *Journal of the Polynesian Society* 86:157–182.
Rosaldo, Michelle Zimbalist
 1974 Woman, Culture, and Society: A Theoretical Overview. In
 Woman, Culture, and Society, ed. Michelle Zimbalist Rosaldo and
 Louise Lamphere, pp. 17–42. Stanford: Stanford University
 Press.
Rosaldo, Michelle Zimbalist, and Jane Monnig Atkinson
 1975 Man the Hunter and Woman: Metaphors for the Sexes in Ilongot
 Magical Spells. In *The Interpretation of Symbolism*, ed. Roy Willis,
 pp. 43–75. New York: John Wiley and Sons, Inc., Halsted Press.
Ross, Harold M.
 1973 *Baegu: Social and Ecological Organization in Malaita, Solomon Islands.*
 Illinois Studies in Anthropology, no. 8. Urbana: University of
 Illinois Press.
Rubel, Paula G., and Abraham Rosman
 1978 *Your Own Pigs You May Not Eat: A Comparative Study of New
 Guinea Societies*. Chicago: University of Chicago Press.
Ruby, Jay, ed.
 1982 *A Crack in the Mirror: Reflexive Perspectives in Anthropology.*
 Philadelphia: University of Pennsylvania Press.
Sacks, Karen
 1975 Engels Revisited: Women, the Organization of Production, and

Private Property. In *Toward an Anthropology of Women*, ed. Rayna R. Reiter, pp. 211–234. New York: Monthly Review Press.

1976 State Bias and Women's Status. *American Anthropologist* 78:565–569.

Sahlins, Marshall D.

1962 *Moala: Culture and Nature on a Fijian Island.* Ann Arbor: University of Michigan Press.

Salisbury, Richard F.

1956 Asymmetrical Marriage Systems. *American Anthropologist* 58:639–655.

1962*a* *From Stone to Steel: Economic Consequences of a Technological Change in New Guinea.* Victoria: Melbourne University Press, for The Australian National University.

1962*b* Early Stages of Economic Development in New Guinea. *Journal of the Polynesian Society* 71:328–339.

1970 *Vunamami: Economic Transformation in a Traditional Society.* Berkeley, Los Angeles, London: University of California Press.

Samoan Church (LMS)

1958 The Commission. Duplicated Report of the Commission Appointed 1952 to Review the Life and Work of the Church. Mimeographed. Apia: Congregational Christian Church of Samoa.

Sanday, Peggy R.

1974 Female Status in the Public Domain. In *Woman, Culture, and Society*, ed. Michelle Zimbalist Rosaldo and Louise Lamphere, pp. 189–206. Stanford: Stanford University Press.

Saunders, Kay

1980 Melanesian Women in Queensland, 1863–1907: Some Methodological Problems Involving the Relationship between Racism and Sexism. *Pacific Studies* 4:26–44.

Savage, Candace

1976 *A Harvest Yet to Reap: A History of Prairie Women.* Toronto: The Women's Press.

Scheffler, Harold W.

1965 *Choiseul Island Social Structure.* Berkeley and Los Angeles: University of California Press.

Schlegel, Alice

1972 *Male Dominance and Female Autonomy: Domestic Authority in Matrilineal Societies.* New Haven: Human Relations Area Files, Inc.

Schneider, Albert

1976 Tahiti: Membres de l'Église, Diacres, Pasteurs. *Journal des Missions Évangéliques* 151:147–157.

Schneider, David M.
 1961 Introduction: The Distinctive Features of Matrilineal Descent Groups. In *Matrilineal Kinship*, ed. David M. Schneider and Kathleen Gough, pp. 1–29. Berkeley and Los Angeles: University of California Press.
 1968 *American Kinship: A Cultural Account*. Englewood Cliffs, New Jersey: Prentice-Hall, Inc.

Schoeffel, Penelope
 1977 The Origin and Development of Women's Associations in Western Samoa, 1830–1977. *Journal of Pacific Studies* 3:1–21. Suva, Fiji: University of the South Pacific, School of Social and Economic Development.

Scholte, Bob
 1972 Toward a Reflexive and Critical Anthropology. In *Reinventing Anthropology*, ed. Dell Hymes, pp. 430–457. New York: Random House, Inc., Vintage Books.

Schultze, V.
 1910 Decennial Review of Women's Work in German Samoa, 1900–1910. London: Council for World Mission Archives. Unpublished manuscript.

Schwimmer, Erik
 1973 *Exchange in the Social Structure of the Orokaiva: Traditional and Emergent Ideologies in the Northern District of Papua*. London: C. Hurst and Co., Ltd.

Seton, Georgina
 1978 Transcript of interview in J. Boutilier's possession.

Silverman, Elaine
 1978 Preliminaries to a Study of Women in Alberta, 1890–1929. *Canadian Oral History Association*, pp. 22–26. Ottawa: Canadian Oral History Association.

Slater, Mariam K.
 1976 *African Odyssey: An Anthropological Adventure*. Garden City, New York: Doubleday and Co., Inc., Anchor Books.

South Pacific Commission
 1967 Background of Women's Interests Work in the South Pacific Region and the Foundation of the SPC Community Education Training Centre. Suva, Fiji: Community Education Training Center. Manuscript.

Souvenir
 1964 *Souvenir of the First Fiji Methodist Conference, July 1964*. Suva, Fiji: Methodist Church in Fiji.

Spindler, George, and Louise Spindler, eds.
1978 Foreword to *The Kapauku Papuans of West New Guinea*, by Leopold
 Pospisil, pp. v–vi. 2d ed. New York: Holt, Rinehart and
 Winston, Inc.
Stember, Charles H.
1976 *Sexual Racism: The Emotional Barrier to an Integrated Society*. New
 York: Elsevier.
Strathern, Andrew
1970 The Female and Male Spirit Cults in Mount Hagen. *Man* (n.s.)
 5:571–585.
1971 *The Rope of Moka: Big-Men and Ceremonial Exchange in Mount
 Hagen, New Guinea*. Cambridge: At the University Press.
1972 *One Father, One Blood: Descent and Group Structure among the Melpa
 People*. London: Tavistock Publications, Ltd.
1975 Why is Shame on the Skin? *Ethnology* 14:347–356.
1977 Melpa Food-Names as an Expression of Ideas on Identity and
 Substance. *Journal of the Polynesian Society* 86:503–511.
1979a 'It's His Affair': A Note on the Individual and the Group in
 New Guinea Highlands Societies. *Canberra Anthropology* 2:98–
 113.
1979b Men's House, Women's House: The Efficacy of Opposition,
 Reversal, and Pairing in the Melpa *Amb Kor* Cult. *Journal of the
 Polynesian Society* 88:37–51.
1982 The Division of Labor and Processes of Social Change in Mount
 Hagen. *American Ethnologist* 9:307–319.
Strathern, Marilyn
1968 *Popokl*: The Question of Morality. *Mankind* 6:553–562.
1972 *Women in Between. Female Roles in a Male World: Mount Hagen,
 New Guinea*. London: Seminar Press.
1975 *No Money on Our Skins: Hagen Migrants in Port Moresby*. New
 Guinea Research Bulletin, no. 61. Port Moresby and Canberra:
 New Guinea Research Unit, Australian National University.
1978 The Achievement of Sex: Paradoxes in Hagen Gender-Think-
 ing. In *Yearbook of Symbolic Anthropology*, vol. 1, ed. Erik Schwim-
 mer, pp. 171–202. Montreal: McGill-Queen's University Press.
1980 No Nature, No Culture: The Hagen Case. In *Nature, Culture,
 and Gender*, ed. Carol P. MacCormack and Marilyn Strathern,
 pp. 174–222. Cambridge: Cambridge University Press.
1981a Culture in a Netbag: The Manufacture of a Sub-Discipline in
 Anthropology. *Man* (n.s.)16:665–688.
1981b Self-interest and the Social Good: Some Implications of Hagen

Gender Imagery. In *Sexual Meanings: The Cultural Construction of Gender and Sexuality*, ed. Sherry B. Ortner and Harriet Whitehead, pp. 166–191. Cambridge: Cambridge University Press.

Streit, Robert, and Johannes Dindinger
1955 *Missionsliteratur von Australien und Ozeanien, 1525–1950.* Bibliotheca Missionum, vol. 21. Freiburg: Herder.

Strong, Philip N. W.
1947 *Out of Great Tribulation.* The Presidential Address and Charge of the Right Reverend Philip Nigel Warrington Strong, M.A., Bishop of New Guinea, to his Diocesan Conference at Dogura, Papua, on Monday, June 30, 1947. East Cape, Papua: R. V. Grant.

Suárez, J. R.
1921– Letters. In *Cartas de la Provincia de León.* Vols. 3–4. Camillas,
1922 Spain.

Theile, Kenneth
1957 Annual Report, Kewamugl Bible School. Mimeo. Copy located at Nomane Lutheran Mission, Chibu (Simbu Province).

Tiffany, Sharon W.
1978a Models and the Social Anthropology of Women: A Preliminary Assessment. *Man* (n.s.) 13:34–51.
1978b Introduction. In *Mission, Church, and Sect in Oceania*, ed. James A. Boutilier, Daniel T. Hughes, and Sharon W. Tiffany, pp. 301–305. ASAO Monograph, no. 6. Ann Arbor: University of Michigan Press.
1978c The Politics of Denominational Organization in Samoa. In *Mission, Church, and Sect in Oceania*, ed. James A. Boutilier, Daniel T. Hughes, and Sharon W. Tiffany, pp. 423–456. ASAO Monograph, no. 6. Ann Arbor: University of Michigan Press.
1979a Introduction: Theoretical Issues in the Anthropological Study of Women. In *Women and Society: An Anthropological Reader*, ed. Sharon W. Tiffany, pp. 1–35. Montreal: Eden Press, Women's Publications.
1979b Women, Power, and the Anthropology of Politics: A Review. *International Journal of Women's Studies* 2:430–442.
1982a The Power of Matriarchal Ideas. *International Journal of Women's Studies* 5:138–147.
1982b *Women, Work, and Motherhood: The Power of Female Sexuality in the Workplace.* Englewood Cliffs, New Jersey: Prentice-Hall, Inc., Spectrum Books.
1982c Women in Cross-Cultural Perspective: A Guide to Recent An-

thropological Literature. *Women's Studies International Forum* 5(5): 497–502.

1983 Customary Land Disputes, Courts, and African Models in the Solomon Islands. *Oceania* 53:277–290.

n.d. Feminist Paradigms and Anthropological Discourse: Reflections on Cross-Cultural Knowledge of Gender, Sex, and Power. Manuscript.

Tiffany, Sharon W., and Kathleen J. Adams

1984 *The Wild Woman: An Inquiry into the Anthropology of an Idea.* Cambridge, Mass.: Schenkman Publishing Co., Inc.

Tomlin, James W. S.

1957 *Awakening: A History of the New Guinea Mission.* London: New Guinea Mission.

Tudor, Judy

1966 *Many a Green Isle.* Sydney: Pacific Publications.

Turner, Mrs. R. L.

1917 Wife Training in Papua. *The Chronicle of the London Missionary Society* 82:162–163.

Ullrich, Helen E.

1977 Caste Differences Between Brahmin and Non-Brahmin Women in a South Indian Village. In *Sexual Stratification: A Cross-Cultural View*, ed. Alice Schlegel, pp. 94–108. New York: Columbia University Press.

Vie Protestante

1966 *La Vie Protestante. Journal Mensuel de L'Église Evangélique en Nouvelle Calédonie et aux Îles Loyauté.* Noumea, New Caledonia: Evangelical Church of New Caledonia and the Loyalty Islands.

Villeroy de Galhau, Jehanne

1967 *Vingt-Trois Filles Papoues, Mère Solange Bazin de Jessey, Ancelle de Notre-Seigneur en Papouasie, 1906–1942.* Mulhouse: Editions Salvator. Paris: Tournai, Casterman.

Voget, Fred W.

1975 *A History of Ethnology.* New York: Holt, Rinehart & Winston.

Wagner, Roy

1977 Speaking for Others: Power and Identity as Factors in Daribi Mediumistic Hysteria. *Journal de la Sociétié des Océanistes* 33 (56–57):145–152.

Wallace, Anthony F. C.

1961 *Culture and Personality.* New York: Random House, Inc.

Wallman, Sandra

1978 Epistemologies of Sex. In *Female Hierarchies*, ed. Lionel Tiger and Heather T. Fowler, pp. 21–59. Chicago: Beresford Book

and Subscription Service.

1979 Introduction. In *Social Anthropology of Work*, ed. Sandra Wallman, pp. 1–24. ASA Monograph, no. 19. London: Academic Press, Inc.

Wax, Rosalie H.
1979 Gender and Age in Fieldwork and Fieldwork Education: No Good Thing is Done by Any Man Alone. *Social Problems* 26:509–522.

Weiner, Annette B.
1976 *Women of Value, Men of Renown: New Perspectives in Trobriand Exchange*. Austin: University of Texas Press.
1978 The Reproductive Model in Trobriand Society. *Mankind* 11:175–186.
1980 Reproduction: A Replacement for Reciprocity. *American Ethnologist* 7:71–85.

Wench, Ida
1961 *Mission to Melanesia*. London: Elek Books.

Western Pacific High Commission (WPHC)
 Inwards Correspondence (WPHC, IC). Files located in the National Archives, Honiara, Solomon Islands. (The date of each piece of correspondence and its appropriate file number are included in the text.)

Wetherell, David
1980 Pioneers and Patriarchs: Samoans in a Nonconformist Mission District in Papua, 1890–1917. *Journal of Pacific History* 15:130–154.

Whiting, John W. M.
1941 *Becoming a Kwoma: Teaching and Learning in a New Guinea Tribe*. New Haven: Yale University Press, for the Institute of Human Relations.

Whyte, Martin King
1978*a* *The Status of Women in Preindustrial Societies*. Princeton: Princeton University Press.
1978*b* Cross-Cultural Studies of Women and the Male Bias Problem. *Behavior Science Research* 13:65–80.

Williams, Ronald G.
1972 *The United Church in Papua, New Guinea, and the Solomon Islands*. Rabaul, New Britain: Trinity Press.

Williamson, R. W.
1937 *Religion and Social Organization in Central Polynesia*. Edited by Ralph Piddington. Cambridge: Cambridge University Press.

Wilson, Ellen
 [1936] White Women Workers and Their Work. In *The Church in Melanesia*, ed. Stuart W. Artless, pp. 39–50. Westminster, England: Melanesian Mission.

Wolfers, Edward P.
 1975 *Race Relations and Colonial Rule in Papua New Guinea.* Sydney: Australia and New Zealand Book Co.

Woodcock, George
 1969 *The British in the Far East.* London: Weidenfeld and Nicolson.

Woods, Christine
 1978 Transcript of interview in J. Boutilier's possession.

Word in the World
 1969 *The Word in the World, 1969. Divine Word Missionaries. Special Issue, New Guinea: A Report on the Missionary Apostolate.* Techny, Illinois: Divine Word Publications.

Wright, Denis
 1980 English Memsahibs in Persia. *History Today* 30 (September): 7–13.

Yanagisako, Sylvia Junko
 1979 Family and Household: The Analysis of Domestic Groups. *Annual Review of Anthropology, Volume VIII*, ed. Bernard J. Siegel, pp. 161–205. Stanford: Stanford University Press.

Young, Florence S. H.
 [1925] *Pearls from the Pacific.* London: Marshall Brothers, Ltd.

Young, Michael W.
 1971 *Fighting with Food: Leadership, Values, and Social Control in a Massim Society.* Cambridge: Cambridge University Press.

Contributors

James A. Boutilier is associate professor of history at Royal Roads Military College and adjunct professor of Pacific Studies at the University of Victoria, Victoria, British Columbia. He attended Birkbeck College, University of London, (Ph.D. 1969) and taught at the University of the South Pacific (1969 to 1971) before taking up his present appointment. He has undertaken extensive historical research in Fiji and the Solomon Islands, has served as the editor of *Mission, Church, and Sect in Oceania*, and has edited *The Royal Canadian Navy in Retrospect*.

Dorothy Ayers Counts received her Ph.D. from Southern Illinois University in 1968 and is now associate professor of anthropology at the University of Waterloo, Waterloo, Ontario. She conducted fieldwork in northwest New Britain, Papua New Guinea in 1966–1967, 1971, 1975–1976, and 1981. Her extensive publications include contributions to various journals and collections of essays and two monographs, *Middlemen and Brokers in Oceania* (1982), A.S.A.O. Monograph No. 9, coedited with William Rodman, and *The Tales of Laopu*, a collection of stories from northwest New Britain, published in Tok Pisin and English by the Institute of Papua New Guinea Studies.

Charles W. Forman is professor of missions at Yale University Divinity School. His work in Oceania is primarily related to the development of theological education, and he has made numerous visits to the Pacific. Forman has also studied the growth of independent church life in Oceania and is the author of *The Island Churches of the South Pacific: Emergence in the Twentieth Century* (1982). He received his Ph.D. from the University of Wisconsin.

Jill Nash received her Ph.D. in social anthropology at Harvard University. She has spent a total of two and one-half years among the Nagovisi of Papua New Guinea. Nash worked as a research fellow at the New Guinea Research Unit of the Australian National University, and is currently an associate professor of anthropology and coordinator of women's studies at the State University College at Buffalo, New York. Among her publications are *Matriliny and Modernization*, and various articles, including "Sex, Money, and the Status of Women in Aboriginal South Bougainville."

Nancy McDowell received her Ph.D. from Cornell University in 1975, and is now associate professor of anthropology at Franklin and Marshall College in Lancaster, Pennsylvania. She has done intensive field research in

Bun and written several articles on this society. She is currently doing comparative work on the Bun, Mundugumor, and other Yuat River peoples of Papua New Guinea.

Denise O'Brien is associate professor of anthropology at Temple University in Philadelphia, Pennsylvania. She received a Ph.D. in anthropology from Yale University. O'Brien did fieldwork with the Konda Valley Dani of Irian Jaya (1961–1963, 1976) and coedited *Blood and Semen: Kinship Systems of Highland New Guinea*. She has also done research in Africa (1976, 1979) and India (1980). Her current interests include women and development and the relationship between ethnography and other literary genres.

Lorraine Dusak Sexton received a Ph.D. in anthropology from Temple University (1980). She conducted fieldwork in Papua New Guinea in 1976–1978 and 1980–1981. As a visiting research fellow at the Papua New Guinea Institute of Applied Social and Economic Research in 1980–1981, she studied the social impact of alcohol use and continued her research on rural women's associations. She has also done research in India (1980) and has been a consultant to UNICEF. Sexton is currently a research associate at the Philadelphia Health Management Corporation, where she is working on a research project about health care in Philadelphia neighborhoods. Her publications include "*Wok Meri*: A Women's Savings and Exchange System in Highland Papua New Guinea," *Oceania* (1982) and "New Beer in Old Bottles: A Community Club and Politics in the Daulo Region, Papua New Guinea," in *Through a Glass Darkly: Beer and Modernization in Papua New Guinea*, edited by Mac Marshall, Boroko: IASER (1982).

Marilyn Strathern received her M.A. and Ph.D. from Cambridge University and is currently a fellow of Girton College, Cambridge. Her fieldwork in the Hagen area of the Papua New Guinea Highlands began in 1964 and included several visits as research fellow of the then New Guinea Research Unit (A.N.U.). She has also done research in Wiru (Southern Highlands) and Port Moresby. Her first book, *Women in Between* (1972) dealt with questions of male/female relations in Hagen, and she coedited a collection of essays entitled *Nature, Culture and Gender*. Strathern was editor of the journal, *Man*, and her most recent book is *Kinship at the Core: An Anthropology of Elmdon in Essex*.

Sharon W. Tiffany received her Ph.D. from the University of California, Los Angeles in 1972. She is currently professor of anthropology at the University of Wisconsin–Whitewater. She has conducted fieldwork in the Pacific and India and has written extensively about Oceanic anthropology and feminist studies. Her most recent book, *Women, Work, and Motherhood*, was published by Prentice-Hall in 1982. She has coauthored (with Kathleen J. Adams) *The Wild Woman: An Inquiry into the Anthropology of an Idea*.

Index

Abuse: passivity and, 80–82, 83; responses to, 75–82; of women, 3, 73, 74, 75–76, 84, 90
Africa, women in, 71, 95, 113–114
Alkire, William H., 67
Allen, Charles, 174, 189, 192
Allen, Percy S., 180
Almond trees, 106
American Board of Commissioners for Foreign Missions, 154
Anggo, David, 130, 149
Anglican church, 159, 162, 163, 171, 172
Anthropology: bias in, 14; on complementarity, 35–37; cross-cultural comparisons by, 14–15; feminism and, 2–3; in Melanesia, ix–x; women in, 2, 3–4, 5; on women, 2–3, 5–9, 14, 53–70
Ardener, Edwin, 6, 36, 45
Asaroka Lutheran Mission, 130, 131–132, 133, 144
Ashley, Mrs. F. Noel, 175, 188
Atkinson, Jane M., 41, 43
Austral Islands, 160
Autonomy: in personhood, 43, 44, 45, 46; of women, 26–27, 31, 44, 97, 111, 113
Axes, 62, 63, 131, 132, 136

Baegu, 111
Banoni-Nagovisi Producers' Society, 105, 116
Barker, Miss E. T., 191
Bateson, Gregory, 34, 35, 43
Beaglehole, Ernest, 160
Beil, Barry, 134
Bena Bena, 96
Bergmann, H. F. W., 147–148
Bergmann, Irmgard, 157
Berndt, Ronald M., 74
Blackwood, Beatrice, 58, 102
Blake, Frances, 175, 176–177, 190, 191, 195, 197
Bolton, Geoffrey C., 180, 181
Boserup, Ester, 95, 119
Bougainville. See Nagovisi; Papua New Guinea; Solomon Islands
Boutilier, James A., 10, 181, 182
Brereton, Virginia L., 172

Bride-price, 59, 132; money for, 134, 143; pigs for, 143; in Wok Meri, 121, 126, 127
Brookfield, Harold C., 95–96, 98–99
Brown, Paula, 73, 111
Buin, 112, 113, 116–117
Bujra, Janet M., 8
Buka Island, 102
Bun, Papua New Guinea, 6, 37–52; child care among, 40; cross-cousins among, 47, 48–51, 52; domestic/public dichotomy in, 40, 41; femaleness concept of, 41, 44; fishing among, 37, 39, 41, 47; formal exchanging by, 45, 46–47, 48, 49, 50; hunting among, 38–39, 41; maleness concept of, 41, 44; marriage among, 40, 46, 47–48, 49–50, 51, 52; personhood concept of, 43–44, 45, 46, 51, 52; reciprocity among, 44, 45–51; relationships among, 45–51, 52; sexual division of labor by, 38–41; sharing by, 45–46, 48, 49, 50
Burrows, Edwin G., 68

Calvert, Mrs. Ken, 192
Caroline Islands, 67, 166
Cash crops, 8; in Buin, 116–117; coffee as, 143, 145; cocoa as, 94, 98,103–105, 106, 107, 115–116; and land use, 106, 107, 116–117; Nagovisi, 98, 103–105, 106, 115–116, 117; and social change, 116–117
Catholicism, 154, 159, 160, 171, 172; indigenous priests in, 167–168, 170; indigenous women in, 165–168; missionaries (nuns) of, 9, 158, 165–168, 181; in Papua New Guinea, 154–155; in Solomons, 181
Celibacy, 165
Central Protestant Theological College, 170
Chambri, 34
Childbirth: anthropological interest in, 64, 68; for European women, 193–194; women defined by, 17–18 n. 3, 19
Chimbu, 73, 74, 92, 147–148
Choiseulese, 58–60
Christianity, 154; changes women's roles, 155, 156–157; in Papua New Guinea, 120, 130, 132–133. See also Anglican church; Catholi-

Designer: UC Press Staff
Compositor: Prestige Typography
Printer: Braun-Brumfield, Inc.
Binder: Braun-Brumfield, Inc.
Text: 10/12 Janson
Display: Janson and Helvetica